Let Us Now Praise Famous Men at 75

Let
Us
Now
Praise
Famous Men
at 75

ANNIVERSARY ESSAYS
EDITED BY MICHAEL A. LOFARO

Anne Bertrand's "Evans's Portrait in Words: A Descriptive History of 'James Agee
in 1936'" was originally written in French and has been translated here by John
Doherty. It appeared in its original language in *Trafic* 97 (Spring 2016).
The Walker Evans photographs in Erik Kline's "'Curious, Obsecene, Terrifying,
and Unfathomably Mysterious': *Let Us Now Praise Famous Men* and Cultural
Freakery" are reprinted by permission. © Walker Evans Archive, The Metropolitan
Museum of Art.

Library of Congress Cataloging-in-Publication Data

Names: Lofaro, Michael A., 1948– editor.
Title: Let us now praise famous men at 75: anniversary essays / edited by
 Michael A. Lofaro.
Description: Knoxville: University of Tennessee Press, 2017. | Includes
 bibliographical references and index.
Identifiers: LCCN 2016032577 | ISBN 9781621902614 (hardback)
Subjects: LCSH: Agee, James, 1909–1955. Let us now praise famous men. | Agee, James,
1909-1955—Criticism and interpretation. | Evans, Walker, 1903–1975—Criticism and
interpretation. | BISAC: LITERARY COLLECTIONS / American / General.
Classification: LCC PS3501.G35 Z765 2017 | DDC 818/.5209—dc23
LC record available at https://lccn.loc.gov/2016032577

For Nancy, Ellen, Christopher, and Helen

Contents

Contents

(Topical)

Introduction

Leading to *Let Us Now Praise Famous Men*

Contemporaries/Inheritors of *Let Us Now Praise Famous Men*

More Views and Re-Views of *Let Us Now Praise Famous Men*

Postscript

Acknowledgments

I wish to thank all the authors who contributed to this volume for the variety of interesting and provocative approaches that they have brought to bear on Agee and Evans's *Let Us Now Praise Famous Men*. It has been a pleasure to work with them. I also wish to thank the trustees of the Better English Fund established by the late John C. Hodges of the Department of English, the College of Arts and Sciences, and the Office of Research, all of the University of Tennessee, for their support and the Rev. Paul Sprecher, the trustee of The James Agee Trust, both for the permission necessary to reproduce the Agee materials treated by the authors in this volume, and for his unstinting encouragement of scholarship on and around James Agee. The staff members of the University of Tennessee's Special Collections division and of the University of Texas's Humanities Research Center have graciously given of their time and expertise in regard to their holdings. And finally, I thank my wife, Nancy, for the loving support that helped this volume come to fruition.

"This was first one trip, not like any other"
An Introduction

Michael A. Lofaro

While neither quite rabbit hole nor wormhole, it does seem that a reader's first experience with James Agee's and Walker Evans's *Let Us Now Praise Famous Men* is meant to introduce an altered state. Whether it is Evans's purposefully uncaptioned photographs that come before any other front matter in the book including the title page, or Agee's experimental and at times almost impenetrably layered prose, it does seem wise to consider the King's advice to the White Rabbit in *Alice's Adventures in Wonderland* to "Begin at the beginning." And in approaching seventy-five years of reading and analyzing *Famous Men*, perhaps it is best to continue to follow his majesty's subsequent grave admonition "to go on till you come to the end: then stop"[1] in each individual's engagement with this notoriously elusive photo-text. At the very least that immersion will echo what Agee and Evans attempted to do in their time in Hale County, Alabama, and then what Agee attempted to translate into the printed word.

The task Agee set himself proved a difficult one, one to him marked by ongoing struggle, accommodation, and capitulation. His problems are more than evident in his comments in his manuscript journals for *Famous Men*:

> Once I decided a preface would be necessary, it took three months to find I couldn't write the one I wanted to. So this will have to do instead: a few words on what this book is and is not, and on how it got started.
>
> For three or four months now it has seemed to me that in twenty-five hundred words or so I could unify and make clear

everything about this book that I wanted to or needed to. I have pretty well given that up now. I will be more than content if in any form I can get done a few of the essentials: information, directives, false scents, and so on.[2]

While the years have shown that the achievements of *Famous Men* far exceed Agee's worried statements, its initial impact was less than stellar, with only approximately six hundred copies selling in the 1940s before it was remaindered. The cultural context of World War II and its aftermath, with its emphasis upon traditional values and quest for stability, did little to enhance the appeal of an avant-garde, idiosyncratic book that questioned those values and was further challenged by its author's egocentric, self-reflexive prose. Fallow in the 1950s, sales of *Famous Men* exploded when reissued in 1960, and for many it became one of the core texts for young participants in the civil rights movement and the war on poverty. Robert Coles, late *emeritus* professor of psychiatry and medical humanities at Harvard, gives one of the best descriptions of that moment:

> I remember not only buying *Let Us Now Praise Famous Men*
> at that time [1960] but seeing many others do so. I remember
> finding copies of the book in hardcover, no less, all over the
> South. And I especially remember copies of the book in Freedom
> Houses, as we called them in the summer of 1964, during the
> Mississippi Summer Project, an effort by young Americans of
> both races to bring voter registration to the steadfastly segrega-
> tionist Delta. In Canton, Mississippi; in Greenwood, Mississippi;
> in Yazoo City, Mississippi; on a table, on the floor, on a bed, on a
> chair; read by white, well-to-do students from Ivy League colleges
> but read as well by black students from the North and from the
> South—it was a bible of sorts, at least for a while, a sign, a symbol,
> a reminder, an eloquent testimony that others had cared, had
> gone forth to look and hear, and had come back to stand up and
> address their friends and neighbors and those beyond personal
> knowing.[3]

While the original intent of the creators of *Famous Men* was not to attack disenfranchisement or poverty directly, what they produced, much like Harriet Beecher Stowe's *Uncle Tom's Cabin* and its portrayals of the slave-holding system, had social consequences beyond what they might have imagined by profoundly affecting their readers. The essayists of this volume are such readers who bring their own varied experiences and considerable talents to bear on Agee and Evans's work to discuss its origins, parallels, influence, and impact.

To foreground these new views, it seems wise to build upon an abbreviated version of its beginnings (more context is available in the subsequent section of the present work, entitled "The History of *Let Us Now Praise Famous Men*"), and then to reconsider excerpts both from Agee's published preface of 1941 and from an early manuscript draft addressing how he conceived of his experience and the narrative he hoped to construct from it. The history begins with Agee on assignment for *Fortune* magazine's Life and Circumstances series and his traveling by train on June 22 from New York City to Chattanooga, Tennessee, where he rents a car and drives to Birmingham then Montgomery, Alabama, where Evans joins him. Agee had requested Evans as his photographer, and Evans had a received a temporary leave from his New Deal Resettlement Administration job (absorbed by the Farm Security Administration when it was created the following year) with the stipulation that any photographs that he took become government property. For the next four and one half weeks, Agee and Evans met with contacts associated with various New Deal agencies and traveled around Alabama searching for a "representative" family of white sharecroppers, finally settling on the Tingle, Fields, and Burroughs families in Mills Hill in Hale County, Alabama, as their subjects. Agee lived with the Burroughs family for three and a half weeks while Evans preferred a hotel, and both returned to New York City in late August. The editors at *Fortune*, however, rejected the article Agee submitted. Houghton Mifflin finally published *Let Us Now Praise Famous Men* in 1941, after winning the famous battle that Agee had to delete all the words that would be banned in Boston, and, while many reviewers commented favorably on Evans's photographs, only Agee's friends and Lionel Trilling saw great value in Agee's prose. The failure of his work likely spurred on Agee's decision to

become a film critic the following year. Had not editor David McDowell published his altered version of Agee's *A Death in the Family* in 1957, two years after the writer's death, a work which won the Pulitzer Prize for Fiction the next year, *Famous Men* would likely not have been republished in 1960. Added to the original edition was a remembrance by Walker Evans entitled "James Agee in 1936." Evans also increased the total number of photographs from thirty-one to sixty-two, and replaced some of the original ones. The "failed" book of 1941, redone in 1960, has never been out of print since that point and created much new interest in both artists' work. It is, in fact, the bestselling of Agee's works.

Agee's hopes and plans for the narrative of *Famous Men* revealed its intended complexity. He says in the preface to the book that his 1936 assignment from *Fortune* magazine was

> rather a curious piece of work. It was our business to prepare, for a New York magazine, an article on cotton tenantry in the United States, in the form of a photographic and verbal record of the daily living and environment of an average white family of tenant farmers. . . .
>
> More essentially, this [effort] is an independent inquiry into certain nominal predicaments of human divinity. . . .
>
> Ultimately, it is intended that this record and analysis be exhaustive, with no detail, however trivial it may seem, left untouched. . . .
>
> Since it is intended, among other things, as a swindle, an insult, and a corrective, the reader will be wise to keep the nominal subject, and his expectation of its proper treatment, steadily in mind. . . .
>
> The photographs are not illustrative. They, and the text, are co-equal, mutually independent, and fully collaborative. . . . It was intended also that the text be read continuously, as music is listened to or a film watched, with brief pauses only where they are self-evident. . . .
>
> This is a *book* only by necessity. More seriously, it is an effort in human actuality, in which the reader is no less centrally involved than the authors and those of whom they tell. . . .[4]

Fortunately, Agee's innermost thoughts at the beginning in his process of creating the earliest draft of *Famous Men* are also described in his handwritten journals. It is worth quoting in full.

> This was first one trip, not like any other. By this time I had been on many trains and many trips, so there was nothing new to me about it; a basic feeling was one of being back in the old rut.
>
> In this sort of pleasure and excitement, I must try & set up the state of mind.
>
> It is calm, in a sense, and relatively light and agile. Your mind and senses are working hard, clear, and very seriously, yet their vigilance is not solemn but is a vigilance similar to that a young man walking a street has for the girls he sees: a vigilance which checks on everything immediately.
>
> There is a certain, definite amount of narcissism in it. A sense of comedy. A thing which Hemingway has expressed and which comes under the influence of Hemingway. A certain cheapness about it if you like, but not by any means so cheap as you may think; for it is the avid, watchful, trained, economical eye partly of the artist and partly of the human being, more interested, in the course of its travels, in technic than in emotions. It is likely to be capable of developing something not far short of a sense of glory out of so simple an ache as sitting in a train or walking around a new or a once familiar city, or going in and ordering a drink, or reading a back number of Judge [weekly American satirical magazine (1881–1947)] in a club car, or acting in some way true to its present special and false to its essential situation. Yes it is certainly liable to streaks of smugness. For a certain amount of it depends on self-consciousness and on self-confidence. The satisfactory feeling you sometimes get of your body in your clothes, your way of walking, watching and speaking; a time when you trust yourself and your analysis; a state of mind which self-mistrust destroys sometimes for a worse and sometimes for a better. It is a state of mind which can be sustained through many that are "better" than it is; for there is much that is serious and solid about it.

All this started in New York. It took me suddenly by train to Chattanooga; by car south into Alabama, round and round and round, becoming more and more serious.

———

This is among other things a straight narrative. But it is not just a narrative, and is bound to break the rules of narrative time and again to give an account of things for their own sake.

An accounting of the train for instance in no way advances the narrative and indeed obstructs it.[5] By mere tricks the narrative could be given suspense: by lack of them it would sag. It will sag I think, for I am here more against tricks than for them.

I am telling it, much of it, from at least two planes at once. As it was when it happened: as it is now, thinking of it. This is liable to confuse. It was a chance of giving musical thickness; and it happens to be just that much nearer than the literal truth. Only by great skill in art could the latter result instead of the former. And entirely aside from my lack of such skill I don't at all know that I want to use it here.

Yet again, I do want to tell the "truth." And the truth was, that none of these things sagged or even confused each other; nor do they in my memory; but were continuously intense, exciting, full of suspense. So perhaps by every possible trick I should try to make them so here.

The picaresque state of mind: always intensified by situation.

This can so easily slacken into a dogged telling of things in the past because they happened.

A thing past is drawn almost immediately into a distance where it reappears all at once, economically, in the form of images and movements or odors or tastes: and these are as valid a part of the truth as the thing was in the extension of its present. As for instance: the tunnel image of the train. And: the train entering Bristol [Tennessee] in full dawn. And for that matter, actual detail, such as the drinks in the diner; getting off at Washington to phone Walker. Breakfast with Holt. Stopping in Knoxville. The southern air of the train & passengers. The summer heat.

There is a way of handling this in which its varieties and contradictions are rich direct and understandable and in which all their talk would be needless; the thing would be explaining itself.

Some use of third person.

Everything is extremely clear to me as images, incidents, essences.

The French word for perfume is wisely chosen, and is I think characteristic of the French.

What I am interested in is infinitely less myself than what by chance I saw. Such as the band concert in Chattanooga. And yet that requires—how much?—my presence and my feeling of amusement, joy and shyness. Espionage. Like watching lovemaking through a window, was nearly everything we did.

The constant presence of this one person I or he and of his feelings & of what he saw is bound to be maddeningly tiresome to a reader and even to me, writing it. This tiresomeness isn't true to the fact for my constant presence was to me neither tiresome nor necessarily exciting. The device is or should be chiefly the constant presence of a thinking & feeling camera. How can such a device be worked. I did not feel smug or self-interested: I was too busy and too interested in what I saw.

What I saw was so damned good at all times.

The way I saw it and the way I felt is just as significant as it is, too. It would be significant if I were God or a genius. It is significant also in that I was simply & exactly what I was.[6]

Agee thinking of himself as "the constant presence of a thinking & feeling camera" in his journal lines up well with the preceding excerpt noted above from his 1941 preface to *Famous Men* that "the reader is no less centrally involved than the authors and those of whom they tell." Walker Evans both clarified Agee's statements and revealed a bit of why they worked so well together in his 1971 taped interview with Leslie Katz. He said of Agee: "He didn't teach, he perceived; and that in itself was a stimulation. We all need that kind of stimulation, wherever it comes from. In a sense you test your work through it and it bounces

back strengthened. My work happened to be just the style and matter for his eye."[7] Similarly, Agee's use of prose, which Evans earlier described as "Sheer energy of imagination,"[8] seems much like Evans's use of his camera; the photographer says that "Something should be said through it, not by it. Your mood and message and point have to come through as well as possible. Your technique should be made to serve that, kept in place as a servant to that purpose."[9]

While these two friends and kindred spirits do share similar artistic visions, such unity contains many counterpoints, not the least of which is bound up in their intended revision of the standard take on the photojournalistic exposé of social problems during the Great Depression. Both Agee and Evans reject the maudlin approach to the plight of the poor and its exploitation by the media of the day, typified for them in *You Have Seen Their Faces* by Margaret Bourke-White and Erskine Caldwell,[10] the work most often compared to *Famous Men*, but do so by yoking together the unbridled romantic experimentalism of Agee's prose to the realism of Evans's stark, uncaptioned documentary photographs to attempt to elevate their human subjects and to render the material objects portrayed and described as art. That union in *Famous Men* is thus one of opposites, but the vision is the same. By exploring the contrast between the written word and the photographs, Agee and Evans engage in an almost mythic endeavor to catch and display the essential nature and universality of the human soul—both its divinity and predicaments.

And originally *Famous Men* was meant only to catch, not preserve or immortalize. It was Agee's wish at one point that their work be published on cheap newsprint paper to be sure it would decay and no trace of it would remain after a few years. Celebrating its seventy-fifth anniversary is therefore a trifle ironic, as is the fact that the essays in the present volume analyze as well as emotionally respond to the text, but the occasion does provide a starting point for new examinations of this now classic text at a particularly auspicious time. All the authors have been able to benefit from the new scholarly edition of *Famous Men* edited by Hugh Davis, which replicates the structure of the rare 1941 first edition, annotates it, facilitates its comparison with the somewhat altered 1960 edition (the text which has been reprinted through the pres-

ent day), and provides a wealth of other supplementary materials that were previously unavailable. It is itself a massive achievement and resource for understanding this most complex work.

The proof that *Famous Men* still engenders multifaceted stimulation and involvement of authors-subjects-readers is testified to by the sixteen essayists of this volume who are in fact those engaged, participating readers and viewers of whom Agee and Evans speak and who wish to share their experiences with a wider audience. Their work is presented in two ways, as noted by the dual tables of contents. The first is a more organic development, much like *Famous Men* itself; the second, one organized into main topics with, of course, some inevitable overlap. While in no sense a complete guide to *Famous Men*, their many and varied approaches provide the most comprehensive and wide-ranging view of the work to date. Ranging from appreciations to computational analyses with much literary, historical, journalistic, film, photographic, social, and cultural criticism in between, these essays illustrate some of the many new approaches and ways in which scholars respond to this photo-text at the present time and demonstrate the fascination and debate which *Let Us Now Praise Famous Men* still generates after seventy-five years.

NOTES

1. Lewis Carroll, *Alice's Adventures in Wonderland*, 1865, Chapter 12, Project Gutenberg, May 15, 2015 <http://www.gutenberg.org/>.

2. Michael A. Lofaro and Hugh Davis, eds., *James Agee Rediscovered: The Journals of* Let Us Now Praise Famous Men *and Other New Manuscripts* (Knoxville: U. of Tennessee P, 2005) jour. 6.3, 143. Also available in James Agee and Walker Evans, Let Us Now Praise Famous Men: *An Annotated Edition of the James Agee-Walker Evans Classic, with Supplementary Manuscripts*, ed. Hugh Davis, vol. 3 of *The Works of James Agee*, gen. eds. Michael A. Lofaro and Hugh Davis (Knoxville: U of Tennessee P, 2015) 800. Henceforth cited as Davis, *LUNPFM*.

3. Robert Coles, *Lives We Carry with Us: Profiles of Moral Courage* (New York: The New Press, 2010) 91. In an earlier collected volume, Coles again comments upon the impact of *Famous Men*, but in a somewhat different way:

> I remember seeing *Let Us Now Praise Famous Men* in the South during the civil rights movement in those 'Freedom Houses' in Mississippi, carried by students who went south in 1964 hoping to help register African-Americans to vote in the courthouses of the various counties in the Delta of Mississippi.

The book was there, a huge presence, and was being republished with a new life. I remember when Dr. King marched at the head of thousands, from Selma to Montgomery. This book was carried by people, white and black, in their knapsacks.

Robert Coles, *Handing One Another Along: Literature and Social Reflection*, ed. Trevor Hall and Vicki Kennedy (New York: Random House, 2010) 28.

4. Davis, *LUNPFM* vii–ix.

5. Lofaro and Davis, *James Agee Rediscovered* 3–7. The first section of journal 1 focuses upon Agee's evocative ruminations of his train trip from New York City to Chattanooga, Tennessee (3–7). The quoted pages constitute the second section of Agee's first journal, 7–10. For "Draft of the Introduction" to *Famous Men*, see jour. 6.3, 143–55. Drafts of three other sections follow.

6. Lofaro and Davis, *James Agee Rediscovered* 7–10. Comments clarifying Agee's words are included in brackets. For the original quotation, see also Davis, *LUNPFM* 767–69.

7. Leslie Katz, *Walker Evans: Incognito* (New York: Eakins Press Foundation, 1995) 10; the interview is also available as Leslie Katz, "Interview with Walker Evans," *Photography in Print: Writings from 1816 to the Present*, ed. Vicki Goldberg (Albuquerque: U of New Mexico P, 1981) 358–69. Agee's estimate of Evans's work was equally high: "Walker Evans, the photographer I mentioned in the memo, was in my opinion the best photographer alive," Lofaro and Davis, *James Agee Rediscovered* jour. 1.6, 18.

8. Walker Evans, "James Agee in 1936," a piece that serves as his foreword to the second edition of *Famous Men*, in James Agee and Walker Evans, *Let Us Now Praise Famous Men* (Boston: Houghton Mifflin, 1960) x.

9. Katz 23–24.

10. Margaret Bourke-White and Erskine Caldwell, *You Have Seen Their Faces* (New York: Viking, 1937). For a full review of the origin of the text, see Davis, "Agee and the Composition of *Let Us Now Praise Famous Men*," *LUNPFM* 483–512.

The History of *Let Us Now Praise Famous Men*

Michael A. Lofaro

The following timeline is not meant as a biography of either James Agee or Walker Evans or an analysis of their work together, but merely to trace those parts of their lives and careers that might inform and those that eventually lead to the publication and then the revision of *Let Us Now Praise Famous Men.*

1903	Walker Evans is born in St. Louis, Missouri, on November 2, though he preferred November 3.
1909	James Rufus Agee is born on November 27 to Laura Tyler Agee and Hugh James Agee in Knoxville, Tennessee.
1922–23	Evans attends Williams College for a year and studies literature.
1924	Evans works at the New York Public Library.
1926–27	Evans spends a year in Paris.
1928	In the fall, Hart Crane moves into Evans's New York neighborhood, and they become friends.
1928–32	Agee attends Harvard University.
1929	Agee spends the summer working as a migrant farm laborer in Nebraska and Kansas. Evans has his first publication, three photographs of the Brooklyn Bridge, in Hart Crane's poem *The Bridge.*
1931	In his review of six books of photography for the fall issue of *Hound and Horn*, Evans puts forth some of his views on the art of photography.
1932	On the recommendation of Dwight Macdonald, Agee begins work as a reporter at *Fortune* magazine.
1933	Agee returns to Knoxville to do research and write about the Tennessee Valley Authority for *Fortune*, published in the October issue (pages 81–97). Evans goes to Cuba to photograph the ongoing political unrest. His photographs will serve as illustrations for Carleton Beals's book *The Crime of Cuba*. His first exhibition of photographs at The Museum

of Modern Art goes on display in November. The subject is Victorian houses.

1934 Agee's *Permit Me Voyage* is published in the Yale Series of Younger Poets with an introduction by Archibald MacLeish. Agee's *Fortune* article, "The Great American Roadside," in the September issue (53–63, 172–77) features a photograph by Walker Evans.

1935 Evans embarks upon a photographic expedition focusing upon the plantation architecture of antebellum homes in the general area of New Orleans. He also provides the photographic documentation for the exhibition "African Negro Art" in collaboration with The Museum of Modern Art. Agee returns to Tennessee to produce the follow up article for *Fortune*, "T. V. A.: Work in the Valley" (May, pages 93–98, 140–43). On June 15 Evans accepts a position with the US Department of the Interior to document the government's resettlement community for unemployed West Virginia coal miners and in July extends his work for the Resettlement Administration (RA) to southwestern Pennsylvania. Starting in October, he continues his photographic work during the New Deal for the RA, later the Farm Security Administration (FSA), primarily in the South, through the winter of 1936.

1935–36 On leave from *Fortune* from November 1935 to May 1936, Agee lives with his first wife, Olivia (Via), in Anna Maria, off the west coast of Florida. He writes poetry and completes "Knoxville: Summer of 1915," eventually published in *Partisan Review* in 1938. Departing from Anna Maria in mid-April, Agee and Via return to New York by way of New Orleans and Sewanee, Tennessee, where they spend a month visiting Father Flye. Agee returns to work at *Fortune* as a contract writer on June 1.

1936 On assignment for *Fortune's* Life and Circumstances series, Agee travels by train on June 22 to Chattanooga, Tennessee, where he rents a car and drives to Birmingham then Montgomery, where Evans joins him. Agee had requested Evans as his photographer and Evans received a temporary leave from his FSA job under the condition that the photographs become government property. For the next four and half weeks, Agee and Evans meet with contacts associated with various New Deal agencies and travel around Alabama searching for a "representative" family of white sharecroppers, finally settling on the Tingle, Fields, and Burroughs families in Mill's Hill in Hale County, Alabama, as their subjects. Agee lives with the Burroughs family for three and a half weeks, and he and Evans return to New York in late August. *Fortune* rejects the article Agee submits, which remains unpublished until 2013 and then appears as *Cotton Tenants: Three Families*.

1937 On assignment from *Fortune*, Agee and Walker Evans investigate Havana's tourist industry, as well as the steamship lines that connect Cuba to the

United States; together with Via, the three spend six days on a cruise ship doing research for an article entitled "Six Days at Sea," which is published in September (pages 117–20) as "Havana Cruise." In late 1937 *Fortune* releases the sharecropper article to Agee, and he begins shaping the Alabama material into a book. In the subsequent two years, Agee wrote much of the manuscript while living in Frenchtown and then Stockton, New Jersey.

1938 Agee's "Knoxville: Summer of 1915" is published in the *Partisan Review* (vol. 5, August–September). "Walker Evans: American Photographs," opens at The Museum of Modern Art, New York, the first exhibition in this museum devoted to the work of a single photographer. The Museum publishes his work in a book, *American Photographs*, to accompany the exhibition.

1939 When he refuses to make suggested changes, Harper and Brothers releases Agee from his contract for "Three Tenant Families." Houghton Mifflin subsequently accepts "Three Tenant Families," now called *Let Us Now Praise Famous Men*.

1940 The annual *New Directions in Prose and Poetry* pairs excerpts from *Famous Men* with phototexts from Wright Morris's *The Inhabitants* in an article entitled "The American Scene." Evans receives a Guggenheim fellowship to continue his work in documentary photography.

1941 Houghton Mifflin publishes *Let Us Now Praise Famous Men*. While many reviewers comment favorably on Evans's photographs, only Agee's friends and Lionel Trilling see great value in Agee's prose.

1942 Agee begins his career as a film critic.

1943 Evans joins Agee at *Time* as a movie and art critic.

1945 Evans transfers to *Fortune* and remains its staff photographer and its photographic editor for the next two decades.

1947–48 Agee writes a substantial part of *A Death in the Family*, which is published posthumously in 1957.

1948 American composer Samuel Barber's *Knoxville: Summer of 1915*, for soprano and orchestra with text by Agee, debuts in Boston.

1949 *The Quiet One*, a documentary film by Helen Levitt, for which Agee writes the narration, opens; it is named Best Film at the Venice Film Festival. Levitt was a friend of Agee and particularly Evans since 1937/38. Agee's "Comedy's Greatest Era" appears in *Life* magazine (September 3).

1950 Agee goes to California to write the screenplay for John Huston's *The African Queen*. "Undirectable Director," Agee's portrait of Huston, appears in *Life* (September 18). Evans is one of ten leading photographers invited by Edward Steichen, now head of photography at The Museum of Modern Art,

to participate in a symposium entitled "What is Modern Photography?" It is broadcast on local radio in New York City and overseas by the Voice of America.

1951 On January 15, Agee suffers his first major heart attack and is hospitalized. Huston finishes the screenplay for *The African Queen*; the screenplay is nominated for an Academy Award. Houghton Mifflin publishes *The Morning Watch*, Agee's novella based on youthful experiences at St. Andrew's school. A sixty-page treatment focusing on the Civil War and set in Middle Tennessee, entitled *Bloodline*, is submitted to Twentieth Century-Fox in September but is never filmed.

1952 On April 22 Agee signs a contract with the Ford Foundation to write a five-part series—running for two and one half hours—on Abraham Lincoln for *Omnibus*. The script is completed in October and the TV program begins airing on November 16 and is broadcast every other week through February 8, 1953. Agee adapts another Stephen Crane story, "The Bride Comes to Yellow Sky," for Huntington Hartford, eventually incorporated as one half of *Face to Face*, directed by John Brahm and Bertaigne Windust.

1953 Agee writes the screenplay for *Noa Noa*, based on Paul Gauguin's diary.

1954 Agee meets Tamara Comstock on May 1, beginning an affair which would last through August. Their time together proves to be a period of great activity in Agee's writing of *A Death in the Family*. Agee writes the screenplay for *The Night of the Hunter*, directed by Charles Laughton. Agee begins, but never completes, work on a script about the Tanglewood school for young musicians in collaboration with *New York Times* music critic Howard Taubman and director Fred Zinnemann. Agee offers ideas and lyrics for the Lillian Hellman-Leonard Bernstein musical *Candide*.

1955 Agee is commissioned to write a thirty-minute orientation film about Colonial Williamsburg. On May 16, Agee dies of a heart attack in a New York City taxi. He is buried on his farm in Hillsdale, New York.

1956 *Sports Illustrated* assigns Evans to a story on British sporting events.

1957 *A Death in the Family*, edited by David McDowell, is published by McDowell, Obolensky.

1958 *A Death in the Family* wins the Pulitzer Prize for Fiction. McDowell, Obolensky publishes the first volume of *Agee on Film*, a collection of selected reviews and essays.

1960 McDowell, Obolensky publishes the second volume of *Agee on Film*, a collection of screenplays. Houghton Mifflin reissues *Let Us Now Praise Famous Men* with a remembrance by Walker Evans entitled "James Agee in 1936." Evans also increases the total number of photographs from thirty-

one to sixty-two, and replaces some of the original ones. The "failed" book now experiences commercial success in the atmosphere of protest movements and the beginning of a cult around James Agee. A new generation also discovers Evans's photographs.

1965	*A Way of Seeing*, a book of photographs by Helen Levitt with an essay by Agee, is published by Viking. Evans becomes professor of photography on the faculty for graphic design at the Yale School of Art and Architecture.
1966	Evans's *Many Are Called* with an essay by Agee and his *Message from the Interior* are published by Houghton Mifflin and Eakins, respectively.
1975	On April 10, Evans dies in New Haven, Connecticut.
1988	John Hersey writes the introduction to Houghton Mifflin's new edition of *Let Us Now Praise Famous Men*.
1989	In *And Their Children after Them*, Dale Maharidge and Michael Williamson revisit the families documented in *Let Us Now Praise Famous Men*.
2005	The University of Tennessee Press publishes *James Agee Rediscovered: The Journals of* Let Us Now Praise Famous Men *and Other New Manuscripts*, edited by Michael A. Lofaro and Hugh Davis. The Library of America publishes a two-volume set of James Agee's work: *Let Us Now Praise Famous Men, A Death in the Family, and Shorter Fiction* and *Film Writing and Selected Journalism*.
2007	*The Works of James Agee*, the authoritative scholarly edition edited by Michael A. Lofaro and Hugh Davis, begins. The first volume in the series, published by the University of Tennessee Press, is *A Death in the Family: A Restoration of the Author's Text*, edited by Michael A. Lofaro.
2013	The second volume of *The Works*, titled *Complete Journalism, Articles, Book Reviews, and Manuscripts*, edited by Paul Ashdown, is published. Agee's rejected *Fortune* article, edited by John Summers, is published as *Cotton Tenants: Three Families*. It is available as an appendix in volume three of *The Works* (565–646). See below.
2015	Let Us Now Praise Famous Men: *An Annotated Edition of the James Agee-Walker Evans Classic, with Supplementary Manuscripts*, edited by Hugh Davis, is published as volume three of *The Works of James Agee*.

"Consider the Ancient Generations": Sharecropping's Strange Compulsion

David Moltke-Hansen

Many Depression-era writers and photographers shared dismay at the South's entrenched racism, poverty, and ignorance. In addition, some among them deeply resented the superficial and tendentious stereotypes often used to portray the region's poor. Most of these writers and photographers tried to explain, illustrate, or at least keep in view the political and economic contexts in which their subjects struggled. Why did James Agee and Walker Evans not follow suit when writing and using photographs to explore the lives of "Cotton Tenants: Three Families" for *Fortune* magazine in 1936?

After all, these documentarians' colleagues garnered considerable attention, even acclaim, for what they did. Indeed, some moved people to action. Among the authors were Jessie Daniel Ames writing on lynching, Erskine Caldwell treating poor whites, Josephus Daniels surveying the South's problems and potential, W. E. B. Du Bois examining the historical consequences of racism, Howard Odum assessing the social and environmental forces that shaped southern lives, and Richard Wright dramatizing how the violent, segregationist Jim Crow regime influenced the perceptions and judgments of many African Americans. Notable photographers who captured Depression-era southern racism and poverty in similarly compelling and influential fashion included Margaret Bourke-White, Esther Bubley, Jack Delano, Dorothea Lange, Arthur Siegel, and fiction writer Eudora Welty. Their images made vivid the dignity of, and the ravages suffered by, many southerners, black and white.[1]

When James Agee and Walker Evans documented cotton tenant farmers, however, they refused to follow such examples. Instead, they relegated any consideration of race and the South as a whole to the last several pages in the second and final appendix of their original submission to *Fortune*. In part this was because they anticipated addressing those contexts of the lives of the tenant families in two later works. In part, and equally important, they resented the standard journalistic framing of their assignment. That attitude made Agee and Evans harbingers of the New Journalism. In the process, it transformed their work into a challenge to almost every journalistic and literary convention shaping other contemporary treatments of cotton tenants.[2]

There is no direct evidence, but the circumstantial case is compelling: the two documentarians virtually invited the rejection of the work they submitted to *Fortune*. Despite the power of Evans's photographs and the evocative detail of Agee's prose descriptions, the thirty thousand words, which the two men turned in early in the fall of 1936, together with a selection of Evans's photos, did not fulfill the apparent assignment. They did not answer the journalist's standard litany of questions: Who? What? Where? When? How? And why? This mattered all the more after the change in editorial direction at *Fortune* that took place while Evans and Agee were in Alabama researching their report. The new managing editor discontinued the Life and Circumstances series in which Agee and Evans had expected their Alabama work to appear. The magazine would no longer include such investigations of the ills resulting from capitalism, whether in manufacturing or in agriculture. Instead, *Fortune* would emphasize more explicitly than ever how the rewards of capitalism could mean a better, more abundant life for people. Using such evocative evangelical language, the magazine cast itself as a missionary on behalf of the cause.[3]

Even given this shift, the opening lines of "Cotton Tenants" did not diverge from what readers of *Fortune* might have expected. The introduction began by indicating the geographic scope of cotton tenancy: "The cotton belt is sixteen hundred miles wide and three hundred miles deep." Agee continued by indicating the subset of the people there who were of interest to him: "Sixty percent of those whose lives depend di-

rectly on the cotton raised there, between eight and a half and nine million men, women and children, own no land and no home but are cotton tenants." Yet, except in occasional brief comments thereafter, the report did little to situate the subject tenant families in the expected journalistic fashion.[4]

Brushing aside sociological, historical, political, and economic topics often covered *ad nauseam*, Agee dramatically concentrated his account in "Cotton Tenants." He did so by what he left out, by what he focused on, and by what he said about what he left in. Evans in effect supported Agee's approach through what he chose to photograph (or not) and the kinds of images he produced. These documentarians recorded the details and preoccupations of daily life rather than explained how those ways of life had come to be and to shape and constrain people's circumstances and futures.

Seventy-five years have passed since the publication of *Let Us Now Praise Famous Men* and eighty years since Agee and Evans went to Hale County, Alabama, to write and photograph the story of sharecropping's hardness amid the Dust Bowl and the Great Depression. Today the subject is alien to most readers. It was vivid then. Debt and despair tied millions to farms they did not own and that hardly produced. Too often the soil was exhausted by relentless use, and so were they. Job-killing mechanization and falling commodity prices made things worse. More tenant farmers—many of them black—lived in the South than anywhere else, but some of those hardest hit—mostly white—worked land in the Great Plains states, where their lungs filled with dust and their days with misery and want. Through the 1930s and 40s some three and a half million of these latter left in search of clean air and livelihoods that could sustain them.[5]

John Steinbeck followed some white "Okies" to California in his 1939 Pulitzer Prize- and National Book Award-winning novel, *The Grapes of Wrath*. He was just one of many who found the plight of sharecroppers compelling. The young folksinger Woody Guthrie left Texas and joined tenant farmers displaced from the Dust Bowl and by the Depression. They too went west. In California, he recorded and later performed their music. During these years as well, the major American weeklies and

monthlies returned again and again, in stories, reports, and analyses, to the plight of these migrants and those they left behind.[6]

Still, few writers attempted what Agee and Evans did. At this remove, it is hard to recapture the relevance of their 1936 report. It is harder to comprehend intellectually and emotionally the experiences that these documentarians filtered through their sensibilities as they sought to make those experiences significant to others. In their treatments, Agee and Evans did not give readers conventional aids to understand, or to orient themselves to, life in the Alabama black belt.

That world has greatly changed since these documentarians went to Hale County. Although within the penumbra of Tuscaloosa, now a growing university city twenty-five miles from where Agee's tenants lived, Hale County continues to lose population. With approximately 40% fewer inhabitants now than in 1940, at that time it was already about 25% less populous than in 1900, when the census count reached its peak. Most of those—both white and black—who left before World War II either sought work in southern mines and mills or joined in the great migration north and west. As the current population mix—58% black, 41% white, and 1% other—suggests, the outmigration of blacks was even greater than that of whites. Before moving, the great majority of both races had worked the soil. More than a quarter of today's Hale County residents fall below the poverty line—over a third of those below age 18. Consequently, the county is one of the poorest in Alabama, with a poverty rate more than 40% higher than that of the state as a whole.[7]

Although the changes since the 1930s have been tremendous, those before were dramatic as well. After all, when Agee and Evans went to Alabama, both Hale County and the central role of sharecropping there were not even seventy years old. Before the Civil War, enslaved African Americans had made the bands of rich, black soil in this part of the state productive. As elsewhere in the South, poor whites tended to live on less favored lands, like the red clay hills in the northern part of the future Hale County. They did not become a significant part of the cotton South's economy until after the Civil War. Outside the areas dominated by established cotton plantations, however, they accounted for up to 40% of the rural population.[8]

Despite their marginality in much of the richest parts of the cotton belt, poor whites figured centrally in the humorous literature of the rising South, of which antebellum Alabama was a burgeoning part. Indeed, they had become a literary staple much earlier. As far back as 1728, William Byrd of Westover, in Virginia, produced scathing accounts of lazy and ignorant backwoodsmen in North Carolina who lived beyond the pale of plantation settlements and culture. Just over a century later, Augustus Baldwin Longstreet humorously treated the interactions of bumpkins and gentry in the backwoods of contemporary Augusta, Georgia. Many writers followed his lead. Johnson Jones Hooper did so in Alabama in the 1840s, also first publishing his humorous sketches in his newspaper and then gathering them into a wildly popular book. His best known character, Simon Suggs, famously declared: "IT IS GOOD TO BE SHIFTY IN A NEW COUNTRY," such as Alabama then was.[9]

Reinforced by these disparaging and derisive images of frontier and backwoods scoundrels and "crackers," planters long resisted renting good lands to poor whites. Indeed, many landowners regarded "crackers" as inferior to blacks because they were considered more inclined to restiveness and less inclined to work. Agee heard the preference for black sharecroppers again and again. So did Erskine Caldwell, who investigated tenant farming at the same time. Even before the Civil War, landlords' decisions reflected such judgments. Yet, then slavery meant planters did not need to rent rich fields to poor whites, at least not after the thick virgin forest lands had been cleared for planting. Rather, they put the enslaved to work on the good soil and offered waste tracts to "crackers."[10]

The sudden end of the old regime confronted large landowners with an acute problem. They did not have cash to pay field hands. At the same time, many African Americans vigorously rejected returning to gang labor on the places where they had been enslaved. They also opted, when they could, to leave rather than pay rent for the slave quarters in which they had lived. Like poor whites, they preferred to work for themselves and dwell on their own plots. Yet they could not buy the land, only rent, as sweat equity was all most had to invest in their pursuit of independence.[11]

In the early years of Reconstruction, landowners floundered as they tried to solve these labor problems. Eventually, with the support of the Freedmen's Bureau, many decided to capitalize on people's desire to rent tracts. They put shacks on these plots, provided tools and fertilizer, and frequently advanced the renters seeds for planting and credit for food. Some tenants made cash payments for use of the land, quarters, equipment, and supplies or committed a combination of currency and shares of the crops being raised. More often, however, tenants could only pay with pledged future crop shares. Sometimes, in addition, especially in bad crop years, they needed to supplement such payments with labor in the landowners' fields. It took much of the Reconstruction period to develop the contracts, the commercial structures, and the daily practices that would govern the operation and legal dimensions of the greatly expanded tenant farming regime of the postbellum South.

This regime was not new either in the region or elsewhere. Indeed, in many places, it had long been common. It grew increasingly so in some areas. In Ireland between 1847 and 1855, for instance, the potato famine forced many small landowners to sell their few acres or to surrender their rented properties to large-scale landlords. Thereafter, more and more owners sought to free their lands of vestigial feudal claims, making those holdings rentable on the open market. Consequently, by 1870 tenants worked 97% of Irish land, and just 750 families owned half of the island. In Russia at about the same time, many peasants who had been serfs became tenant farmers after their emancipation from serfdom. They then had to pay for the plots allotted them. Often they found that they could not, so resorted to sharecropping or the sale and rent back of those small holdings.[12]

Following the Civil War, tenant farming increased dramatically in America as well. This development mattered so much that in 1880, for the first time, the United States census takers systematically recorded whether farmers owned or rented their land (or did both). Following this expansion of tenant farming in the South and West in the 1880s and 90s, black and white farmers—many of them tenants—sought to organize politically to advance their interests through the People's, or Populist, Party. Two generations later, when Agee and Evans went to Alabama,

Depression-era activists, members of the Alabama Tenant Farmers Union and other organizations, pursued more radical agendas.[13]

By themselves, those elements of the history of tenant farming did not lead people at *Fortune* to find the topic of sharecropping compelling. Neither did their understanding of the South as America's chief economic and social problem. To some degree, competition with *The Saturday Evening Post* and other magazines gave purchase to the topic of tenant farmers, but still broader concerns influenced the judgments that made the sharecropper seem an apposite focus for a business magazine in 1936. The Depression-era commitment to social realism and the urgent sense of the need for reform were not restricted to the South. *Fortune* at the time advocated both. The evangelical orientation of *Fortune*'s founder partly explains this sense of mission. Editors and writers at the magazine also shared an awareness of the growing gaps between city and country, industrial and agrarian America, and the past and future. All of these developments would shape the New Journalism that Agee, Evans, and others anticipated.[14]

The Federal Writers' Project and the photography program of the Resettlement Administration (later the Farm Security Administration) set to work in 1935 to document these subjects. Between them they recorded, *inter alia*, the memories and aftermath of slavery, the people of Appalachia and their poverty, the travails of sharecroppers and other agricultural laborers, and despair and resilience in Depression-era cities and southern mill villages. A year after the launch of these federal documentary initiatives, the founder, publisher, and executive editor of *Fortune*, Henry R. Luce, acquired the faltering magazine *Life* and transformed it into a highly successful photojournalistic venue. In the same year, he and his new wife, Clare Booth Luce, bought a Low Country South Carolina plantation, Mepkin. Near that fabled estate, once the home of Henry Laurens, a president of the Continental Congress, many of the large landowners rented to sharecroppers.[15]

Despite early forays into the South as an evangelist, while a student at Union Theological Seminary, Luce had little experience with tenant farmers. Nevertheless, he approved the sending of Evans and Agee to Alabama. The two men spent the hottest months of the summer locating,

documenting, and examining the lives and circumstances of cotton tenants, identifying and then focusing on one locale and three interconnected families. Having started the year before, photographer Margaret Bourke-White and novelist Erskine Caldwell took a different tack in their eighteen-month investigation and recording of sharecropping from South Carolina to Arkansas.

This entire swath of country had been under attack by the boll weevil since the 1920s—much earlier in Mississippi and Alabama. The drastic diminishment of cotton crops that resulted, together with falling commodity prices, led to the further immiseration of tenant farmers. According to Caldwell, in his 1935 pamphlet *The Tenant Farmer*, the Great Depression compounded the problem even in the face of government efforts to help tenant farmers. Caldwell and Bourke-White made vivid in their 1937 book, *You Have Seen Their Faces*, the terrible, region-wide scope of sharecroppers' toil and poverty.[16]

Agee and Evans, by contrast, concentrated on one place at the heart of the cotton belt. Vital to the status of *Famous Men* as a classic, this strategy did not succeed in the short run. *Fortune*'s new managing editor decided not to publish their initial report. Because no documentation of the decision has surfaced, one has to infer the editor's reasons and then assess what Agee and Evans submitted. From the editor's point of view, it seems clear that Agee and Evans did not fulfill their assignment. "Cotton Tenants" reveals attitudes, assumptions, and priorities that radically repurposed, and thereby undercut, *Fortune*'s editors' apparent expectations of this investigation of sharecropping.

Examination of *Famous Men* further illustrates and explains how and why Agee and Evans chose to recast the assignment. Yet one does not understand how they could have come to this position or how anomalous it was until one compares *Famous Men* with other works published at the time. The contrast makes it possible to see, first, how radical Agee and Evans had become in their moral critique of the journalism and literature that were shaping the South in the nation's eyes and, second, how their stance both constrained and structured what they presented.

One glaring omission in "Cotton Tenants" was history. In the language of journalism, Agee failed to give his story's background. Indeed,

he saw little value in doing so, arguing that the coverage by other writers, and its misleading consequences, made the exercise pointless. As a result, one gets no sense of how long Agee's subject families had lived where he and Evans discovered them and where antebellum humorists found the "crackers" they used to create characters who became literary forebears of the stereotypes shaping people's reactions to such Depression-era, rural, poor whites.

Perhaps Agee did not feel the need to go back in time to the area's settlement in the wake of the Choctaw cession of 1816. Still, other writers nevertheless found compelling the fact that among the first whites were soldiers returning from the American victory over the British at the Battle of New Orleans. Others also felt it necessary to record that those who came after did so primarily from North and South Carolina, Tennessee, and Georgia, and that the majority arrived in the 1830s, 40s, and 50s.[17] In his 1936 submission, however, Agee ignored such antecedents. It was as if his subjects had always been in the hills east of the Black Warrior River, dwelling in hardscrabble poverty. Treating them so, he was resorting, as Karen Fields notes, to the ethnographic present then popular among anthropologists.[18]

A howling wilderness in the eyes of travelers in the 1820s, a generation later the area seemed to some observers tamed by cotton planting and civilized through prosperity. On the eve of Alabama's secession from the American Union, dozens of plantations within a hundred miles of Moundville had a hundred or more slaves and huge acreages. Yet the enslaved population was larger than the portion on grandees' plantations. Many smaller farmers owned a few slaves as well. Consequently, there were almost four times as many blacks as whites in the area, a demography that the end of slavery did not drastically change. Hale and adjacent counties, out of which Hale was formed in 1867, had been among the most heavily populated by black people in Alabama for much of the previous half century. They would continue to be so.[19]

Evans and Agee did not go to those parts of the county. The hilly northern portion of Hale, where they ended up, looked different, although they did not say so in their 1936 report. Those clay ridges and sandy slopes, falling down to the bottomlands of the Black Warrior

River at Moundville, were steeper, less rich, and more gullied than the black prairie to the south or the river bottoms to the west. Consequently, they earlier had proved less attractive to major slave holders and therefore had a smaller black population. Even so, as Agee wrote in "Cotton Tenants," there still were not "enough white people in the neighborhood [of his subjects] to support a church." The country was too poor and rural, and the separation of the races was nearly absolute.[20]

Elsewhere in Alabama, tenant farmers' poverty and deprivation fueled political agitation. It had done so fifty years before, in the era of the People's Party, and would do so again in the 1930s. When Evans and Agee got to Hale County, the mostly black and Communist Alabama Sharecroppers Union, founded five years before, had ten to twelve thousand members. The Socialist, interracial Southern Tenant Farmers' Union had twice as many across the cotton belt, mostly west and north of Alabama. One might suppose that Agee and Evans would have pondered the implications of these developments for their "Cotton Tenants." After all, Agee identified himself as "a Communist by sympathy and conviction," and Evans humanized "The Communist Party" in America in a 1934 photo essay that he and Dwight Macdonald published in *Fortune*. Yet the two collaborating documentarians gave no evidence in 1936 that the people whose lives they sought to convey, or others whom they knew, were even aware of political agitation to improve the lot of tenant farmers.[21]

Many journalists would have asked, "Why not?" Events in southern Hale County justified the question. In March 1936, *The Crisis*, the magazine of the National Association for the Advancement of Colored People, reported the murder there of several black cotton croppers. The killings came in the wake of Alabama Sharecroppers Union strikes and slowdowns across the Alabama cotton belt. They occurred despite the dramatically increased national attention to lynching.[22]

Even so, Evans and Agee chose not to address the issue. Doing so might have helped other journalists develop perspective and fulfill expectations, first of editors and then of readers. Agee vehemently resisted. In the introduction to *Famous Men*, he explained his position. In his view, that line of questioning would have eviscerated his subjects,

tearing all meaning out of their lives. Replacing it would have been the presumptuous, superficial, and fundamentally uncomprehending and predictable, even stereotypical, responses one might expect of metropolitans made myopic by their sense of superiority and sophistication.

By the same token, to have focused on the racist dynamics that crippled effective collective action even in the midst of the Depression would have made racial violence and discord the central features of Agee and Evans's report on "Cotton Tenants," not the humanity of the farmers and their condition. Disappointed by the failed promise of interracial Populist political alliances a half century before, C. Vann Woodward did just that in 1938 in his biography, *Tom Watson, Agrarian Rebel*. There he portrayed the failure of the Georgia People's Party leader. That career's tragic ending was, in Woodward's account, racial and religious intolerance, invective, and violence.[23]

Agee and Evans wanted to establish a radically different perspective—hence their focus on the details of daily life and the immediate environments in which their subjects lived. Their closeups rendered the backgrounds virtually invisible. Indeed, Evans's camera and Agee's typewriter largely obliterated foregrounds as well. The lack of distance between viewer and viewed, or describer and described, sometimes gave the encounters a flavor of voyeurism mixed with presumptuous intimacy. Heightening this sense were Agee's use of the second person and frequent comments on the sexuality of some tenant women.[24]

What was true of "Cotton Tenants" was both more and less true of the much longer work that appeared five years later. The regime under which sharecroppers lived in the 1930s had only recently become dominant in the cotton belt; it was not an inheritance across uncounted generations. Yet evoking the book of Ecclesiasticus, or Sirach, from the Apocrypha that follows the Old Testament in the King James Bible, the title of *Let Us Now Praise Famous Men* made the transitory seem ancient and immutable. Thereby it lent grandeur to those who, as the passage says, "have no memorial, who are perished as though they had never been."[Ecclesiasticus 44:9] At the same time, it suggested cultural perceptions and movements that would soon rewrite the places of race and poverty in America.

Implicit arguments against journalistic conventions in "Cotton Tenants" became explicit in *Famous Men*. Agee framed his account as a voyage of self-discovery through exploration of the other, in this case, cotton tenants. Although creative nonfiction, at this level the book worked as if it were a *Bildungsroman* or a story of a journey toward self-realization, growing maturity and knowledge, even enlightenment. That journey took Agee through self-doubt about his mission, its purpose, and their communication. Thus his meditation on the inadequacy of writing to convey experiences, perceptions, and understandings. Thus, too, his assertion that one must hear Beethoven, not describe the listening. In his eyes, photographs failed as well to communicate Beethoven's music.[25]

Yet while photography necessarily also misrepresented or fell short in its rendering of its subjects, Agee felt it nevertheless could do better than writing. This was only true, however, if the photographer had the ethical sense of a Walker Evans. By contrast, Margaret Bourke-White was slickly commercial. She either posed and shot her subjects or surreptitiously took photos of them to achieve maximum effect rather than convey their circumstances and sense of themselves. A companion theme in *Famous Men* is how journalism compounded the problems of effective writing by its presuppositions, priorities, and fundamental amorality. Journalistic truths were shallow, when not outright false, and reflected market considerations, received wisdom, and professional habits instead of empathetic engagement with the subjects treated. By giving readers what they expected, journalists avoided pushing themselves and consumers past their comfort zones towards understanding of and empathy for others.[26]

Between 1936 and 1941, Agee devised a way to make that kind of push. He used his own voyage, the attendant explorations, and his doubts about both to structure his narrative. This allowed him to reflect not only on race and class, the subjects he relegated to an appendix in "Cotton Tenants," but also on other considerations that he simply omitted in 1936. Among these formerly excluded and disruptive topics were the Communist organizations of Alabama industrial workers and sharecroppers, starting at the beginning of the decade. In *Famous Men* Agee used arresting encounters to depict these and other social, political, and

economic developments within the South. He also identified their regional characteristics and consequences.

In addition, between 1936 and 1941, Agee found ways to distinguish the typical from the atypical on the farmsteads he visited, in the food he ate and the clothing people wore, and in the work and other activities that shaped those cotton tenants' daily lives. In his and Evans's initial submission to *Fortune*, he for the most part had resisted such contextualization. He had not yet settled on a means of showing how his particular experiences led him toward larger understandings, however fissured by uncertainty. Passionately objecting to presentations of tenant farmers by other writers, he usually relied in "Cotton Tenants" on concrete examples that he had recorded in his notebooks, letters, and conversations or recollected—and sometimes imagined—afterwards.[27]

The recasting in *Famous Men* of those remembered and recreated times and places as parts of an educational venture—and adventure—allowed Agee to sum up the implications of those experiences. He tallied his observations under different headings while at the same time illustrating them with his interactions and observations in the field. No wonder, then, that, in his chapter on education, he railed against the ways in which classroom didacticism undermined educational processes and commitments. He wanted to lead himself and others to insight and empathy, rather than lecture people about sociological and economic problems. Therefore, in *Famous Men* he concentrated on what it meant to live as a cotton tenant, what it meant to try to capture and convey that reality in words and photos, what kinds of feelings and perspectives one needed to bring to bear, and consequently what conventions one had to resist.[28]

In communicating his frustrations with journalistic expectations, Agee from time to time made journalistic statements and then showed their inadequacy. On the one hand, he demonstrated how journalism foreshortened and denigrated its subjects. He did so by evoking the cosmic patterns shaping and challenging the trivial and the mundane that journalists too often slighted but that were the stuff of most people's existence. On the other hand, he measured the lives, and abjections, of his cotton tenants by the passions and sorrows to which William Shakespeare's characters and biblical figures give voice. These indices

of meaning mattered far more, he insisted, than the windy generalities of standard journalism.[29]

With this challenge Agee destabilized more than journalistic conventions. He also attacked the operations of class and race that he witnessed while in Alabama but had almost entirely ignored in "Cotton Tenants." The forthright, sometimes obsessive, sexuality that emerges at many points in his narrative assaulted bourgeois morality. Agee wanted to overturn these restrictions and evasions just as he wanted to free education from its role in fortifying them. Like the economic constraints shaping daily lives, these inescapable frameworks oppressed the poor and the marginalized. Cotton tenants endured the condescension and scorn, rather than received the love and support, of the rich and the powerful—the people who also commanded the deceitful and manipulative language that protected and projected their social capital.

Often, Agee has been compared to other writers among his contemporaries. Erskine Caldwell, William Faulkner, and John Steinbeck also portrayed tenant farmers in emotionally charged ways. Like Agee, André Gide, in his travels to the Congo, voyaged across novelist Joseph Conrad's wake to the dark enchantment and disturbing revelations of a place more distant than miles can measure. He did so, as well, together with a camera-bearing comrade. There he discovered much about the child he had been, the yawning gap and the perpetual conflict between art and reality, and the difficulty of escaping racial stereotypes while in the pursuit of one's humanity.[30]

On the other side of the mountains from Agee's childhood home in Knoxville, Tennessee, Thomas Wolfe grew up in Asheville, North Carolina. Later he also cultivated an explosive and exhausting, often self-referential language and narrative. Like Agee, too, he depended upon support from sometimes bemused or frustrated but also well-placed New York friends. In each case, these supporters proved remarkably willing to spend significant cultural capital on a southern *enfant terrible.* Other voices did not receive such favored attention in the Depression but later claimed it for their experiences then. Ned Cobb's *All God's Dangers* and *The Narrative of Hosea Hudson: His Life as a Negro Communist in the South* are about African Americans, not poor whites. Despite earlier reports, in *The Crisis* and elsewhere, these narratives only emerged

fully in the 1970s, long after Agee's death. Yet Richard Wright's *Uncle Tom's Children* appeared in expanded form in 1940 and garnered significant attention for the black experience of Jim Crow and the sharecropping regime at the time that Agee was finishing *Famous Men*.[31]

These comparisons are all germane, but others suggest themselves as well. One wonders how much W. J. Cash's *The Mind of the South*, published in 1941, like *Famous Men*, preempted the second part of the work on cotton tenants that Agee originally had in mind. Agee had explained that the second report would be "a generalized piece, a big fatassed analysis of the situation and of cotton economics and of all Government efforts to Do Something about it. . . ." Never mind that Cash's history of the South treated the region's early English colonial roots as well as agricultural tenantry in the cotton belt of the 1930s. Never mind that it included, too, the New South's textile mills and encompassed the tobacco South and more than three centuries. Although focused more on the piedmont than the black belt, his was in short a powerful and "bigassed analysis" of what dragged the South down; it was also a passionate characterization of the emergence and nature of the region's people and culture.[32]

No Communist, Cash yet shared with Agee dismay at the influence of racism and class conflict. As Bruce Clayton has observed, "There was a natural link between Agee and his contemporary W. J. Cash." The two authors both published, in the same year, "a unique, anguished, flowery, deeply southern book. . . ." Yet, as John Shelton Reed has noted, "W. J. Cash put a thesis on the table in a way Agee did not." In preparing to write the book that the Knopf firm commissioned on the basis of his 1929 article on "The Mind of the South," Cash also did other things Agee chose not to do. Notably, although also a journalist, Cash took years, not months, to research and write *The Mind of the South*. In part, this was because he sought the tutelage of University of North Carolina sociologist Howard Odum.[33]

Like Agee, Odum did field research, but, unlike Agee in *Famous Men*, he seldom intruded with an interviewer's voice. Besides, Odum extensively used data from the census and other sources, something Agee hardly did at all. Most importantly, Odum treated the region as at once a complex physical environment and a distinct cultural zone. Cash felt

drawn to Odum in part because of this emphasis. Already in the 1920s he had concluded that each group of people has a *Volksgeist*, a collective or shared mind or spirit reflective of geographic and cultural antecedents and conditions. He therefore sought to portray the *Volksgeist* of southerners and its development, using the data and discipline Odum provided. While abjuring that approach to the region, Agee nevertheless also accepted some degree of environmental determinism and understood it to have cultural consequences. Nevertheless, he remained reluctant to cast "the land of cotton" or its people in such terms. He wanted to emphasize the humanity, not the limitations and the complex environments of his subject families.[34]

Consequently, according to Angie Maxwell, the fundamental difference between Cash's and Agee's books was this: "*The Mind of the South* sought to explain the South to the world, while *Let Us Now Praise Famous Men* made people care about the region." Yet there is also another, equally important difference: Cash thought historically; Agee did not, at least not in *Famous Men*. Cash made much of the fact that most of the region had been settled by whites and blacks for less than a century and a half, giving a frontier cast to the society and the culture that determined, into his own day, many aspects of how people thought and interacted. With only a scant handful of historical references, Agee's portrait of the cotton belt intentionally lacked that specific historical dimension.[35]

Agee did not want the past to obscure or extenuate the sins or the possibilities of the present. The drama he saw was a morality play, not a historical one. In his dramatization, the South was a fixed stage, without changing sets. While he gave voice to the individuality of cotton tenants with whom he interacted, in the end those people's voices blended to create a shared narrative that reflected a common culture. The individual humanness, together with the commonness of the experience, of these cotton tenants served to validate and advance Agee's and Evans' commitment to the common people.

Yet the timing was slightly off. Had it not been, Agee could have benefited from a work gestating as he was writing *Famous Men*. For years Fernand Braudel had been working on his history of the Mediterranean. In 1940, after the Germans invaded France, he became a prisoner of war. While incarcerated, he wrote much of *The Mediterranean and the*

Mediterranean World in the Age of Phillip II, although the three-volume work only appeared in 1949, two years after he received his doctorate. It argued, *inter alia*, that most of what has concerned historians is superficial: fundamental historical change occurs over the long term, not as a result of transitory actions and actors. Braudel also insisted that the Mediterranean was at once one and many worlds.[36]

Such conceptualizations could have invited Agee to think differently about the relationship of time and place to biography. It might have allowed him to consider simultaneously the South as a whole and as a mosaic. In that case, history and geography might have signified more than ways to disempower and disembody, by defining, those lives' meaning and power. As reflectors rather than transformers of history and geography, after all, individuals necessarily are also bearers of both and are ultimately the reason that time and place matter. To grasp this point, however, requires escaping, even ignoring, the usual understandings of the interactions of history and geography and the changes that are part and parcel of those contexts of the human condition.

Still a Communist in 1941, Agee believed in change. At the same time, he understood the necessity and difficulty to be the result of abiding legacies, relations, and patterns. His anger at the tyranny of history, sociology, and geography grew out of this awareness. Freedom, humanity, and individuality meant not being bound by such things when seeking to understand others, as well as oneself. Even so, the journey to freedom did not define life's struggles.[37]

Those confrontations also were over the deep injustices of capitalism and the injuries inflicted on individuals' psyches. If only one would pay attention, the anonymity of most people's lives could testify about those forces. The multitude might not be famous, but they deserved the same hearing that princes, presidents, and generals received. In the end, even the deep structures of historical time, as understood by Karl Marx or Fernand Braudel, flattened in the face of justice and eternity. That, finally, was the moral of the story. And morality had to be the narrative driver.

Most writers saw cotton tenants differently—as victims, not bearers of humanity and history. This perception made sharecropping a compelling subject for them. How awful, such writers and their readers said. How sad. How remote and, yet, by turns how fascinating and

distressing, as well as exotic and, yes, comforting: for, after all, there but for the grace of God might be the desperate sadness of one's own family. Agee rejected all such conclusions and the easy, too often smug superiority that underlay them. Instead, he wanted to rewrite *Everyman* in a vernacular that came at once out of the cotton belt, the cosmopolitanism of New York, and the Communist sense of justice. Where better to go than to a place far from the industrial capitalism distancing the modern world from the timelessness of impoverished agriculture? In rural Alabama, as in rural Russia, the necessity and virtual impossibility of revolution compelled attention.

NOTES

The following have my thanks for their help in clarifying my argument and prose: Vernon Burton, Christopher Curtis, Louis Ferleger, Karen Fields, Sarah Gardner, Barbara Ladd, Alexander Moore, Patricia Poteat, and Patrick Scott, fine scholars and editors all.

1. See Sarah Gardner's forthcoming book, tentatively titled "Reviewing the South: The Literary Marketplace and the Creation of the Southern Renaissance" (New York: Cambridge University P), esp. chapters 3–6. The *www.photoprogrammar.yale.edu* website maps about ninety thousand images, now at the Library of Congress, taken between 1935 and 1945 by photographers working for the United States Farm Security Administration and Office of War Information. All the photographers named, except Eudora Welty, participated. No selection from FAA photos more influentially showed African American life than Richard Wright and Edwin Rosskam, *12 Million Black Voices: A Folk History of the United States* (New York: Viking Press, 1941). See "From Eye to We: Richard Wright's *12 Million Black Voices*, Documentary, and Pedagogy," *American Literature* 78.3 (2006): 549–83. On Welty's photography, see Harriet Pollack and Suzanne Marrs, "Seeing Welty's Political Vision in Her Photographs," *Eudora Welty and Politics: Did the Writer Crusade?*, ed. Harriet Pollack and Suzanne Marrs (Baton Rouge: Louisiana State UP, 2001) 223–52, and Pearl Amelia McHaney, *Eudora Welty as Photographer* (Jackson: UP of Mississippi, 2009).

2. Hugh Davis, "Agee and the Composition of *Let Us Now Praise Famous Men*," in James Agee and Walker Evans, Let Us Now Praise Famous Men: *An Annotated Edition of the James Agee-Walker Evans Classic, with Supplementary Manuscripts*, ed. Hugh Davis, vol. 3 of *The Works of James Agee*, gen. eds. Michael A. Lofaro and Hugh Davis (Knoxville: U of Tennessee P, 2015) 490. Subsequent references to this edition will be noted as Davis, *LUNPFM*. See Maitrayee Basu, "'New Journalism,' Subjectivity and Postmodern News," *Proof 2010: Journalists Defending Journalism*, Set 1, Sept. 2010, 14 Feb. 2015 <www.proof-reading.org/-new-journalism-subjectivity-and-modern-news>; Paul Ashdown, "Prophet from Highland Avenue: Agee's Visionary

Journalism," *James Agee: Reconsiderations*, ed. Michael A. Lofaro, Tennessee Studies in Literature 33 (Knoxville: U of Tennessee P, 1992) 59–81; and Julia Lee May, "Off the Clock: Walker Evans and the Crisis of American Capitalism, 1933–1938," diss., U of C, Berkeley, 2010, Chapter 2.

3. Agee lists the journalist's questions as "who, what, where, when and why (or how)" and calls them "the primal cliché of journalism." See Davis, *LUNPFM* 189). MIT-trained chemical engineer Eric Hodgins succeeded Ralph Ingersoll as managing editor in 1935, having been associate managing editor since 1933 and becoming publisher in 1937. See Michael Augspurger, *An Economy of Abundant Beauty:* Fortune Magazine *and Depression America* (Ithaca: Cornell UP, 2004) 124, 155.

4. James Agee, "Cotton Tenants: Three Families," in Davis, *LUNPFM* 566, and see 276: "The tenants' idiom has been used ad nauseum by the more unspeakable of the northern journalists. . . ." Cf. Davis, *LUNPFM* 12, 84–93, 189–98, 318–37.

5. James Noble Gregory, *American Exodus: The Dust Bowl Migration and Okie Culture in California* (New York: Oxford UP, 1989), examines the migration of a sub-set of the Great Plains population and the cultural community and life those in-migrants created in California.

6. Charlie J. Shinde, *Dust Bowl Migrants in the American Imagination* (Lawrence: UP of Kansas, 1997), explores the mythologizing of the Dust Bowl experience by Steinbeck and others and the consumption of those myths; Woody Guthrie, *The (Nearly) Complete Collection of Woody Guthrie Folk Songs* (New York: Ludlow Music, 1963). See Gardner, "Reviewing the South" ch. 5–6.

7. "Population of Counties by Decennial Census: 1900 to 1990," United States Census Bureau, 17 Feb. 2015 <www.census.gov>; "State & County Quick Facts," United States Census Bureau, 17 Feb. 2015 <www.quickfacts.census.gov/qfd/states/.../101065/>.

8. See Frederick A. Bode and Donald E. Ginter, *Farm Tenancy and the Census in Antebellum Georgia* (Athens: U of Georgia P, 1986), which describes the rates and range of tenancy in Georgia in 1860; Wayne J. Flynt, *Poor but Proud: Alabama's Poor Whites* (Tuscaloosa: U of Alabama P, 1989), describes the culture and lives of poor whites in Alabama, beginning in the antebellum period.

9. On images of poor whites in the southern British colonies and up through the antebellum years, see Matt Wray, *Not Quite White: White Trash and the Boundaries of Whiteness* (Durham: Duke UP, 2006) 21–64. The quote is at Johnson Jones Hooper, *Some Adventures of Captain Simon Suggs, Late of the Tallapoosa Volunteers* (Philadelphia: Carey and Hart, 1845) 12. On the complexities of the culture out of which and on which Longstreet and Jones were writing, see John Mayfield, *Counterfeit Gentlemen: Manhood and Humor in the Old South* (Gainesville: U of Florida P, 2009), particularly chapters 2 and 3. On the specifically antebellum Alabama settings of writers like Jones, see Johanna Nicol Shields, *Freedom in a Slave Society: Stories from the Antebellum South* (New York: Cambridge UP, 2012), esp. 47–60. "The rising South" is Shields's term: *Freedom* 2–14.

10. Agee, "Cotton Tenants" 630–31; Erskine Caldwell and Margaret Bourke-White, *You Have Seen Their Faces* (New York: Viking P, 1937), xxii. On Caldwell and Bourke-White's project, see Wayne Mixon, *The People's Writer: Erskine Caldwell and the South* (Charlottesville: UP of Virginia, 1995) 93–117.

11. Regarding the transitions and attitudes affecting African American life in the cotton belt after the Civil War, see, for instance, Peter Kolchin, *First Freedom: The Response of Alabama's Blacks to Freedom* (Westport: Greenwood P, 1972); Daniel A. Novak, *The Wheel of Servitude: Black Forced Labor After Slavery* (Lexington: UP of Kentucky, 1978); Frank S. McGlynn and Seymour Drescher, eds., *The Meaning of Freedom: Economics, Politics, and Culture after Slavery* (Pittsburgh: U of Pittsburgh P, 1992); Orville Vernon Burton, "African American Status and Identity in a Postbellum Community: An Analysis of the Manuscript Census Returns," *Agricultural History* 72.2 (1998): 213–38.

12. For statistics on tenancy's expansion, see Kirby A. Miller, *Emigrants and Exiles: Ireland and the Irish Exodus to North America* (New York: Oxford UP, 1985) 280–344; David T. Gleeson, *The Irish in the South, 1815–1877* (Chapel Hill: U of North Carolina P, 2001); Barbara Lewis Solow, "A New Look at the Irish Land Question," *The Economic and Social Review* 12.4 (1981): 301–14; David Moon, *The Abolition of Serfdom in Russia, 1762–1907* (Harlow: Longman, Pearson, 2001).

13. Sheldon Hackney, *Populism to Progressivism in Alabama* (Princeton: Princeton UP, 1969), and Samuel L. Webb, *Two-Party Politics in the One-Party South: Alabama's Hill Country, 1874–1920* (Tuscaloosa: U of Alabama P, 1997), disagree about the consequences of the traditionalist values and orientation of Populism. Webb agrees with Steven Hahn, *The Roots of Southern Populism: Yeomen Farmers and the Transformation of the Georgia Upcountry, 1850–1890* (New York: Oxford UP, 1983), about the anti–government and anti-capitalist nature of southern Populism. Hahn, however, also ties his Georgia Populists to the radicalism of the labor movement. In the first edition of his book, he did not see effective interracial cooperation. Later, in *A Nation Under our Feet: Black Political Struggle in the Rural South from Slavery to the Great Migration* (Cambridge: Harvard UP, 2003), he determined that rural, working class blacks were adept at pursuing and using inter-racial alliances. Gerald Gaither, *Blacks and the Populist Movement: Ballots and Bigotry in the New South* (Tuscaloosa: U of Alabama P, 2005), disagrees, arguing that suspicion and animosity divided blacks and whites even among the Populists.

14. On perceptions of the South and Luce's approach, see, for instance, Natalie Ring, *The Problem South: Region, Empire, and the New Liberal State, 1880–1930* (Athens: U of Georgia P, 2012); Augspurger, *Economy of Abundant Beauty*, 124, 155; Alan Brinkley, *The Publisher: Henry Luce and His American Century* (New York: Alfred K. Knopf, 2010) 163–65.

15. A convenient overview of Luce's missionary background is James L. Baughman, *Henry R. Luce and the Rise of the American News Media* (Boston: Twayne, 1987) 8–22. Most of the recent biographies of Luce pay no attention to his purchase of Mepkin, but see Robert Edwin Hertzstein, *Henry R. Luce: A Political Portrait of the Man Who Created the American Century* (New York: C. Scribner's Sons, 1994) 73. Daniel Vivian

is revising a study of northern purchasers of low country South Carolina plantations and their reshaping of these properties' aesthetics and social functions and meanings. Mepkin figures there, as it does in several locally published tours by area writer William P. Baldwin.

16. On the boll weevil and its published reflections, see, for instance, Fabian Lange, Alan L. Olmstead, and Paul W. Rhode, "The Impact of the Boll Weevil, 1892–1932," *Journal of Economic History* 69 (Sept. 2009): 685–718; James C. Giesen, *Boll Weevil Blues: Cotton, Myth, and Power in the American South* (Chicago: U of Chicago P, 2011); Erskine Caldwell, *Tenant Farmer* (New York: Phalanx P, 1935). For a brief comparison of Erskine Caldwell and Margaret Bourke-White's *You Have Seen Their Faces* with Agee and Evans's *Famous Men*, see Alan Trachtenberg's foreword to the Brown Thrasher edition of *You Have Seen Their Faces* (Athens: U of Georgia P, 1995); for a more detailed consideration of these documentarians, see Jeff Allred, *American Modernism and Depression Documentary* (New York: Oxford UP, 2010) 59–132.

17. Agee would have had available to him Thomas Perkins Abernathy, *The Formative Period in Alabama, 1815–1860* (Montgomery: Alabama State Department of Archives and History, 1922); Walter L. Fleming, *Civil War and Reconstruction in Alabama* (New York: Columbia UP, 1905); and R. W. Rowe, William G. Smith, and C. S. Waldrop, "Soil Survey of Hale County Alabama," in Milton Whitney, *U.S. Department of Agriculture Field Operations of the Bureau of Soils, Eleventh Report, 1909* (Washington, DC: US Printing Office, 1912) 677–703. To put these older works in perspective, see, for instance, J. Mills Thornton, *Politics and Power in a Slave Society: Alabama, 1800–1860* (Baton Rouge: Louisiana State UP, 1978), and Daniel Dupre, "Ambivalent Capitalists on the Cotton Frontier: Settlement and Development in the Tennessee Valley of Alabama," *Journal of Southern History* 54 (Nov. 1988): 565–96. It is clear from Agee's notes that he understood but then chose to leave out historical and geographical dimensions when writing "Cotton Tenants"; see Davis, *LUNPFM* 853–55; see also Davis, "Agee and the Composition . . ." 490, and also Paul Ashdown, "From Almost as Early as I Can Remember: James Agee and the Civil War," *Agee Agonistes: Essays on the Life, Legend, and Work of James Agee*, ed. Michael A. Lofaro (Knoxville: U of Tennessee P, 2007) 105–26.

18. Fields's observation is in a private electronic communication of March 7, 2015. On Agee's ethnographic gaze, see John Dorst, "On the Porch and in the Room: Threshold Moments and Other Ethnographic Tropes in *Let Us Now Praise Famous Men*," *New Critical Essays on James Agee and Walker Evans: Perspectives on* Let Us Now Praise Famous Men, ed. Caroline Blinder (New York: Palgrave Macmillan, 2010) 41–70. On the recent revival of interest in the concept and application of the ethnographic present, see, for instance, Kirsten Hastrup, "The Ethnographic Present: A Reinvention," *Cultural Anthropology* 5.1 (1990): 45–61; Roger Sinjek, "The Ethnographic Present," *Man* 26.4 (1991): 609–28; and Narmala Halstead, "Experiencing the Ethnographic Present," *Knowing How to Know: Fieldwork and the Ethnographic Present*, eds. Narmala Halstead, Eric Hirsch, and Judith Okely (New York and Oxford: Berghahn Books, 2008) 1–20.

19. On the frontier condition and its passing, see William Gilmore Simms, *The Social Principle: The True Source of National Permanence* (Tuscaloosa: Erosophic Society of the University of Alabama, 1843) 5–6; Allen Tullos, "The Black Belt," *Southern Spaces* 19 Apr. 2004, 23 Feb. 2015 <www.southernspaces.org/2004/black-belt>.

20. Agee, "Cotton Tenants" 623; Davis, *LUNPFM* 853–55.

21. For the Agee quote, see Davis, *LUNPFM* 201; on the Evans photo essay, see Belinda Rathbone, *Walker Evans: A Biography* (New York: Houghton Mifflin, 1995) 90–92, and Michael Wreszin, ed., *Interviews with Dwight Macdonald* (Jackson: UP of Mississippi, 2003) 108, 121–23.

22. Harold Preece, "Epic of the Black Belt," *The Crisis* 43.3 (1936): 75, and esp. 92; Robin D. G. Kelley, *Hammer and Hoe: Alabama Communists During the Great Depression* (Chapel Hill: U of North Carolina P, 1990) 34–56; Amy Louise Wood, *Lynching and Spectacle: Witnessing Racial Violence in America, 1890–1940* (Chapel Hill: U of North Carolina P, 2009) 179–222.

23. Davis, *LUNPFM* 84–93, 189–98, 318–37. See Leigh Anne Duck, "Arts of Abjection in James Agee, Walker Evans, and Luis Bunel," *Oxford Handbook to the Literature of the U. S. South*, eds. Fred Hobson and Barbara Ladd (New York: Oxford UP, 2016) 290–309. On C. Vann Woodward, *Tom Watson, Agrarian Rebel* (New York: Macmillan, 1938), see David Moltke-Hansen, "Turn Signals: Shifts in Values in Southern Life Writing," *Dixie Redux: Essays in Honor of Sheldon Hackney*, eds. Raymond Arsenault and Orville Vernon Burton (Montgomery: New South Books, 2013) 166–99, esp. 159–74 and 189–92.

24. Linda Wagner-Martin, "*Let Us Now Praise Famous Men*—and Women: Agee's Absorption in the Sexual," in Lofaro, *James Agee* 44–58, argues for the voyeuristic quality of *Famous Men*, but the same may be said of "Cotton Tenants," although there that quality is a less commanding feature. See also Paula Rabinowitz, *They Must Be Represented: The Politics of Documentary* (London: Verso, 1994) 35–55.

25. These meditations occur, *inter alia*, in Davis, *LUNPFM* 12–14, 188–89, 327–28, 366–69. Also see David Madden, "The Test of a First-Rate Intelligence: Agee and the Cruel Radiance of What Is," in Lofaro, *James Agee* 32–43; also Paul Hansom, "Agee, Evans, and the Therapeutic Document: Narrative Neurosis in the Function of Art," in Blinder, *New Critical Essays*" 105–20; and Alan Spiegel, *James Agee and the Legend of Himself: A Critical Study* (Columbia: U of Missouri P, 1998) 11–12, 42, 51.

26. On Bourke-White, see, for instance, Paula Rabinowitz, *They Must Be Represented* 56–74.

27. On Alabama Communists, see Davis, *LUNPFM* 304, 369. Other episodes are strewn through the work, but two on race are early, at. 24–27 and 34–37. Examples of Agee's use of language about what was average or typical are in Davis, *LUNPFM* vii, 99, 128, 165–68, 175, 213–14, 227, 242, 244–45, 247, 278, and 297.

28. [Context]Davis, *LUNPFM* 233–55.

29. [on...]See Ashdown, "Prophet from Highland Avenue."

30. On Gide, Davis, *LUNPFM* 287; Davis, "Agee and the Composition . . ." 48, 503–505.

31. On Wolfe and Agee, see Richard H. King, *A Southern Renaissance: The Cultural Awakening of the American South, 1930–1955* (New York: Oxford UP, 1980) 194–241. On Cobb, see Theodore Rosengarten, *All God's Dangers: The Life of Nate Shaw* (New York: Random House, 1974), and James C. Giesen, "Creating 'Nate Shaw': The Making and Remaking of *All God's Dangers*," *Southern Poverty Between the Wars, 1918–1939*, eds. Richard Godden and Martin Crawford (Athens: U of Georgia P, 2006) 163–78. On Hudson, see Nell Irvin Painter, *The Narrative of Hosea Hudson: His Life as a Negro Communist in the South* (Cambridge: Harvard UP, 1979). On Wright, see Gardner, "Reviewing the South" ch. 4.

32. Quoted in Davis, "Agee and the Composition . . ." 490; W. J. Cash, *The Mind of the South* (New York: Knopf, 1941).

33. Bruce Clayton, "Southern Intellectuals," *Debating Southern History: Ideas and Action in the Twentieth Century*, eds. Bruce Clayton and John A. Salmond (Oxford: Rowan and Littlefield, 1999) 50; John Shelton Reed, "*The Mind of the South* and Southern Distinctiveness," The Mind of the South *Fifty Years Later*, eds. Bruce Clayton and Charles W. Eagles (Jackson: UP of Mississippi, 1992) 137.

34. Howard W. Odum, *Southern Regions of the United States* (Chapel Hill: U of North Carolina P, 1936); Lynn Moss Sanders, *Howard W. Odum's Folklore Odyssey: Transformation to Tolerance through African American Folk Studies* (Athens: U of Georgia P, 2003); Jack Temple Kirby, "The Chapel Hill Regionalists and the South ern Landscape," *The United States South: Regionalism and Identity*, eds. Valeria Gennaro Lerdra and Tjebbe Westendorp (Rome: Bulzoni Editione, 1991) 167–85; Karen Smith Rotabi, "Ecological Theory Origin from Natural to Social Science or Vice Versa? A Brief Conceptual History of Social Work," *Advances in Social Work* 8.1 (2007): 113–29.

35. Angie Maxwell, "Feeling Burdened: James Agee, W. J. Cash, and the Southern Confession," in Lofaro, *Agee Agonistes*, 196.

36. Fernand Braudel, *La Mediterranee et le monde Mediterraneen a l'epoque de Phillipe II*, 3 vols. (Paris: Armand Colin, 1949); Pierre Daix, *Braudel* (Paris: Flammarion, 1995); Francois Dosse, *New History in France: The Triumph of the* Annales, trans. Peter V. Conroy, Jr. (Urbana: U of Illinois P, 1994); Gabriel Piterberg, Teofilo F. Reiz, and Geoffrey Symcox, eds., *Braudel Revisited: The Mediterranean World, 1600–1800* (Toronto: U of Toronto P, 2010).

37. On the shifting nature of Agee's Communism, see Hugh Davis, *The Making of James Agee* (Knoxville: U of Tennessee P, 2008) 140–50.

A Southerner in New York:
James Agee and Literary Manhattan
in the 1930s

Sarah E. Gardner

Daily book critic Ralph Thompson hated *Let Us Now Praise Famous Men*. At least he hated James Agee's prose. He admired Walker Evans's photographs, noting that the book's accompanying illustrations told as much about tenant farmers in the cotton South as did Agee's "self-inspired, self-conscious and self-indulgent" 150,000-word text. College students across the country would surely flunk first-year composition, he railed, for turning out Agee-esque sentences. "When the mood is on him," which was more often than not Thompson thought, "Mr. Agee is arrogant, mannered, precious, [and] gross." Taken as a whole, Thompson continued, *Famous Men* was "a monument to what can be done in the field of sociological reporting if an author gives himself enough rope." Agee's promise that *Famous Men*, a mere "portent and fragment," served as an "experiment, [a] dissonant prologue" to a longer work sent Thompson shuddering. "Let us now wait and hope and pray," he concluded, more than a bit disingenuously.[1]

Thompson's *New York Times* review occasioned swift response from irate readers. His characterization of Agee's writing as "extravagant [and] pretentious" had convinced one reader that he could dismiss the book as "hysterical, silly, and incompetent." Only when a friend raved about the study of three tenant families in Alabama did he reconsider his initial judgment. Persuaded to pick up a copy, the reader soon discerned Agee's hyper subjectivity: "Looking at [southern poverty] with a poet's shock and his agonized guilt over his own richly comfortable Harvard background," Agee was "impelled to write about it in a way that would

make others see [. . .] and feel with the shock and agony and guilt like his own."[2]

A second reader shared this discomfort. Thompson's "evident anger at and fear of the book" rendered his judgment "invalid," she believed. *Famous Men* was a new kind of work, one of "passionate and convincing sincerity." She found especially offensive Thompson's complaint that Agee's wrote without humor. "Mr. Agee's subject is unfunny," she declared. "That he should be criticized for omitting humor and cunning from catalogues of human agony and deprivation" was simply galling. Readers were entitled to "more than the sneering and superficial consideration" Thompson had given the book, she argued. More to the point, she feared that his review had done great damage. Those readers who accepted his judgment without question would "miss reading a book which has been for me and for many of my friends, one of the finest experiences in years."[3]

Neither Thompson's review nor these two letters would have surprised regular readers of the *Times* daily book page. Publishers had complained about Thompson's overly critical reviews there, arguing the job of a daily critic was to treat the publication of a book as news; critical assessment, they believed, should be reserved for those who penned longer pieces for the Sunday supplements and the intellectual weeklies.[4] Readers also expected critics to follow the conventions of the genre, which had become established over the past two decades, during the golden age of reviewing. As literary scholar Stephen Cushman has explained, "[T]he nature of genre becomes an issue because the generic identity of a work amounts to a contract between writer and reader."[5] Readers accused Thompson of abrogating their trust. Thompson's dismissiveness and mean-spirited tone had crossed the line, they charged. Both readers forgave Agee's penchant for excess and his tendency to overwrite. Describing his prose as "precise and powerful," and "especially vivid and telling," Thompson's correspondents testified to Agee's effectiveness.[6] Quite simply, Thompson's correspondents empathized with the tenant families, and Agee's prose aided rather than hindered the development of this response.

Much has been written about Thompson's review. Indeed, Agee's biographer, Laurence Bergreen, declared it a "disaster" and a "debacle." Be-

cause it was the first to appear, he argued, it set the tone for other reviews, thereby preventing *Famous Men* from receiving a fair hearing. Neither journalists nor reviewers come off well in *Famous Men*, leading Bergreen to surmise that Thompson's ungenerous review was in some measure a retaliatory move for Agee's public contempt for the profession.[7] Whatever Thompson's motivation, little evidence suggests that Thompson took personal offense at Agee's criticisms or that the nation's book critics followed his lead. Moreover, by the time the book was published, little the reviewers said, regardless of what they said or how they said it, would influence the nation's readers. As critic Malcolm Cowley observed in 1943: "The public is buying books," although "not always the books that critics think it ought to be reading."[8] The mood of the country had changed, and as the nation geared for war the lives of three tenant farmers no longer seemed immediately relevant.

In examining *Famous Men*'s relationship to the national discourse on the South's poor during the Great Depression, it becomes clear that the New York literary context mattered as much as Depression-era Alabama in shaping the manuscript and its reception. As a member of the New York literati, even if only grudgingly and often contemptuously, Agee was well aware of the review culture that informed the literary marketplace during the interwar years. So too were his readers, as the two letters to Thompson suggest. Reviewers did not read *Famous Men* in a vacuum; rather, they understood Agee's text in the context of Depression-era publications, both fiction and nonfiction, on southern poverty. Although critics had found much to admire in Agee's work, the book industry had largely passed Agee by. Put another way, *Famous Men* did not continue the conversation; it was the last word, a coda, although one that few people heard. But if wartime changes in the book industry worked against Agee in the 1940s, the persistence of prize culture helped ensure Agee's lasting literary currency. Agee owed his postwar reputation to the Pulitzer Prize for Fiction awarded posthumously in 1958 for *A Death in the Family*. As in the case of Faulkner's (re)discovery by the public after the Mississippian received the Nobel Prize in 1950, Agee's popularity blossomed nearly two decades after the Tennessean completed his extended nonfiction work. Although the literary marketplace had failed Agee in the 1940s, it proved his salvation in the

1950s. *Famous Men* owes its legacy to this fact, as much as to the resurgence of New Journalism and the "documentary impulse" in the 1960s.

James Agee arrived in New York in 1932. He could not have arrived at a better time. The past decade had witnessed a tremendous expansion of the book industry, with new firms, such as Knopf, Random House, Viking, and Farrar and Rinehart, quickly becoming powerhouses in the business. The growth of the publishing industry in turn encouraged newspapers to pay greater attention to the world of books. Beginning in the 1920s, a proliferation of daily book columns and separate Sunday book supplements reflected the growing audience of educated readers with disposable income and an appetite for books and reviews. *The Saturday Review of Literature* and the *New York Herald Tribune Books* were both founded in 1924, for example. So too was Simon & Schuster. *Time*, Agee's eventual employer, had appeared the year before, and by the 1930s it consistently appeared on, at, or near the top of readers' polls that surveyed preferred reviewing outlets. Significantly, books "became news" at a time when southern writers began to turn inward and interrogate long-held customs and assumptions. Simultaneously, northern journalists and editors found material in the South worthy of national coverage.[9]

The center of the publishing world was New York. Admittedly, a few publishing houses were located in the periphery—Bobbs-Merrill in Indianapolis, Indiana, for example—but even they maintained New York offices. Most of the major reviewing outlets were located in New York as well, although they, along with the publishing firms, often employed provincials to direct them, many of them southerners: *Books*'s editor Irita Van Doren hailed from Tallahassee, Florida; Harper and Brothers' Edward C. Aswell from Nashville, Tennessee; the *New York Post*'s Hershel Brickell from Senatobia, Mississippi; and *The New Republic*'s Stark Young from Como, Mississippi. Regardless of origin, however, these industry insiders shared a commitment to the New York literary world, even as other allegiances tugged—sometimes violently—at their sympathies. As Brickell once confessed, "New York is a hard place for a Southerner to work."[10] Nashville agrarian Stark Young often found it tough going at the left-leaning *New Republic*; so did the radical Agee at Time, Inc. But make no mistake, their day-to-day world was lived in the literary metropole,

and that world was often as insular and circumscribed as that of the inhabitants of Faulkner's Yoknapatawpha County.[11]

Agee might have found that insularity insufferable; yet it was the New York literary world that recognized his talent, gave him employment, allowed him to publish, even fed his fulminations. It was this world that made *Famous Men* possible, not just because *Fortune* handed Agee the original assignment but because major publishing firms expressed keen interest in the original thirty thousand-word manuscript once it had been rejected. When Agee's constant delays in submitting a revised manuscript forced Harper and Brothers, his initial publisher, to terminate his contract, Houghton Mifflin jumped on signing Agee to its list. Yet Edward Aswell, Agee's erstwhile editor at Harper, regretted the decision he had to make. "Let me tell you now how greatly I envy you the privilege of publishing this book," he confessed to Houghton Mifflin's Lovell Thompson. "It was a great blow to me personally that things turned out as they did. Agee is certainly one of the most remarkable writers I have ever known," he continued, "and the only one now living, who, I feel sure, is an authentic genius." Only Aswell's business relationship with Agee had been ruined; his friendship with and his admiration of the author remained firm.[12]

It was into this world that Agee arrived during one of the leanest years of the Great Depression. As C. Vann Woodward remarked more than sixty years ago, "For some reason never fully explained the 'poor whites' seem to have been more numerous in periods of economic depression than in other times."[13] What Woodward meant of course was that the South's poor went largely unnoticed until times of national economic downturn. That was certainly the case during the Great Depression, when southern poverty suddenly came into sharp focus. All manner of novelists, reporters, photographers, government investigators, folklorists, sociologists, and economists entered the conversation, in large measure to assess the degree to which southern poverty hindered efforts at national recovery. For many, the answer to that question hinged on whether the South's poor proved exceptional, having deviated from the national norm.

By the mid-1930s, Erskine Caldwell was perhaps the best known chronicler of the South's poor. Although his *Tobacco Road* (1932) and *God's*

Little Acre (1933) did not earn healthy sales when first released, they generated a lot of buzz, aided by a successful stage adaptation of the former—it ran for more than three thousand performances, becoming one of the longest-running non-musicals on Broadway—and by a highly publicized censorship case involving the latter. Whatever Caldwell intended—and he professed a desire to chronicle "proletarian life in the South"—critics took something else way from his fiction.[14] By and large, his use of the grotesque elicited revulsion and contempt for his subjects, who seemed too degenerate and depraved to improve their lots in life. William Terry Couch, director of the University of North Carolina Press, calculated that Caldwell had irreparably damaged national understanding about the plight of the South's poor. Couch understood that sympathy could not develop in the absence of familiarity and connection. Yet Caldwell's grotesque caricatures of southern tenant farmers and sharecroppers alienated readers, a point made by Random House's Bennett Cerf in a particularly acerbic (and widely discussed) review of *God's Little Acre*. "I do not doubt for an instant that there actually exist people like the characters in Erskine Caldwell's *Tobacco Road* and *God's Little Acre*," Cerf explained. "I simply say that if almost any one of them were to march unannounced into the world I travel in, he would create about as great a sensation as a wild elephant or a naked cannibal brandishing a spear." Caldwell's characters were, Cerf continued, "a foreign species to me, with emotions and reactions that I not only have never experienced myself, but have never even heard of before."[15] Cerf was not alone in this estimation. Small wonder, then, that Caldwell complained no reviewer, save one, had "got" his novels.[16]

Caldwell fared no better critically with two pieces of nonfiction that he published at mid-decade, the pamphlet "Tenant Farmer," an elaboration of a series of articles Caldwell had written for the *New York Evening Post*, and his collaborative essay with photographer Margaret Bourke-White, *You Have Seen Their Faces*. In both cases, Caldwell sought to make real for his readers the plight of the South's most desperate poor. In what might be read as a jab at Bennett Cerf, Caldwell explained, "[T]hese are the men, women, and children that many urban residents deny that exist." Yet stories of two infants "sucking the dry teats of a mon-

grel bitch" or of a six-year-old boy, suffering from anemia and rickets, who licked a piece of paper that had once wrapped a piece of meat did nothing to render the South's poor any less exotic than the characters that populated Caldwell's fiction.[17] Herein rested the problem for Couch, who reviewed both the pamphlet and the essay. Caldwell's nonfiction could not be separated from his fiction, and the South's poor could not be separated from Caldwell's literary creations. "If the pictures of tenant farmers and of poor people in the South generally, as rendered in 'God's Little Acre' and 'Tobacco Road,' are authentic," Couch despaired in his review of *You Have Seen Their Faces*, "then there is little which can be done by landlord or tenant, by government or God, unless of course, Mr. Caldwell's writings should arouse the interest of the Deity that He would then proceed to make tenant, landlord, and land all over again."[18] Whatever response Caldwell's portrayals might elicit from readers, Couch concluded, none was conducive to reform.

Agee, too, thought Caldwell's sensationalized writings misled American readers. True, Agee did not name Caldwell, but the textual evidence suggests that Agee considered Caldwell among those writers on the South's poor who had done the greatest damage. In "Cotton Tenants: Three Families," the long unpublished 1936 presentation of early material in *Famous Men*, Agee explained his choice to profile the Burroughs family and their kin. None worked for the "worst type of landlord," but none worked for the best either. The text singles out the Burroughs family for special attention, he continued, because it "presents the least flagrant picture." Agee intuited that his readers had, by 1936, come to expect accounts of brutal and rapacious landlords, of physically and intellectual stunted tenants too weak to improve their lots. Yet he also understood that the most gratuitous portraits undercut the force of the purported argument. "And if the life of the tenant is as bad as it has been painted," Agee reasoned, "and it is worse—it will show its evil less keenly, essentially, and comprehensively, in the fate of the worst treated than in that steady dripping of daily detail which effaces the lives even of the relatively 'well' treated."[19] Agee carried this point through in *Famous Men*, maintaining that he wrote about "actual" living human beings. George Gudger was not, for example, "some artist's or journalist's

or propagandist's invention: he is a human being: and to what degree I am able it is my business to reproduce him as the human being he is; not just to amalgamate him into some invented, literary imitation of a human being" (194).

Yet unlike Couch, Agee considered the threat that grotesque and exaggerated portrayals posed to reform utterly irrelevant. That point, he insisted was a misdirection, encouraging readers to look at one thing—the problem of the tenant farmer—when really they should be looking someplace else entirely. "We would be dishonest," he insisted, "to cheer ourselves with the thought that in ameliorating the status of the cotton tenant alone, any essential problem would be solved." The "problem" most emphatically was not the tenant farmer. Agee made this clear in "Cotton Tenants." "Human life," he wrote honestly, if pedantically, "is somewhat more important than anything else in human life, except possibly what happens to it. And since," he continued, "every possibility human life holds, or may be deprived of, of value, of wholeness, or richness, of joy, of dignity, depends all but entirely on circumstances are proportionately worthy of the serious attention of anyone who dares to think of himself as a civilized human being." This point was the crux of the matter for Agee. A civilization that disadvantages a human being, any human being, a civilization that exists only by privileging some and disadvantaging others "is worthy neither of the name or of continuance." And in a confessional mode, he condemned those who benefitted by the disadvantaging of others as no better than the common parasite, "the bedbug, the tapeworm, the canter, and the scavengers of the deep sea."[20] He would go on to make these same points more passionately, insistently, and angrily in *Famous Men*.

Of course, Caldwell did not have a monopoly on the national conversation on southern poverty. By the late 1920s, the intellectual weeklies, including *The New Republic* and *The Nation*, had begun to report on the profound crisis in southern agriculture. And by the time Agee and Evans published *Famous Men*, the Chapel Hill regionalists had begun to churn out weighty tomes that documented the South's economic and sociological peculiarities. Too, the federal government had weighed in, first issuing in 1938 its "Report on Economic Conditions in the South,"

which famously declared the region the nation's "Number One" economic problem, and then, in the following year, a collection of life stories conducted by the Federal Writers' Project and edited by William Couch.[21]

None of these efforts earned Agee's approbation. His scorn, especially of journalism, was palpable. He identified himself as a "spy," posing as a journalist. Immediately following his promise that *Famous Men* served as a mere prologue, a promise that sent Ralph Thompson's eyeballs rolling, Agee reminded his readers that "the present volume [. . .] is intended, among other things, as a [. . .] a corrective." The reader would do well, therefore, to interrogate his own "expectations" of the subject's "proper treatment. For that," Agee clarified, "is the subject with which the authors are dealing, throughout. If complications arise, that is because they are trying to deal with it not as journalists, sociologists, politicians, entertainers, humanitarians, priests, or artists, but seriously" (xvi, viii). Agee sensed that any sort of disconnect that emerged between his text and readers' understanding stemmed from the cultural weight carried by false, even mendacious, portrayals of the South's poor that had circulated in 1930s discourse.

Agee's criticisms of journalism run throughout the text. Perhaps none was as sharp as the jab directed at the Luce empire, a point not missed by Ralph Thompson in his review. Agee's desperate need to disassociate himself from *Time/Fortune* is palpable, and his 171-word sentence on his former employer that prefaces his text can barely contain Agee's revulsion:

> It seems to me curious, not to say obscene and thoroughly terrifying, that it could occur to an association of human beings drawn together through need and chance and for profit into a company, an organ of journalism, to pry intimately into the lives of an undefended and appallingly damaged group of human beings, an ignorant and helpless rural family, for the purpose of parading the nakedness, disadvantage and humiliation of these lives before another group of human beings, in the name of science, of "honest journalism" (whatever that paradox may mean), of humanity,

of social fearlessness, for money, and for a reputation for crusad-
ing and for unbias which, when skillfully enough qualified, is
exchangeable at any bank for money (and in politics, for votes,
job patronage, abelincolnism, etc.*); and that these people could
be capable of meditating this prospect without the slightest doubt
of their qualification to do an "honest" piece of work, and with a
conscience better than clear, and in the virtual certitude of almost
unanimous public approval. (7) *Money

Elsewhere, Agee charged: "our soundest and most final ideas of justice"
are, in fact, hopelessly "cavalier and provincial and self-centered" (201).

Yet if Agee found fault with the producers of content—the novelists,
the sociologists and statisticians, the reporters, the government inves-
tigators—he was similarly disgusted by the nation's critics, those who
passed judgment on all of this literary output. Indeed, by the time he
published *Famous Men*, his disdain of the culture of reviewing was well
known. This was Agee's world. He was in it, if not of it, and often found
himself caught in its machinery. Robert Fitzgerald, who had worked with
Agee at *Time/Fortune*, recalled their time together writing reviews. If a
book captured Agee's imagination, he would draft lengthy comments,
many of which came back from the managing editor trimmed down to
one paragraph. Others remained unpublished. Despite the intervention
of T. S. Matthews, a senior editor at *Time*, the efforts to see important
books reviewed were often thwarted.[22]

Publicly and privately Agee recorded his scorn of this reviewing cul-
ture. In one of his journals he jotted down a line of verse about Henry
Seidel Canby, editor of *The Saturday Review of Literature*: "Hurrah for
our Seidel / Side by Seidel / oleo golden mediocrity." Further down the
page, he continued:

> Now, with an eye for the side of bread that's buttered,
> Three loud cheers for the Saturday review,
> Which, with faith good sense has seldom fluttered
> Has plugged the elderly, ignored the new,
> Licked every well-shined boot, scratched every back.

As the leading journal of literary criticism during one of the most "vivid and dangerous decades of American life and literary history," the *Saturday Review* failed to meet its obligations to its readers and to authors. "Constantly advancing the safe, the cowardly, the dull-hearted and the evil and as constantly opposing the adventurous, the courageous, the serious and the good," the *Saturday Review* "blind[ed] and drugg[ed]" an audience already blind and drugged." Its failings could be matched, Agee added, "only by the *New York Times*."[23]

Agee did not reserve his comments for his private journals. He included a particularly scathing section on the state of literary criticism in America in *Let Us Now Praise Famous Men*, inspired by a questionnaire sent out by *Partisan Review* in 1939 on "the situation in American Writing." The third question asked respondents to evaluate the criticism their work had received. The editors were particularly interested in learning whether authors believed advertising departments and political pressures had corrupted the literary magazines and liberal weeklies, thus rendering "serious literary criticism an isolated cult." The summer issue included the responses from Allen Tate, John Dos Passos, Katherine Anne Porter, and Gertrude Stein. The fall issue promised to include James Agee.[24]

Agee's responses were damning. He prefaced his remarks by questioning the value of *Partisan Review* to American letters. "You are supposed to be and I guess are the best 'American' 'literary' and 'critical' magazine. In other words, these questions, the best you can ask, prove a lot about American literature and about you, the self-assumed 'vanguard,'" he wrote. The questionnaire, Agee believed, exposed *Partisan Review* as a fraud. It proved to him that the magazine was as irrelevant, even damaging, to good work as every other journal, as well as the "parlor talkers," publishers, and "most of the writers themselves." He declared the questions so bad as to be unanswerable. They served only to betray *Partisan Review*: "You only think you know what good work is, and have no right to your proprietary attitude about it." Despite his protestations to the contrary, Agee eventually answered the questions posed. He agreed that literary supplements and the liberal weeklies were corrupt, although not because of advertising or politics, but because of

the small minds that ran them. In this respect, he added, "I think nearly everything I have read in the Partisan Review is quite as seriously corrupting, and able further to corrupt the corruptible" (285–90). Not surprisingly, *Partisan Review* chose not to publish his responses.

This New York literary world—as much as the world of Alabama farm tenancy—shaped what Agee thought about and how he presented his material. Yet even before *Fortune* sent him and Walker Evans to Alabama, he knew that he wanted to tell a different kind of story, no matter its subject matter. As Hugh Davis, Agee's literary biographer, has explained, Agee confessed as early as 1932 that he wanted to invent "a sort of amphibious style—prose that would run into poetry when the occasion demanded poetic expression"; by 1937 Agee had, according to Davis, proposed "a form of writing that would combine the precision of scientific description with the imaginative scope of art."[25] As Agee revised his manuscript, initially for Harper and Brothers, he confided to Walker Evans his difficulty in conveying what he thought and felt "in such a way that anyone who can read or hear spoken language and who can see a photograph [. . .] will understand it." Still, he doubted whether "there is [. . .] any other proper way of writing."[26] By and large, it was this "amphibious style" that reviewers noted, finding it either self-indulgent and tiresome or illuminating and transcendent.

A number of factors influenced the assigning of reviews, including the critic's familiarity with the subject matter, the reviewing outlet's desire to create or avoid literary controversy, the critic's "name recognition" and his or her reputation for turning copy in on time, and a magazine or newspaper's obligation to meet the anticipations of its readers. In short, managing editors assigned reviews with intent.[27] Significantly, none of the major reviews mentioned Agee's diatribe against professional criticism. Indeed, Paul Goodman's review, which appeared in *Partisan Review*, remained conspicuously silent on this point.[28] Apparently, some in Agee's immediate circle expected a reprisal. Selden Rodman's review for the *Saturday Review of Literature*, for example, imagined: "It is easy (and not unpleasant) to picture the rage that is going to draw blood to the faces of certain self-righteous reviewers of books" when they begin reading *Let Us Now Praise Famous Men*. "Not

that these connoisseurs of stylized fiction and high-minded, politically impeccable war-reportage will travel much farther than the introductory pages," he surmised, "but that the author has set traps for them so cunningly, and with such calculated cruelty, that opening almost at random should serve to produce the desired result."[29] Even if Agee did set traps, however, no reviewer fell into them, at least not in public.

Ralph Thompson was the only reviewer who mentioned Agee's equally derisive commentary on contemporary journalism, chastising the author for his sanctimonious attitude. After all, Thompson reminded his readers, Agee "makes at least part of his living as a journalist himself."[30] Yet even *Time* refrained from going after Agee, although it did run a more critical review than the one originally commissioned. *Time* had originally assigned staff writer Robert Fitzgerald to review *Famous Men*. Fitzgerald's draft exceeded 1,500 words, long for *Time*. In it he praised Agee and Evans for their monumental achievement. "The book is," he informed his would-be readers, "among other things, a fully intelligent collaboration of still photography and writing" as well as a "beautiful study of tenant farming in the deep South." Fitzgerald spent the better part of the review conveying Agee's intentions. Agee impresses upon his readers his subjects' humanity, Fitzgerald explained. Agee minimizes their "degradation," for "fortunate readers" have become accustomed to becoming briefly saddened and then forgetting their fellow man's suffering. "Agee's concern is that this book shall not fall in the trap of ineffectual sentiment; nor into the trap of facile 'reformist' or 'revolutionary' talk. He has no intention of 'idealizing' his people," Fitzgerald continued, nor of "exploiting their possibilities for entertainment." In Fitzgerald's estimation, *Famous Men* "demands directly of the reader his pain, his awareness, and his repentance. It scourges, with a precise fury not often equaled, certain peculiarly American vices of self-complacence and blatancy." Fitzgerald imagined that reviewers would resent Agee's bravery and the demands he exacted from his readers. "Criticisms of that type will convict themselves," Fitzgerald believed. "A thoughtful reader may better feel that if meaning is to be restored in the 20th Century to such clichés as 'the dignity of man,' 'the brotherhood of man,' and 'the worship of God,' it is work like this that will do it."[31]

Fitzgerald's review was scrapped, and the magazine ran instead a much shorter, and less enthusiastic, notice. *Famous Men*, the review began, was the most "distinguished failure" of the literary season. "Its author," the reviewer declared, "willed it so"; Agee's "bad manners, exhibitionism, and verbosity" conspired to undermine the book's success. Still, the review made clear Agee's intent was to impress upon his readers that the tenants, "whose hopeless, subhuman lives he reverently exposes, are now alive, human brothers of the reader, sharers of 'certain normal predicaments of human divinity.'"[32] Fitzgerald had thought the book's "moments of strain, childishness, and precocity," were incidental and thus should remain unmentioned in a "brief review." Although the published review conceded that Agee's obsession to force readers to acknowledge his subjects' humanity drove him to write "some of the most exciting U.S. prose since Melville," the piece nonetheless argued that Agee often failed to make his own "thoughts and feelings" comprehensible.[33]

Although not as effusive as Fitzgerald's review, the published notice was hardly a hatchet job. In part, that would go against *Time*'s ethos. *Time*, a 1939 memo insisted, did "not bestow either blessings or curses on books; that is the first world of difference it has (and means to have) from the 'usual' review. The Good books need no such blessing. The Bad books are curses to themselves." *Time*'s intent, the memo continued, was not to "transform the reader," but rather to "do something" to the material it reported. Reviews thus needed to keep this intention "even more scrupulously before it than in the presentation of material of other kinds: to avoid everything that might be the cultivation of an attitude—literary, political, etc., etc.—in its readers." Reviews in the intellectual weeklies, such as *The New Republic*, "are bent on the cultivation of attitudes, are constantly transferring the burden of 'knowing about' the books they describe to their readers." Such a reviewing policy equaled tyranny, the memo concluded. "The result of such a tyrannic method is weariness. The stupefied readers of the usual book reviews and articles can scarcely distinguish between knowledgeableness and weariness."[34]

Yet there were other, equally important, reasons that *Time* refrained from "retaliating" against Agee. Even *Time*, perhaps especially *Time*, recognized Agee's talent, and talent mattered. As a case in point, three years earlier the reviewing community had rallied against an author who had

exhibited equally "bad manners" but far less talent. Virginian Julian Meade had been well placed in the literary scene, counting among his friends and supporters Pulitzer Prize-winning author Julia Peterkin. The publication of his autobiographical sketches in 1935 had caused a minor kerfuffle, however, with other leading lights of the southern renaissance, including Stark Young, Margaret Mitchell, and Ellen Glasgow. His ungenerous comments about Ellen Glasgow so offended her that she called on Stark Young to make sure that *The New Republic* failed to review his book. Young was happy to oblige. "Wasn't it sweet," he cooed, "how a tip from you kept Mr. Meade out of the [*The New Republic*] reviews entirely?"[35] Irita Van Doren, managing editor of the *New York Herald Tribune Books*, did not snub Meade; instead she ran a damning review that accused Meade of, among other things, plagiarism. Three years later, when Meade published his debut novel in 1938, he included an insufferable character that bore the name of Glasgow's good friend, Carrie Duke. Once again, the reviewing community retaliated. And once again, Meade's book was panned in the pages of *Books*. Reviews, when they did appear, were short, buried, and not particularly favorable. By and large, however, reviewers were silent.

Meade was certainly a competent writer, at times even witty, but he was hardly a genius. Agee was, at least according to the nation's leading critics. Even those frustrated by *Famous Men* recognized it as something extraordinary. Most reviewers saw the text as idiosyncratic, confused, uneven, solipsistic, flawed, and brilliant. And most were struck by Agee's indictment of his readers for complacency in the face of human depravation. How could they not be? "This book is [. . .] an act of violence," George Barker proclaimed in his review for *The Nation*. In an effort to rouse its readers to awareness, it seeks its ends "by hammering desperately and cold-bloodedly on the sense of astonishment." In the same vein, Harvey Breit called *Famous Men* "an appeal for continuous *tension*" and "propaganda intended to corrode our habitual acceptances." According to Rodman, the book confronted readers with the awful truth that "acceptance of great art and complacence before human poverty and degradation" is ultimately "soul-damaging." More optimistically, Ruth Lechlitner noted that Agee's text asked readers to consider, "What can we do for these people?" Recognizing the harmful

effects the avoidance of poverty has had on middle-class readers, however, she suggested the more important question was: "What can we do for each other?"[36] In other words, in acknowledging their own complicity, readers might find the way to their own salvation.

In the end, of course, none of these reviews mattered. Had the book appeared in the mid-1930s, it might have found traction. By the fall of 1941, however, the mood of the country had changed, and no advertising blitz or concerted campaign from the nation's critics could drum up readers' interest in *Famous Men*. The intellectual weeklies, which had devoted considerable space to the plight of the southern tenant farmer during the prior decade, turned their attention to the deepening crisis in Europe and Asia. Symposia on American intervention and articles on the perils of European fascism and Japanese militarism replaced commentary on domestic problems. *Publishers Weekly*, the industry's trade journal, documented the changes in readers' tastes and demands as the nation inched closer to war. Even before America entered the conflict officially, readers demanded less general nonfiction and more technical books, especially those which detailed the finer art of "aircraft construction and shipbuilding, on all sorts of blueprint reading, on carpentry, machine work, autos, motors, chemistry, and plastics."[37] A sales manager at Alfred A. Knopf also noted readers' renewed interest in books that promoted democratic ideals and practices. "The constant flow of newspaper editorials, magazine articles, sermons, and Congressional debates on the dangers that threaten our political system," he declared, "is having its effect."[38] Lastly, booksellers reported increased interest among their customers for books on past conflicts that offered both "guidance for today's decisions" as well as testified to the strains and stresses "nations have lived through and survived."[39] None of these trends proved auspicious for *Famous Men*. Despite Agee's efforts to emphasize the universality of human suffering—the references to *King Lear* and to Beethoven and Bach—despite his agonized appeal to readers to see his subjects as part of "the brotherhood of man," it is clear that both the book industry and general readers regarded *Famous Men* as a study of a particular region at a particular moment in time. That time and place were no longer critical to the nation's survival, Agee's protestations to

the contrary. It was apparent to all in the book industry that, at the time *Famous Men* was published, southern poverty was no longer in vogue.[40]

NOTES

1. Ralph Thompson, "Books of the Times," *New York Times*, 19 Aug. 1941: 19; James Agee and Walker Evans, Let Us Now Praise Famous Men: *An Annotated Edition of the James Agee-Walker Evans Classic, with Supplementary Manuscripts*, ed. Hugh Davis, vol. 3 of *The Works of James Agee*, gen. eds. Michael A. Lofaro and Hugh Davis (Knoxville: U of Tennessee P, 2015) viii. Subsequent references to this edition will be noted parenthetically in the text, and abbreviated in the notes as Davis, *LUNPFM*.

2. B. H. Haggin, letter, *New York Times*, 6 Sept. 1941, Ralph Thompson Papers, New York Public Library.

3. Helen Dankin, "To Ralph Thompson," 8 Sept. 1941, Ralph Thompson Papers, New York Public Library.

4. Sarah E. Gardner, "Reviewing the South: The Literary Market Place and the Making of the Southern Renaissance, 1920–1941,"(Cambridge UP, forthcoming).

5. Stephen Cushman, *Belligerent Muse: Five Northern Writers and How They Shaped our Understanding of the Civil War* (Chapel Hill: U of North Carolina P, 2014) 99.

6. Haggin, letter, Ralph Thompson Papers; Dankin, "To Thompson," Ralph Thompson Papers.

7. Laurence Bergreen, *James Agee: A Life* (New York: E. P. Dutton, 1984) 257–258.

8. See Malcolm Cowley, "The Literary Business in 1943," *The New Republic* 27 Sept. 1943: 417–19; Cowley, "Books by the Millions," *New Republic* 11 Oct. 1943: 482–485.

9. Gardner, "Reviewing the South."

10. Herschel Brickell, "To Aaron Bernd," 25 Nov. 1927, Aaron Bernd Papers, Manuscripts and Rare Book Reading Room, Emory University.

11. Gardner, "Reviewing the South."

12. Edward C. Aswell, "To Lovell Thompson," 16 July 1940, Houghton Mifflin Company Records, Houghton Library, Harvard University.

13. C. Vann Woodward, *Origins of the New South, 1877–1913* (1951; Louisiana State UP, 1971) 110.

14. Erskine Caldwell, Guggenheim Application, 21 July 1931, *Erskine Caldwell: Selected Letters, 1929–1955*, ed. Robert L. McDonald (Jefferson, NC: McFarland, 1999) 64; See, too, Wayne Mixon, *The People's Writer: Erskine Caldwell and the South* (Charlottesville: UP of Virginia, 1995) 37–117.

15. Bennett A. Cerf, rev. of *God's Little Acre*, *Contempo* 15 Mar. 1933: 1, 4. See also Bennett A. Cerf, "To Milton Abernathy," 17 Jan. 1933, Contempo Archives, Harry Ransom Center for the Humanities, University of Texas.

16. Erskine Caldwell, "To Milton Abernathy," 13 Feb. 1933 and 26 Feb. 1933, Contempo Archives, Harry Ransom Center for the Humanities, University of Texas.

17. Erskine Caldwell, *Tenant Farmer* (New York: Phalanx Press, 1935) 5, 14.

18. William T. Couch, "Landlord and Tenant," *Virginia Quarterly Review* 14 (Spring 1938): 309.

19. First published as James Agee and Walker Evans, *Cotton Tenants: Three Families*, ed. John Summers (Brooklyn, NY: Melville House, 2013); in this article I use the scholarly edition of *Famous Men*, which includes *Cotton Tenants* as appendix 2, Davis *LUNPFM* 565–646. The quotations noted are on pp. 566–67.

20. Davis, *LUNPFM* 568.

21. See National Emergency Council, "Report on Economic Conditions of the South" (Washington, DC: U.S. Government Printing Office, 1938): 1.

22. David Madden and Jeffrey J. Folks, *Remembering James Agee*, 2nd ed. (Athens: U of Georgia P, 1997) 72. See also memo, GK, 26 May 1939, and, T. S. Matthews, draft of memo to [Henry R. Luce], T. S. Matthews Papers, Firestone Library, Princeton University; "Reminiscences of T. S. Matthews: Oral History, 1969," pp. 11–13, Columbia Center for Oral History, Columbia University.

23. Michael A. Lofaro and Hugh Davis, eds., *James Agee Rediscovered: The Journals of* Let Us Now Praise Famous Men *and other New Manuscripts* (Knoxville: U of Tennessee P, 2005) 306–307.

24. See "The Situation in American Writing: Seven Questions," *Partisan Review* 6 (Summer 1939): 25–51 and (Fall 1939): 103–123. The responses were illuminating.

25. Hugh Davis, *The Making of James Agee* (Knoxville: U of Tennessee P, 2008) 167.

26. James Agee, "To Walker Evans," 18 Jan. 1939, James Agee Collection, HRC.

27. On factors of review assignments, . . . Gardner, "Reviewing the South."

28. Paul Goodman, "Let Us Now Praise Famous Men," *Partisan Review* 9 (Jan./Feb. 1942): 86–87.

29. Laurence Bergreen, *James Agee: A Life*, 258; Selden Rodman, "The Poetry of Poverty," *Saturday Review of Literature* 24 (23 Aug. 1941): 6.

30. Thompson, "Books of the Times" 19.

31. Robert Fitzgerald, Typescript, "Three Tenant Families," enclosed with letter to Jack [Jessup] and Whit [Chambers], 13 Aug. 1941 and Fitzgerald, "To Jack [Jessup], 18 Sept. 1941, James Agee Collection, Harry Ransom Center for the Humanities, University of Texas.

32. "Experiment in Communication," *Time* 13 Oct. 1941: 104.

33. The quotation comes from Robert Fitzgerald's letter to Jack Jessup, 18 Sept. 1941, James Agee Collection, Harry Ransom Center for the Humanities, University of Texas. See also "Experiment in Communication;" T. S. Matthews, memo to the staff, 11 Sept. 1941, Robert Fitzgerald Papers, Beinecke Library, Yale University.

34. *Time* memo, 26 May 1939, T. S. Matthews Papers, Rare Books and Special Collections Library, Princeton University.

35. Stark Young, "To Ellen Glasgow," [24 Nov. 1935], *Stark Young: A Life in Letters, 1900–1962*, ed. John Pilkington, vol. 1 (Baton Rouge: Louisiana State UP, 1975) 469.

36. George Barker, "Three Tenant Families," *Nation* 27 Sept. 1941: 282; Harvey Breit, "Cotton Tenantry," *New Republic* 15 Sept. 1941: 348, 350; Rodman, "The Poetry

of Poverty" 6; Ruth Lechlitner, "Alabama Tenant Families," *New York Herald Tribune Books* 24 Aug. 1941: 10.

37. "Further Needs for Technical Works Defined," *Publishers Weekly* 13 Sept. 1941: 905–06.

38. Bernard Smith, "Books for Democracy," *Publishers Weekly* 20 Sept. 1941: 1077–79.

39. Frederic G. Melcher, "New Light from the Past," *Publishers Weekly* 27 Sept. 1941: 1291.

40. Robert Linscott, "To James Agee," 9 Sept. 1941, James Agee Collection, HRC; and Robert Linscott, "To Agee," 6 Oct. 1941, Houghton Mifflin Company Records, HL; Bergreen, *James Agee*, 260.

Evans's Portrait in Words:
A Descriptive History of "James Agee in 1936"

Anne Bertrand

In the summer of 1937, the photographer Walker Evans (1903–1975) took a portrait of his journalist friend James Agee, showing him in the full bloom of youth, enigmatic, a solar figure.[1] The different images of the writer, which contributed to the admiration he inspired beyond literature, are striking in their intensity, sometimes remarkable in their protean character. And this is among the most memorable of them.

It was taken a year after *Fortune* magazine commissioned Agee to do a report on the living conditions of sharecroppers in the American South with Evans as his photographer and four years before *Let Us Now Praise Famous Men* was published.[2] But despite a few positive critical reactions, just six hundred copies were sold. As the work itself proclaimed: "The photographs are not illustrative. They, and the text, are co-equal, mutually independent, and fully collaborative" (viii).[3]

In 1960, i.e., five years after Agee's premature death, a second edition of the book came out. The text was the same, though the jacket was different: plain light gray,[4] with the title in darker gray, except for the word "Praise," which was in white, as were the names of the authors, at the bottom. But two important changes to the content were introduced, and they were retained in subsequent American editions, which, apart from the covers, were identical. The innovative decision to place Evans's black-and-white photographs at the start of the book, even before the title page, and without captions, was maintained. But the initial thirty-one photographs had now increased to sixty-two.[5] And a preface by Evans, "James Agee in 1936," was inserted between the photographs (followed by the title page) and Agee's text.[6]

Evans kept numerous documents relating to the second edition (and in particular its preface), which are now in the Walker Evans Archive (WEA) at the Metropolitan Museum of Art in New York. They indicate the importance he attached to the work; and they trace out, in part, the genesis of the reissue, notably regarding his own text on Agee.

As a young man, Evans had wanted to write. After cutting short his studies, he became, as he put it, a passionate reader. In 1926–7 he was in Paris as a would-be writer, though little came of it. Back in New York, having given up on the idea, he gradually (and, in 1929, definitively) turned to photography. But apart from the period between the early 1930s and the early 1940s, during which he worked exclusively as a photographer, he never ceased to write. And in 1971 he cited a writer, Flaubert, as the reference for his own visual work. The WEA contains a number of his youthful writings, some of which were published by Jeff Rosenheim and Douglas Eklund.[7] A few of his major texts have been reproduced here and there, in anthologies on photography,[8] and in monographs.[9]

Under his own name, Evans published a wide variety of writings and interviews, some of which have made decisive contributions to the history of photography, such as the essay on the current state of photography that he published in 1931 in Lincoln Kirstein's review *The Hound & Horn*, in which, notably, he mounted a defense of Atget and Sander.[10] His interview with Leslie Katz in 1971 for the magazine *Art in America* referred to his "documentary style."[11] Between 1948 and 1965, he published a series of portfolios, combining texts and images, in *Fortune* magazine;[12] and between 1958 and 1962 he made similar contributions to *Architectural Forum*.[13] In 1969, the chapter "Photography" in the collective work *Quality: Its Image in the Arts*[14] set out his personal pantheon.

He was also the author of less central texts that nonetheless give an idea of his diversified interests, such as the translation from French of an extract from Blaise Cendrars's novel *Moravagine*, which appeared in the review *Alhambra* in 1929. This was actually the first text he published, accompanied by his first published photograph.[15] In 1943, *Time* hired Evans, and he wrote regularly for the magazine on the cinema, then on art, for two and a half years. In line with the magazine's policy,

his contributions were not signed, but the archives of Time Inc. confirm his authorship. Between 1950 and 1956, he penned ten signed articles on books about photography, art, and the cinema for the *New York Times Book Review*. During the 1950s, he wrote two statements about photography for the Museum of Modern Art in New York. And at Yale, in 1964, he gave a celebrated lecture that went well beyond the old postcards that illustrated it. In parallel, he used magazines, catalogs, and portfolios to champion a new generation of photographers, from Robert Frank, starting in 1957,[16] to William Christenberry, in 1973,[17] via Lee Friedlander, in 1963.[18] During his last years, he gave numerous interviews, notably to journalists, in which he discussed his career (and in some cases rewrote history).[19] But it is clear that he was reluctant to write about his own photography. He preferred to have it defended by the art historian and critic Kirstein in *American Photographs*, in 1938.[20] And in 1966, though he wrote an introduction to *Many Are Called* for the subway portraits he produced between 1938 and 1941,[21] he finally dropped it in favor of a text by Agee, dating from 1940.[22]

Agee was certainly Evans's best friend: longer-standing than Hanns Skolle, closer than Kirstein, more influential than Thomas Dabney Mabry. But Evans was never specific about the circumstances under which he met Agee.[23] In 1934, while the latter was writing for *Fortune*, Evans made his first contribution to the magazine, with a series of photographs for Dwight Macdonald's article "The Communist Party," which appeared in the September issue. One of his pictures also illustrated Agee's text "American Roadside." And when Agee was asked to report on sharecroppers in the South for the Life and Circumstances series, he requested that Evans accompany him. The intense experience of their journey through Alabama cemented their friendship, as demonstrated in 1941 by the book to which it gave rise. In the meantime, Evans kept Agee's spirits up while he was working on the text that would accompany his images.[24] In 1939, the two worked together for *Fortune* on a (then unpublished) article about Brooklyn.[25] That same year, Agee was recruited to write book reviews for *Time* by its managing editor, T. S. Matthews; and in October 1941, he started doing film reviews, which suited him better still. Between December 26, 1942, and

1948, when he left *Time*, he did a cinema column for *The Nation*, while also writing unsigned "special feature stories" for *Time* from 1945 on.

It was no doubt thanks to Agee and to their mutual friend Wilder Hobson, another of the magazine's writers, that in the spring of 1943 Evans was hired as a contributing editor, first taking over from Agee to write film reviews, and then, in the summer, art criticism, at around an article a week. He carried on doing this up to September 1945, when he rejoined *Fortune* as the magazine's first full-time staff photographer. Evans and Agee were thus colleagues at *Time* between 1943 and 1945,[26] and they continued to be close until 1950, when Agee, having left Time Inc. and worked freelance for different magazines, moved to Hollywood, where he worked as a screenwriter. This meant that they saw less of each other; but they remained in contact. Evans was worried about Agee's health and was deeply affected by his death in May 1955.

In 1958, Evans published two portfolios of photographs and texts in *Fortune*;[27] the next portfolio he entirely designed and signed was published in 1960.[28] In January 1958, he began writing for another Time Inc. publication, *Architectural Forum*, whose artistic director was his friend Paul Grotz.[29] In September 1958, he wrote a short text on a painting by Hedda Sterne, Saul Steinberg's wife,[30] for *Sports Illustrated*, which also belonged to the Time Inc. group. In 1959, he was awarded a second Guggenheim Fellowship for a book about the United States. And the following year he applied, unsuccessfully, for a Ford Foundation Fellowship to follow through on the same project, as "a book of documentary non-artistic photography, with text essay and extended captions, recording American society as it looks today."[31] This was also the year of his second marriage, to Isabelle Boeschenstein (b. 1933), after her divorce from her first husband, Alec von Steiger. It was a decade of intense sociability, partly with the Century Association, which Evans joined at the start of 1954. Now, more than ever, he was part of the New York intellectual microcosm, with its journalists, writers and publishers, to which Agee had also belonged, though he was also wary of it. But Evans aspired to an easier life; which explains his embourgeoisement, along with the allusion he made, in his text on Agee, to the "straight dandy"[32] he himself had turned into.

When they met in the mid-1930s, these two men, different in background, age (Evans was six years older than Agee) and temperament, but equally ambitious, soon gravitated toward the same socio-professional universe. They admired, and understood, each other's work. Evans was well versed in literature, while Agee had an affinity for photography, about which he was a keen commentator. The eventful summer they spent in Alabama, and the long gestation of the resulting book, brought them still closer together. However, Agee's genius could not but inhibit Evans's urge to write, given how closely he followed the development of the text for *Famous Men*, the manuscript of which Agee gave him as a Christmas present in 1938. (Evans later mislaid it.) Who could possibly write, having observed Agee write this book?[33] It is ostensibly all the more remarkable that he produced a preface for the second edition of the work. By then, however, Agee was dead, and Evans had gained authorial confidence and recognition writing for *Time*, *Fortune*, and other newspapers and magazines, including the *New York Times*.[34] On several occasions, starting in the early 1950s, he defined himself not just as a photographer, but also as a writer.[35]

W. H. Auden, who in 1944 described Agee's articles on the cinema in *The Nation* as "the most remarkable regular event in American journalism today," may have been approached to write an introduction to *Famous Men*.[36] But if so, nothing came of it. Among the documents Evans conserved in relation to *Famous Men*, there is his substantial correspondence with the publisher,[37] and a thick file containing the successive versions of "James Agee in 1936."[38] He generally produced multiple preliminary sketches, from scattered notes to the version that would finally be published, and he kept intermediate versions of writings he considered important. These include a number of early texts that remain unpublished, some *Fortune* portfolios, and his Yale lecture.

Evans was in contact with people at Houghton Mifflin, notably Paul Brooks and Lovell Thompson, who had supervised the original edition of *Famous Men*.[39] On August 15, 1958, having reread the book, Thompson wrote to Evans: "It is really an extraordinary book. For me at least, way ahead of anything else Jim Agee ever wrote. In fact way ahead of most things that most people have written."[40] A year later, the

project was launched. On August 20, 1959, the assistant production manager, Morton Baker, informed Evans that he was sending him "62 photoprints and 2 photostats of each one for dummying."[41] One might wonder, in passing, how it came about that the number of photographs in the new edition was doubled.[42] This might be seen as an attempt to rebalance the relationship between the initial, restricted (however efficacious) portfolio and Agee's long text. Nevertheless, the press release issued by Houghton Mifflin in July 1960 stated: "In the original edition [of *Famous Men*], 31 photographs were printed. This was only half the number Evans intended to publish."[43]

On October 2, 1959, Thompson informed Evans that he had called Agee's widow about the possibility of a further contribution by the photographer: "I told her we were proceeding according to plan, that you were considering [. . .] whether or not there was anything that should be said in a possible special introduction to this edition and I asked her if she also would consider if there was any comment she felt should be made."[44] On October 15, he added:

> As things stand now, we are proceeding with a new book which
> is in fact precisely the old book except the new pictures [. . .].
> The more I think of it the more I think a shortish, informal,
> retrospective comment from you would be of great interest. I
> have been repeating as best I could your description of landing
> on the scene with Jim Agee and wondering with him how you
> would ever crack the surface of this new destitute world. For
> one who knows or who is about to find out how far beneath that
> surface you reached this seems a very effective piece of historical
> information.[45]

On December 27, Evans sent his text to Thompson and to Paul Brooks, adding: "This piece of writing could be either Foreward [*sic*] or Appendix."[46] On January 12, 1960, Thompson informed him that he would be paid the usual rate, i.e., a total of $115.50, and that the possibility of an advance publication in a magazine might be envisaged.[47] On

January 14, Brooks complimented Evans: "Your foreword is superb—it is exactly what was needed. And as a piece of writing, it is quite on a par with the text it introduces."[48]

On March 1, Thompson told Evans that within a month he would be receiving the proofs of his introduction, and of a number of his photographs: "We are making trial plates now."[49] On March 24, an initial set of proofs of the preface was sent to Evans for checking, and he returned them almost immediately.[50] On March 28, Baker wrote to him that the printing process had been selected; and it was also Evans's choice, based on tests that had been sent to him. It was the Meriden Gravure Company's offset process, and the contract stipulated that proofs for the photographs be submitted to Evans, for comparison with the original prints.[51]

On March 30, Thompson sent Evans two further sets of proofs, adding that he intended offering the text to *The Atlantic Monthly*.[52] On April 4, Margaret Perry of Houghton Mifflin's publicity department indicated that the plan was to publish the book in September 1960.[53] On April 14, *The Atlantic Monthly* accepted the text for publication in its August or September issue.[54] On May 5, Emily Flint, the managing editor of the review, sent Evans a set of proofs, saying that the text would be published in July,[55] as indeed it was. Evans replied on May 10, with a number of suggested corrections.[56] On June 8, Houghton Mifflin's David Harris confirmed that a word could still be changed before the book was printed.[57] On July 14, Baker informed Evans that the printing was under way, that he would take delivery the next day, and that Evans would be receiving copies the following week.[58]

Of the numerous versions of the texts that Evans conserved, few, unfortunately, are dated. The first to be so was written in 1959.[59] An annotated carbon copy marked "FINAL" is dated February 10, 1960.[60] And a set of proofs, also annotated, is dated March 22.[61] It is thus difficult to follow the modifications carried out by Evans, or indeed the period during which they took place. Other texts by him, and their preliminary versions, suggest that the process extended over several months, even for the shorter texts. There again, the character of the one in question

may have resulted in the need to choose each word with exactitude, and to polish each sentence with care. Or it could be that the exceptional relationship between Evans and Agee led to a kind of crystallization.

There are variations on the published text, and notes written on index cards. This was something Evans started doing in the 1950s, and it recalled the lists he had begun making at the end of the 1920s. On one of the carbon copies there are six names written in pencil, probably those of the people to whom he submitted the text. They include "Alice" S. Morris, who had typed up a part of *Famous Men*; her husband, Harvey Breit, reviewed it in *The New Republic* in 1941, and in 1951 she became the literary editor of *Harper's Bazaar*. There is John "Jessup," a friend of Agee and Evans, and possibly the author of the 1941 review of *Famous Men* in *Time*, but also a friend of Henry Luce, at the head of Time Inc. There is "Frances" Lindley, the editor of *American Photographs* at MoMA in 1938, who began working for Harper & Row in 1953, and who was a friend of Evans. There is Albert (Bill) "Furth," the executive editor of *Fortune*, whose talent Evans, along with others, appreciated, on account of his respect for his authors. And there is Father "Flye," who was a friend and mentor of Agee's.[62]

The different versions of the text show, above all, that its main components took shape early on, though some details were later changed.[63] The most important of these changes was the excision of an initial passage, which, in Evans's own view, did not necessarily need to be retained. It was more than an anecdote, however significant, relating to Agee's arrest shortly after the two northerners arrived in Alabama, and Agee's relationship to authority.[64] For Evans it apparently recalled an incident that occurred during Robert Frank's travels around the United States, which gave rise to his book *The Americans*. On November 7, 1955, Frank was arrested in McGehee, Arkansas, for no good reason, interrogated, and held for twelve hours. He immediately recounted this traumatic experience in a long letter to Evans.[65] Frank's journey echoed that of Evans in 1935–36, and, to a lesser extent, that of Evans and Agee in the South during the summer of 1936. In the end, Evans did not mention it. He also cut out some shorter passages, including an incipit that situated his text in relation to that of Agee.[66] The general tenor of Evans's

preface did not fundamentally change from one version to another. Its structure remained the same, as did the succession of themes and its foremost elements.

It began with the first impressions made by Agee and his appearance (or appearances), followed by his voice, his accent, and his empathic adaptability. Then came his dress, how it defined an attitude, a social position. There is his physique, his build, his hands and gestures, along with his voice, once again, or rather his language ("He talked his prose, Agee prose"),[67] the way it came across, and its irresistibility. The charm was that of the writer talking, which, even in its dispersion, did not diminish his work, to which he devoted himself entirely. "Night was his time."[68] Night was also the time of *Famous Men*, when Agee, fleeing New York and the intellectual society to which he belonged, immersed himself in Alabama, and in his subject, blending in with those he was describing, and from whom, in the end, he was not so different. How was he to gain their confidence? He was prone to self-doubt, thinking of others first, as a result of his upbringing and self-imposed moral code.[69] His work revealed these families' lives to his readers. It was also an expression of a personal revolt that characterized his person and his character.

Writing this preface involved the usual work of reformulating certain passages, the adoption of nuances, the choice of the most fitting term—the most striking or the most sonorous—and the most rhythmic phrasing. Evans's texts are highly crafted. Stylistically, they do not pretend to simplicity but make masterful use of a selected vocabulary and a range of literary effects. The way in which Agee's arrest was originally reported was subsequently attenuated. The passage "Later we realized it was in fact lucky for us we were not just then communizing, organizing, or jewing. The Depression years were indeed no safe time for stray Northerners to be in any Southern town whatever doing anything whatever that was not obviously on the service of Church or Bank, preferably Bank" was crossed out and replaced by "I hasten to say we were in no danger from regular authorities. The stupid police interview ended without issue. I speak of it only to begin recalling details of Agee's appearance and bearing during four working weeks twenty Odd [*sic*] years ago."[70]

In some places, the text was pared down to its bare essentials, as with the sentence: "For instance, he talked a little country-southern in Alabama and I may say got away with it to the farm families and to himself ~~simply because he was never a politician or any other kind of a fake~~."[71] Other passages were developed to give them more density and immediacy. In the typescript, the passage "His clothes were deliberately cheap, not only because he was relatively poor but because he wanted to be able to forget them, to have them ~~suit~~ fit work and every kind of living automatically" was followed by the handwritten note:

> He would work a suit into fitting him perfectly by the simple method of not taking it off much. The cloth would model itself to his rangy frame. Cleaning and pressing would have undone this beautiful process.
>
> I exaggerate, but it did sometimes seem that rain and work and mockery were his clothiers. Agee was brought up by women. His rebellion was total, and unquenchable, self damaging, deeply principled and, in the end, priceless.[72]

So the last phrase of this, which was also the last in the definitive version, first appeared in another context. And the sentence "In Alabama he swerted [*sic*: sweated] and scratched with everyone else, effortlessly fitting in to as primordial a life as you can get anywhere, in the United States working economy"[73] took on, in the end, more distance, or more perspective: "In Alabama he sweated and scratched with submerged glee."[74]

One modified passage, "He wasn't playing. That is why in the end he left out/discard [*sic*] certain passages of writing that were entertaining. These are lost, at the moment. One was a long hilarious aside on the subject of hens; one was a minute description of a battle with bedbugs. That was Benchley rewritten by Kafka, edited by Chaplin,"[75] became, "He wasn't playing. That is why in the end he left out of *Let Us Now Praise Famous Men* certain completed passages that were entertaining, in an acid way. One of these was a long, gradually hilarious aside on the subject of hens. It was a virtuoso piece heightened with allegory and bemused with the pathetic fallacy."[76] The typescript concluded: "Those

heady, ~~sweaty days went swiftly~~ timeless days came gently/abruptly to their end. ~~What they were really like Agee had shown far too fully to allow an addition.~~"[77] But there was a handwritten (and sometimes barely legible) addition a page long that seemed like an alternative, though only a part of it was finally used: "Probably it was his diffidence that disarmed and won the families from the start. That non assurance, I later reasoned, was one mark of his very Christian training. (Anglican) [. . .] Perhaps he was an unfrocked lay priest. [. . .] Carrying a weight like that, he addressed everyone and handled everyone with excruciating, gasping care. Yet somehow the burden of this was successfully hidden. The pain of it, that is. You felt only the care; and you felt infinity."[78]

The typescript sent to Lovell Thompson and Paul Brooks seems to have been more or less final in form, with relatively few corrections apart from the replacement of a long sentence by a shorter one in the first paragraph regarding the status of this preface, which in the end was cut, and the bracketing of another sentence, which was also dropped, as was a third, incidental sentence. There were a number of spelling mistakes, as well as the addition, deletion, or replacement of particular words.[79] The so-called "FINAL" version (the "THIRD REVISE (LATEST)") was the one whose first paragraph Evans cut, the one that situated his text in relation to Agee's prefaces. He made very few modifications to it after that, and it differed little from the published version.[80] Finally, the proofs dated March 22, 1960, which Evans annotated, had only four minor corrections, including the description of Agee as "~~neo~~ Christian," and the replacement of an "almost" by a "probably"[81] (which in the end became "perhaps").[82]

But the notes (some of them scribbled on index cards) bring to light other lines of reflection, and, in general, are more spontaneous, but also more sensitive. This comes out in the handwriting, which is hasty, occasionally unclear. A dozen or so of these notes are written in capitals. They encapsulate Evans's emotional recall of his dead friend, along with his awareness of Agee's talent, and his desire to give an account of it. One of the drafts suggests a major precursor of Agee's text: "The following openly personal recollection may substitute for introduction to this book—which can be seen to be no more a study of American Southern tenant farmers than Moby Dick is a work about the whaling industry."[83]

In the final version of his preface, Evans did not mention the Melville connection, which had already been noted by Dwight Macdonald in a 1957 *New Yorker* article on Agee.[84]

In another draft he cited a series of authors and artists: "AGEE / Dostoevsky / Donne / Blake / Joyce / Swift / Shakespeare / Eliot / Celine / Melville / [. . .] Chaplin."[85] And he added, "I can imagine an older man who has achieved 'wisdom' taking the young James Agee aside. 'But Jim you can't be Shakespeare, Dostoevsky, Savonarola, Blake, Don Quixote, Byron and [. . .] Saint Francis of Assisi [. . .]' / 'Oh I can't, can't I. . .'"[86] In his attempt to define Agee's personality, Evans even referred to Nabokov:[87] "'The moral sense in mortals is the duty / We have to pay on mortal sense of beauty.' 190 II Lolita / In this respect he was rich and you were poor, / so it hurt."[88] Given Agee's personality, situating him among other writers required a moral, or affective, point of view. Thus, "The man reminded me of Savonarola Blake Shelley at his best & Dostoevsky at his worst. / human smallness, dishonest stupidity, venality literally tortured him."[89] And another note reads: "Emotional / Writing about Agee becomes overpersonal possibly because he made everyone who knew him feel extremely close, immediately. / Agee's almost outrageous sensitivity. / Agee was excess itself, in everything."[90] There is a revealing comment on the relation between Agee's text and Evans's photographs, along with their respective forms of involvement and temperament: "The writing in Let Us Now Praise Famous Men comes out of a religious mind. The photographs, I am constrained to say, were made not in the least religiously. I have always thought that this was why Agee liked them. I think anything untormented in others relieved him, somewhat."[91]

Finally, there is a group of thirty-one index cards that includes the following sentences, in which Evans's urgent need to express himself is similar to that of Agee in 1936 and afterward:

YOU HAVE TO REMEMBER THAT JIM AGEE WAS NOT A PUBLIC FIGURE DURING HIS LIFE. HE IS NOT A PUBLIC FIGURE TO ME NOW. AND PUBLIC ANECDOTAL REMINISCENCE SEEMS A DISTASTEFUL ACT ANYWAY. FOR ONE THING, AGEE WAS SO POWERFUL HE COULD

OVERSIZE YOUR THOUGHTS ABOUT HIM AT DISTANCE.
THIS KIND OF POWER DOESN'T CEASE WITH DEATH. SO
I CAN'T GIVE YOU ANY INTIMACY AT THE MOMENT.[92]

MEN LIKE THAT ARE OFTEN SO DISTRESSED BY THE
WORLD THAT THEY CAN DISTRESS YOU AND DISORGA-
NIZE YOU TOO. YET AGEE WAS ORGANIZED ENOUGH
TO WORK.[93]

ALMOST EVERYTHING HE DID WAS BASED ON HIS FIGHT
AGAINST PURITANISM, PHILISTINISM AND INJUSTICE. IT
WAS QUITE A WAR, I ASSURE YOU.[94]

Did Evans have a literary model in mind when he wrote this text?
Its title suggests both a portrait and a number of memories linked to a
precise time that he shared with Agee. The summer of 1936 in Alabama
was the crucible of the book for which this was the preface. But when-
ever Evans was asked to provide a tribute to Agee, it was always to this
time that he referred.[95] Because it was their great moment together, the
great moment of their friendship; a great moment for both of them, and
for their art. And it was the great moment in Agee's life; one only has
to read *Famous Men* to realize this. It was also one of the great mo-
ments in Evans's life, intense and intimate, although, given his secret,
complex nature, one cannot be sure that it was the high point in his
creative career. If there had been a climax, he would not have shared it
with anyone.

In any case, it was with enthusiasm that he recalled those weeks he
and Agee spent together in the South. His preface was the first instance
of his doing so in writing; but he did so again in the interviews he gave
during his last years—three of which were published in his lifetime, the
others after his death—with further information and analysis, though
he was at first reserved and discreet. When Leslie Katz, in a 1971 in-
terview, asked him about the few close friends who led him to "take
[photography] seriously," Evans cited Kirstein, adding: "Agee [. . .] didn't
teach, he perceived; and that in itself was a stimulation. [. . .] In a sense

you test your work through that and it bounces back strengthened. My work happened to be just the style and matter for his eye. I could go on at length about Agee, but won't."[96]

In February 1974, the *Yale Alumni Magazine* published a transcript of an interview in which students asked Evans about the experience that had given rise to *Famous Men*:

> That of course is the most conspicuous thing I've done, entirely due to Agee. I have a lot of false renown because I was working with a tremendous man, and I'm embarrassed just talking about it because Agee's character doesn't fit the apotheosis he's gone through. [. . .] But I will say, he was a great friend of mine before we went off and worked in the South together, and he was distinctly the leader-instigator of that project and I don't think we could have succeeded without his talent with people.
>
> Incidentally, part of a photographer's gift should be with people. [. . .] You've got to take them off their defensive attitude and make them participate. Agee was very good at that. [. . .] At that time we didn't know it was going to be a book—this was just for a magazine article—and he told them all about it and made them feel that they were participating. We made ourselves into paying guests, with their understanding, and they hadn't seen any money for the longest time, and although that wasn't a corrupt gesture it did make them feel a little bit ahead of the game. Since the game was zero right then.[97]

In May 1974, finally, Evans went to the University of Texas at Austin, for an exhibition of photographs relating to *Famous Men*, with a catalog that included a brief statement:

> I feel that I have come into too much prominence on the tail of Agee's genius. I regard *Let Us Now Praise Famous Men* as his book—and it certainly is.
>
> I try to imagine what Agee would think of this exhibit. He would be uneasy, as am I, about its taking place in a university.

[. . .] He wouldn't approve of that, as he wouldn't approve of reading *Let Us Praise Famous Men* for a class assignment—because it robs the work of its freedom. Agee was never reasonable about the heavy hand of duty.[98]

Some of the texts that were published after Evans's death included other nuances. In the spring of 1971, William Stott recorded a conversation with Evans, taken up again afterward, which he cited in his book *Documentary Expression and Thirties America* (1973): "Agee was an embarrassing man [. . .]. I love the prose, but sometimes I blush reading it."[99] In the 1986 edition of this book, however, there is an afterword in which Stott cites statements made by Evans in Austin in March 1974, which are closer to Agee's moral viewpoint and recall Evans's fondness for the French language:

> I do have a weakness for the disadvantaged, for poor people, but
> I'm suspicious of it. I have to be, because that should not be the
> motive for artistic or aesthetic action. If it is, your work is either
> sentimental or motivated toward "improving society," let us say.
> I don't believe an artist should do that with his work. If he does,
> if you weep over a picture or a piece of writing, that's bad. Jean
> Cocteau of all people [. . .] once said, "Real feeling is drawn from
> us not by a sad spectacle but by the miracle of something done
> perfectly." You want to hear it in French? "Les bonnes larmes ne
> nous sont pas tirées par une page triste, mais par le miracle d'un
> mot en place."[100]

On October 29, 1971, Evans answered questions from students at the University of Michigan in Ann Arbor. Beaumont Newhall was also present, and he published a transcript of the meeting in 1980. Asked how he felt while working on the project that culminated in *Famous Men*, Evans said:

> Well, I felt very stimulated, excited, and I felt it was a very valid
> thing to do. [. . .] But that has a lot to do with the validity of Agee,

my respect and interest in him and his mind. [. . .] By that time Agee had established himself, in my mind, as a great man really. He was only 27 years old but, I perceived, and I turned out to be right, that this man had a touch of genius anyway. You don't see that very often. Here I was, down there, with somebody that I really felt had genius.[101]

In 1974, Jude Cassidy and Ross Spears began preparations for a documentary film about Agee, which was completed finally in 1979. In 1985, they published the views of Evans, who said: "Agee [. . .] had a great gift of making people not only like him, but love him. [. . .] I just sort of followed his lead that way. Although I did pick up the family first, he took on from there."[102] He then talked about how he and Agee worked side by side, rather than together, and about their zeal:

We were friends, and we were both working rather defiantly, really. Agee and I worked in distant harmony, paying no attention really, by agreement, to each other, but working on the same subject. Our styles were admittedly very different, but we had enormous respect for each other and a great interest and intensity about that work. [. . .] I was absorbed in the technical and aesthetic task to such an extent that what my reaction was was really one of professional pleasure: I knew I had some very rich material to work with and I was excited to work with it. I didn't identify myself subjectively nearly as much as Agee did. I was working objectively on the visual material in front of me, which was incredibly rich. That was really hard work, but not thought of as such at the time. If you're young and interested, as we were, you throw yourself into work like that without any thought of sparing yourself, or without any thought of the time invested or energy either. That is work at its best, the way all work ought to be, and seldom is.[103]

There was nothing self-evident about working with Agee, given his temperament; but what Evans recalled, more than anything else, was the quality of his engagement, and his results:

Agee was really a much more powerful, intense and interesting man than you would expect to work with, and as such presented enormous difficulties too. He required a great deal of understanding and forbearance and was very hard to handle because he had violent tendencies when frustrated, and there was a lot of frustration in that work. He used to get so angry at not being able to go ahead and do what he wanted to do, and his rage was paralyzing to him and to everyone around him. I don't see how he kept enough control of himself to do such controlled work. He didn't look like a man disciplined enough to do what he did do. So there was a surprising sort of confusion between Agee's appearance as I saw it and his accomplishment, which is on record as being tremendous.[104]

In the autumn of 1974, Evans was interviewed by Bill Ferris of Mississippi, whom he had met two years previously at Alan Trachtenberg's home in New Haven, and who had observed his nostalgia for the South.[105] The interview was published in 1977. Evans recalled: "I didn't see much of Agee. He was working all day, interviewing and taking notes, and I was photographing. We knew what we were doing. We were doing a documentary sort of evidence and interview with the kind of people that we thought ought to be our subject. And they were. But we didn't have any pretensions at all as social scientists or documentarians or anything of that sort."[106] When asked about the fact that the work had now achieved the status of a classic, Evans replied unambiguously:

Well, it's all due to Agee, really. [. . .] To this day I don't know why it's become as well-known as it is. I say I don't know because greatness, which Agee put into it, doesn't usually become known right away. Think of *Moby Dick*, for example, which is a great dedicated work of research and poetry together. It was probably not read at all. Nor was this read at all—I compare them together. And it was just a strange turn of events that made this thing famous in its revival. It was reissued and it was reborn like the Phoenix. It was just right for the time, because the young wanted some honesty. [. . .] After all, it's remarkable to think that

Agee was [. . .] very young [. . .]. And what he wanted to do was
to shock and scare people. He wanted to make people who were
not poor, for example, really feel what it was like to be up against
it. And he wanted to rub it in. He was angry. He wanted to say,
"Look, you sons of bitches and you bastards! What the hell do you
think you're doing? Living this way while these people are living
this way. And the hell with you! I wish you would all go to hell!"
Which is a young and immature attitude, but he was that way.
[. . .] Agee put his very soul into that work. He was an intense,
born writer. He just wrote himself almost to death on that work,
and it shows it. It shows his immaturity, but it shows his greatness
and his dedication, too. He was really a great poet.[107]

The last interview given by Evans, on April 8, 1975, just two days be-
fore his death, to students at Radcliffe College, was published in *The New
Republic* in November 1976. He talked about *Famous Men*, and about
Agee, to whom he paid tribute one last time, while maintaining a cer-
tain distance:

Well, I was overawed by (*Praise*). I immediately felt that I was
reading great prose. I was rather too much overawed by it because
I could have been of some critical assistance. In fact, Agee asked
me to do some editing, but I wouldn't do it. I still think it is a
great book. It has many flaws, of course, but it is a very big and
large and daring undertaking and a terrific moral effort, as one
reviewer said. [. . .] I knew [Agee] a long time before we went
down there. I was in very close sympathy with that mind; I am
very impressed with it. I disapprove a whole lot too. [. . .] He used
to shock me. I have inhibitions about exposing the personal ego
and feelings, and he seems to think that is *the* material and that
that is one of the functions of an artist—exposing obscure and
hidden parts of the mind and so on.[108]

Over the course of time, Evans had both reiterated his admiration for
Agee's work and paid tribute to him; but he also reclaimed his place in
the overall picture of their collaboration.

Among Evans's texts, "James Agee in 1936" was unprecedented, and it had no direct successors. This is partly due to the unique character of its subject, the relationship between Evans and Agee, and their joint adventure. No one else could have written it. Evans was an eyewitness, attentive to detail, but he was also capable of analyzing and synthesizing the sense and scope of details. He set out the qualities that characterized Agee, both then and afterward: beyond his appearance, his writerly way of expressing himself, without compromising his writing; his presence in the world, both among his peers, when he addressed them, and alone, writing in the dead of night, though without ever cutting himself off from others; and finally his uncompromising ethic—"Agee's rebellion was unquenchable, self-damaging, deeply principled, infinitely costly, and ultimately priceless."[109] The perspicacity, prudence, and pertinence of the portrait identify Evans as a writer, though of course there was neither comparison nor competition with Agee. This was a tribute both to Agee and to the book, though on a terrain that was not supposedly Evans's own. But talent and friendship generated an acute sense of Agee's genius.

As a champion of the "short form,"[110] Evans wrote essays to accompany his photographs, or other images, in the portfolios published by *Fortune* and elsewhere. As a critic, he discussed other photographers, whether his predecessors, his contemporaries, or his successors, expressing himself with esteem, enthusiasm, and perceptiveness, but never with such a combination of depth, respect, and ardor as in this preface. It is among his best pieces: among the most ambitious, most inspired, and most accomplished. His publisher appreciated it and used it for a flyer of which Evans saved a mockup: "On the following page you will find the Foreword, recently written by Walker Evans for this new edition. With these words he has photographed James Agee as successfully as he did in the pictures you saw on page 3 and 5."[111]

The images produced by Evans in Alabama during the summer of 1936 contained no self-portraits. This, in any case, was a genre that did not particularly interest him after the period of his youth. Only his shadow is visible in the portrait of Dora Mae Tingle.[112] He is present in Agee's text, as is Agee himself, writing in the first person for the sake of realism,

which did not exclude a palpable fear of appearing more prominent than the sharecroppers themselves, and their families. A single photograph by Evans—that of Bud Fields sitting bare-chested on his bed—shows Agee's face and hands at the bottom left-hand side as he leans over taking notes. This photograph was number 22 in the 1960 edition of *Famous Men*, but reframed around Fields, and it has rarely been reproduced in its entirety.[113] It was the emotive byproduct of an accident.

As François Brunet recalls, some authors have discussed the competition between Evans's images and Agee's text.[114] But as Agee wrote: "If I could do it, I'd do no writing at all here.It would be all photographs [. . .]" (11). In the new edition of their book, though not denying the power exerted by the images, now more numerous, it was through writing that Evans brought Agee back to life.

An aside

In France, the first edition of *Famous Men—Louons maintenant les grands hommes*—was published in 1972 in the Terre Humaine collection that Jean Malaurie had created at Plon,[115] though an extract had already appeared in the review *Les Temps modernes* on Simone de Beauvoir's instigation.[116] There were four differences between the Plon edition and the 1960 American edition. The title page was at the beginning. Evans's photographs were reproduced in a central section of 32 pages; there were now 40 of them (22 having been cut), and their order was different, notably with regard to a number of them that Evans had placed face to face, while some were reduced to a quarter page, and one was reversed. There were omissions in the text, which were partly explained in a note added by the translator. And Evans's preface (now simply entitled "James Agee") became an afterword, which meant that, as in the initial 1941 layout of the book, there were no intercalations between the portfolio and Agee's text.

Louons maintenant les grands hommes has since been republished. In 1993, fortunately, the photographs were placed at the beginning, though their order remained different from that of the American edition, with two groups occupying different positions from those of Evans's sequence.

And besides an index there was an afterword by Bruce Jackson (translated by Frank Straschitz) after Evans's text. The work has since been reissued, and it has been available as a paperback from Presses Pocket since 2003. But the ordering of the images has not been corrected, and the cuts in the text have been maintained.[117]

In the Bibliothèque nationale de France's online catalog, which contains a copy of the original French translation, along with copies of the 1993 and 2003 editions, James Agee continues to be presented as the sole author of the work (with Evans simply being given the photographic credits), despite the fact that the cover bears both names, in alphabetical order, as coauthors.[118] And this also applies to Plon's website.[119]

NOTES

1. See Walker Evans, *James Agee, Old Field, Long Island, New York*, July–Aug. 1937, film negative, 4x5 in., Walker Evans Archive (WEA), Metropolitan Museum of Art (Met), New York, 1994-254-11. This picture belongs to a series of portraits made by Evans during that summer. The negatives are held in the Walker Evans Archive: see WEA, Met, 1994-254-3 to 12.

The present article has been translated from the French by John Doherty, whom I thank for his perceptive work. I am grateful to Paul Ashdown, who first suggested that I submit this article, and to Michael Lofaro, who approved the idea. I would also like to thank Jeff Rosenheim for giving me access to the Walker Evans Archive at the Metropolitan Museum of Art in New York and Meredith Reiss for her practical support. Their generous assistance is greatly appreciated.

2. See the start of James Agee's preface to *Famous Men* (1941): "During July and August 1936 Walker Evans and I were traveling in the middle south of this nation, and were engaged in what, even from the first, has seemed to me rather a curious piece of work. It was our business to prepare, for a New York magazine, an article on cotton tenantry in the United States, in the form of a photographic and verbal record of the daily living and environment of an average white family of tenant farmers." James Agee and Walker Evans, Let Us Now Praise Famous Men: *An Annotated Edition of the James Agee-Walker Evans Classic, with Supplementary Manuscripts*, ed. Hugh Davis, vol. 3 of *The Works of James Agee*, gen. eds. Michael A. Lofaro and Hugh Davis (Knoxville: U of Tennessee P, 2015) vii. Subsequent references to this edition will be noted parenthetically in the text, and abbreviated in the notes as Davis, *LUNPFM*.

3. The contract, signed on April 25, 1940, stipulated that 75% of the royalties would go to Agee, 25% to Evans. See four-page copy of signed royalty agreement between James Agee and Walker Evans and Houghton Mifflin for *LUNPFM*, dated

April 25, 1940, annotated in pencil by Evans on verso. WEA, Met, 1994-250-75 (1). In one of Agee's twelve drafts of the introduction to the book, there is the following passage: "By contract there are to be thirty-two pages of photographs, by the coauthor, Walker Evans, and between sixty and seventy-five thousand words of text, by me. The photographs are in no sense to be presented or interpreted as illustrations, or as otherwise subservient material; they are their own book, and the authorship is fully and equally collaborative." See Davis, "Draft on Introduction," *LUNPFM* 792.

4. This color was similar to that of the jacket of Evans's first book, *American Photographs* (New York: Museum of Modern Art, 1938), and it was his preference. A number of monographs devoted to his work followed this example, with variations, and the same color was used as a background to one of his photographs on the cover of the catalog of his exhibition at MoMA in 1971. See *Walker Evans*, John Szarkowski, introduction, (New York: Museum of Modern Art, 1971). And this color was also used after his death, e.g., for the cover of Walker Evans, *First and Last* (New York: Harper & Row, 1978).

5. As Hugh Davis specifies: "When the second edition of *Let Us Now Praise Famous Men* was published in 1960, Walker Evans made a number of changes to the photographs, increasing their number from thirty-one to sixty-two, replacing six of the original shots with new images, and resizing and recropping many of the originals as well." Davis, "General Textual Method," *LUNPFM* 513, and see "Ordering of Photographs" 951–953.

6. In 1957, according to Hugh Davis, The Reader's Subscription, a book club run by W. H. Auden, Jacques Barzun, and Lionel Trilling wanted to reprint four or five thousand copies of *Famous Men*. And the publishers Grosset & Dunlap were also interested. See Hugh Davis, *The Making of James Agee* (Knoxville: U of Tennessee P, 2008) 5. And in 1958, David McDowell, a publisher and member of the James Agee Trust, began publishing Agee's writings on the cinema, *Agee on Film*, with drawings by Tomi Ungerer as vol. 1, *Reviews and Comments* (New York: McDowell, Obolensky, 1958); vol. 2, *Five Film Scripts* (New York: McDowell, Obolensky, 1960).

7. Jeff L. Rosenheim and Douglas Eklund, *Unclassified: A Walker Evans Anthology. Selections from the Walker Evans Archive, Department of Photographs, The Metropolitan Museum of Art*, introduction by Maria Morris Hambourg (Zurich, Berlin, and New York: Scalo, 2000).

8. See, for example, Alan Trachtenberg, ed., *Classic Essays on Photography* (New Haven: Leete's Island Books, 1980), which includes Walker Evans, "The Reappearance of Photography" (1931) 185–187; Vicki Goldberg, ed., *Photography in Print: Writings from 1816 to the Present* (New York: Simon and Schuster, 1981), which includes Leslie Katz, "An Interview with Walker Evans" (1971) 358–369; and Jane Rabb, *Literature and Photography Interactions 1840–1990* (Albuquerque: U of New Mexico P, 1995), which includes "James Agee in 1936," (1960) 300–303.

9. For example, Jeff L. Rosenheim, ed., *Walker Evans and the Picture Postcard* (New York, Göttingen: The Metropolitan Museum of Art and Steidl, 2009), which includes the "Yale Lecture" given by Evans in New Haven on March 11, 1964 (103–125).

Opposite the text are reproductions of the postcards he projected in the form of slides to illustrate the lecture.

10. Walker Evans, "The Reappearance of Photography," *Hound & Horn* Oct.-Dec. 1931: 125–128.

11. Leslie Katz, "Interview with Walker Evans," *Art in America* Mar.–Apr. 1971: 82–89.

12. The first of these in which both the images and the text bore the photographer's signature was Walker Evans, "Main Street Looking North from Courthouse Square," *Fortune* May 1948: 102–106; the last was Walker Evans, "American Masonry," *Fortune* Apr. 1965: 82–89. Starting in 1945, numerous portfolios of Evans's photographs published by *Fortune* included texts that, being unsigned, and undocumented, cannot be attributed with certainty to Evans.

13. The first of these is Walker Evans, "Color Accidents," *Architectural Forum* Jan. 1958: 110–115; the last, Walker Evans, "Come on Down," *Architectural Forum* July 1962: 96–100.

14. Louis Kronenberger, ed., *Quality: Its Image in the Arts* (New York: Atheneum, 1969), specifically Walker Evans, "Photography" 169–171; "Diane Arbus" 172–173, "Robert Frank" 174–175, "Eric[h] Salomon" 176–177, "Paul Strand" 178–179, "Wright Morris" 180–181, "Edward Steichen" 182–183, "John Szarkowski" 184–185, "Bill Brandt" 186–187, "Harry Callahan" 188–189, "Henri Cartier-Bresson" 190–191, "Lee Friedlander" 192–193, "Nadar" 194–195, "W. Eugene Smith" 196–197, "Julia [Margaret] Cameron" 198–199, "Ginni Hubbard" 200–201, "Brassaï" 202–203, "Helen Levitt" 204–205, "Alfred Stieglitz" 206–207, "[Color]" 208–210, and "Lunar Orbiter I" 211.

15. Walker Evans, "Mad by Blaise Cendrars," *Alhambra* 1.3 (Aug. 1929): 34–35, 46.

16. Walker Evans, "Robert Frank," *US Camera Annual 1958* (New York: US Camera Publishing, 1957) 90.

17. Walker Evans, [Untitled], *William Christenberry Photographs* (Washington: Corcoran Gallery of Art, 1973) n. pag.

18. Walker Evans, "The Little Screens" [Photographs by Lee Friedlander], *Harper's Bazaar* Feb. 1963: 126–129.

19. See, for example, Jonathan Goell, "Walker Evans Recalls Beginning," *Boston Globe* 19 Sept. 1971: 53, 55.

20. Lincoln Kirstein, "Photographs of America: Walker Evans," *American Photographs*, by Walker Evans (1938; New York: Museum of Modern Art, 2012): 189–198.

21. Walker Evans, *Many Are Called*, introduction by James Agee (Boston: Houghton Mifflin; Cambridge: Riverside Press, 1966) n. pag.

22. According to Jane Rabb, citing David Herwaldt, some of Agee's letters to Evans, now in the Harry Ransom Humanities Research Center, University of Texas, Austin, indicate that the photographer had asked the writer to contribute a text to *American Photographs* in 1938, but that Agee, busy writing *Famous Men*, declined the invitation, arguing that he would have other opportunities to write about Evans's photography. See Rabb 303n4. Evans's text "James Agee in 1936" is included in the anthology compiled by Rabb, although her last comment on him, rather than commenting on

his authorial qualities, discusses the numerous texts, many of them poetic, that were inspired by his images. See Rabb 303n5.

23. February 1972 saw the publication of *The Harvard Advocate Commemorative to James Agee* (who had edited the periodical forty years previously), to which Evans contributed a set of photographs, with a presentation that begins: "Walker Evans and James Agee met in Greenwich Village in the early thirties [. . .]." See "Walker Evans," *Harvard Advocate Commemorative to James Agee* 105.4 (Feb. 1972): 28. Kirstein and Agee were at Harvard together, and Kirstein published Agee's poem "Ann Garner" in *Hound & Horn* in April 1929, mentioning Agee in his diary on October 19 and 20, 1930, i.e., less than a month before Evans appeared there. (See Lincoln Kirstein, manuscript diary, 14 Oct. 1930–23 July 1931, Lincoln Kirstein Papers, New York Public Library, Box 3, Folder 14, 6–7.) But it cannot be concluded that the photographer and the writer met through him. According to Susanna White, who in 2007 organized an exhibition of Silvia Saunders's photographs at the Ruth and Elmer Museum of Art, Hamilton College, Clinton, New York, Evans and Saunders went to Saratoga in the autumn of 1933 to take pictures; and this is mentioned in a letter from Olivia Saunders-Agee to her sister Silvia in October 1933 (or slightly earlier), now in the Saunders Family Papers at the college's archives. See Susanna White, email to the author, 13 May 2014. James Agee and Olivia ("Via") Saunders were married in January 1933.

24. The thirty-one photographs published in 1941 were chosen, and probably arranged in a sequence, since Harper & Brothers sold the photogravures to Houghton Mifflin. But it is not known when exactly Evans (taking advice from Agee?) made his selection, between their article for *Fortune* and the book for Harper & Brothers. Belinda Rathbone dates this choice to 1938, though without providing any source. See Belinda Rathbone, *Walker Evans: A Biography* (Boston and New York: Houghton Mifflin, 1995) 161–162. Further information can be found in a letter from Edward Aswell, at Harper & Brothers, to Lovell Thompson, at Houghton Mifflin, in the summer of 1940:

> For various reasons, it took Agee a good deal longer to finish it than he had anticipated, but, meanwhile, we, acting in good faith under the contract, went ahead with our plans to publish and had plates made for the Evans photographs. I doubt if any engraver's plates were ever made under such careful and loving scrutiny as Walker Evans gave to these. He spent a good deal of time at the engraving plant supervising the job, and, as I recall it, several of the plates were made over and infinite pains were taken in correcting small imperfections in others, until finally Evans was satisfied and the whole batch of plates was pronounced perfect. The engraving costs, as I told you, were $195.00.

See letter from Edward Aswell, "To Lovell Thompson," 18 July 1940, Davis, *LUNPFM* 917.

25. Agee's text did however appear in *Esquire* in December 1968, under the title "Southeast of the Island: Travel Notes," then in book form as James Agee, *Brooklyn*

Is: Southeast of the Island, Travel Notes (New York: Fordham UP, 2005). It has been translated into French: James Agee, *Brooklyn existe: Sud-Est de l'île, carnet de route*, trans. Anne Rabinovitch (Paris: Christian Bourgois, 2010).

26. Another secondary parameter in their relationship: in 1946 Agee married Mia Fritsch, a research associate at *Fortune*. Between journalism and publishing, the socioprofessional network to which the two men belonged was closely knit. It essentially recruited students from Harvard and Yale, and was just as essentially founded on a principle of cooptation, with some women playing an active role. For example, *Famous Men* was offered to Edward Aswell at Harper & Brothers through his wife, Mary Louise White, a friend of Via Agee. In 1940, it was recommended to Houghton Mifflin by Eunice Clark, the sister of the writer Eleanor Clark, who in 1952 married Robert Penn Warren. In 1937 Eunice had married John Jessup, a fellow student of Hobson at Yale, who in 1935 was taken on by Henry Luce at *Fortune*, and who was with *Time* from 1940 to 1944, writing a review of Agee and Evans's book in 1941 (though the article was also attributed to Whittaker Chambers, or again T. S. Matthews), before occupying a major role at *Life* magazine up to 1969.

27. Walker Evans, "The Last of Railroad Steam," *Fortune* Sept. 1958: 137–141; and Walker Evans, "The Pitch Direct," *Fortune* Oct. 1958: 139–143.

28. Walker Evans, "On the Waterfront," *Fortune* Nov. 1960: 144–150.

29. Walker Evans, "Color Accidents," *Architectural Forum* Jan. 1958: 110–115; and Walker Evans, "The London Look," *Architectural Forum* Apr. 1958: 114–119.

30. Walker Evans, "Sport in Art: Pigskin Combat," *Sports Illustrated* 22 Sept. 1958: 93.

31. Walker Evans, four-page carbon typescript draft of application [to the Ford Foundation], 29 Apr. 1960, p. 1, WEA, Met, 1994-250-85 (2).

32. Walker Evans, "James Agee in 1936," *Let Us Now Praise Famous Men*, by James Agee and Walker Evans (1941; Boston: Mariner Books, 2001) VI.

33. Hugh Davis's authoritative edition of *Famous Men* includes the large amount of material Agee used in the compilation of his work. Although it is not clear how much of it Evans may have read (apart from the original manuscript of the book), it seems likely that he knew about some texts, and that he was impressed by the ambition, lucidity, and style of his friend's numerous writings for this project. See Davis, *LUNPFM*, "Cotton Tenants" 565, "Plans for Work" 647, "Unused Chapters" 673, "Drafts" 773, and "Notes" 839; and see James Agee's letters to Walker Evans, "Selected Letters" 891.

34. The anonymity policy applied by *Fortune* was initially the same as that of *Time*, but it was gradually relaxed, notably with the appointment, in February 1953, of a new managing editor, Hedley Donovan.

> The only thing stingy about *Fortune* was its by-line policy. I was concerned that this could cost us valuable people, the hunger for recognition being so powerful in writers. Traditional *Fortune* doctrine was '*Fortune* says,' not some writer says; the full weight of the magazine was behind every article,

and if the writer wanted recognition, he could look up his name on the masthead. [. . .] The policy had loosened up a little by the time I became M. E. I loosened it altogether. Apart from individual ego gratification, I thought that as our better writers became known in their various skills and specialties, their by-lines enlarged the audience for their pieces.

See Hedley Donovan, *Right Places, Right Times: Forty Years in Journalism Not Counting My Paper Route* (New York: Henry Holt, 1989) 144.

35. In May 1948, *Fortune* published an initial portfolio that included a text signed by Evans, with the comment: "Walker Evans, whose poignant album on postcards appears on page 102 to 106 of this issue, may also be sampled in that space as a writer of delicacy and evocative power." See *"Fortune*'s Wheel: Freewheeling Camera," *Fortune* May 1948: 32. In 1953, when applying for membership to the prestigious Century Association in New York, Evans described himself as a "photographer-writer." See Walker Evans, one page handwritten letter to Charles Fuller, dated March 27, [1953] [among Fifty-four items related to the Century Association, March 27 [1953]–February 13, 1974]. WEA, Met, 1994-250-83 (1). And the lead-in to his text on Agee when it was first published in July 1960 in *The Atlantic Monthly* was: "Now an associate editor of FORTUNE, WALKER EVANS has claim to the double distinction of writer and photographer." See Walker Evans, "James Agee in 1936," *Atlantic Monthly* 206.1 (July 1960): 74.

36. The WEA contains a draft letter, unfortunately undated, from Evans to Auden, asking him to write an introduction to the new edition of the book: "Jim Agee's and my Let Us Now Praise Famous Men is being republished. Mia Agee and I have decided to ask you whether you'd like to write an introductory essay or statement (of any length) to be included in this new edition. [. . .] I have no idea whether you know the book. It is a youthful one, but a major Agee work. [. . .] I can of course give you the book in its first edition and tell you anything you might want to know about it." See Walker Evans, twenty-three miscellaneous notes and original folder, marked "Houghton Mifflin / Let Us Now Praise Famous Men / Correspondence, Notes, Agee material, etc.," undated, WEA, Met, 1994-250-75 (14). Agee also used a quotation from Auden as an epigraph for the article "Cotton Tenants: Three Families," which he originally submitted to *Fortune* in the fall of 1936: "Despair so far invading every tissue has destroyed in these the hidden seats of the desire and of the intelligence—W. H. Auden." See Davis, *LUNPFM*, "Cotton Tenants" 565. The edited draft of the article was published as James Agee, *Cotton Tenants: Three Families*, photographs by Walker Evans, ed. John Summers (Brooklyn and London: The Baffler, Melville House, 2013). It was translated into French as James Agee, *Une saison de coton : Trois familles de métayers*, photographs by Walker Evans, ed. John Summers, trans. Hélène Borraz (Paris: Christian Bourgois éditeur, 2014).

37. Professional papers. Correspondence, contracts, notes, papers, and ephemera relating to *Let Us Now Praise Famous Men*, 1st and 2nd ed., and galleys and picture proofs for 2nd ed., 1970–1974, WEA, Met, 1994-250-75.

38. Personal papers. Seventy-one manuscript and typescript drafts and notes, carbons, and page roofs (in forty-one folders), relating to "James Agee in 1936," which was published as the introduction to *Let Us Now Praise Famous Men*, 2nd. ed., WEA, Met, 1994-250-53.

39. Lovell Thompson, one page typescript letter to Walker Evans, 16 Apr. 1941, annotated in pencil by Evans on verso, WEA, Met, 1994-250-75 (7). According to Hugh Davis, "Robert Linscott [was] the editor who handled the manuscript for Houghton Mifflin." See Hugh Davis, "Agee and the Composition of *Let Us Now Praise Famous Men*," *LUNPFM* 510; and [Correspondence between James Agee and Robert Linscott, from Late December 1940 to 19 Dec. 1941], "Selected Letters" 919. See also in Davis, Edward Aswell, "To Lovell Thompson," 18 July 1940, "Selected Letters" 916–918; and James Agee, "To Lovell Thompson," August 1941, "Selected Letters" 928.

40. [One of] twenty-nine letters from Lovell Thompson at Houghton Mifflin, to Walker Evans, one page, 15 Aug. 1958, WEA, Met, 1994-250-75 (29).

41. Morton Baker, one-page typescript letter to Walker Evans, 20 Aug. 1959, [among twenty-nine letters from Lovell Thompson at Houghton Mifflin], WEA, Met, 1994-250-75 (29).

42. Hugh Davis's edition of *Famous Men* contains a letter from James Agee to Walker Evans, written in March 1939, mentioning a possible increase in the number of photographs included in the book (to match the increase in the length of Agee's text) to be published by Harper & Brothers: "[M]ore photographs probably cost too much, probably no hope of them." See James Agee, "To Walker Evans," March 1939, in Davis, *LUNPFM* 913. As William Stott noted, citing a statement by Evans in 1971:

> When a second edition was planned, Evans intended to repeat all the photos in the 1941 edition and add again as many. He did not see his job as a "revision" of the experience he had recorded in 1936 and composed for the book in 1939; he wanted the 1960 photograph section "to be identical in intent and style and meaning—just stronger. An amplification." Yet he admits that what he actually made is different enough to seem "another composition."

See William Stott, *Documentary Expression and Thirties America* (1973; Chicago: U of Chicago P, 1986) 280.

43. Two-page Houghton Mifflin press release for *LUNPFM*, annotated in pencil, July 1960, p. 1, WEA, Met, 1994-250-75 (39).

44. [One of] twenty-nine letters from Lovell Thompson at Houghton Mifflin [to Walker Evans], one page, 2 Oct., 1959, WEA, Met, 1994-250-75 (29).

45. [One of] twenty-nine letters from Lovell Thompson at Houghton Mifflin [to Walker Evans], one page, 15 Oct., 1959, WEA, Met, 1994-250-75 (29).

46. Walker Evans, [One of] two carbon typescript letters to Lovell Thompson, one page, 27 Dec. 1959, WEA, Met, 1994-250-75 (31).

47. [One of] twenty-nine letters from Lovell Thompson at Houghton Mifflin [to Walker Evans], one page, 21 Jan. 1960, WEA, Met, 1994-250-75 (29).

48. And Brooks continued praising Evans the writer: "Having read these few pages, I cannot help wishing that you wrote a great deal more. Perhaps you do—perhaps I am just out of touch. If you do have any book plans—in the publisher's cliché phrase—I hope you will let me know." See [One of] two typescript letters from Paul Brooks, at Houghton Mifflin, to Walker Evans, one page, 14 Jan. 1960, WEA, Met, 1994-250-75 (28).

49. [One of] twenty-nine letters from Lovell Thompson at Houghton Mifflin [to Walker Evans], one page, 1 Mar. 1960, WEA, Met, 1994-250-75 (29).

50. 50. See, respectively, [One of] six letters from David Harris, at Houghton Mifflin [to Walker Evans], one page, 24 Mar. 1960, WEA, Met, 1994-250-75 (33), and [One of] six letters from David Harris, at Houghton Mifflin [to Walker Evans], one page, 28 Mar. 1960, WEA, Met, 1994-250-75 (33).

51. [One of] six letters from Morton Baker, at Houghton Mifflin, to Walker Evans, one page, 28 Mar. 1960, WEA, Met, 1994-250-75 (32).

52. [One of] twenty-nine letters from Lovell Thompson at Houghton Mifflin to Walker Evans, one page, 30 Mar. 1960, WEA, Met, 1994-250-75 (29).

53. One-page letter from Margaret Perry, at Houghton Mifflin, to Walker Evans, one page, 4 Apr. 1960, WEA, Met, 1994-250-75 (35).

54. One-page copy of letter from Ted Weeks to Lovell Thompson, 14 Apr. 1960, WEA, Met, 1994-250-75 (20).

55. One-page letter from Emily Flint, at *The Atlantic Monthly*, to Walker Evans, 5 May 1960, WEA, Met, 1994-250-75 (21).

56. Walker Evans, one-page carbon typescript letter to Emily Flint, 10 May 1960, WEA, Met, 1994-250-75 (22).

57. [One of] six letters from David Harris, at Houghton Mifflin, to Walker Evans, one page, 8 June 1960, WEA, Met, 1994-250-75 (33).

58. [One of] six letters from Morton Baker, at Houghton Mifflin, to Walker Evans, one page, 14 July 1960, WEA, Met, 1994-250-75 (32).

59. Walker Evans, six-page annotated carbon, "Foreword," 1959, annotated by author in pencil, WEA, Met, 1994-250-53 (21).

60. Walker Evans, seven-page annotated carbon, "James Agee in 1936," 10 Feb. 1960, annotated by author in ink and pencil (inscribed by author in pencil, "FINAL"), WEA, Met, 1994-250-53 (25).

61. Walker Evans, four-page annotated reproduction proofs, 22 Mar. 1960, annotated by author in pencil, WEA, Met, 1994-250-53 (27). In the 1960 Houghton Mifflin edition of *Famous Men*, "James Agee in 1936" is dated "New York, 1960." See Walker Evans, "James Agee in 1936," in James Agee & Walker Evans, *Let Us Now Praise Famous Men* (vii).

62. Walker Evans, six-page annotated carbon, "Foreword," 1959, annotated by author in pencil, WEA, Met, 1994-250-53 (21). Evans also submitted his text to his

friend Tom Mabry. See Evans, seven page annotated carbon, "James Agee in 1936," 10 Feb. 1960, annotated by author in ink and pencil (inscribed by author in pencil "FINAL"). WEA, Met, 1994-250-53 (25). But the WEA contains no comments or suggestions by these readers.

63. "A Recollection of James Agee in Alabama, 1936" was another version of the title. See Walker Evans, eight-page annotated typescript, "A Recollection of James Agee in Alabama, 1936," annotated by author in pencil, WEA, Met, 1994-250-53 (3).

64. Oddly enough, there seems to be no mention of this incident in the series of notes Agee wrote about his itinerary and contacts in Alabama, unless there is a relation between his arrest, as subsequently recounted by Evans, and an entry in his itinerary that reads "10. The fine." See "Agee's Itinerary [2]," in Davis, *LUNPFM* 656.

65. Robert Frank, nine-page manuscript letter, "To Walker Evans," 9 Nov. 1955, WEA, Met, 1994-260-6 (12) 10.

66. "'Let Us Now Praise Famous Men' contains, in effect, several Prefaces within its own pages. The following fragmentary personal recollection of James Agee in 1936 suggests itself in place of a conventional foreward [*sic*], at this point of the book's life. In any event, this work asks to be discovered by itself." See Walker Evans, eight-page annotated typescript, "Copy, For Lovell Thompson and Paul Brooks for 'Let Us Now Praise Famous Men,'" 1960, annotated by author in blue ink and pencil [inscribed by author "corrected copy"], WEA, Met, 1994-250-53 (12).

67. Evans, "James Agee in 1936," in Agee and Evans, *Let Us Now Praise Famous Men* vi.

68. Evans, "James Agee in 1936," in Agee and Evans, *Let Us Now Praise Famous Men* vi.

69. Hugh Davis writes: "One of the major themes of *Let Us Now Praise Famous Men* is the idea that the least among us are worthy of love and respect; indeed, that they are not only human but holy." See Davis, *LUNPFM* 502.

70. Walker Evans, eight-page annotated typescript, "A Recollection of James Agee in Alabama, 1936," annotated by author in pencil, pp. 1–2, WEA, Met, 1994-250-53 (3).

71. Evans, "A Recollection" 2.

72. Evans, "A Recollection" 2–4.

73. Evans, "A Recollection" 6.

74. Evans, "James Agee in 1936" in Agee and Evans, *Let Us Now Praise Famous Men* vii.

75. Evans, "A Recollection" 8.

76. Walker Evans, "James Agee in 1936," in Agee and Evans, *Let Us Now Praise Famous Men* vii.

77. Evans, "A Recollection" 8.

78. Evans, "A Recollection" 7.

79. Evans, eight page annotated typescript, "Copy, For Lovell Thompson and Paul Brooks for 'Let Us Now Praise Famous Men,'" WEA, Met, 1994-250-53 (12).

80. See Evans, seven page annotated carbon, "James Agee in 1936," 10 Feb. 1960, WEA, Met, 1994-250-53 (25). As shown by a note Evans wrote on the top of the first page, "January 27, [1960], this copy was initially meant for Tom Mabry, who was to read it and send it back to Evans.

81. Four-page annotated reproduction proofs, 22 Mar. 1960, annotated by author in pencil, pp. 1, 3, WEA, Met, 1994-250-53 (27).

82. There are several minor differences between the text in the September 1960 Houghton Mifflin edition and the one that had been published in July of that year in *The Atlantic Monthly*. The only important change (apart from synonyms, commas, and hyphens) was the replacement of the sentence "In Alabama he was possessed with the business of finding out everything he could about the lives he intended to describe" by "In Alabama he was possessed with the business, jamming it all into the days and the nights." See Evans, "James Agee in 1936," *The Atlantic Monthly* 206.1 (July 1960): 74–75; and "James Agee in 1936," in Agee and Evans, *Let Us Now Praise Famous Men* vi–vii.

83. Walker Evans, four-page manuscript, ["This extraordinary book. . ."], WEA, Met, 1994-250-53 (8).

84. "It is a miscellaneous book, as hard to classify as that earlier failure, 'Moby Dick,' which it resembles, being written in a 'big' style and drawing poetry from journalistic description." See Fourteen reproduction proofs of Dwight Macdonald, "Death of a Poet," *The New Yorker* 16 Nov. 1957: 224–241 [included in a selection of James Agee press clippings, eleven items, 6 Dec. 1953–7 Apr. 1969], p. 239, WEA, Met, 1994-250-80 (2). Macdonald's citation was used by Houghton Mifflin in the press release that announced the publication of the work. See two-page Houghton Mifflin press release for *LUNPFM*, annotated in pencil, July 1960, 1, WEA, Met, 1994-250-75 (39). The 1941 review of the book in *Time* had already described it as "some of the most exciting U.S. prose since Melville." See "Books: Experiment in Communication," *Time* 13 Oct. 1941: n.p.

85. Walker Evans, [One of] two manuscript notes, ["AGEE Dostoevsky Donne Blake . . ."], list for essay, WEA, Met, 1994-250-53 (28). Blake and Céline appear as "unpaid agitators" among the "Persons and Places" listed by James Agee at the beginning of *Famous Men* (Davis, *LUNPFM* xvi). According to Hugh Davis: "An early version of this list of 'unpaid agitators' (TN MS-2730, box 5, folder 52) contains the names Ludwig van Beethoven, William Blake, Ferdinand-Louis [*sic*] Céline, Johnathan [*sic*] Swift, Jesus Christ, and Fyodor Dostoyevsky" (*LUNPFM*, 386n16).

86. Walker Evans, one-page manuscript, ["I can imagine an older man . . ."], WEA, Met, 1994-250-53 (35).

87. In her memoirs, Evans's second wife, Isabelle Storey, mentions the copy of *Lolita* she gave him in 1959, which he refers to here. It was probably the original 1955 edition in two volumes published by the Olympia Press, Paris. See Isabelle Storey, *Walker's Way. My Years with Walker Evans*, Brooklyn: powerHouse Books, 2007, p. 16.

88. Walker Evans, two-page manuscript, ["Agee himself was so personal . . ."], p. 2, WEA, Met, 1994-250-53 (31).

89. Walker Evans, [one of] three manuscript notes on perforated paper, one page, ["AGEE/The man reminded me . . ."], WEA, Met, 1994-250-53 (38).

90. Walker Evans, one-page manuscript, ["Writing about Agee becomes . . ."], WEA, Met, 1994-250-53 (30).

91. Walker Evans, one-page manuscript note, ["The writing in Let Us Now . . ."], WEA, Met, 1994-250-53 (37).

92. Walker Evans, thirty-one grouped manuscript notes on 3x5 inch index cards, miscellaneous notes on James Agee, c. 1960, on one of the two index cards numbered 1, WEA, Met, 1994-250-53 (41).

93. Evans, index card 16, WEA, Met, 1994-250-53 (41).

94. Evans, index card 20, WEA, Met, 1994-250-53 (41).

95. "James Agee in 1936" was reprinted in David Madden and Jeffrey J. Folkes, ed., *Remembering James Agee* (1974; Athens: U of Georgia P, 1997) 97–99. Evans could no doubt have depicted another Agee, bringing up particular qualities or episodes. But it was no coincidence that, unlike a number of their colleagues at Time Inc.—Robert Fitzgerald, Dwight Macdonald, Whittaker Chambers, T. S. Matthews, James Stern, Louis Kronenberger—he did not leave behind any reminiscences of Agee during the latter's years as a journalist and a critic, which he himself had shared. On this subject, see James Agee, *Complete Journalism*, ed. Paul Ashdown, vol. 2 of *The Works of James Agee* (Knoxville: U of Tennessee P, 2013) and Robert Vanderlan, *Intellectuals Incorporated: Politics, Art, and Ideas Inside Henry Luce's Media Empire* (Philadelphia: U of Philadelphia P, 2010).

96. Katz, "Interview with Walker Evans" 83.

97. Walker Evans, "The Thing Itself Is Such a Secret And So Unapproachable," *Yale Alumni Magazine* 37.5, Feb. 1974: 12.

98. Walker Evans, [Untitled], *Walker Evans: Photographs from the* Let Us Now Praise Famous Men *Project*, exhibition catalog, Michener Galleries, Humanities Research Center, U of Texas at Austin, 24 Mar.-5 May 1974, n. pag.

99. Walker Evans, in Stott 265.

100. Evans, in Stott 320. The unexpected reappearance of Cocteau in Evans's conversation with William Stott, so long after Evans translated Cocteau's "Scandales" in 1928 (see Walker Evans, "Scandales," Jan.-Feb. 1928, WEA, Met, 1994-250-1 (26-29), might be related to the publication of Francis Steegmuller's *Cocteau: A Biography* (Boston: Little, Brown, 1970), given that Evans and Steegmuller were both members of the Century Association in New York, and devotees of Flaubert. Cocteau also appears in Agee's text in *Famous Men*, first implicitly, in a footnote quoting his *Essai de critique indirecte* (1923), then explicitly, with regard to Picasso and painting. Davis, *LUNPFM* 8n2, 193n1.

101. "Walker Evans, Visiting Artist: A Transcript of His Discussion with the Students of the University of Michigan," *Photography: Essays & Images. Illustrated*

Recordings of the History of Photography, ed. Beaumont Newhall (New York: Museum of Modern Art, 1980) 318.

102. Walker Evans, [Untitled] in *Agee: His Life Remembered*, ed. Ross Spears and Jude Cassidy (New York: Holt, Rinehart and Winston, 1985) 58. The "first meetings" with "the family" (or more accurately, some members of the three tenant families) are recounted by James Agee in *Famous Men*. See Davis, *LUNPFM* 295.

103. Walker Evans, [Untitled] in *Agee: His Life Remembered*, 64, 66. Evans's account might be likened to one of James Agee's manuscript variants of *Famous Men*: "With the most nearly 'representative' of the three [families] we lived a little less than four weeks, seeing them and the others intimately and constantly, Evans making photographs and valuably adding to my perception and research, I questioning, watching, deducing, and making notes." See Davis, *LUNPFM*, James Agee, "Major manuscript Variants, Notes and Appendices," 552.

104. Walker Evans, [Untitled] in *Agee: His Life Remembered*, 114.

105. In his introduction to Walker Evans's interview that was published two years after the photographer's death, Bill Ferris remembers: "When I told Walker I was from Mississippi, he spoke of the South with nostalgia and recalled the scenes he had photographed near my home in Vicksburg." See "A Visit with Walker Evans," *Images of the South: Visits with Eudora Welty and Walker Evans*, Southern Folklore Reports 1 (Memphis, TN: Center for Southern Folklore, 1977) 28. In a former interview, Evans had expressed his dislike to the notion of nostalgia in relation to his photographs:

> I've certainly suffered when philistines look at certain works of mine having to do with the past, and remark, 'Oh, how nostalgic.' I hate that word. That's not the intent at all. To be nostalgic is to be sentimental. To be interested in what you see that is passing out of history, even if it's a trolley car you've found, that's not an act of nostalgia. You could read Proust as 'nostalgia,' but that's not what Proust had in mind at all.

See Katz, "Interview with Walker Evans" 87. According to Jerry L. Thompson, Evans "was interested in the South, but in a way that involved both attraction and critical regard. On the one hand he called it, in conversation, 'the only place in this country where there is any *real* culture.' On the other, he was able to look at it in the way suggested in his essay [Walker Evans, "The Reappearance of Photography" 125–128]: as through 'an open window looking straight down a stack of decades.'" Jerry Thompson, email to the author, 16 Feb. 2015.

106. See "A Visit with Walker Evans" 32. A slightly different version of the interview (without Ferris's questions) was published in William R. Ferris, "Walker Evans, 1974," *Southern Cultures* 13.2 (Summer 2007): 29–51. My thanks go to David Campany for drawing my attention to this publication.

107. Ferris, "A Visit with Walker Evans" 32.

108. "Walker Evans on Himself," ed. Lincoln Caplan, *New Republic* 175.20. 13 Nov. 1976: 25.

109. Walker Evans, "James Agee in 1936," in Agee and Evans, *Let Us Now Praise Famous Men* VII.

110. Olivier Lugon, personal interview, 9 Dec. 2012.

111. Mockup of the flyer for the second edition of *Let Us Now Praise Famous Men*, p. 3 (of 12), WEA, Met, 1994-250-75 (25).

112. *Dora Mae Tingle (Evans's Shadow in Foreground), Hale County, Alabama*, Summer 1936, LC-USF33-31301-M4, in Walker Evans, *Photographs for the Farm Security Administration 1935–1938* (New York: Da Capo Press, 1973) n. pag. The same image appears in the frontispiece.

113. There is a print of this image, *James Agee (at left) Interviewing Bud Fields in His Bedroom, Hale County, Alabama*, August 1936, in the photographic collection of the Harry Ransom Humanities Research Center, The University of Texas at Austin (968:004:024). It was exhibited there by William Stott during Evans's visit to the university in 1974 (William Stott, email to the author, 24 Jan. 2014). Stott included it in the iconography of the second edition of *Documentary Expression and Thirties America*. And in 2000 it was reproduced in Rosenheim and Eklund 93.

114. "The placement of the photographs, uncaptioned and unnumbered at the front of the book, their silent sequence constituting in fact a separate 'Book One,' was a formal 'anomaly' that pointed to a 'mediamachia,' in Peter Cosgrove's terms—a battle between picture and text." See François Brunet, *Photography and Literature* (London: Reaktion Books, 2009) 58, and 155n29. Davis, *LUNPFM*, 11.

115. James Agee and Walker Evans, *Louons maintenant les grands hommes : Alabama, trois familles de métayers en 1936*, trans. Jean Queval (Paris: Plon, 1972).

116. See James Agee and Walker Evans, "Louons maintenant nos grands hommes," trans. Michelle Vian, *Les Temps modernes* 27 (Dec. 1947): 1004–1027. Though this text did not include any images, the authorship was attributed to both men, like that of the book itself. The translator's husband, Boris Vian, penned a caustic foreword to this extract, which was rejected by the review but was published in his *Chroniques du menteur*, ed. Noël Arnaud (Paris: Christian Bourgois, 1974) 121–123.

117. In 1996, the French novelist, poet, and essayist Pierre Alferi, who at the time, along with Olivier Cadiot, edited the *Revue de littérature générale*, opened its second issue (unpaged) with a group of "fragments prélevés" from *Louons maintenant les grands hommes*, under the title of "Le Tabernacle" (trans. Françoise de Laroque), specifying that they "had not been entirely translated in the French edition."

118. <http://catalogue.bnf.fr/ark:/12148/cb34604573h>. 26 Nov. 2016.

119. <http://www.plon.fr/ouvrage/louons-maintenant-les-grands-hommes/9782259001694>. 26 Nov. 2016.

"As If Admonished from Another World": Wordsworth's *Prelude*, Schopenhauer, and *Let Us Now Praise Famous Men*

Hugh Davis

In Book VII of his long autobiographical poem *The Prelude*, William Wordsworth describes his residence in London[1] between leaving Cambridge University and scholarly pursuits and traveling to France and discovering his true vocation as a poet of Nature. Dominated by images of theatrical spectacle, Book VII focuses not only on performances of the legitimate "theatre, which then were my delight" (402), but also the popular entertainments of Sadler's Wells, including puppet shows, "singers, rope-dancers, giants and dwarfs, / Clowns, conjurors, posture-masters, harlequins" (294–95), not to mention the performances of lawyers in court and preachers in the pulpit and even the theatricality of public executions.[2] Wordsworth's attention soon turns to the audiences for these various spectacles as spectacles in themselves, though, and he finds that carnivalesque street scenes such as that at St. Bartholomew's Fair, which, with its "anarchy and din, / Barbarian and infernal" (660–61), offer a pageant of life more intriguing and entrancing than any work of dramatic art. "How often in the overflowing streets," he writes, "Have I gone forwards with the crowd, and said / Unto myself, 'The face of every one / That passes by me is a mystery'" (595–98).

His attempts to penetrate the "what, and whither, when and how" (600) of these individual passing lives falter before their overwhelming number and particularity, however, and they blend together, dissolving into a ghost-like immateriality such as "appears in dreams" (603). Rather than penetrating the mystery of these other lives, he instead experiences a failure to conceptualize them at all, which leads to a state in which the "present, and the past, hope, fear, all stays, / All laws of acting,

thinking, speaking man" are suspended, producing only a type of mute, numb ignorance (605–6). In one of the most striking images of the poem, Wordsworth then crystallizes the intersection of his desire to look and his inability to see in the figure of a blind beggar:

> And once, far travelled in such mood, beyond
> The reach of common indications, lost
> Amid the moving pageant, 'twas my chance
> Abruptly to be smitten with the view
> Of a blind beggar, who, with upright face,
> Stood propped against a wall, upon his chest
> Wearing a written paper, to explain
> The story of the man, and who he was.
> My mind did at this spectacle turn round
> As with the might of waters, and it seemed
> To me that in this label was a type
> Or emblem of the utmost that we know
> Both of ourselves and of the universe;
> And, on the shape of the unmoving man,
> His fixèd face and sightless eyes, I looked
> As if admonished from another world. (610–23)

Lost in a "second-sight procession" (602) through which the stream of impressions at first seems to gather into some higher understanding beyond its perception by the senses, Wordsworth is suddenly arrested by the vision of the beggar—or rather the sign on his chest, a form of caption to a living photograph, which purports to explain the "story of the man, and who he was" but instead admonishes the poet that words are never equivalent to the thing they describe. Literally interposed between Wordsworth and the beggar, the written text signifies the limits of representation, revealing not what the reader can know about the person it attempts to define but the fact that we can never really know him at all. The text is a mere label; the poem can capture the beggar's outward appearance but has no real access to his experience of the world. Realizing that "the utmost that we know" is conditioned "chiefly [by] such structures as the mind / Builds for itself" (625–26), Wordsworth can ulti-

mately see not the beggar but only himself as the observer reflected in the beggar's sightless eyes.

Although the situation to which James Agee hoped to do justice in 1930s rural Alabama was far removed from the urban spectacle of teeming London, the figure of Wordsworth's blind beggar serves equally well as a metaphor for the main tensions in *Let Us Now Praise Famous Men*. Agee certainly knew this passage from *The Prelude*—in a 1931 letter to Father Flye, he described his reading as "[a] good deal of Wordsworth and Donne and Joyce, and some Chaucer, and Coleridge, are the main things, with emphasis all on Wordsworth, Joyce and music"[3]—and the vast autobiographical project that Agee outlined in the late 1940s, and of which *A Death in the Family* and *The Morning Watch* are but the third and fifth volumes, may owe something to Wordsworth's poem as well.[4] Furthermore, he invokes the passage about the blind beggar almost directly in *Famous Men* in asking a question that captures an identical moment of both himself and the reader: "For one who sets himself to look at all earnestly, at all in purpose toward truth, into the living eyes of a human life: what is it he there beholds that so freezes and abashes his ambitious heart?" (83).[5] A key intertext to *Famous Men*, Book VII of Wordsworth's *Prelude* raises a number of issues at the center of Agee's project, including those having to do with the limits of knowledge and difficulty of literary representation. While Wordsworth largely fails to resolve these problems and ultimately retreats from them, Agee reframes them through an appeal to the philosophy of Arthur Schopenhauer.

Agee echoes the concerns of Book VII over and over again in *Famous Men*, lamenting the fact that "[w]ords cannot embody; they can only describe" (192), an obstacle he had identified in early notes to the book, writing, "A sudden and unexplained past portrait of Allie Mae in her best hat, young. And embodied, not described or conjectured" (888). At times defending poetry as "the most dangerous and impossible of bargains" (193) that representation can make with reality, Agee also admits, "If I could do it, I'd do no writing at all here," conceding, "A piece of the body torn out by the roots might be more to the point" (11). When he writes that he and Walker Evans are trying to deal with their subject "not as journalists, sociologists, politicians, entertainers, humanitarians, priests, or artists, but seriously" (viii), he is expressing the difficulty

of interpreting anything outside of preexisting cognitive frameworks, a difficulty that both writer and reader must overcome if they are to apprehend the doubly paradoxical "normal predicaments of human divinity" (viii).

Following his account of the blind beggar, Wordsworth tries to find transcendence in "Scenes different . . . which take, with small internal help / Possession of the faculties" (626–28) and include "the peace / of night, for instance, the solemnity / Of Nature's intermediate hours of rest" (628–29) as well as "empty streets" (635) and the "feeble salutation from the voice / Of some unhappy woman now and then / Heard as we pass" (639–41). This description resonates in Agee's evocation of a sublime and "lucky situation of joy, this at least illusion of personal wholeness or integrity" (184), which may occur as the result of experiences ranging from "the fracture of sunlight on the façade and traffic of a street; the sleaving up of chimneysmoke" (184) to "[w]andering alone; in sickness; on trains or busses; in the course of a bad hangover" (185). For Wordsworth, however, these experiences are tempered by the fact that they may be "falsely catalogued" since "things that are, are not, / Even as we give them welcome, or assist" (643–44) by apprehending and articulating them. For Agee, too, they are "not only finally but essentially beyond the power of an art to convey" (185).

Confronted by the beggar's blindness, Wordsworth is forced to admit his own: in Kantian terms, there is a transcendental, mind-independent object that is the cause of human senses, but which they are unable to perceive and which the human intellect is unable to conceptualize. In his description of the mobs at St. Bartholomew's Fair, Wordsworth numbers among the "albinos, painted Indians, dwarfs" (681) the "horse of knowledge, and the learned pig" (682), a reference to animals such as Toby the Learned Pig, who answered questions and performed other mental feats such as addition and subtraction and playing cards. Not only do the crowds, through sheer multiplicity, resist being conceptualized, but these four-legged Turing tests also undermine Wordsworth's faith in his ability to know what is right in front of him by offering the semblance of rationality in a dumb animal. The animals' performances are a parody of knowledge yet indistinguishable on the surface from hu-

man understanding; as such, they admonish the poet that human attempts to exceed the limitations of the senses are equally grotesque.

In *Famous Men*, Agee uses the metaphor of blindness in the same way, though with subtle variations. On one level, blindness refers simply to ignorance, as with the sharecroppers' inability, as Agee puts it, to "conceive of or be interested in what they have never tasted or heard of" (253) or, as he writes in an early draft of an introduction to the work: "This is a record of blindness as well as of perception; no attempt, it is hoped, will be made to conceal the blindness" (805). In fact, one of the most distinctive and most daunting features of *Famous Men*, Agee's propensity to catalogue in the most minute detail not only the sharecropper's physical environment but his own thoughts and impressions of it, is an open admission of the impossibility of his ever truly grasping either one. In his book *Ignorance: On the Wider Implications of Deficient Knowledge*, philosopher Nicholas Rescher distinguishes between truth and facts, defining a truth as "any correct statement" and emphasizing that it "has to be framed in *linguistic/symbolic* terms."[6] A fact, on the other hand, "is not a linguistic term at all, but an actual aspect of the world's state of affairs which is thereby a feature of reality. Facts correspond to potential truths whose actualization as such waits upon their appropriate linguistic embodiment. Truths are statements and thus language-bound, but facts outrun linguistic limits."[7] Making a true statement requires a fact with which it must align; it also requires a conceptual framework within which to exist in the first place. In his discussion of scientific inquiry, Rescher notes that valid questions are those whose presuppositions are taken to be true. When the presuppositions change, as in the shift from Newtonian physics to modern quantum theory, the questions change, creating a new conceptual framework in which previous truths are rendered not even false but merely moot.

Both thematically and formally, *Famous Men* foregrounds conceptual instability by forcing the reader to adopt different interpretive strategies for each part of the book. "Inductions" is a fairly straightforward narrative, for instance, but "On the Porch: 2" contains an extended meditation on aesthetics, and "Intermission: Conversation in the Lobby" functions mostly as a polemic. Each of these sections requires a distinct type

of analysis, and together they challenge the reader to create still another category that can encompass all of their conceptual contradictions. Agee's refusal to submit to a single controlling idea is also reflected in the book's composition. Originally, he conceived the work as

> three pieces: the first on the family, the second a generalized piece, a big fatassed analysis of the situation and of cotton economics and of all Governmental efforts to Do Something about It, which latter I was quite sure could beautifully hang themselves on their own rope; and the third a straight union piece, starting with inch-by-inch process of a couple of organizers opening up new territory, leading that on through night-riding et cetera, and mushrooming it into a history of both unions. (760)

When *Famous Men* appeared in print five years later, however, it was with its overt political commentary subsumed under thick description of the sharecroppers' material conditions and its focus on what was to have been an "inch-by-inch" treatment of union organizing reduced to a single mention in the book as published. Agee also emphasizes the variable nature of the text through the use of footnotes, especially in "On the Porch: 2," where they serve as a running commentary on the text, which he points out was written in 1937 and is therefore perhaps no longer completely operative. Mentioning that he is setting up the porch as a site "to which from time to time the action may have occasion to return," he immediately undercuts the notion in a footnote, writing, "It still may, but not in this volume" (196). The book itself occupies a transitional conceptual space, then, between what Agee may have thought at one time and what he may think in the future, and he wants the reader to keep the fluid nature of his treatment of any subject fully in mind. While his reluctance to commit to a particular position at any given moment may be frustrating ("These words are quoted here to mislead those who will be misled by them" (xiii)), by suspending judgment Agee is actually exhibiting a profound intellectual humility in recognition of our severely limited capacity to know the "truth" of ourselves, the world, and our own creations.

Statements of scientific truth are historically contingent, then, products of the presuppositions that frame and support them, and as such can never be taken as the final word or, in Rescher's term, as facts themselves. Furthermore, each answer generates many more questions, which means that in "overcoming ignorance by securing answers to our questions in the course of inquiry we do not reduce the overall volume of identifiable ignorance in terms of the number of visible questions to which we lack answers."[8] Paradoxically, the number of true statements we can make about any fact may be inversely proportional to our understanding of the fact itself. Since "the domain of fact inevitably transcends the limits of our capacity to *express* it,"[9] a comprehensive list of truths about a fact can never completely comprehend it, even though the list can continue to grow and is itself inexhaustible. Further progress along these lines becomes "ever more cumbersome" and "ever more prolix,"[10] though, eventually tending to collapse under its own weight. When Agee lists the contents of a room down to the "eleven rusty nails, one blue composition button, one pearl headed pin (imitation), three dirty kitchen matches, [and] lump of toilet soap" (143) in the bottom of a shaving mug or when he focuses on the individual grains of a single board or details every scrap of calendar art and advertising on a mantelpiece, he is simultaneously asserting the facticity of the families' existence and reminding the reader that he will never quite capture it. The exhaustive nature of the attempt is its own meaning. The fact remains just out of reach, even if, as Allie Mae Burroughs later remarked, "everything in there's true. What they wrote in there was true."[11]

Although Agee employs the words "fact" and "truth" in a contrary sense from the way Rescher defines the terms, he is making an identical point in the following passage from "On the Porch: 2":

> It seems very possibly true that art's superiority over science and
> over all other forms of human activity, and its inferiority to them,
> reside in the identical fact that art accepts the most dangerous
> and impossible of bargains and makes the best of it, becoming,
> as a result, both nearer the truth and farther from it than those
> things which, like science and scientific art, merely describe, and

those things which, like human beings and their creations and the
entire state of nature, merely are, the truth. (192–93)

Art's superiority to science is precisely its acknowledgement that what
it describes is not the thing itself: art creates truths, which may illu-
minate a certain fact without being equivalent to it. In *The Prelude*,
Wordsworth, in his description of the "multifarious" (288) entertain-
ments of Sadler's Wells, writes of witnessing a performance in which
Jack the Giant-killer

> dons his coat of darkness, on the stage
> Walks, and achieves his wonders, from the eye
> Of living mortal safe as is the moon
> 'Hid in her vacant interlunar cave'.
> Delusion bold (and faith must needs be coy)
> How is it wrought?—his garb is black, the word
> INVISIBLE flames forth upon his chest. (304–310)

Whereas the sign on the blind beggar's chest confronts the poet with
the inadequacy of language, leading to a crisis of representation, here
the sign, by calling attention to its own paradoxical nature, is able to
mediate between fact and truth. The word "invisible" is visible, as is Jack,
and it signals the audience, who can clearly see Jack, to pretend not to.
In other words, the audience is in on the joke and can take pleasure in
its double response, suspending belief and disbelief simultaneously. In
Famous Men, Agee may at times don the guise of a "bodyless eye" (153),[12]
but he does so clumsily, as he makes it impossible for the reader to miss
him lumbering across the stage. In fact, by introducing himself as a
"spy" (xvi) along with the rest of its mostly true-to-life characters a list
of *dramatis personae*, he is explicitly highlighting the book's theatrical
nature. In this way he comes "both nearer the truth and farther" from it,
accepting the impossible bargain of representation on its own terms. To
the extent to which the reader does not mistake the word for that which
it labels, Agee implies, he may very well be able to see through it.

While both Agee and Wordsworth use the metaphor of blindness to
refer to a Kantian ignorance that defines the transcendental object as

necessarily inaccessible to the senses, they also hint at a deeper level of existence that is accessible through a type of non-intellectual phenomenological awareness. For Agee, for instance, "Fish halted on the middle and serene of blind sea water sleeping lidless lensed" represent a type of unconscious or preconscious (really aconscious) purely physical existence, alive but unaware of itself as separate from the sea in which it sleeps, beneath and beyond any attempt to conceptualize it, "their breathing, their sleeping subsistence" equivalent to "the effortless nursing of ignorant plants" (17). Human beings share this substrate of existence, of course, emerging as we do from "the blind bottom of the human sea" (85) and conceived in "a redblack cherishing of a blind and beating of hurt unvanquishable blood" (86). In this sense, Agee is closely aligned with Arthur Schopenhauer, who in *The World as Will and Representation* posits phenomenal existence as an illusion, mere representation that disguises the actual foundation of reality, the "blind force of nature"[13] that he calls the will. The operation of will—mindless, aimless, irrational—is evident in the phenomenal world, including human beings, who are the will objectified, that is, its self-conscious expression. Schopenhauer's philosophy is essentially pessimistic, since the ultimate ground of being, and therefore human existence, is nothing more than unappeasable appetite and completely devoid of meaning or purpose. Like "that long and lithe incongruous slender runner a vine spends swiftly out on the vast blank wall of the earth, like snake's head and slim stream feeling its way" (58), our lives unravel, blindly impelled by a force beyond reason. As Agee asks rhetorically, framing a question about Ivy and Miss-Molly Pritchert's inner lives that applies more broadly than most of us would like to admit: "What are the dreams of dogs?" (65).

Although Schopenhauer characterizes life in terms of suffering and frustrated desire, he also argues that the pain of existence can be transcended, at least temporarily, through aesthetic perception, which allows the individual to lose himself in contemplation of a beautiful object. Since the true object of aesthetic perception is not the physical object itself but its Platonic ideal, Schopenhauer claims that the person who perceives it "is no longer individual, for in such perception the individual has lost himself; but he is the *pure*, will-less, painless, timeless *subject of knowledge*."[14] However, for Schopenhauer, the aesthetic object is not separate

from the will but rather the will in its most essential form: "The will is the 'in-itself' of the Platonic Idea, which fully objectifies it; it is also the 'in-itself' of the particular thing and of the individual that knows it."[15] In other words, the aesthetic experience transcends space and time, as the subject's mind, in apprehending the object in its ideal form, achieves the same ideal existence. To be sure, most people are unable to sustain this state for very long, but a true artist is one who transmits this ideality of the will most clearly. The mind of the artist of genius, according to Schopenhauer, is "a clear mirror of the inner nature of the world."[16]

In *The Prelude*, the will manifests itself as an emergent property of crowds, as Wordsworth watches "crude Nature work in untaught minds" (298) at Sadler's Wells and sees the "whole creative powers of man asleep" (655) at St. Bartholomew's Fair create a "work that's finished to our hands" (654). While Wordsworth is fascinated by the spectacle of all the "far-fetched, perverted things" (688) that the tents and booths are "vomiting" (698) forth, he also finds it threatening, recoiling from the grotesque "parliament of monsters" (692). Unwilling to lose himself in the pandemonium of the fair, Wordsworth flees, quickly closing Book VII and retreating to the "mountain's outline and its steady form" (723) and solitary communion with Nature. The irony, of course, is that the poem itself is evidence that the crowd's creative impulse springs from the same "Nature" as his own.

Whereas Wordsworth seems to want to appeal to a Nature that has none of Nature's darkness and danger, Agee is much more comfortable with the implications of Schopenhauer's aesthetics of the will. Describing the morning ritual of the Ricketts family, he recalls a "lonely Mass" when he was a student at St. Andrew's during which "from the rear of the empty church stole forward a serene widow and a savage epileptic, softly blind, and knelt, and on the palms of their hands and at their mouths they took their strength and, blind, retired" (74). In taking communion, the widow and the epileptic are participating in a ritual that takes them out of individual existence into a sacred space that transcends consciousness and time. The epileptic is "savage," and both are "blind," but blindness here does not refer to knowledge or ignorance but rather the objectivity of the will that constitutes their motions. Schopenhauer defines

grace as consisting in "the pure, adequate expression of its intention, or of the act of will, without any superfluity" (289). Just as the Ricketts' preparation of breakfast is a "grave dance" (74), so the widow and epileptic's simple, graceful, blind procession through the church reveals a hidden impulse working through their bodies, as, in tune with the will, they literally incarnate its rhythms and mysteries without attempting to understand or explain them.

Similarly, in a description of the Gudgers' bedroom, Agee calls attention to the "bureau, squared on a corner, and its blind mirror receiving, reflecting, the blindness of the bed" (70). On a literal level, the mirror is "blind" because the room is dark, so darkness is all it can see. However, Agee uses "blind" in an identical way when describing the outside of the Gudgers' house, as he raises his eyes, "slowly, in face of this strength of sun, to look the house in its blind face" (117). Again, on one level, Agee is confronting the "blind face" of the house in order to emphasize its sheer materiality: he wants to see it—blindly—as it is in the full light of its physical presence without any preconceptions or conceptual biases. However, the blind mirror, the blind bed, and the blind house are also all blind in the sense that they, like the graceful widow and epileptic in their ritual movements, are phenomenal products of the blind force that produces them, the will. In his discussion of the way that the will manifests itself in the natural world, Schopenhauer writes, "The bird of a year old has no idea of the eggs for which it builds a nest; the young spider has no idea of the prey for which it spins a web."[17] While such "blind activity"[18] may be accompanied by a type of knowledge, it is not guided by it, he continues, and then extends the argument to human beings: "the house of the snail is no more made by a will which is foreign to the snail itself, than the house which we build is produced through another will than our own; but we shall recognise in both houses the work of a will which objectifies itself in both the phenomena."[19] While human beings are certainly more complex in understanding, motivation, and manipulation of the physical world than snails, Schopenhauer's point is that the same blind force that creates beauty and symmetry in nature according to the forms through which it operates also creates beauty and symmetry in art through man and his particular form of objectivity.

The mirror in the Gudgers' bedroom reflects both its blindness and Agee's, which are one in the same.

In fact, Agee expresses this idea in almost identical terms in "Shelter": "Or the farm is also as a water spider whose feet print but do not break the gliding water membrane: it is thus delicately and briefly that, in its fields and structures, it sustains its entity upon the blind breadth and steady heave of nature" (108). Almost breathing, the house and its "fields are organic of the whole, and of their own nature, and of the work that is poured into them: the spring, the garden, the outbuildings, are organic to the house itself" (108). The farm emerges in the same way that a spider spins a web or crosses a stream: organically and with an internal, necessary logic that is shaped by local stimuli but is nonetheless in its most basic sense a blind expression of the will. Or, as Agee writes: "the Beethoven piano concerto #4 *IS* importantly, among other things, a 'blind' work of 'nature,' of the world and of the human race; and the partition wall of the Gudgers' front bedroom *IS* importantly, among other things, a great tragic poem" (165).

For Schopenhauer, music is the most perfect form of art; unlike painting or literature, it does not copy the phenomenal world but is, rather, "*a copy of the will itself.*"[20] In *Famous Men*, Agee seems to share this assumption and attempts to transcend the limitations of the written word by giving his work "a form and set of tones rather less like those of narrative than like those of music" (197), which he equates, like Schopenhauer, with the highest form of knowledge, betraying a "more than reasonable suspicion that there is at all times further music involved there, beyond the simple equipment of our senses and their powers of reflection and deduction to apprehend" (185). In an admittedly imperfect analogy, Schopenhauer suggests that bass tones correspond to "unorganised nature, the mass of the planet"[21] and the high voice singing the melody to "the highest grade of the objectification of will, the intellectual life and effort of man,"[22] with the intervals between representing various gradations of existence that together create the harmony of the whole. Agee deals with a range of musical styles in a similar fashion, identifying primarily African American genres such as jazz, blues, and spirituals with the bass notes—"But here it was entirely instinctual; it tore itself like a dance of sped plants out of three young men who stood sunk to their

throats in land, and whose eyes were neither shut nor looking at anything" (26)—and classical music with the melody: "the simple roaring of all souls for joy before God, as I have seen occur a few times when Beethoven through Toscanini has imparted his full mind (he who truly hears my music can never know sorrow again)" (319).

The most important connection between Agee and Schopenhauer in their treatment of music, though, is the relation between aesthetic and ethical awareness. Aesthetic perception in its purest form is a loss of individuality; for Schopenhauer, the mind in apprehending the ideal object is one with it, and both are mirror images of the will that knows and is known. Having pierced the veil of Maya, the illusion of individual consciousness, the mind sees that the Golden Rule is less a maxim suggesting a certain behavior than it is a description of basic reality: one cannot do unto others as others but only as oneself. As a consequence, "According to the true nature of things," Schopenhauer writes, "everyone has all the suffering of the world as his own," and even "a happy life in time, the gift of chance or won by prudence, amid the sorrows of innumerable others, is only the dream of a beggar in which he is a king, but from which he must awake and learn from experience that only a fleeting illusion had separated him from the suffering of his life."[23] For Schopenhauer, compassion is the capacity to experience another's pain; each individual, seen in his relation to the will as a phenomenal part that manifests the whole, bears the suffering, pain, and guilt of the world. This recognition of shared suffering is the foundation of morality and is central to Agee's strategy in *Famous Men* to "perceive simply the cruel radiance of what is" (10).

In the "Work" chapter Agee calls attention to the photograph of Allie Mae Burroughs and emphasizes that, although she is "a single, unrepeatable, holy individual," among "the two billion human creatures who are alive upon the planet today . . . the huge swarm and majority are made and acted upon as she is" (261). He urges the reader, who is presumably among those drawn into the "complications of specialized anguish" generated by aesthetic and moral awareness, to "contemplate, try to encompass, the one annihilating chord" (261) that reveals individuality to be an illusion. Similarly, in the "Preamble," Agee instructs the reader as follows:

> Get a radio or a phonograph capable of the most extreme
> loudness possible, and sit down to listen to a performance
> of Beethoven's Seventh Symphony or of Schubert's C-Major
> Symphony. But I don't mean just sit down and listen. I mean
> this: Turn it on as loud as you can get it. Then get down on the
> floor and jam your ear as close into the loudspeaker as you can
> get it and stay there, breathing as lightly as possible, and not
> moving, and neither eating nor smoking nor drinking. Con-
> centrate everything you can into your hearing and into your
> body. You won't hear it nicely. If it hurts you, be glad of it. As
> near as you will ever get, you are inside the music; not only in-
> side it, you are it; your body is no longer your shape and sub-
> stance, it is the shape and substance of the music. (13)

In encouraging the reader/listener to become "the shape and substance" of the music, Agee is restating Schopenhauer's idea that aesthetic perception entails a loss of individuality as the subject and object of knowing become one; that it is painful emphasizes that what is being perceived is not the phenomenal object but the will itself. Agee continues: "Is what you hear pretty? or beautiful? or legal? or acceptable in polite or any other society? It is beyond any calculation savage and danger-ous and murderous to all equilibrium in human life as human life is; and nothing can equal the rape it does on all that death; nothing except anything, anything in existence or dream, perceived anywhere remotely toward its true dimension" (13–14). Or, as he asserts in an even more anguished passage: the "most sanguine hope of godhead is in a billionate choiring and drone of pain of generations upon generations unceasingly crucified" (84). Agee's objective in *Famous Men* is to make the reader "feel what wretches feel" (xiii): the book is supposed to hurt.

Book VII of *The Prelude* begins with a "quire of redbreasts" (24) per-forming "the most gentle music of the year" (29) and Wordsworth, re-turning to the poem after a long silence, promising to "chaunt together" (37) with them. In the swarming, congested streets of London, though, this gentle music is replaced by a demonic cacophony, as he finds him-self thrust into a "hell / For eyes and ears" (659–60), a "din / Barbarian

and infernal" (660–61) populated by "buffoons against buffoons / Grim-acing, writhing, screaming" (672–73). Only when he escapes to the mountains at the end of the book can he once again find peace within Nature's "Composure and ennobling harmony" (741). In his reformulation of *The Prelude*, Agee also appeals to the transcendent qualities of music but more than Wordsworth recognizes that the desire to transcend the pain of the world inseparable from the pain itself. In the "Notes and Appendices" to *Famous Men*, Agee reproduces part of a newspaper clipping that reads as follows:

> BEETHOVEN SONATA
> HELD NO DISTURBANCE
> San Francisco, Dec. 6 (A. P.).
> — 'Beethoven,' said Judge
> Herbert Kaufman, 'cannot dis-
> turb the peace.'
> So he freed Rudolph Ramat,
> 69 years old and blind, of a
> charge of disturbing the peace by
> playing his accordion on Market
> Street.
> Your honor,' Ramat pleaded
> yesterday, 'I have worked . . . (365)

As a counterpart to Wordsworth's blind beggar, Agee offers Rudolph Ramat, a blind accordion player who was apparently arrested for playing in public. The rest of the short article, which Agee omits, completes Ramat's statement and provides a bit more detail: "'I have worked all my life. I don't want any pension. I play my accordion, maybe not well, but only the classics. Listen.' And he played Beethoven's 'Moonlight Sonata' for the judge."[24] While the "fixèd face and sightless eyes" (622) of the blind beggar serve as a rebuke to Wordsworth and his poetic project, admonishing him that "the utmost that we know / Both of ourselves and of the universe" (619–20) is nothing more than the "label" (618) we affix to them, Agee's blind musician not only speaks for himself but makes his

most eloquent argument without words, allowing the *Moonlight Sonata* to speak for and through him. Rather than being admonished by Ramat, Agee identifies with him, seeing in Ramat's literal blindness an analogue to his own and asking no more than to be heard. The judge asserts that Beethoven "cannot disturb the peace," but Agee knows that Beethoven is "savage and dangerous and murderous to all equilibrium in human life" (13): disturbing the peace is the point. Agee is not appealing to a temporal judge like Herbert Kaufman, however, but what Schopenhauer calls "eternal justice,"[25] the idea that the will both creates and experiences all the misery and suffering in the world, resulting in a type of perfect retributive justice: "The inflicter of suffering and the sufferer are one."[26] Trapped in the illusion of individuality, the will "buries its teeth in its own flesh, not knowing that it always injures only itself";[27] transcending this illusion is the first step towards sympathy, the ability to understand another's suffering as one's own. While Wordsworth's blind beggar is emblematic of the isolation of individual consciousness, the brief account of Agee's blind musician hints at mercy, identification, and transcendence of self through aesthetic perception. "To be cured of this illusion and deception of Maya," Schopenhauer writes, "and to do works of love, are one and the same."[28]

In his introduction to *Many Are Called*, Walker Evans's book of subway photographs, Agee writes that the strength of the photographs is that, since Evans used a concealed camera, his subjects are unaware that they are being observed and have therefore dropped the masks they usually wear to conceal their faces not only from others but also themselves. "Only in sleep (and not fully there)," he writes, "or only in certain waking moments of suspension, of quiet, of solitude, are these guards down; and these moments are only rarely to be seen by the person himself, or by any other human being."[29] As an example, he cites the final scene of Charlie Chaplin's *City Lights*, in which the Little Tramp, "gently gnashing apart the petals of his flower, his soul, his offering . . . perceives, in the scarcely pitying horror of the blind girl to whom he has given sight, himself as he is."[30] Although Wordsworth's beggar cannot look back, he nevertheless, like the flower girl, forces the poet to gaze into himself. For Agee, to see the families and individuals depicted in *Famous Men* as more than

abstractions requires a viewer similarly willing to look at himself with "scarcely pitying horror," to see himself as he sees them. Only then can he realize that the "effort in human actuality" that constitutes *Let Us Now Praise Famous Men* is one "in which the reader is no less centrally involved than the authors and those of whom they tell" (ix).

NOTES

1. Although Wordsworth lived in London in 1791, the poem does not follow a strict chronology and includes experiences from as late as 1802.

2. Wordsworth, William, *The Prelude: 1799, 1805, 1850*, ed. Jonathan Wordsworth, M. H. Abrams, and Stephen Gill (New York: Norton, 1979). All quotations from *The Prelude* are from Book VII of the 1805 edition of the poem and are cited parenthetically by line number in the text.

3. James Agee, *Letters of James Agee to Father Flye*, 2nd ed. (Boston: Houghton Mifflin, 1971) 55.

4. See "Outline and Possible Introduction to Agee's Massive Autobiographical Project and the Place of 'This book' in It" in James Agee, *A Death in the Family: A Restoration of the Author's Text*, ed. Michael A. Lofaro (Knoxville: U of Tennessee P, 2007) 579–80.

5. James Agee and Walker Evans, Let Us Now Praise Famous Men: *An Annotated Edition of the James Agee–Walker Evans Classic, with Supplementary Manuscripts*, ed. Hugh Davis, vol. 3 of *The Works of James Agee*, gen. eds. Michael A. Lofaro and Hugh Davis (Knoxville: U of Tennessee P, 2015). Subsequent references to this edition will be noted parenthetically in the text, and abbreviated in the notes as Davis, *LUNPFM*.

6. Nicholas Rescher, *Ignorance: On the Wider Implications of Deficient Knowledge* (Pittsburgh: U of Pittsburgh P, 2009) 48.

7. Rescher 48.

8. Rescher 31.

9. Rescher 55.

10. Rescher 53.

11. John Hersey, introduction, *Let Us Now Praise Famous Men*, by James Agee and Walker Evans (Boston: Houghton Mifflin, 1988) xxxix.

12. An allusion to Ralph Waldo Emerson's metaphor of the "transparent eyeball" in his essay "Nature," which, like the Whitmanesque catalogs in *Famous Men*, underscores the fundamentally Romantic sensibility of the work.

13. Arthur Schopenhauer, *The World as Will and Representation*, trans. R. B. Haldane and J. Kemp (London: Kegan Paul, 1909) 143.

14. Schopenhauer 231.

15. Schopenhauer 233.

16. Schopenhauer 240.

17. Schopenhauer 148.

18. Schopenhauer 148.

19. Schopenhauer 148.

20. Schopenhauer 333.

21. Schopenhauer 333.

22. Schopenhauer 335.

23. Schopenhauer 456.

24. "Beethoven Sonata Held No Disturbance," *New York Sun* 6 Dec. 1938: 21.

25. Schopenhauer 452.

26. Schopenhauer 457.

27. Schopenhauer 457.

28. Schopenhauer 482.

29. James Agee, introduction, *Many Are Called*, by Walker Evans (New Haven: Yale UP, 2004) 16. Although they were not published until 1966, Evans took the subway photographs between February 1938 and January 1941, and Agee wrote the introduction in October 1940. In other words, this project coincided exactly with Agee's completion of *Let Us Now Praise Famous Men*, which was published in August 1941.

30. Agee, introduction, *Many Are Called* 16.

Agee, Dostoevsky, and the Anatomy of Suffering

Brent Walter Cline

In his 1960 remembrance of James Agee, Walker Evans states of his friend and co-spy, "After a while, in a round-about way, you discovered that, to him, human beings were at least possibly immortal and literally sacred souls."[1] As a declarative statement it is remarkably qualified, as Evans must say that only an interrogation over time would lead to a mitigated belief that Agee believed people were in anyway divine. The indeterminacy inherent in both Evans's statement as well as Agee's own shifting beliefs is repeated consistently by biographers and critics. All that might be definitively said is that in an era when writers such as T. S. Eliot, W. H. Auden, and Robert Lowell converted or returned to High Church Anglicanism, James Agee—despite the similar spiritual and political wrestling he endured—clearly never returned to a formal Christian faith.[2] In a 1949 letter to Father James Flye, Agee sounds every bit the deist or agnostic: "[God] does not interfere with the Laws of Nature (which as their Creator He gave autonomy), or with the human laws of creation or self-destruction."[3] At the same time, *Let Us Now Praise Famous Men* is roundly understood to be a book with religious vision; David Madden writes, "In Alabama, everything was runic to Agee, iconic," and George Brown Tyndall states that Agee writes in the posture of "an Old Testament Prophet."[4] Seemingly, the most precise one can be of Agee's spiritual life is that he is an admirer, critic, and skeptic of Christianity.

While there is little benefit in giving Agee a religious label in order to understand his literary context, more can be said of how religious thought influenced him, specifically in the writing of *Famous Men*. In Agee's same lists that found Christ with William Blake and Charlie

Chaplin, another common name is Fyodor Dostoevsky (e.g., "Jesus, Dostoevsky, Blake, / Weeping Child and Bestial eye" and "Christ: Blake: Dostoyevsky: Brady's photographs: everybody's letters; family albums" in *Famous Men*).[5] Laurence Bergreen writes that discovering Dostoevsky at Harvard gave Agee "another artist-hero worthy to join Blake and Beethoven."[6] Despite his religious shifts, Agee never became interested in Dostoevsky's Eastern Orthodox faith, and as a writer never seems to have been particularly influenced by Dostoevsky's dramatic prose. Whether by accident or intention, however, Agee does share some of Dostoevsky's same metaphysical concerns in his writing.

In a text like *Famous Men*, Agee's affection for the tenant families echoes Dostoevsky's love for the Russian peasant. Neither writer feels the poor must overcome their weakness through reform or charitable acts of pity; rather, the divinity of the poor is *because* of their weakness, and the strong who observe it do well to share the passion rather than alleviate it. Just as the Eucharist of Agee's youth is made from the most ordinary of items without those items losing their identity, so Agee shows the tenant farmers in their suffering as divine examples of beauty, yet importantly without their suffering becoming a romanticized victimhood that readers can fetishize. Ultimately, Agee repeats Dostoevsky's idea that suffering is not something to be avoided, or, in Agee's cultural case, to be reformed. Instead, suffering offers the possibility of redemption in so far as that can *ever* occur in Agee's ideology, whether it be through one's own suffering or the voluntary sharing of another's suffering. None of this need suggest that Agee actively imitated Dostoevsky's understanding of suffering; rather, by placing Agee's concern with the tenant families within the shadow of Dostoevsky's concern with the myriad of suffering Russians of whom he wrote, we can uncover new, more precise meanings about Agee's intent of displaying the "normal predicaments of human divinity" (viii).

The Conditions of Suffering

During his Siberian imprisonment for involvement in revolutionary politics, Dostoevsky found himself disgusted by the criminals who surrounded him. He seemed to have more in common with the Polish pris-

oners, who saw themselves as better than the drunken, violent peasants of the prison. During Easter week, Dostoevsky was particularly disgusted by the criminals and fled their company in the barracks, passing by a Polish noble who, in solidarity with the writer, expressed his hatred of the men. When Dostoevsky returned to the barracks, however, he began to reminisce about an encounter with a peasant when he was only a child. The peasant rescued him from a paralyzing fear of being attacked by a wolf and carried Dostoevsky safely home. With an Agee-like tenderness in recalling the experience, Dostoevsky writes in *A Writer's Diary*, "Our encounter was solitary, in an open field, and only God, perhaps, looking down saw what deep and enlightened human feeling and what delicate, almost feminine tenderness could fill the heart of a coarse, bestially ignorant Russian serf who at the time did not expect or even dream of his freedom."[7] The memory turns Dostoevsky away from hatred for the poor criminals, causing him to eventually pity the Poles who had no access to the potential beauty of the Russian peasant. Such a recollection captures Dostoevsky's complicated relationship with the Russian poor. Dostoevsky's experience with prison did not allow him to fetishize the poor into angelic beings incapable of wickedness, but he nevertheless retained an influential belief that the poor were closer to salvation, and closer to bringing Russia to its salvation: "[I]t is we who ought to bow down before the People and wait for everything from them, both ideas and the form of those ideas; we must bow down before the People's truth and acknowledge it as the truth."[8]

The belief that the poor were somehow closer to God and a true Russian spirit did not preclude Dostoevsky from a desire to alleviate their physical suffering. While perhaps most famous for his intellectual characters who destroy themselves in nihilism and godlessness, Dostoevsky consistently drew attention to the social plight of the poor in his works. For instance, the pathetic Marmeladov family from *Crime and Punishment* are a holdover from Dostoevsky's original idea about writing a novel called *The Drunkards*, which decried the social conditions of urban poverty.[9] In *The Brothers Karamazov*, it is the Snegiryov family, too poor to care properly for their dying son, that draws the heroic Alyosha Karamazov away from his family's debauchery and into a beatific role with the town's children. Even his villains cannot

ignore the physical conditions of the poor, as Dostoevsky's most famous intellectuals like Rodion Raskolnikov and Ivan Karamazov are self-proclaimed reformers who profess theories on how to create a more just society.

The inherent tension between Dostoevsky's concern for the physical suffering of the poor, as well as his belief that poverty provides a closeness to God, is perhaps best revealed through two moments in *The Brothers Karamazov*. When Ivan Karamazov, sounding like Agee in his skepticism of faith, interrogates his brother Alyosha's religious beliefs, he rejects any explanation that might make an unjust world part of a divine scheme. To claim that the pain and suffering of this life somehow creates the proper recipe for eternal harmony is repulsive to Ivan, and he uses the lives of children to make his point:

> Listen: if everyone must suffer, in order to buy eternal harmony with their suffering, pray tell me what have children got to do with it? It's quite incomprehensible why they should have to suffer, and why they should buy harmony with their suffering. Why do they get thrown on the pile, to manure someone's future harmony with themselves?[10]

Ivan's answer comes not from his brother but ultimately from the recollected homilies of his brother's mentor, Zosima, elder of the local monastery. In his final words before death, Zosima states, "If the wickedness of people arouses indignation and insurmountable grief in you, to the point that you desire to revenge yourself upon the wicked, fear that feeling most of all; go at once and seek torments for yourself, as if you yourself were guilty of their wickedness. Take these torments upon yourself and suffer them, and your heart will be eased."[11] Ivan's understanding of suffering emerges from a materialist philosophy: he cannot accept a God or afterlife; therefore, suffering can have no more meaning than the physical pain that it causes. If fairness is the only judge, then suffering must only occur to those who are guilty. Zosima's response is the exact opposite as suffering is not a product of guilt. Instead, it is the object of pursuit because suffering is how one communes with others, as well as

a God who voluntarily chose to suffer. Suffering in Zosima's paradigm is something that should bind the judge to the penitent; it assumes all judges are involved in the sins of the criminals, and the shared fate unites them together with the divine. Zosima has no real answer as to how to eliminate physical suffering. While we witness him attempting to comfort the suffering within the monastery, he is no social reformer or miracle healer. Instead, he simply gives a response to the suffering that already exists.

This response of communion between those who suffer and those who do not is the exact opposite of the reformers who populate Dostoevsky's novels. Whether they be clowns like Lebeziatnikov in *Crime and Punishment* or virtually satanic like Pyotr Verkhovensky in *Demons*, Dostoevsky's reformers express ostensible outrage for suffering but, by viewing it only as a physical condition, find little need (or sincere desire) to live with those who suffer. Their collected failure occurs not because Dostoevsky fetishizes physical suffering or is an apologist for tsarist policies, but because these reformers isolate themselves in materialist philosophy and self-love, all the while believing in their own magnanimity toward the poor. These reformers fail because they "are often involved in solipsistic isolation, they are compelled to create some 'other' to which they can relate on an intellectual level . . . when the 'I' does not know how to look, then it creates a fictitious other with which to relate, an intellectualized other, and not a truly human other."[12] If not freed from their intellectualizing of suffering, they are lost to meaningless breakdown or suicide, leaving the poor, as Agee writes, to "be betrayed at the hands of such 'reformers'" (168). Despite their abandonment, however, the poor encounter true suffering in both its physical manifestation and metaphysical possibility, and through it respond to others with a unifying compassion that leads to redemption. It is precisely this belief that provides the memory of a wretched peasant carrying a child home the power to convert hatred of prison criminals into renewal and abiding love.

While hardly sharing Dostoevsky's religious or political beliefs, Agee shares both a concern for the physical conditions that create suffering, as well as an utter disdain for the distant reformers whom he sees as

more likely to consume than aid the poor. When Agee first receives the assignment to travel to Alabama to research the tenant life, he wants to get in contact with an Alabama communist party organizer.[13] He declares himself a Communist (among other things) in the book and is consistently outraged at the conditions of the families, to the point that he cannot imagine why schools would hope to educate children. As he reasons, "One could hardly say that any further knowledge or consciousness is at all to their use or advantage, since there is nothing to read, no reason to write, and no recourse against being cheated" (239).[14] While readers may suspect Agee of aestheticizing the tenant farmers, no serious reader of *Famous Men* can suggest that the tenant system and the poverty it creates is anything but despicable, to the point that the poor are born into nothing but slavery: "[T]his creature, the motive even of his creation, is sprung, is sprained, is slaved and ordered by a crimesoaked world: for he is made for work, for a misuser, not his own even illusive master nor even mere slave of his parents or a healthful state, but of misuse without which he shall not live at all" (239).[15] Like Dostoevsky, Agee's problem with reformers, these "rapid marchers in the human vanguard" (174), represented most clearly in the documentary work of Margaret Bourke-White, is not based in reform itself, but the utter false pretense that reform efforts entail.[16] Tenant families must remain individuals when represented, not converted into a sentimental commodity packaged for the mass culture consumer.[17] Thus, Bourke-White is sarcastically described as a woman who dresses like Hepburn and who "commands quite a few dollars" (366). She is defined by her distance, whereas Agee hopes to define his work through intimacy, to show that "it is my business to reproduce [George Gudger] as the human being he is; not just to amalgamate him into some invented, literary imitation of a human being" (194).

While Agee's abhorrence of (especially northern) reform movements does not keep him from pointing out the injustice of the tenant system, he nevertheless is unable to see the suffering of the rural poor strictly in material victimhood.[18] This is, after all, a man who even during his "revolutionary phase" of writing proletarian poetry cannot leave the language of his religious upbringing.[19] He may claim to be a Communist,

but he cannot quote in the opening epigraph Marx's cry for the workers of the world to unite without the enigmatic footnote: "[These words] mean, not what the reader may care to think they mean, but what they say" (xiii). In an unused chapter of the book, Agee recognizes his weakness of adopting the reformist politics of whom he is nearest: "I began to despise myself over the degree to which I align to whatever personality I am involved with" (711). Yet while this indeterminacy need not create doubt about Agee's desire for reform in the tenant system, we can also be sure Agee views the suffering of the tenant families akin to Zosima's charge: "Take these torments upon yourself and suffer them, and your heart will be eased." It is not our present concern whether Agee's religious beliefs were canonical Christianity or a "radically Gnostic theology that . . . undermined and supplanted the traditional Christian conception of divine authority."[20] Agee clearly is more Ivan than Zosima when it comes to a belief in God or an afterlife. Nevertheless, *Famous Men*, like Dostoevsky's works, presents the suffering of the poor as more than a political or social demand for reform; it is the opportunity and means for redemption.

Redemption through Suffering

In writing about Dostoevsky and Agee's comparative faiths, Jeffrey Folks writes, "Agee's tenant families are presented in spiritual terms as embodiments of holiness. Yet this apparent similarity only attests to how different were Agee's and Dostoevsky's conceptions of the sacred."[21] To claim that they both believe that suffering can lead to redemption is not to suggest that redemption means the same to both men. Dostoevsky's version would expectedly be more consistent with traditional Christianity, involving doctrinal points such as resurrection and eternal reward. Agee's is more difficult to assign a name, but one that is no less associated with the holiness and dignity involved in Dostoevsky's understanding of personhood. In his reading of Annie Mae Gudger in *Famous Men*, Jeffrey Folks calls her depiction "of a strongly mystical and metaphysical nature."[22] So too is Agee's understanding of redemption, so that an "independent inquiry into certain normal predicaments of human divinity" is a matter of belief rather than poetic license. [citation]

Perhaps the most recognizable of Dostoevsky's isolated, rationalistic characters in need of redemption is *Crime and Punishment*'s Raskolnikov, whose half-believed theories of righteousness and reform leave him guilty of a double murder. His redemption does not come with legal retribution, but with an embrace of suffering at the prodding of the prostitute Sonya: "Accept suffering and redeem yourself by it, that's what you must do."[23] And of course, this is what Raskolnikov ultimately does, not only confessing his crime to police but also bowing at the crossroads, kissing the earth, and declaring to the world that he is a murderer, so that eventually everything "softened in him all at once, and the tears flowed."[24] His theories of being a superman above morality begin to dissolve in the embrace of his suffering.

Of course, for all his fame, Raskolnikov is as problematic as he is helpful when considering suffering in *Famous Men*, as he is indeed guilty of a crime; he is not a victim of poverty or condescension, but a conscious agent of destruction. This is why Sonya herself stands as the real emblem of suffering in *Crime and Punishment* (for present purposes), as she takes on suffering that is in no way connected to justice, and yet is able to create a new Raskolnikov, who is, as one critic notes, "resurrected through a synthesis of his latent idealism, his intelligence and vigour, and the experience of suffering seen through the eyes of Sonya."[25] It is a choice that Raskolnikov initially cannot fathom, and he consistently mocks her for her feebleness, irrationality, and piety: "And what does God do for you in return?"[26] She is, after all, a prostitute due to a drunk father she enduringly loves, a punching bag for her grieving stepmother, and ultimately a geographic and social outcast for Raskolnikov, who she follows to Siberia in order to aid his redemption. And Sonya is hardly the only one, as those who suffer in the book are consistently connected with redemption. Even those who masochistically seek out undue suffering are treated with dignity. A painter, part of a schismatic religious group in Orthodox Russia, confesses to the murder of the pawnbroker even though he is innocent. The chief investigator hunting Raskolnikov, Porfiry Petrovich, considers such an action dignified, if not justified: "Do you know, Rodion Romanych, what suffering means for some of them? Not for the sake of someone, but simply the need for suffering

. . . I do know—don't laugh at this—that there is an idea in suffering. Mikolka is right."[27] Even Dostoevsky understood this kind of frenzied desire for suffering is nothing if not beatific.[28] Raskolnikov is called to suffer in order to be saved, and such a demand is verified by the beatific life of someone like Sonya and recognized by Raskolnikov's intellectual better, Porfiry Petrovich.

In *Famous Men*, the connection between suffering and redemption begins early in the work, when Agee attempts to rhetorically imagine the isolation of the tenant families. With the haunting refrain of "How were we caught?" Agee creates a litany of personal failures in the voice of Annie Mae Gudger that is then punctuated by a perhaps subconscious hope that "it will be different from what we see, for we will be happy and love each other," only to return to the bleakness of "[t]he children are not the way it seemed they might be" (68). When Agee repeats the final refrain of "How were we caught?" he immediately moves into the beatitudes from the Sermon on the Mount. The juxtaposition might be read as ironic against Jesus's most famous words, but too often in Agee's works does he commend Jesus as prophet and poet. It is not irony, here; instead, it is the bold declaration to the reader, whom Agee has already begged to participate in the work, that here are the very people mentioned in the Sermon on the Mount. It is not simply myth or poetry. It is prophecy, and Agee has shown that the litany of sufferings in the life of Annie Mae is the same as the litany of blessings in the beatitudes.

Whatever Agee's religious beliefs actually were, the language of his upbringing allows him the articulation to show that the tenant life, rudimentary as it may be, nevertheless expresses the full divinity inherent within all humans. This tenet is perhaps most explicit when he explains the breakfast routine of the Gudgers through the language of the sacrament of communion. Agee writes that the early morning mass is one of beauty for him, especially at the point of the Eucharist: "[W]ords were thrilling brooks of music and whose motions, a rave dance: and there between spread hands the body and the blood of Christ was created among words and lifted before God" (74). The communion is fulfilled when two participants of compromised positions, a "serene widow and a savage epileptic," approach the altar. Within the same paragraph, Agee

moves us out of the past church at dawn and into the present clay hills of Alabama where he describes a wife and mother, implicitly Annie Mae Gudger, preparing not the Eucharist, but an ordinary breakfast: "the biscuits tan, the eggs ready, the coffee ready, the meat ready, the breakfast ready." Instead of water and wine forming the body and blood of Christ, "the flour is sifted . . . and mixed with lard and water, soda, and a little salt." Instead of feeding the flock of the church, the flock of the family is fed. The connection is that the sacramental act of consuming Christ is the same as the ordinary breakfast meal of the tenant farmer. The holy church is the holy tenant family, both as priest as well as parishioner. If Annie Mae Gudger is sanctifying the daily routine, then her family is the physically compromised widow and epileptic who partake. This act of eating a communion-breakfast is explicitly associated with the misery of their days and not just their common humanity: "[O]n this food must be climbed the ardent and steep hill of the morning . . . so that your two halves are held together and erect by this food as by a huge tight buckle as big as the belly, giving no ease but chunk, stone, fund, of strength" (75). Breakfast is the Eucharist, and their lives the holy act of saints within their church, rhetorically equal to the traditional modes of redemption and sacrament that Dostoevsky would recognize and with which Agee began the passage.

What Agee attempts to create rhetorically between the Eucharist and the early breakfast before the oppressive work day is a meaning made more explicit in other parts of the text where he directly relates the suffering of the tenant families to the lives of the saints. In the same paragraph where Agee describes himself as a spy for cataloguing their lives, he writes that the beauty of the tenant home "is made between hurt but invincible nature and the plainest cruelties and needs of human existence in this uncured time, and is inextricable among these, and as impossible without them as a saint born in paradise" (112). When he describes the silence of the homes upon the work day's close, Agee states, "I feel that if I can by utter quietness succeed in not disturbing this silence . . . I can tell you anything within the realm of God, whatsoever it may be" (45). The lives of the tenant families, so consistently defined by their suffering in poverty, are simultaneously connected to the "realm

of God." When describing the homes of the tenant families, Agee states they "shin[e] quietly forth such grandeur, such sorrowful holiness of its exactitudes in existence, as no human consciousness shall ever rightly perceive, far less impart to another" (112). The grandeur of the homes, and in this Agee seems to mean the unflinching dignity of these homes, is described in explicitly religious language: the experience cannot be conveyed in language, and the very essence of the existence implies a kind of sorrow. The life itself, with all its surrounding squalor, does not simply provide impetus for holy thinking; the essence of the tenant families themselves, once again here clearly linked to sorrow and suffering, is necessarily holy. What Sonya Marmeladov knows Raskolnikov must submit to is what Agee suggests is fundamentally true about these tenant families: while the result of cruelty and injustice, their suffering nevertheless transforms them into divine, redeemed beings.

Redemption and Voluntary Co-Suffering

Of course, *Famous Men* is no less about the suffering of the poor tenant families than it is about the quasi-northern writer who has come from New York to act as spy and voyeur. Agee brings his own complex suffering to Alabama with him, but what respite he receives comes from his interaction with the tenant farmers rather than a cessation of physical or emotional conditions due to a change of environment. It is Agee's decision to live with the tenant farmers, to participate in their lives, that offers him the chance at redemption. This voluntary choice of co-suffering is the final aspect of Dostoevsky's view of suffering, what ultimately causes the judge and the penitent to be bound together in a compassionate unity that supersedes issues of guilt and circumstance.

Dostoevsky's *The Idiot* provides perhaps the most complete example of not only the redemptive quality of those who suffer, but also the divinity of those who consciously choose to share that suffering as well. In a story of an epileptic thrust into Petersburg's social elite, Prince Myshkin and his "holy fool" persona attempt to save the corrupted lives of those around him. This desire to save is most clearly seen in his relationship to Nastasya Filippovna, a former "kept woman" whose own

story of trauma leaves her ashamed and pursuing self-destruction in the form of the nihilist Rogozhin, who seeks to destroy her through his perverted love. Nastasya cannot accept the offer of selfless love by Myshkin and consistently chooses Rogozhin, who she fully knows will murder her; for Nastasya, this is what she feels is her just punishment. Myshkin, to counter this lack of self-worth, offers to marry Nastasya. Nastasya, however, simply cannot accept the prince's offer of compassion. Like Agee's worry of his influence on viewing the tenant families, Nastasya is convinced she will corrupt him: "You're not afraid, but I'd be afraid to ruin you and have you reproach me afterwards. . . . It's better this way, Prince, truly better, you'd start despising me tomorrow, and there'd be no happiness for us."[29] Myshkin's determined attempt to save Nastasya is an act understood only through Dostoevsky's view of suffering. Myshkin's attempt at marrying Nastasya is the perfect sacramental embodiment of this attachment to the one who suffers. Myshkin, who is both innocent and guileless, nevertheless knows that salvation for the oppressed Nastasya can only happen through shared suffering, as the Elder Zosima demands. Whether Nastasya "deserves" her suffering (as arguably Raskolnikov does) or whether her suffering is partially due to her own maimed view of her nature is irrelevant to Myshkin.

Myshkin's choice to share in Nastasya's suffering seemingly produces no immediately positive result. Rogozhin murders Nastasya, then subsequently has a nervous breakdown before his imprisonment. Rivers of ink have been spilled over Myshkin's response as he plays out Dostoevsky's own personal nightmare: his epilepsy devolves into permanent idiocy. The pessimists, if not the nihilists, seem to win. Michele Frucht Levy sees this final idiocy as the eradication of Myshkin's Quixote-like idealism in a "Marriage to the Abyss."[30] Sarah Young, in her work on the narrative structure of the novel, sees Myshkin's final state as a permanent oblivion, so that the nihilists' "nightmare vision replace[s] the prince's religious experience[.] . . . [T]he end of the novel is exceptionally bleak, pointing to the impossibility of sustaining the ideal of selfless love in human interactions."[31] If suffering can be considered redemptive, then it must also be considered a potential eradication, both of the original victim and those who would share the suffering.

Yet there is another reading of Myshkin's failure to save Nastasya, one that is consistent with his vaulted view of all those who suffer. Myshkin's consistent act in the novel is his attempt to convince Nastasya that she is an honest woman, capable and deserving of more than the "maimed life" that the men around her create for her. Throughout the novel the prince's vision of a saintly, divine Nastasya is what leads others to think him simple, idiotic, destructive, or "a little freak." His devotion to her is a kenotic act, emptying himself of pride, reputation, and opportunity. He certainly does not save Nastasya from death nor himself from cognitive breakdown, but Bakhtin has taught us how to regard deaths and failures in Dostoevsky's novels:

> [I]n Dostoevsky's world there are only murders, suicides, and insanity, that is, there are only death-acts, responsively conscious[.] . . . Dostoevsky does not acknowledge death as an organic process, as something happening to a person without the participation of his responsive consciousness. Personality does not die. . . . The person has departed, having spoken his word, but the word itself remains in the open-ended dialogue.[32]

Bakhtin knows that in the polyphony of Dostoevsky's novels, the immediate physical success of an act is less important than the "voice" that act lends to the entire text. In this case, Myshkin's decision, as a man who does not suffer, to share in the suffering of another does not lead him or Nastasya to a romantic ending; like Agee himself, his decision to co-suffer does not result in the termination of suffering. Myshkin's decision does, however, offer up the vision of ethical perfection. Myshkin himself is silenced, but his "word itself remains in the open-ended dialogue."

The Idiot best performs Dostoevsky's belief that suffering is redemptive and the sharing of that suffering is both a self- and other-oriented kind of salvation. *The Idiot* also displays the alternative, as best seen in the character Aglaya Epanchin, aristocrat daughter and potential bride of Myshkin. More than most in the novel, Aglaya understands why Myshkin is consistently devoted to the fallen Nastasya. Recognizing but

unable to perform what Myshkin does, Aglaya turns away from the redemption offered by uniting herself to one who suffers. Instead, she suffers a fate even worse than idiocy in Dostoevsky's mind: marriage to a Polish man. The wealth and status that a Polish count promises her is an illusion, and Aglaya ends having become "a member of some foreign committee for the restoration of Poland and on top of that had ended up in the Catholic confessional of some famous padre, who had taken possession of her mind to the point of frenzy."[33] This is Dostoevsky at his most glib, and while his ubiquitous derision of Poland is best discussed elsewhere, Aglaya's voice of self-interest becomes even more bleak and nihilistic than the broken physical status of Myshkin. Instead, Myshkin joins that cabal of Dostoevsky characters who have a full understanding of human divinity and its rooted nature in suffering.

Agee has little desire (or ability) to recognize himself as a "prince Christ" or holy fool, as Myshkin is regarded throughout *The Idiot*. While the author is therefore not the innocent rube that Myshkin is, he is nevertheless in the position of choosing to perceive suffering from a comfortable distance, or participate in solidarity with those who suffer. It is no mistake that integral to the makeup of the tenant families' suffering is isolation, and Agee's brief but direct encounter with them stands in contrast with the communities of which they are supposedly members. The tenant families stand apart as the white trash living on the wastelands of useless farm plots. Early in the work Agee takes on the voice of the collective community, stating, "George Gudger? Where'd you dig *him* up? I haven't been back out that road in twenty-five year. . . . Ivy Pritchert was one of the worst whores in this whole part of the country: only one that was worse was her own mother. They're about the lowest trash you can find . . ." (66). If the collective community despises them, the collective women of the three families are perfectly aware of this hatred, as their own collective voice states, first as daughter—"My mother made me the prettiest kind of a dress, all fresh for school; I wore it the first day and everyone laughed and poked fun at me . . ."—and then as mother—"Oh, thank God not one of you knows how everyone snickers at your father"(page). Even within families separation occurs: wives are resentful of their husbands, husbands look toward other women or

business ventures, and throughout the homes a lack of communication from the weight of poverty exists.[34] Therefore, if suffering in the family is an unavoidable reality, the presence of Agee and Evans as outsiders on a job assignment provides the important rhetorical position of voluntary co-suffering. The choice to share in the experience of the tenant families, as Myshkin longs to share in the experience of Nastasya, even for such a short amount of time, suggests that suffering is not only easier to endure when shared, but also arguably more important for the writer Agee, there is redemption for the voluntary participant in the suffering.

Perhaps the most important moment of showing the redemption of adopting another's suffering comes in an early moment when Annie Mae Gudger's sister Emma must leave Alabama to marry a man she clearly has no desire to wed. Emma is crushed, and the response of both Agee and Evans, men whose foreignness and power may make them consider that they can influence the situation, simply endure Emma's suffering with her. In one of the more emotional passages of the book, Emma states, as she says goodbye to Agee, "[Y]ou make us feel easy with you; we don't have to act any different[.] . . . [W]e don't have to worry what you're thinking about us, it's just like you was our own people and had always lived here with us" (55). Key here in Emma's language is the solidarity, the equality, she feels with Agee and Evans. Agee's response is an even greater desire to suffer for her: "[A]lways characteristic, I guess, of the seizure of the strongest love you can feel: pity, and the wish to die for a person, because there isn't anything you can do for them that is at all measureable to your love" (page). Agee can give no action toward Emma that equals his willingness, but he knows that he must maintain eye contact with her to maintain that equality, to show he is one of the them and not merely displaying pity for show or as a means of establishing dominance. Emma, of course, must go on out of Alabama to marry into what Agee assumes will be a horrifying marriage. The suffering cannot be resolved, but in this moment Agee, as a voluntary co-sufferer with Emma Woods, attains an intensely unifying, emotional connection that no means of external reform can create.

Emma's departure from the Gudgers is one of the few scenes in the work where something actually happens. The tenant families are

generally frozen in portraiture as in Evans's photographs; only rarely do we witness Agee interact with the families. This need not be a criticism, as Alan Spiegel describes: "Rather than view their presentation as a flaw in the author's technique, there is considerably more justice in learning to think of them—their rendering and effects—as the necessary results of a deliberate moral and artistic strategy."[35] It is nevertheless key to recognize that when Agee does interact with the families, whether at Emma's departure or during a late meal with the Gudgers, he is filled with a desire for unity that has its roots in the family's suffering. For instance, the preamble to Agee's first night with the Gudgers (though it occurs late in the book) involves an episode of self-consciousness and displacement in the author of and from every person he encounters. When driving through Alabama on a Sunday afternoon, he is inundated with loneliness and considers taking a homely prostitute just for some kind of companionship. Recognizing the spiritual lunacy of the act, Agee moves on to contemplate purposely killing himself in a car accident, echoing his father's death when he was still a child. Eventually, this car ride ends with a visit to the Ricketts and Gudger homes. He writes about his conversion by means of inclusion into the home, and although it lacks the religious connotation of Raskolnikov or Dmitri Karamazov, the reader still sees a young man overwhelmed by the beauty he sees in these tenant farmers and the desire to unite to them even in the midst of their suffering. Agee states, "[T]he music of what is happening is more richly scored than this; and much beyond what I can set down: I can only talk about it" (328). Agee eventually spends the evening with the Gudger family, writing, "[T]hat I was not crying for joy was only that there was so much still to watch, to hear, and to wonder before, while we stood on the front porch and talked, George saying, over and over, while we looked out upon the resplendent country, how good a season it had been" (329). This moment of connection to the oppressed is the closest *Famous Men* comes to an eternal divine; the moment is not saturated with religious language, but we understand it to be the spiritual answer to Agee's own malaise seen earlier in his drive. Agee is no dogmatic Christian and cannot go so far as to accept Dostoevsky's theology that makes claims to eternal reward for a person's divine participation in

others' suffering. Agee can, however, find an end to isolation and narcissism where beauty and communion with the newly-recognized holiness of the poor, the only rhetorical means of redemption, can be found.

This participation that Agee at least intermittently experiences with the tenant families is likewise consistently extended to the reader. *Famous Men* is not a book about a young man in dialogue with poverty; it is a triangular relationship that demands the reader participate as much as Agee himself could. From the outset of the work Agee includes the readers in the very problem of such a documentary work, writing, "Who are you who will read these words . . . and for what purpose, and by what right do you qualify to, and what will you do about it?" (8). Later, Agee reminds the reader of the unavoidable responsibility of completing the text that he began: "[I] leave to you much of the burden of realizing in each of them what I have wanted to make clear of them as a whole: how each is itself; and how each is a sharpener" (92). These admonitions to the reader are not a rhetorical attempt at generating interest, but the completion of an ethical demand for the reader to share the suffering that Agee himself admittedly cannot fully comprehend. That inability to truly participate in the tenant families' suffering must remain a burden to both Agee and reader, because to escape it is not simply to return to wealth and opulence, but to deny oneself redemption:

> And how is this to be made so real to you who read of it, that it
> will stand and stay in you as the deepest and most iron anguish
> and guilt of your existence that you are what you are, and that
> she is what she is, and that you cannot for one moment exchange
> places with her, nor by any such hope make expiation for what she
> has suffered at your hands, and for what you have gained at hers
> . . . not losing the knowledge that each is a single, unrepeatable,
> holy individual. (261)

Perhaps more frenzied than Dostoevsky's Zosima, this is nevertheless the monastic elder calling on all to suffer for the suffering of others, because all guilt is shared, and one must "[t]ake these torments upon yourself and suffer them." After Agee returns north from his time in

Alabama, he writes to Father Flye that, "the trip was very hard, and certainly one of the best things I've ever had happen to me."[36] Certainly one can understand the quote in less than metaphysical grounds; Agee, after all, writes virtually nothing else to his confidant about the project. Nevertheless, the seeds of recognizing the power of suffering are perhaps already present in Agee's immediate reaction to the experience, only to be publicly articulated in the publication of *Famous Men* five years later.

Conclusion

Famous Men is virtually bookended by two lengthy quotes from the Bible. The first, as previously discussed, is the beatitudes from the Sermon on the Mount; the second is from the Wisdom of Sirach, or Ecclesiasticus, which obviously gives the work its title. A reading of this oft-mentioned but rarely analyzed passage is fitting here, as it appropriately and directly reminds the reader of Dostoevsky's shadow cast on the text. The direct intent of Agee's use of the text is not clear, as according to Robert Fitzgerald, Agee had originally intended "Let Us Now Praise Famous Men" to be the title of an earlier short story.[37] The effect of the passage, however, is powerful in light of the text's understanding of suffering.

The passage is from chapter 44 of Ecclesiasticus, which begins a six-chapter catalog of godly figures from the Hebrew Bible, the very "famous men" we are called upon to praise. Agee only quotes the introduction of the praises, which can effectively be broken into three parts. The first is a prologue of the famous men to be named in later chapters as Moses, Joshua, Elijah, David, and others. Then, in what I term the second part, the author, Jesus ben Sirach, pauses to remind the reader that there were good men who have perished with all collective memory of them lost, "and are become as though they had never been born; and their children after them" (361). Agee clearly intends these words to reference the tenant families of the text, but allows the introduction to continue, which leads to the third part: a return to those names that *have* been remembered. The distinction is clear at the beginning of the

third part (Agee does not list the verses, but it is 10): "But these were merciful men, whose righteousness hath not been forgotten" (page). Clearly, Jesus ben Sirach is not speaking of those good men who have been wiped from history since the "merciful men" have not been forgotten. This quotation raises an important question: Why does Agee continue the passage, which quickly returns to the powerful men whose names are still known? Why not stop at the single verse, which does indeed praise those who have been forgotten? Like with the beatitudes at the beginning of the text, it is possible to read this passage ironically. Given how *Famous Men* treats the suffering of the poor and the power that participating in that suffering might bring, ironic distance does not seem to be the most effective reading. Instead, the addition of the third part of the introduction suggests that Agee is rewriting the original text. Cutting off the passage when Jesus ben Sirach begins to finally name the famous men, Agee suggests that these tenant farmers *are* the famous men who might rival those men of the Hebrew Bible who claimed witness to the divine presence. Granted, he uses pseudonyms to protect their real identities, but Agee writes new names into Jesus ben Sirach's list. They are indeed now famous, or as it is often translated, "godly," and it is not due to the cold distance of the reformer or the artist aestheticizing pain. Instead, these tenant farmers are now among the famous men that must be praised due to their suffering; and that praise, as the very title suggests, is done not only by Agee but also by all the readers. It is a conclusion that the materialist reformer Ivan Karamazov would reject, as he declares that he must have justice or he will destroy himself. It is, however, a conclusion remarkably similar to the Elder Zosima's belief that through suffering one is able to see that "all is God's truth, moving, reconciling, and all-forgiving."[38] Though Agee never accepted the metaphysical certainties of Dostoevsky's religious beliefs, he nevertheless portrays the redemption of suffering as a truth that all those who open the pages of *Let Us Now Praise Famous Men* are invited, if not demanded, to recognize.

NOTES

1. Walker Evans, "James Agee in 1936," *Remembering James Agee*, eds. David Madden and Jeffrey Folks, 2nd ed. (Athens: U of Georgia P, 1997) 99.

2. See Mark Doty's *Tell Me Who I Am* and Jeffrey Folks's chapter "Agee's Angelic Ethics," *Agee Agonistes: Essays on the Life, Legend, and Works of James Agee*, ed. Michael A. Lofaro (Knoxville: U of Tennessee P, 2007).

3. *Letters of James Agee to Father Flye* (New York: George Braziller, 1962) 177.

4. David Madden, "The Test of a First Rate Intelligence: Agee and the Cruel Radiance of What Is," *James Agee: Reconsiderations*, ed. Michael Lofaro (Knoxville: U of Tennessee P, 1994) 38. And George Brown Tindall, "The Lost World of Agee's *Let Us Now Praise Famous Men*," *James Agee: Reconsiderations* 24.

5. Michael A. Lofaro and Hugh Davis, eds., *James Agee Rediscovered: The Journals of* Let Us Now Praise Famous Men *and Other New Manuscripts* (Knoxville: U of Tennessee P, 2005) 298. James Agee and Walker Evans, Let Us Now Praise Famous Men: *An Annotated Edition of the James Agee-Walker Evans Classic, with Supplementary Manuscripts*, ed. Hugh Davis, vol. 3 of *The Works of James Agee*, gen. eds. Michael A. Lofaro and Hugh Davis (Knoxville: U of Tennessee P, 2015) 287. Subsequent references to this edition will be noted parenthetically in the text, and abbreviated in the notes as Davis, *LUNPFM*.

6. Laurence Bergreen, *James Agee: A Life* (New York: E. P. Dutton, 1984) 96.

7. Fyodor Dostoevsky, *A Writer's Diary, Volume 1: 1873–1876, trans. Kenneth Lantz (Evanston, IL: Northwestern UP, 1994) 355.*

8. *Writer's Diary* 349.

9. Joseph Frank, *Dostoevsky: A Writer in His Time* (Princeton, NJ: Princeton UP, 2009) 467.

10. Fyodor Dostoevsky, *The Brothers Karamazov, trans. Richard Pevear and Larissa Volokhonsky (New York: Farrar, Straus, and Giroux, 2002) 244.*

11. *Brothers Karamazov* 321.

12. Bruce A. French, *Dostoevsky's Idiot* (Evanston, IL: Northwestern UP, 2001) 168.

13. *James Agee Rediscovered* 18.

14. See also Agee's February 17 letter to Father Flye: "I'm pretty sure I'll never be [Communist], and there are things about it I despise. But there are things all through the world as it is that look to me bad, and there are many things in that set of ideas which look to me good; and I think more of them may conceivably succeed than we have any cynical right to think," *Letters of James Agee to Father Flye* 85.

15. Or a less poetic version: "[The tenant farmer] will have no money and can expect none, nor any help, from his landlord: and of having no money during the six midsummer weeks of laying by, he can be still more sure." *Letters of James Agee to Father Flye* 100.

16. Agee includes in *Famous Men* a *New York Post* review by May Cameron of Bourke-White's *You Have Seen Their Faces*, including the subheadline, "Margaret Bourke-White Finds Plenty of Time to Enjoy Life Along With Her Camera Work," Davis, *LUNPFM* 366.

17. Jeff Allred, *American Modernism and Depression Documentary* (Oxford: Oxford UP, 2010) 103.

18. An example of Agee's disdain for northern reform, from an unused chapter in *Famous Men*: "About three weeks before I had left town the Fall before I had joined a thing Smith was organizing called The Southern Workers Defense Committee. Its primary purpose was to raise money, and its secondary purpose was I suppose educational. Also I suppose it succeeded mildly well on both counts; I don't really know. The whole thing made me somewhat sick. It was made up too much of young women who liked to hear imported negroes tell how they had been beaten with tire chains and burned with matches and who got still another thrill out of pumping the hands of the negroes," Davis, *LUNPFM* 711.

19. Hugh Davis, *The Making of James Agee* (Knoxville: U of Tennessee P, 2008) 41–42.

20. Jeffrey Folks, "Agee's Angelic Ethics" 75.

21. Jeffrey J. Folks, "Agee and Dostoevsky: Two Writers Possessed," *The Heartland of the Imagination: Conservative Values in American Literature from Poe to O'Connor to Haruf* (Jefferson, NC: McFarland, 2012) 99.

22. Jeffrey J. Folks, "James Agee's Quest for Forgiveness in *Let Us Now Praise Famous Men*," *Southern Quarterly* 34 (1996): 47.

23. Fyodor Dostoevsky, *Crime and Punishment*, trans. Richard Pevear and Larissa Volokhonsky (New York: Vintage Books, 1992) 420.

24. *Crime and Punishment* 525.

25. Malcolm Jones, *Dostoevsky: The Novel of Discord* (London: Paul Elek Books, 1976) 86.

26. *Crime and Punishment* 324.

27. *Crime and Punishment* 455, 461.

28. Steven Cassedy writes, "The religious men [Dostoevsky] read of were interesting more for what they did than for what and how they believed. Humility and a capacity to suffer irrationally are the qualities that drew him." *Dostoevsky's Religion* (Stanford, CA: Stanford UP, 2005) 62.

29. Fyodor Dostoevsky, *The Idiot*, trans. Richard Pevear and Larissa Volokhonsky (New York: Vintage Books, 2001) 169, 170.

30. Michele Frucht Levy, "Trouble in Paradise: The Failure of Flawed Vision in Dostoevsky's *Idiot*," *South Central Review* 2 (1985): 58.

31. Sarah J. Young, *Dostoevsky's* Idiot *and the Ethical Foundations of Narrative* (London: Anthem Books, 2004) 121, 134.

32. Mikhail Bakhtin, *The Problems of Dostoevsky's Poetics*, trans. Caryl Emerson (Minneapolis: U of Minnesota P, 1984) 300.

33. *The Idiot* 614.

34. This should not go unnoted, as it is an example, as with Dostoevsky, that the suggestion of suffering's redemptive quality need not create a fetishizing of either poverty or suffering itself. Agee is willing to show his faults as a "spy," as he is willing to show the faults of the families themselves.

35. Alan Spiegel, *James Agee and the Legend of Himself: A Critical Study* (Columbia: U of Missouri P) 122.

36. *Letters of James Agee to Father Flye* 94.

37. Robert Fitzgerald, "A Memoir," *Remembering James Agee* 47.

38. *Brothers Karamazov* 292.

Let Us Now Praise Famous Men
Is the *Moby-Dick* of Nonfiction

David Madden

Many parallels are to be seen between Herman Melville's *Moby-Dick* and James Agee's *Let Us Now Praise Famous Men*.[1] Melville and Agee were myriad-minded "thought-divers" into reservoirs of facts and seas of symbols. Avowed American anti-philosophers, they were among the most philosophical of American writers. They brought ultra literary styles into the service of fact-purveying. They wrought epics out of the laboring lives of simple workers: whale hunters and tenant farmers. Their risky digressions were more compelling than their unfocused adventure and journalistic narratives.

In classes, in conversations, and in print, I have often, over many years, professed that *Let Us Now Praise Famous Men* is the *Moby-Dick* of nonfiction. In 1990 and 1992, I wrote briefly about parallels between Agee's book and Melville's.[2] Linda Martin-Wagner includes *Famous Men* and *Moby-Dick* in her list of "inexplicable and unpredictable American masterpieces."[3] In "Mapping Agee's Myriad Mind," I expressed my desire to study parallels between Agee's book and Melville's.[4] Searching the books by and about Agee for references to Melville, I found only one mention of Melville in the all the pages of Agee's journals of *Famous Men*. "I'm likely to talk a great deal about myself. Herman Melville and I used to call it using one's own sperm to prime one's pump."[5] In a tape-recorded letter, Agee told Father Flye that John Huston had asked him to adapt *Moby-Dick* in 1954. "I think it's the, outside of *Huckleberry Finn*, the most beautiful piece of writing that I know in American writing." But Agee chose to continue a different venture that failed.[6] I persuaded

Agee's widow Mia to contribute to *Remembering James Agee*. "John Huston came to town ready to get started on their long-planned project of *Moby-Dick*, a book both Huston and Jim had talked about doing together for years and that they both had special feelings for."[7] Very few mentions of Agee in regard to Melville appear in other books and, I speculate, articles. So comparisons between *Famous Men* and *Moby-Dick* arise out of my intuitive assumption, as a novelist, that they are there to be lifted up.

Explorations of similarities and contrasts among *Famous Men* and *Moby-Dick* illuminate both. Melville's autobiographical narrator, Ishmael, tells about the mythic Ahab and ordinary men living and working under the special circumstances of whale hunting. *Moby-Dick* could have been called *Let Us Now Praise Famous Men*. Ishmael's first-person narration is only a device; readers soon forget him as a fictional character (he is seldom more than a witness and often less than that). It is Herman Melville's own searching voice we follow into his oceanic encyclopedic consciousness. Melville's "Cetology" and "The Whiteness of the Whale" chapters exhibit the kind of narrative-commentary polarity that is characteristic of both books.

"I must excuse myself this apparent digression . . . [,]" says Agee (318).

In both books set pieces suddenly appear. Compare the purely technical, so-called digressions in both *Moby-Dick* and *Famous Men* with Agee's similar approaches to the sixty-some-odd inspired pieces he wrote for *Time* and *Fortune* as mere work for hire, on cockfighting, strawberries, food, glass, rain, half of which he published before he went down to Alabama. Both men had a published history of fascination with and facility in writing about common objects, esoteric and jejune. Here is Agee writing about orchids:

> A bee, lured among those lordly flora leaves, hikes his thighs
> around many unusual corners, departs woolly with pollen, and,
> falling for another labyrinthine love trap, leaves that yellow dust
> against the sexual organs of another orchid. Shortly the flower
> droops shut against any later invasion.[8]

And here is Melville in *Moby-Dick*:

> . . . [A]mbergris is soft, waxy, and so highly fragrant spicy, that
> is largely used in perfumery, in pastilles, precious candles, hair-
> powders, and pomatum. The Turks use it in cooking, and also
> carry it to Mecca. . . . Who would think, then, that such fine
> ladies, and gentlemen would regale themselves with an essence
> found in the inglorious bowels of a sick whale. [(408)]

The pulpit, forge, needle, life buoy, cabin table, masthead, the gam, the monkey rope, and the chart are among other interruptive narrative subjects in *Moby-Dick*. Money, shelter, clothing, education, work, houses, beds, shoes, and overalls are among other such subjects in *Famous Men*. "A new suit of overalls has among its beauties those of a blueprint: and they are a map of a working man" (216).

Both Melville's and Agee's books are meditations, but the subjects *per se* are of the historical facts, while their processes of meditation remain absorbing even as they deal out facts.

A simple comparison of one of the most famous opening and closing lines in American fiction—*Moby-Dick*'s "Call me Ishmael" and "And I only am escaped alone to tell thee"—with those in Melville's first five novels may suggest the polarities of the author's lifelong interests: the facts and meditation upon the facts. Melville's whaling novels deal with "desertion, captivity, beachcombing, and enlistment in the U.S. Navy," says Elizabeth Ranker.[9] Author of the introduction to the Signet Classic edition of *Moby-Dick* and *Strike through the Mask: Herman Melville and the Scene of Writing* (1996), she is my go-to Melville scholar. The whaling travel novels, from 1846 to 1850, average 60 titled chapters in an average of 300 pages (*Omoo*; *Typee*; *Mardi and a Voyage Thither*; *White Jacket, or the World in A Man-of-War*; *Redburn: His First Voyage*). The chapter titles are generally fact-based, as in these few examples: "natural history," "some account of the wild cattle in Polynesia," "a glance at the principal divisions into which a man-of-war's crew is divided," and "the way I came by it was this." "In no respect does the author make pretensions to philosophic research," Melville assures the reader of his second novel,

Omoo: A Narrative of Adventures in the South Seas. "In a familiar way, he has merely described what he has seen."[10] The opening line often plunges the reader into narrative action that is sustained throughout. "It was the middle of the bright tropical afternoon that we made good our escape from the bay"; the closing line promises more story, another novel: " . . . all before us was the wide Pacific."[11] Melville labeled his travel books as "jobs, which I have done for money"; Agee wrote for *Time* and *Fortune* out of a similar attitude. Both, even so, wrote as well as they could. In the final pages of *Moby-Dick* and *Famous Men* fewer parallels appear; they provide mostly relatively simple passages of description and narrative.

The 135 chapters of *Moby-Dick* are named very much as in his 5 travel novels: many places and things, and then people related to those places and things. The tone is almost comic, often satirical. Chapters 1 through 11 are fairly narrative, as are the openings, such as 3: "[E]ntering that gable-ended Spouter-Inn, you found yourself in a wide, low, straggling entry with old-fashioned wainscot, reminding one of the bulwarks of some condemned old craft" (12). Here are a few other factual or narrative chapter titles: 16, "The Ship"; 21, "Going Aboard"; 28 and 29 focus finally on Ahab; 32, "Cetology"; 41 focuses finally on Moby Dick himself, juxtaposed to 42, "The Whiteness of the Whale"; 50, "Ahab's Boat and Crew"; 55, 56, 57 are all about whales; 61, "Stubb Kills a Whale"; 65 focuses again on facts with "The Whale as the Dish"; 74, "The Sperm Whale's Head—Contrasted View"; 75, "The Right Whale's Head—Contrasted View"; then anatomy chapters: 89, "Fast-Fish and Loose-Fish"; 103, "Measurement of the Whale's Skeleton"; 104, "The Fossil Whale"; 133, 134, 135, on the immediate end of "The Chase." The components (as opposed to chapters) of *Famous Men* are similarly named: "The Great Ball on Which We Live"; "Persons and Places"; and "Money," "Shelter," "Clothing," "Education," "Work," "Negroes," "Sleep," "Overalls," "House," "Odors," "Beds," "Fireplace," "Porch," "Spring," and "Photography."

Melville and Agee indulge in religious rites, terminology, and phrases. "The Chapel," "The Pulpit," and "The Sermon" come after the first six chapters (34-48). "And I only am escaped alone to tell thee," from Job (573). Agee ends "PART THREE: Inductions" (293–362) with The Lord's Prayer (356) and Ecclesiasticus—"Let us now praise famous men . . ." (359). Agee and Melville are God's spies.

In 1990, I included *Moby-Dick* in my textbook *8 Classic American Novels*. For each novel, I asked an expert to create an alphabetized list, with page numbers. Among the themes and elements that Bainard Cowan has listed are meditations/blackness, darkness/interracial perception, and interaction/friendship/genius/humor, loss of identity/death/dream/phantasm/philosophical/detachment/skepticism/speculation/melancholy/politics/religion/writing—all of which were among Agee's preoccupations in *Famous Men*. For Agee's huge book, readers would be well-served by such a list.

In the "Cetology" chapter, Melville provides an elaborate, very specific classification outline.

> First: According to magnitude I divide the whales into three primary BOOKS (subdivisible into Chapters). and these shall comprehend them all, both small and large.
> I. THE FOLIO WHALE; II the Octavo Whale; III the DUOCECIMO WHALE.
> FOLIOS. Among these I here include the following chapters (137).

In *Famous Men*, readers come upon such classification outlines as this:

SHELTER: AN OUTLINE
THE GUDGER HOUSE
I: The Front Bedroom
II: The Rear Bedroom
III: The Kitchen
IV: The Storeroom

. . .

The Wood's House
The Rickett's House

. . .

Notes:

. . .

Recessional and Vortex

Following each of the above numbered items are subdivisions.
(105–106)

Like Agee, Melville, behind the nearly transparent Ishmael mask, often talks to the reader about the mechanics and aesthetic difficulties of writing the book. Melville ends the "Cetology" chapter thus:

> Finally: It was stated at the outset, that this System would not
> be here, and at once, perfected. You cannot but plainly see that I
> have kept my word. But I now leave my cetological System stand-
> ing thus unfinished, even as the great Cathedral of Cologne was
> left, with the crane still standing upon the top of the uncompleted
> tower. For small erections may be finished by their first archi-
> tects; grand ones, true ones, ever leave the copestone to posterity.
> God keep me from ever completing anything. This whole book
> is but a draught—nay, but the draught of a draught. Oh, Time,
> Strength, Cash, and Patience! (145)

Melville's creative agony is expressed in the opening of the metaphysi-
cal chapter "The Whiteness of the Whale."

> [There was] a nameless horror concerning him, which at times by
> its intensity completely overpowered all the rest; and yet so mysti-
> cal and well nigh ineffable was it, that I almost despair of putting
> it in a comprehensible form. It was the whiteness of the whale
> that above all things appalled me. But how can I hope to explain
> myself here; and yet, in some dim, random way, explain myself I
> must, else all these chapters might be naught. (188)

If those examples of Melville's voice fail to sound like *Famous Men*, my
premise falls to pieces.

Like Melville, Agee felt unworthy facing the creative task, sinful in
the act of performing it, and guilty for the finished work.

> To come devotedly into the depths of the subject, your respect for
> it increasing in every step and your whole heart weakening apart
> with shame upon yourself and your dealing with it: To know at
> length better and better and at length into the bottom of your

soul your unworthiness of it: Let me hope in any case that it is something to have begun to learn. (259)

Melville and Agee often speak to and of the reader.
Melville:

Here, now, are two great whales, laying their heads together; let us join them, and lay together our own. . . . Let us now note what is least dissimilar in these heads.
. . . but come out now, and look at this portentous lower jaw. . . .
Ere this, you must have plainly seen the truth of what I started with—that the Sperm Whale and the Right Whale have almost entirely different heads.
I but put that brow before you. Read it if you can. (329, 332, 335, 347)

Agee:

The text was written with reading aloud in mind.
Continuously, as music is listened to or a film watched.
This is a *book* only by necessity. (ix)

Melville, reviewing *Mosses from Old Manses*, called writing "the great Art of Telling the Truth," and he praised Hawthorne and Shakespeare.[12] Directly or indirectly, chapters 14, 33, and 44 of *The Confidence-Man: His Masquerade* deal with the art of fiction, almost in the way Thomas Mann does in his *Confessions of Felix Krull, Confidence Man*.

As Melville wrote *Moby-Dick*, "he was newly in love with the works of Shakespeare[,] . . . drunk with the texture of words and ablaze with literary ambition," says Renker.[13] "To produce a mighty book," wrote Melville, "you must choose a mighty theme" (456). Of course, that is true equally of Agee's book: the plight of tenant farmer families in the American Depression. In both books Agee and Melville "strike through the mask" as "thought-divers."

Melville's sea contrasts with Agee's Alabama plains, but Agee often reaches for boat metaphors. The sharecroppers and their way of life and Captain Ahab and life at sea are not the main elements of those books;

rather, what readers most intensely experience are the emotions, imaginations, and intellect of Agee and Melville. Agee is both Ishmael as witness-chronicler and Ahab as pursuer of far more than the ostensible subjects. Agee is in pursuit of the deepest, rather metaphysical, understanding of the Alabama tenant experience. The house: "the simultaneity in existence of all its rooms in their exact structures and mutual relationships in space" (150). In contrast to Agee's deliberate, conscious effort to understand his responses to the tenant farmers, Melville-Ishmael's effort to understand the deepest ways of whales and whaling is conducted under the surface of the narrative of Ahab's obsessive pursuit of Moby Dick.

Because the words come to the reader from the emotions, the imaginations, the intellect of the narrator, all first-person, fictional narrations are fundamentally about the narrator, as in *The Great Gatsby* and *All the King's Men*. That is clearer, of course, in Agee's nonfiction work than in Melville's novel; according to my long-held theory, *Moby-Dick* is about the narrator, but Melville himself usurps Ishmael's voice. Ostensibly, Melville-Ahab is in pursuit of Moby Dick the whale. But the whale Melville pursues is the book itself. The whales Agee and Melville pursue in their monster books are themselves. *Moby-Dick* is less a work of fiction than it is a work of autobiography, in the sense that Agee's book is autobiography. Directly and indirectly, both are autobiographical.

Melville: "Call me Agee."

Agee: "Call me Melville."

The early works of Agee and Melville were not in purely imagined fiction. Agee's journalism, especially his film criticism, compares with Melville's sea travel books, told straight, disguised as fiction.

Although most of the 134 chapters dwell upon facts, realities, and 27 are—as labeled—explicitly factual, Melville almost always rises/soars to a symbolic, metaphorical, philosophical, or metaphysical level, allowing one to become mindful of Agee—if one is of a mind to do that.

In "The Whiteness of the Whale" chapter, Ishmael expresses what the white whale meant to him; it follows the first chapter to focus on the whale Moby Dick—the lyrical, metaphysical following upon the practical, narrative element, beyond the obvious fear of the white whale. He

makes use of such words and phrases as "let us try," "this elusive quality," "clouds of spiritual wonderment and pale dread," "mystic sign," nature's "malicious agencies," "untutored ideality," "exaggerating the terror," "incantation," "indefiniteness," "heartless voids," "immensities of the universe," and "tell me, why." "But thou sayest, methinks this white-lead chapter about whiteness is but a white flag hung out from a craven soul; thou surrenderest to a hypo, Ishmael" (188–195).

Following the phrase "[o]ther anglosaxon monosyllables" (370–72), Agee gives us two full pages, a mere list. What we experience in both books is a sustained sense of a great love of language, of Melville and Agee alive in language, awash, drenched, submerged in language, in the immediate present. Their most abstract style is more than philosophical; their most specific style is usually more than journalistic. Agee opposes "the deifying of the imagination," as if he has not had to imagine the words, phrases, sentences that comprise his well-wrought style, as in this unique phrasing: "[B]ut now, in the short yet extreme winter of that shadow of itself through which a continuous half of the Earth twists its surface . . ." (199). The details are imaginatively described: "At the middle of the table is a mason jar" and other objects, "all surrounding the unlighted lamp which stands in the bare daylight in the beauty of a young nude girl" (149). "In a split in the bottom of the drawer, a small bright needle, pointed north, as the swan above it is" (140). "The partition wall of the Gudgers' front bedroom IS importantly among other things, a great tragic poem." (165)

Agee anticipates the distinctive Alain Robbe-Grillet style, as in Robbe-Grillet's "The Secret Room."

> The first thing to be seen is a red stain, of a deep, dark, shiny
> red, with almost black shadows. It is in the form of an irregular
> rosette, sharply outlined, extending in several directions in wide
> outflows of unequal length, dividing and dwindling afterward
> into single sinuous streaks. . . . Alongside the bloody hemisphere
> another identical round form, this one intact, is seen at almost the
> same angle of view.[14]

In *Famous Men,*

> [T]he barn is set off a few feet to the right of center of the rear
> of the house. Half between the barn and house, symmetrical to
> the axis of the house, the henroost and the smokehouse face each
> other across a bare space of perhaps twelve feet of dirt. (111)

> The house stands just sufficiently short of vertical that every
> leaf of shingle, at its edges, and every inch of horizontal plank
> (blocked, at each center, with squared verticals) is a most black
> and cutting ink: . . . each texture in the wood, like those of bone,
> is distinct in the eye as a razor: each nail-head is distinct: each
> seam and split; and each slight warping; each random knot and
> knothole . . . (119)

Precise but poetic.

Other such phrases of Agee's echo both authors: "these wild fugues
and floods of grain" (122), "the patterns and constellations of the heads
of the driven nails" (122). Many Melville passages employ phrases simi-
lar to those by Robbe-Grillet and Agee.

All five of the early travel books are offered as fiction, but Melville
states in prefaces that they are based on his own travel as a seaman to ex-
otic places and that they are thoroughly factual. Agee makes similar, re-
peated claims of reverence for the facts, of obligation to be accurate, but
veers off into the metaphysical stratosphere.

> [W]e undertake not much yet some, to say: to say, what is his
> house: for whom does he work: under what arrangements and in
> what results: what is this work: who is he and where from, that
> he is now here; what is it his life has been and has done to him:
> what of his wife and of their children, each, for all of these each
> is a life, a full universe: what are their clothes: what food is theirs
> to eat: what is it which is in their senses and their minds: what is
> the living and manner of their day, of a season, of a year: what,
> inward and outward, is their manner of living; of their spending

and usage of these few years' openness out of the black vast and
senseless death; what is their manner of life: . . . (92)

The two writers are very often inclined to philosophize—even meta-
physicalize—even though they state an aversion to it, in themselves and
in other writers. Melville boasts of adhering to the facts, eschewing phil-
osophy in early works, but indulges, as Agee does, at long last in *Moby-
Dick*, in philosophy, psychology, biology, metaphysics, politics, and
religion.

Starting off with "Etymology" of the word "whale," Melville loads
up the front of his book with thirteen pages of quotations from a wide
range of famous and obscure sources, such as Montaigne, Thomas
Beale, Lord Bacon, Elizabeth Oakes Smith, Sir Thomas Browne, Colnett,
Milton, Baron Cuvier, Uno Von Troil, Alexander Pope, King Alfred, and
Darwin. Agee opens with relatively few quotations, but spins off a good
many throughout, along with a long list of names of figures who might
create a "usable past" for present authors (taken from his rejected re-
sponse to the *Partisan Review* questionnaire on "Some Questions that
Face American Writers Today"): Melville, Whitman, Crane, Cummings,
Malraux, Gide, Mann, Dostoyevsky, Mathew Brady, Eisenstein, Chaplin,
Van Gogh, Celine, Swift, Kafka, Joyce, Beethoven, William Blake, Jesus
Christ. And, on the same page, he rejects their influence:

> [Y]ou learn as much out of corruption and confusion and more,
> than out of the best work that has ever been done. Only after a
> while you begin to know certain sectors by heart and in advance,
> and then they are no further use to you. (287)

Agee makes frequent anti-intellectual statements against analysis,
but the work as a whole is probably the most intellectual work by a nov-
elist, as in this abstractly intellectual passage:

> This asymmetry now seems to us to extend itself into a worrying
> even of the rigid dances of atoms and of galaxies, so that we can
> no longer with any certitude picture ourselves as an egregiously

complicated flurry and convolved cloud of chance sustained
between two simplicities. (187)

Agee is up front about the unique nature of his work. "For I must say
to you, this is not a work of art or entertainment, nor will I assume the
obligations of the artist or entertainer, but is a human effort which must
require human co-operation" (92). And, "Above all else: in God's name
don't think of it as art" (13).

Melville, too, is up front, although the narrative begins much as his
early travel books. "Some years ago—never mind how long precisely—
having little or no money in my purse, and nothing particular to in-
terest me on the shore, I thought I would sail about a little and see the
watery part of the world" (3). *Typee*, his first novel begins: "Six months
at sea! Yes, reader, as I live, six months out of sight of land; cruising after
the sperm whale beneath the sorching sun of the Line, and tossed on the
billows of the wide rolling Pacific—the sky above, the sea around, and
nothing else!"[15]

Melville praised "the whole corps of thought-divers, that have been
diving & coming up again with bloodshot eyes since the world began,"
and included himself.[16] Both Melville and Agee are "thought-divers,"
who "strike through the mask." "All visible objects" are masks. "If man
will strike, strike through the mask!" (164). Out of their "seining of ex-
perience," they seek to express "the cruel radiance of what is" (189, 10).

Ishmael's quest, to classify and describe whales, is finally a quest to
comprehend what those elements mean. Ahab's quest, by contrast, is
not one to classify whales in general, but to avenge himself upon one
whale in particular. We better understand Melville's and Agee's obses-
sion with striving to strike through the masks of objects and people if
we consider Hegel's concept of consciousness of self as developed in *The
Phenomenology of Spirit* (along with Henri Bergson's "An Introduction
to Metaphysics"). Hegel's dialectical theory is that self-consciousness
is achieved when consciousness recognizes itself in objects and in self-
conscious people. Both writers achieve the first much more successfully
than the last. Melville-Ishmael's self-consciousness does not penetrate
Ahab's; Agee's narcissism prevents him from succeeding in his goal of
penetrating the self-consciouses of the farming folk.

In "The Crotch" (ch. 63), Melville, according to Renker, "gives us, as a model for his narrative, an outbranching tree."[17] "The novel is in fact an encyclopedia of forms . . . that combines dictionary, whaling manual, comedy, tragedy, epic, prophecy, sermon, soliloquy, drama, bawdy humor, and tales within tales, as well as a myriad of sources, including the Bible, Shakespeare, Milton, adventure narrative, technical books on whales and whaling and many more."[18] All that is very unlikely if we accept only Ishmael the seaman as the narrator, instead of agreeing that the novel is really about Melville, who uses Ishmael as a mask. *Famous Men* is, obviously, an out-branching tree, in ways no other work of nonfiction is.

In *Moby-Dick*, Melville experiments with the eccentric use of multiple forms, as do Laurence Sterne in *Tristram Shandy* and James Joyce in *Ulysses*, and Agee in *Famous Men*. Both Agee and Melville suddenly introduce passages in dialogue or play form, Melville in chapters 30, 36–40, and, with focus on Ahab, in 108–109. For example, the opening of chapter 39:

> Chapter 39.
> First Night-Watch.
> Fore-top
> (Stubb solus, and mending a brace)
> Ha! . . . (171)

After a single page on Stubb, the entire next chapter is in play form.

Here are examples from *Famous Men*: "Colon, Curtain Speech" (83) and "Intermission: Conversation in the Lobby" (283). Three major parts are called "On the Porch," the porch being a kind of stage for soliloquies, the book itself being one long, lyrical soliloquy, often interrupted by lunges into facts and speculations.

> PART TWO
> SOME FINDINGS AND COMMENTS
> Under that heading, he deals out facts and documentations.
> (95–257)

Renker calls *Moby-Dick* "a uniquely 'American work,'" a powerful re-
cord of "the times."[19] Even though his ostensible subject is Depression-
era tenant farmers, I am not so sure that those terms apply as strictly
to Agee's book, which often seems on some levels more like classic and
modern European nonfiction works, from St. Augustine to Rousseau, to
Goethe. Renker notes Melville's political concerns, the role of blacks (a
whale would sell for thirty times what Pip would as a slave in Alabama),
but in the mode of meditation not advocacy.[20] *Israel Potter* (1855) is a
satire set during the American Revolution; Agee had an abiding interest
in the American Civil War, expressed eloquently in his 1952 five-part
Omnibus television script, *Mr. Lincoln and the Civil War*.

In both books one may see qualities of *Walden*. Speaking directly in
his own lyrical voice, Thoreau focuses not upon human beings in nature
but upon the external world of the pond and of artifacts in ways that
enable him to reveal the internal life of people. He could have called
his book *Thoreau*. It, too, exhibits—in "Economy" and "Solitude," for
instance—the kind of polarities between which Melville and Agee
struggled. The extrovert seaman Melville of *Moby-Dick* and the intro-
vert idler Thoreau of *Walden* are combined in the introverted extrovert
Agee of *Let Us Now Praise Famous Men*.

Regarding the nonfiction-fiction notion, other such works one might
mention, just in passing, that compare in one way or another with
Agee's and Melville's are Whitman's *Leaves of Grass*, William Gaddis's
The Recognitions, Capote's *In Cold Blood*, Comte de Lautréamont's
Le Chant de Maldoror, Walter Pater's *Marius The Epicurean*, George
Gissing's *The Private Papers of Henry Ryecroft*, Huysman's *Against the
Grain*, and Frank Conroy's *Stop Time*. Both Melville's and Agee's books
are like Joyce's *Ulysses*—myriad-minded.

* * *

Other Agee-Melville comparisons and contrasts that I find interesting
but that may not be relevant to my main interest are:

Walker Evans's vision affected Agee, and Nathanael Hawthorne's af-
fected Melville profoundly. Their relationships were similar.

Melville dedicated his book to Hawthorne; Agee and Walker Evans

dedicated their book to "Those of whom the record is made. In gratefulness and love."

Arguments that Walker Evans's great photographs enhance Agee's subjective responses to the same people, places, and things are rather strained. Rockwell Kent's striking drawings illustrate Melville's narrative directly and very well, but not the submerged psychological, philosophical, and mystical experiences of Melville as Ishmael, which come to the surface in the so-called digressions, especially in "The Whiteness of the Whale."

Agee began with poetry, *Permit Me Voyage* (1934), which included two long poems, "Ann Garner" and "John Carter." Melville's last works were mainly in poetry: *Battle Pieces and Aspects of the Civil War* (1866), *Clarel: An Epic Account of a Pilgrimage to the Holy Land* (1876), and *John Marr and Other Sailors* (1888).

After *Typee*, Melville was failing physically and mentally. In 1867, "his wife and some of the family on both sides were convinced he was insane"; the oldest child, eighteen, committed suicide.[21] Both Agee, middle-aged, and Melville, elderly, died in New York City of heart attacks.

Both men left unfinished works behind, *A Death in the Family* and *Billy Budd*, picked up and parsed out by editors and scholars.

Much of Agee's work appeared posthumously; by contrast, almost all of Melville's work appeared in his lifetime.

Both books had to wait until after their authors' deaths to become famous: *Moby-Dick*, 76 years, republished in 1929; *Famous Men*, 19 years, republished in 1960.

My own first novel, *The Beautiful Greed*, was a novel of the sea; published in 1961, it is one of the last about a young writer in the Merchant Marine. The setting of Agee's *A Death in the Family* and early drafts of my second novel, *Cassandra Singing*, and my third novel, *Bijou*, is Knoxville, Agee's hometown and my own.

* * *

Moby-Dick and *Let Us Now Praise Famous Men* are huge books that many readers refuse to open or that they abandon early, some because tenant farmers and seamen killing whales do not interest them. Com-

ments include the word "boring" most often. Specifically, readers slog through the digressions, or say that the ostensible hero, Ishmael, appears too seldom, or they assert that Agee's obsession with his own feelings distracts from the ostensible subject, the tenant farmers. I first made a willing stab, quit, then made a dutiful plunge, then a reluctant commitment, finally, a willing indulgence in each of these forbiddingly huge works.

When as visiting scholar at the University of Delaware in 1980, I taught the Agee and Melville works, they gave my students fits. As I noted elsewhere, "They weren't interested in Alabama sharecroppers in the mid-1930s, and they were certain that Agee was more interested in himself than in those sharecroppers. . . . Moby Dick the whale was lost, for them, in a dead sea of whale lore and nautical jargon."[22] Ironically, until scholars rediscovered *Moby-Dick* in about 1929 as a profound monument of American literature, it was for many years given over to kids, as Agee's rediscovered book never will be; some libraries shelve *Famous Men* in "agriculture."

Both books are everything anyone has ever said in praise of them, but if readers, especially first-time readers, set aside the focus on tenant farmers and the focus on Ahab and the whale and shift focus to Agee's and Melville's subjective experiences, then they will have, not necessarily a better, but, simply (though deeply), a *different* experience. Both books deserve and reward re-readings by questing "thought-divers."

NOTES

1. Herman Melville, *Moby-Dick, or, The Whale*, eds. Harrison Hayford, Hershel Parker, and G. Thomas Tanselle (Evanston, IL: Northwestern UP, 1988). Subsequent references to *Moby-Dick* will be noted parenthetically in the text. And James Agee and Walker Evans, Let Us Now Praise Famous Men: *An Annotated Edition of the James Agee-Walker Evans Classic, with Supplementary Manuscripts*, ed. Hugh Davis, vol. 3 of *The Works of James Agee*, gen. eds. Michael A. Lofaro and Hugh Davis (Knoxville: U of Tennessee P, 2015). Subsequent references to this edition will be noted parenthetically in the text, and abbreviated in the notes as Davis, *LUNPFM*.

2. David Madden, "James Agee Never Lived in This House," *The Last Bizarre Tale* (Knoxville: U of Tennessee P, 2014) 40–41. First published in Michael A. Lofaro, ed., *James Agee: Reconsiderations*, Tennessee Studies in Literature 33 *(Knoxville: U of Tennessee P, 1995) 35–36.*

3. Linda-Martin Wagner, "*Let Us Now Praise Famous Men* and Women: Agee's Absorption into the Sexual," *James Agee: Reconsiderations* 57.

4. David Madden, "Mapping Agee's Myriad Mind," *Agee Agonistes: Essays on the Life, Legend, and Works of James Agee*, ed. Michael A. Lofaro (Knoxville: U of Tennessee P, 2007), 12–14.

5. *James Agee: Reconsiderations* 178.

6. Michael A. Lofaro, ed., *Agee at 100: Centennial Essays on the Works of James Agee* (Knoxville: U of Tennessee P, 2012) 260–61.

7. David Madden, ed., *Remembering James Agee*, 2nd ed. (Athens: U of Georgia P, 1997) 224.

8. James Agee, "U.S. Commercial Orchids," *Complete Journalism: Articles, Book Reviews, and Manuscripts*, ed. Paul Ashdown, vol. 2 of *The Works of James Agee* (Knoxville: U of Tennessee P, 2013) 278.

9. Elizabeth Ranker, introduction, *Moby-Dick, or The Whale*, by Herman Melville (New York: New American Library, 1998) xii.

10. Herman Melville, *Omoo: A Narrative of Adventures in the South Seas*, eds. Harrison Hayford, Hershel Parker, and G. Thomas Tanselle (Evanston, IL: Northwestern University Press, 1968) xv.

11. *Omoo* 5, 316.

12. Ranker xii.

13. Ranker x.

14. Alain Robbe-Grillet, "The Secret Room," *Snapshots* (Evanston, IL: Northwestern UP, 1986) 63.

15. Herman Melville, *Typee: A Peep at Polynesian Life*, eds. Harrison Hayford, Hershel Parker, and G. Thomas Tanselle (Evanston, IL: Northwestern UP, 1968) 3.

16. Ranker xii.

17. Ranker xiii.

18. Ranker xiv.

19. Ranker xiv–xv.

20. Ranker xvi.

21. Ranker xi.

22. Madden, "James Agee Never Lived in This House" 40–41.

Parallel Poetics:
Ways of Seeing in James Agee
and Federico García Lorca

Jesse Graves

James Agee and Federico García Lorca began their lives on separate continents, and in very different social worlds, though only a decade separated their births. Agee was raised in Knoxville, Tennessee, in what he called "a little bit mixed sort of block, fairly solidly lower middle class, with one or two juts apiece on either side of that."[1] Lorca was born in Spain, near the Andalusian city of Granada, in 1899, into a family of wealth and privilege. Though the home lives of their childhoods were quite distinct, they lived through the same global events, and took part in the same intellectual debates and conflicts. Less than a decade before James Agee and Walker Evans took their *Fortune* magazine assignment and headed to rural Alabama, Federico García Lorca left his native Andalusia region of Spain to spend the academic year of 1929–30 at Columbia University in New York City. Given the considerable number and nature of differences between the two writers' lives, many striking intersections can be found in their works. Both writers began as poets, and wrote always in a lyrical style that revealed this background, while becoming better known later for working in other genres. Two books in particular reveal their shared sensibilities, Lorca's *Poet in New York*, begun in 1929 and published posthumously in various versions beginning in 1940, and Agee's *Let Us Now Praise Famous Men*, begun in 1936 and published in 1941. These two books share not just a random assortment of similarities, but also a fundamental likeness of endeavor, an aim to embody the spirit of a particular place through an unsentimental view of the ways of life of its inhabitants, taking a special focus on those who live with the greatest hardships and the least security.

James Agee's boyhood in East Tennessee may have prepared him, somewhat, for the poverty he found in Hale County, Alabama, when he arrived with Walker Evans to complete their magazine assignment. Agee makes his purpose for the book clear: "The nominal subject is North American cotton tenantry as examined in the daily living of three representative white tenant families."[2] He had seen country life firsthand, visiting his father's family in the rural counties north of the city of Knoxville. Agee could even modulate his accent to make himself sound like less of an outsider to the Alabama sharecroppers whose lives he was there to document. Nothing, however, had prepared Lorca for the urban poverty he would encounter in New York City, in the fall of 1929. His upbringing had been near idyllic, growing up in an artistic and musical family, who were not unlike Agee's relations on his mother's side. What Lorca found in New York shocked the young man, as witnessed in the poem "Dawn":

> Dawn in New York has
> Four columns of mire
> And a hurricane of black pigeons
> Splashing in the putrid waters (1–4)[3]

Certain biographical similarities between the two writers provide an interesting groundwork for the ways in which their works run parallel. Agee and Lorca were raised in the early part of the twentieth century, in regions of their respective countries known for political conservatism, particularly concerning matters of race and class, and for especially devout religious communities. Beyond the similarities of the two authors' personal circumstances, the two texts also share some elements of a common fate. Both books suffered considerable delay before publication, though for very different reasons. The well-documented stories of how the books finally reached the audiences that would eventually declare them masterpieces must certainly contribute to the near-mythical status of their authors.

Both writers looked closely at their own childhood experiences in earlier works, and used autobiographical materials freely. A number of common tonalities and images exist between Agee's "Knoxville: Sum-

mer of 1915," and Lorca's poems "Ballad of the Three Rivers" and "Landscape," from his 1921 collection *Poem of the Deep Song.* Agee gives as lyrical a depiction of suburban America as one is likely to find, with many details about food, work, trees, and how people spent their time together. For Lorca, the "Deep Song," or *Cante Jondo,* was the last true expression of Spanish folk-life. As in most instances, Lorca's descriptions in these poems are more elliptical than Agee's—"The river Guadalquivir / Has garnet whiskers" (7–8),[4] for example—but still firmly rooted in the traditions of his place. The subject matter and contents of both books emerge out of other materials, or other intentions. Neither Agee nor Lorca set out to write these particular texts. Agee initially was writing for a very specific assignment for *Fortune* magazine, to show the lives of white tenant farmers. Whereas Lorca had no definite assignment for his trip to New York, his general mission was to study languages at Columbia University, and composing poems was incidental to that purpose.

In a much discussed passage from the introductory chapter of *Famous Men,* Agee describes what would be preferable to trying to write about the lives of the tenant farmers:

> If I could do it, I'd do no writing at all here. It would be photographs; the rest would be fragments of cloth, bits of cotton, lumps of earth, records of speech, pieces of wood and iron, phials of odors, plates of food and of excrement. (10)

Agee feels certain that he will fail to present the full humanity of his subjects, and the reality of the objects that belong to them. His claim also suggests that words are not up to the task of communicating the gravity of the people and their objects, and that only presenting them in total actuality could deliver the full meaning. He goes on to say, "[A] piece of the body torn out by the roots might be more to the point" (10). The point here being, in part, that words can only stand in for, can only *re*-present, the real things they signify. The artist of words is an artist of the air, an artist of the image and the symbol, and words cannot deliver the concrete things themselves.

Both texts look with care at people trying to lead meaningful lives, while having no political freedom, and no social independence.

Particularly in the case of *Famous Men*, the farmers and their families are bound, quite literally through contractual arrangements with their landlords, to the system that suppresses them. To understand Agee's feelings for the families he stays with, one need only consider this portion of a nearly page-long sentence:

> . . . how each of you is a creature which has never in all time existed before, and which shall never in all time exist again and which is not quite like any other and which has the grand stature and natural warmth of every other and whose existence is all measured upon a still mad and incurable time; how am I to speak of you as "tenant" "farmers," as "representatives" of your "class," as social integers in a criminal economy, or as individuals, fathers, mothers, sons, daughters, as my friends and as I "know" you? (84)

The interests of Agee and Lorca merge together most revealingly in their shared senses of intense moral empathy with individuals trampled upon by a generalizing social and economic system. Yet both men were ambivalent about communism, and even though Lorca was murdered by the Fascist supporters of General Franco, he never openly expressed his political sympathies. Both writers resisted doctrinal belief systems, and found truth in the perceptual energies and attentions of the invested individual.

Lorca's *Poet in New York* takes a hard look at economic and spiritual malaise, but the book opens with a sequence of warm, nostalgic childhood poems, suggesting the gentleness of the poet's origins. The tone, which is very much in the vein of Agee's "Knoxville: Summer of 1915," that develops from the opening section of *Poet in New York*, in such poems as "1910 (Intermezzo)" and "Your Childhood in Menton," conveys only Lorca's version of the *Songs of Innocence*, and not yet the *Songs of Experience*. The poem "1910 (Intermezzo)" begins:

> Those eyes of mine in nineteen ten
> saw no one dead and buried,
> no village fair of ash from the one who weeps at dawn
> no trembling heart cornered like a sea horse. (1–4)

The speaker of the poem has seen no suffering, no loss, nothing of what adulthood would later reveal. Lorca calls this opening section of *Poet in New York*, the first of ten numbered sections, "Poems of Solitude at Columbia University." These poems show a foreign student reflecting on the homeland he has left behind, and taking stock of the simplicities of his past before addressing a difficult present.

In Section 2 of the book, titled "The Blacks," Lorca's speaker is a grown man, and already world-weary, looking out at the world in all its disorienting unfairness. He feels great empathy for the African-American residents of New York City, whom he sees as trying to live authentic lives under the altering power of the white social and economic world:

> They hate the bird's shadow
> on the white cheek's high tide
> and the conflict of light and wind
> in the great cold hall of snow.
>
> They hate the unbodied arrow
> the punctual handkerchief of farewell,
> the needle that sustains a rosy tension
> in the seed-bearing spikes of their smiles. (1–8)[5]

Lorca studies the hidden feelings of the African-Americans, the anxiety and oppression they feel in a world in which they are not at home, are not even welcome guests. The image of the "bird's shadow" presents a most disturbing aspect of their lives in twentieth-century America, a place where even nature cannot be trusted, and the makers of beautiful songs may very well betray them. Agee made similar observations about the lives of African-Americans in *Famous Men*, most poignantly during a scene in which he addresses a young couple walking on the road, and feels shame and horror that he has both frightened them and made them aware of their own vulnerability. (34–36)

Both Famous Men and *Poet in New York* take a dark view of the multitude of ways capitalism ravages the poor. Agee's assigned project was to consider the lives of ordinary white sharecroppers, whereas Lorca is most struck in New York City by the culture of African-Americans who

live in a kind of urban poverty the poet has never before witnessed. Agee represented the people of his study in a nearly hyperrealistic manner, down to the worn threads of their garments. Lorca, on the other hand, often depicts his human subjects in more abstract ways, as in these lines from "Blind Panorama of New York":

> Everyone understands the pain that accompanies death,
> but genuine pain doesn't live in the spirit,
> nor in the air, nor in our lives,
> not on these terraces of billowing smoke.
> The genuine pain that keeps everything awake
> is a tiny, infinite burn
> on the innocent eyes of other systems.[6] (lines? 11-17)

Lorca pulls back from the physical and very tactile suffering found in poems from earlier sections of the book, such as "Dance of Death" and "Landscape of a Vomiting Multitude (Dusk at Coney Island)." This speaker seems to say that the real source of human suffering is so far outside our control that it belongs to an entirely different system than the one we recognize, with the "tiny, infinite burn" suggesting a cosmic force at work. This poem concludes with an image of the earth, as if seen from within, and also at a great distance: "There is no pain in the voice. Only the Earth exists here. / The Earth and its timeless doors / which lead to blush of the fruit."[7] [lines 42-46]

The study of poetics goes back to Aristotle and continues from the earliest thinkers about literature to the most current. Jonathan Culler has defined poetics as "the attempt to account for literary effects by describing the conventions and reading operations that make them possible."[8] This definition is in keeping with the rhetorical and linguistic approaches to poetics that became prominent in the last quarter of the twentieth century. A poetics involves more than simply a style, or a sensibility; a poetics comprises a perspective toward or upon its subject. In this regard, it encompasses more of a way of being, or "a way of seeing" (to reference Agee's work with the photographer Helen Levitt),[9] than a particular method or approach. Both style and sense occur within it, and it reaches after some level of essential being. Such an ontological

matter is more difficult to demonstrate than aspects of method or elements of common ideological purpose, though these are two avenues of evidence for establishing a shared poetics.

The poetics of Agee and Lorca do not intertwine, nor intersect, at any precise points, but move along parallel lines throughout their writing lives. These parallel poetics involve both stylistic and ideological matters; while Agee and Lorca both tended to be flamboyant stylists, perhaps excessive at times in their descriptive inclinations, they were also deeply concerned with the lives of others, and with giving value to the unappreciated. They perceived themselves as outsiders, especially in *Famous Men* and *Poet in New York*, and that willingness to think beyond the mainstream likely created a sense of relationship with avantgarde modes of expression. Even certain of their biographical likenesses indicate a parallel line of poetics, such as early musical talent, particularly on the piano, and close associations with visual artists (Walker Evans and Helen Levitt for Agee; Salvador Dali for Lorca), and especially with filmmakers (Charlie Chaplin, John Huston, and Charles Laughton for Agee; Luis Buñuel for Lorca). Agee and Lorca arrived at strikingly similar conclusions about causes of suffering and degradation of life that came at the hands of oppressive political systems. They each hoped to represent humble lives, and the folkways that surround them, with a complex, and often abstract, artistic vision, and through similar stylistic approaches, which were highly divergent from the earlier works of each. Both were lyrical writers, given to intensely detailed descriptions of their surroundings, often in the elevated sensory world of poetic language.

Agee made an attempt to show kinship between experimentalism and political art in his 1936 *New Masses* review of Gertrude Stein's "Geographical History of America, Or the Relation of Human Nature to the Human Mind."[10] Agee does not mention Stein even once after the opening sentence, but he does make a case for the revolutionary value of "[t]he material of dreams and the fluid subconscious, irrationalism, the electrically intense perception and representation of 'real' 'materials.'"[11] He does hold up James Joyce, and several early Russian filmmakers as models of the social relevance of experimental art, claiming, "[F]or the materials of so-called surrealism are the commonest of human property. And a man who cannot by mischance grasp a problem intellectually is

grasped by it if it is presented through the subtler, more forceful, and more primitive logic of movement, timing, space, and light."[12] Agee appears untroubled by the paradox of aligning subtlety, on the one hand, with force and primitivism, on the other. These manners might seem contradictory, but Agee's own writing makes them complementary.

One of the more compelling parallels between Agee and Lorca arises from a shared desire to incorporate poetic means that appear at odds with one another. Both writers undeniably absorbed elements of high modern avant-garde movements, particularly surrealism and imagism, and even some of the darker notes of Dadaism. This fact alone does not set Agee and Lorca apart from many writers of the 1920s and 30s. The influence of the avant-garde was pervasive, even among writers who did not embrace these approaches as their primary style. Agee and Lorca are distinctive, however, in their shared commitment to representing real human voices in their work, which bound them to some degree of verisimilitude. Realism of this type was strictly antithetical to the principles of the avant-garde, yet essential to Agee and to Lorca. Like Agee, Lorca began as a much more traditionalist poet than his later work suggests. Early poems by Lorca are modeled on ballads of Spanish folk-music, and on the late symbolist style of Juan Ramón Jiménez. For Lorca, verisimilitude found a more comfortable home in his dramatic plays. Both Agee and Lorca eventually embrace an oratorical style, incorporating a voice of high dramatic tension. Both were interested in the sonorities of native speech, of the plain and unaffected, but also in the flourish of high literary manner. Agee's most lyrical writing appears in the prose of *Famous Men*, where the textural and sonic effects of language far surpass what he accomplished in his poetry. An example of this style, recalling the oratorical flare of Thomas Wolfe's prose, can be found in a lengthy passage describing the front bedroom of the Gudgers' house:

> At this certain time of late morning, then, in the full breadth
> of summer, here in this dark and shuttered room, through a
> knothole near the sharp crest of the roof, a signal or designation
> is made each day in silence and unheeded. A long bright rod of
> light takes to its end, on the left side of the mantel, one of the

small vases of milky and opalescent glass; in such a way, through its throat, and touching nothing else, that from within its self this tholed phial glows its whole shape on the obscurity, a sober grail, or divinity local to this home; and no one watches it, this archaic form, and alabastrine pearl, and captured paring of the phosphor moon, in what inhuman piety and silent fear it shows: and after a half minute it is faded and is changed, and is only a vase with light on it, companion of a never-lighted twin, and they stand in wide balance on the narrow shelf; and now the light has entirely left it, and oblates its roundness on the keen thumbprint of pine wall beside it, and this, slowly, slides, in the torsion of the engined firmament, while the round rind of the planet runs in its modulations like a sea, and along faint Oregon like jackstrewn matches, the roosters startling flame from one another, the darkness is lifted, a steel shade from a storefront. (153–54)

The breathless force of such writing is Agee at his most poetic, his most connected to the historical weight of the language of poetry. A phrase like "tholed phial" sounds as though it comes straight from *Beowulf,* and from the same rough and elemental world in which Beowulf slays Grendel, a world in which the houses might not be so very different from the tenant house inhabited by the Gudger family in Alabama in 1936.

Lorca's style in *Poet in New York* could be similarly breathless, with the poems often written in long irregular lines, and with infrequent punctuation. The presentation of the lines in such a manner gives the appearance of unbounded thoughts and feelings, a poet driven by a headlong Muse. One example can be found in the following lines from the poem "Crucifixion":

> Blood flowed down the mountain and the angels looked for it,
> but the chalices became wind and finally filled the shoes.
> Crippled dogs puffed on their pipes and the odor of hot leather
> grayed the round lips of those who vomited on street corners.
> and long southern howls arrived with the arid night. It was the
> moon burning the horse's phallus with its candles. (4–9)[13]

Both Agee and Lorca cited the importance of Walt Whitman, and he is the presiding influence over the style and voice of *Poet in New York*, as well as many sections of *Famous Men*. One of the better known poems from *Poet in New York* is called "Ode to Walt Whitman," in which Lorca pays tribute to Whitman's vision and courage, despite taking a much darker view of America and its culture of destruction and greed.

The middle to late modernist period in Europe and America marks an ever-amalgamated search for forms commensurate to increasingly diverse subject material, following the radical approaches of surrealism, cubism, and other avant-garde movements, including James Joyce's "mythical method," as T. S. Eliot called it, for depicting day-in-the-life happenings through the lens of classical mythology. The spirit of the age for 1930s American writing was to embrace whatever means were at hand, to stretch the confines of genre, and to bring as many new voices into literature as possible. John Steinbeck and Clifford Odets, for instance, both sought to incorporate the perspectives of poor and working-class citizens who found little representation in the high modernism of the 1920s. The long poem experienced a particularly vivid renaissance at the time, with the early stages of Ezra Pound's *Cantos*, Eliot's *The Waste Land*, and other experiments that more resembled Lorca, such as Hart Crane's "The Bridge," and the more Agee-like documentary style of early sections of William Carlos Williams's *Paterson*.

In the chapter, "Famous Men as Surrealist Ethnography," from *The Making of James Agee*, Hugh Davis works out much of the context for the surrealist impulse in Agee's writings from the 1930s, and particularly his techniques in *Famous Men. Davis says,*

> While Agee insists that art is incapable of reproducing experience, he does not give up on aesthetics altogether. Like the surrealists, he seeks to integrate the conscious and unconscious and to collapse boundaries between aesthetic categories not so much that art will cease to exist, but that art and life will become one.[14]

Agee shows this tendency often in describing the objects that decorate the lives of the Gudgers, the Ricketts, and the Woods. He does a great deal of Whitmanesque cataloguing of the items found in their houses,

and often employs techniques that show the objects as they appear, but not necessarily in a form recognizable to a reader who has not been there in person to see what Agee sees. He shows a clipping from a Birmingham, Alabama, newspaper, clearly not saved for the story it once told, but for some other, unspecified purpose, likely more practical to the livelihood of the household. The image is rendered as follows:

GHAM NEWS
hursday afternoon, March 5, 1936
Price: 3 cents
 in G
 (else

Thousa
are on d
througho
cording its

for the Birm

(over two photographs:)

 Glass and night sticks fly in (138)

The imagery continues in that way for several pages, with prose digressions interspersed in regular paragraph form. This looks very like the collage approach used in surrealist writings, and also offers a fractured version of the imagist style of an earlier decade. Agee finds an unsentimental method with which to present an emotional subject, and to powerfully, but obliquely, suggest the manifold gaps and absences in the lives of his human subjects.

As a postscript that would have seemed very unlikely at the times of their deaths, literary and popular culture has embraced both writers. James Agee has been recognized as one of the great screenwriters of his era, and a seminal film critic. A selected volume of his film criticism, *Agee on Film*, was chosen by legendary film director Martin

Scorsese for his Modern Library: The Movies Series. Federico García Lorca inspired songs by artists as diverse and esteemed as Tim Buckley, Leonard Cohen, The Pogues, and punk rock icons The Clash, as well as a Hollywood film, *Death in Granada*. In fact, Joe Strummer of The Clash traveled to Granada to search for the site of Lorca's grave in 1984, buying shovels and recruiting friends to help him dig, though like the many who tried before him, Strummer found no grave for Lorca.[15]

International literary figures also continue to hold Agee and Lorca in high regard. The Norwegian novelist Karl Ove Knausgård clearly paid homage to Agee by borrowing one of his book titles. The first installment of Knausgård's 2009 six-volume autobiographical novel, *My Struggle*, is called *A Death in the Family* in European editions. French philosopher Jacques Rancière designates "Hale County, 1936-New York, 1941" as a major aesthetic site in his 2013 book, *Aisthesis: Scenes from the Aesthetic Regime of Art*. He titles his chapter "The Cruel Radiance of What Is" after a line from Agee's *Famous Men*. Rancière says, "It is only possible to account for these lives and their place in the world, however slightly, by going beyond the significant relation between the particular and the general towards the symbolic relation of the part to the unrepresentable whole that expresses its actuality."[16] That the symbolic relations of the parts, namely the images, to the wholes, the experiences embodied, are still subjects for discussion in the works of Agee (and the same process is certainly applicable to Lorca's *New York* poems) surely speaks to the lasting nature of the work they accomplished, and suggests the influence these works will maintain in the future.

NOTES

1. James Agee, A Death in the Family: *A Restoration of the Author's Text*, ed. Michael A. Lofaro, vol. 1 of *The Works of James Agee*, gen. eds. Michael A. Lofaro and Hugh Davis (Knoxville: U of Tennessee P, 2010) 565. Quoted here from an appendix, "Knoxville: Summer of 1915" was published as a prologue to the novel in the 1957 McDowell version.

2. James Agee and Walker Evans, Let Us Now Praise Famous Men: *An Annotated Edition of the James Agee-Walker Evans Classic, with Supplementary Manuscripts*, ed. Hugh Davis, vol. 3 of *The Works of James Agee*, gen. eds. Michael A. Lofaro and Hugh Davis (Knoxville: U of Tennessee P, 2015) x. Subsequent references to this edition will be noted parenthetically in the text.

3. Federico García Lorca, *Poet in New York*, ed. Christopher Maurer (New York: Farrar, Straus, and Giroux, 1998) 73.

4. Federico García Lorca, "The Ballad of the Three Rivers," *Collected Poems*, ed. Christopher Maurer (New York: Farrar, Straus, and Giroux, 2002) 97.

5. *Poet in New York* 21.

6. *Poet in New York* 67.

7. *Poet in New York* 69.

8. Jonathan Culler, *Literary Theory: A Very Short Introduction* (London: Oxford UP, 1997) 66.

9. Helen Levitt and James Agee, *A Way of Seeing: Photographs of New York* (New York: Viking, 1965).

10. Agee, "Geographical History of America, or the Relation of Human Nature to the Human Mind," *New Masses* 15 Dec. 1936: 48.

11. "Geographical History" 48.

12. "Geographical History" 50.

13. *Poet in New York* 145.

14. Hugh Davis, *The Making of James Agee* (Knoxville: U of Tennessee P, 2008) 115. Davis goes into very useful detail about the intertwining of Agee's aesthetic ideas and his political ones, examining also the contexts for surrealism within the political climate of the 1930s.

15. Giles Tremlett, "Joe Strummer to Be Honoured with Square in Spanish City Granada," *Guardian* 15 Jan. 2013, [date of access] <http://www.theguardian.com/music/2013/jan/15/joe-strummer-square-granada>.

16. Jacques Rancière, *Aisthesis: Scenes from the Aesthetic Regime of Art* (London, New York: Verso, 2013) 250.

A Fraternal Relationship:
James Agee and John Berger
on Representing the Rural Poor

Andrew Crooke

In 1999, the British writer John Berger, reflecting on his work with Swiss photographer Jean Mohr, acknowledged: "We started from what James Agee and Walker Evans achieved in their magnificent *Let Us Now Praise Famous Men*."[1] Much as Agee names various artists and sages as "unpaid agitators" of that 1941 encomium on Alabama tenant farmers,[2] so too Berger belatedly pays a debt to him and Evans as the principal inspiration for his own hybrid volumes with Mohr: *A Fortunate Man* (1967), which portrays an English country doctor; *A Seventh Man* (1975), which tracks migrant workers across Europe; and *Another Way of Telling* (1982), which explores peasant livelihoods in the Alps. All four photo-textual endeavors combine precise social documentation with audacious formal experimentation. Continental and generational differences have militated against sustained comparisons of the two creative partnerships,[3] but manifold affinities in their approaches as participant observers and modernist bookmakers warrant a transatlantic analysis that might point to the influence of *Famous Men* on European as well as American depictions of the rural poor.

From among the many empathic annals of places and people slighted by modern society, these unclassifiable projects are set apart by several elements, foremost by the equal weight they accord to images and words. Both pairs of coauthors devise innovative methods for conjoining photography and writing. Both worry over the effects of their pictures and text on their subjects, while pondering how their distinct yet coordinated mediums might affect viewers and readers who share their perspectives as privileged outsiders. Visually and verbally, their books

bristle with two overarching tensions. One concerns whether they identify with their protagonists more for coming from the country or for persevering amid poverty. Lamenting the vulnerabilities of rural impoverishment, Agee, Evans, Berger, and Mohr nevertheless celebrate a commonplace beauty or tenacity bound up with rustic simplicity, if not penury. The second chief friction they generate is between the duties of witness and artistry. An ethical imperative to bear witness for the exploited without inflicting further exploitation rubs against an aesthetic ambition to transform the poor's struggles into art. Hence the paradox of striving for vividness while being scrupulous about reproducing reality, which is tied to the paradox of writers who venerate the imagination yet valorize photographic objectivity, catalyzes ingenious representational techniques.

Agee and Evans investigated cotton sharecropping for *Fortune* magazine in the summer of 1936. After a few false starts, they focused on three interrelated families of white farmers—later given the pseudonyms of Gudger, Woods, and Ricketts—in Hale County, Alabama.[4] What began as a journalistic assignment morphed into an exhaustive purification of the Depression-era documentary genre: an excoriation both of its social purposes and its artistic aspects. Rejected as an article before being expanded into a book, this commercial failure soon fell out of print but, in the wake of Agee's premature death and posthumous fame, was reissued with twice the number of Evans's pictures in 1960. *Famous Men*'s photographs are an austere foil to its effusive text. These characteristics disclose not only the stylistic but also the temperamental bent of each contributor. In spite of the recalcitrant mood guiding both of them, their separate convictions caused crucial disparities in how they bore witness. Whereas Evans was agnostic, apolitical, urbane, unsentimental, and dispassionately devoted to his art, Agee was stirred by his Christian schooling and Communist leanings, as well as by longing for his lost southern roots, rancor toward his middle-class upbringing, disaffection with his citified lifestyle, and angst that language could never adequately render what he believed to be the essential holiness of actuality, all of which underlie his self-tortured scrutiny of the tenants' environment and consciousness.

In contrast to the inherent yin and yang of Agee and Evans, Berger and Mohr are much more likeminded. While the writer is more outspoken politically, both he and the photographer have doggedly adopted a left stance in line with the tenets of revolutionary socialism. Yet both Berger and Mohr meanwhile harbor romantic or atavistic instincts that swerve from the dialectical materialism and historical progress of classical Marxism, thus drawing them less avidly to the proletariat than to the peasantry. Albeit city-bred, they are both enamored with nature, village life, and small-scale agriculture. Their own experiences of self-imposed exile and social activism (Berger) or world travel and humanitarian relief work (Mohr) give them transnational points of view and reinforce their solidarity with the uprooted or disinherited. They overlay their secular groundings, outrage at economic inequity, and emphasis on manual labor with a mystical humanism that imbues their acts of witness and artistry with simultaneous urgency and timelessness.

Berger and Mohr first worked together in the mid-1960s. Their book *A Fortunate Man* is an intertwining photographic and novelistic essay about a doctor's practice among poor foresters in southwestern England. Anticipating his own rapport with French peasants, Berger says that Dr. John Sassall, besides treating his patients skillfully, serves as "the objective witness of their lives" and "the clerk of their records."[5] The writer's conclusion is troubled by his sensitivity, like Agee's, to the dilemma that his subjects are not fictional characters but actual people, and to the contradiction that the society they live in promulgates individualism (self-aggrandizement) yet devalues individuality (personhood). In *A Seventh Man* Berger and Mohr attack the oppressive foundation of this capitalist economy by relating it to the experiences of migrant workers who depart from Europe's underdeveloped southern villages to toil thanklessly in its industrialized northern cities. Maintaining, as does Agee, that his partner's photographs are not illustrative but coequal with the text, Berger affirms mutual autonomy as well as symbiosis between images and words. He and Mohr amplify this concept in *Another Way of Telling*, coupling wordless pictorial sequences with theoretical conjectures about purely visual narration and anecdotal reminiscences that reveal quandaries both behind and beyond the camera. They address readers

in softer strains of Agee's strident appeals for cooperation in his attempt to convey the living textures of tenant farming. Furthermore, they work closely with their protagonists: peasants among whom Berger had dwelt since 1974, when, already an expatriate from Britain, he took up residence in France's mountainous Haute-Savoie, just across the border from Mohr's hometown of Geneva.

In what follows I delineate the broader contours of what Berger refers to as "a fraternal relationship" between himself and Agee.[6] Not just in their collaborations with Evans and Mohr but also throughout their writings, both men of letters promote multidimensional ways of seeing that might reconcile the discrete vantage points of eye and heart, pen and lens, memory and reverie. Each an adroit poet, storyteller, novelist, screenwriter, and documentarian, in addition to Agee's vocations as journalist and film critic and Berger's as essayist and art critic, their versatility has sometimes led to misapprehension or underappreciation. Yet their oeuvres are as rich as they are varied. More than most writers, Agee and Berger interrogate their pathways from perception to communication, asking themselves how much "reality" can really be seen and whether "truth" can truly be told. Although skeptical about the truthfulness of words due to verbal tendencies toward abstraction and bias, they persistently seek to transcribe appearances of real life captured within or glimpsed beyond the borders of still images. Personal, political, religious, and artistic factors impel Agee and Berger toward intimacy with disadvantaged or displaced country folk, who have suffered not only from poverty and injustice but also from impoverished or unjust portrayals. Despite being on guard against idealization, these writers uphold the authenticity of working-class experiences and material deprivation. Self-reflexively probing their penchant for primitivism, they do not sentimentalize so much as heroicize their subjects. Agee's and Berger's ways of seeing tenants and peasants ultimately engender intricate means of praising the rural poor, transforming moments of witness into monuments of artistry and moving those on the margins of modernity to the center of moral consciousness.

Even though the writers' careers only overlapped briefly, two months before his death in 1955, Agee left a tantalizing suggestion in a letter to

Father Flye that he may have read some of Berger's articles in the *New Statesman*, to which the Londoner regularly contributed art criticism during the 1950s. Approving of the British periodical without singling out any of its columnists by name, Agee pinpoints a trait that has always marked Berger's tone, even when sententious or polemical:

> [T]he pleasure is that even when they do special pleading, the lack of shrillness leaves you your own mind, with a sense of courtesy intact between you and the writer, and the thing or person written about,—by *courtesy*, I mean also, a clear sense of mutual assumption that all three parties, however disagreeing, hold the fundamental standards of intelligence and humaneness in common. This will no longer often be found in the United States, as a matter of habit, in print.[7]

Regardless of whether he had Berger specifically in mind, this transatlantic assessment signals Agee's shared determination to transmit his ideas in a forum analogous to an equilateral triangle among writer, reader, and subject. Berger's *Pig Earth* (1979), the first volume of his trilogy *Into Their Labours*, a fictional chronicle of peasants on the move from village to metropolis, hopes to preserve "the dignity of the reader, the experience communicated, and the writer."[8] Similarly, Agee's 1942 debut as an "amateur" movie reviewer for *The Nation* pledges "to use this column about moving pictures as to honor and discriminate the subject through interesting and serving you who are reading it."[9] Although in other platforms, such as at the start of *Famous Men*, Agee could be deliberately shrill and discourteous, and although Berger's early pieces could be quite combative, both writers nonetheless set out, intelligently and humanely, to plumb the tensions between ethics and aesthetics framing all of their literary ventures.

In terms of mechanics, however, their prevailing styles are strikingly disparate. Whereas Agee's is full of long, winding sentences, unconventional punctuation, and baroque descriptions larded with adjectives, archaisms, and neologisms, Berger's is characterized by short declarative statements, fastidiously selected details, and a more sparing or less

tormented authorial presence. In spite of the former's verbosity and the latter's pithiness, their prose, comprising the bulk of each writer's output, cultivates a dialogue with poetry. Not only does poetic language enhance their aesthetic strategies, shaping the rhythms and images of their prose, but it also strengthens their ethical commitments, grounding their identification with the material at hand.

Just before Agee's twenty-first birthday, the precocious Harvard junior wrote to Father Flye that he wanted to formulate an "amphibious style—prose that would run into poetry when the occasion demanded poetic expression."[10] Two years later, in an unsuccessful application for a Guggenheim fellowship to support his work on "John Carter," a satire on Byron's *Don Juan*, one of Agee's ten objectives was to "bring back into poetry a sense of dramatic and narrative (as well as lyrical) vigor and resourcefulness which now, for the most part, is found at its best only in prose."[11] Although he would in fact do his best writing in prose, at this stage, unfulfilled by his job on the staff of *Fortune*, Agee was still tapping into his resources of rhyme and meter to turn out lyrics and sonnets soon gathered for *Permit Me Voyage* (1934), the sole collection of his poetry published during his lifetime. In an unused preface drafted partly as a mock self-review, he dubbed himself an "over-self-conscious and exceedingly ambitious poet,"[12] yet dismissed the majority of his poems as rarefied or imitative. Such flaunting of the gap between intentions and performance became a cornerstone of his anti-artistic façade in *Famous Men*, his "antagonism toward art" in favor of the "dignity of actuality" (198). After another few years as a reluctant reporter, Agee confided to his journal, while struggling with the reconstruction of his recent experiences in the South: "I am so griped that this Alabama book is not poetry (which it should not be) that it's hard to keep writing it."[13] Despite his vexed recognition that the book must be composed in prose, many of its pages experiment amphibiously with the elastic syntax and poetically expressive vocabulary he first tried to merge in college.

Compared with Agee, often eulogized as a poet albeit mainly remembered for his prose,[14] Berger's poetic legacy seems less pivotal. As if to underscore that his writing is better suited to discursive forms, in *Pages of the Wound* (1996), his only book made up primarily of poetry, he remarks, "Poems are born of a sense of helplessness."[15] By helpless, how-

ever, Berger does not mean inept or futile. Instead, when dismayed by the intransigence of facts, he claims that poetry provides him with the supplest outlet for resistance. *And Our Faces, My Heart, Brief as Photos* (1984) contains some insightful distinctions between prose and poetry which elucidate why he gravitates toward the latter when overwhelmed by facts or feelings of fragmentation. Language, avows Berger, can restore a sense of wholeness because "it is potentially the only human home, the only dwelling place that cannot be hostile to man. For prose this home is a vast territory, a country which it crosses through a network of tracks, paths, highways; for poetry this home is concentrated on a single center, a single voice."[16] While Berger's conception of poetry sounds more hospitable to lyric than to epic voices, he stresses its contemporary role as a refuge from ubiquitous cruelties and indifferences. Historically, most social protests have appeared in prose, appealing to reason in order to unearth injustice and alleviate suffering, but Berger thinks "more and more it will be poetry, rather than prose, that receives this truth. Prose is far more *trusting* than poetry; poetry speaks to the immediate wound."[17] What he calls "the labor of poetry" is its ceaseless task to invest language with caring, thereby "reassembling what has been scattered" by violence or separation.[18] Glued throughout his books, Berger's occasional verses assemble scraps of imagery, metaphor, and emotion that cannot be accommodated by his forceful prose. Though largely less memorable than his paragraphs and aphorisms, they perform a gentling or hallowing function upon the totality of his writing. "Poems are nearer to prayers than to stories,"[19] says this storyteller, whose poetic petitions, like his drawings, fill the interstices of his creations with faith in a healing balm that prose may be powerless to impart.

For all their love of language, both writers are heedful of its limitations. While attuned to its musical qualities, Agee also toyed with compiling a dictionary of key words to be "examined skeptically in every discernible shade of their meaning and use," so as to point up "the ambiguity of language."[20] This proposal was just one among forty-seven that he submitted with his second rejected Guggenheim application in the fall of 1937. Topping his list was "An Alabama Record," intended to maintain "as total a suspicion of 'creative' and 'artistic' as of 'reportorial'

attitudes and methods, and . . . likely therefore to involve the development of some more or less new forms of writing and of observation."[21] *Famous Men* indeed exhibits such rhetorical innovations, with heightened if intermittent wariness that language may not only be ambiguous but also deceptive. Hence Agee's frequent use of scare quotes around words whose definitions might be taken for granted, his mordant differentiation of "tenant" from "sharecropper," and his long list of freely associated, commonly unexamined "anglosaxon monosyllables." Words, he rues, "are the most inevitably inaccurate of all mediums of record," and they are hampered by their "inability to communicate simultaneity with any immediacy" (191). A relish of paradox pervades his frustrations with language. "Words cannot embody; they can only describe," Agee concedes, but he strives to give them "an illusion of embodiment" (192). In spite of his self-admonishments about description, he is bursting with descriptive exuberance, prompting him to reconsider "that the lust for describing . . . is not necessarily a vice. Plain objects and atmospheres have a sufficient intrinsic beauty and stature that it might be well if the describer became more rather than less shameless" (193). Unashamed of finding ordinarily overlooked things beautiful and cataloging them to excess, as he does in "Shelter" and "Clothing," Agee wishes that his words could outdo what all words can only do, could embody all at once what they can only describe one by one.

Berger echoes these hesitations in his novel *G.* (1972), which, like many of his fictional works, shares Agee's propensity in *Famous Men* to interrupt dramatic scenes with didactic commentary on the aesthetic and ethical predicaments of literary representation. "Description distorts," Berger states.[22] When trying to embody all the sensations of a woman making love to his Don Juan hero, he admits, as if relieved by his shortcomings: "Armed with the entire language of literature we are still denied access to her experience."[23] While this denial of his verbal arsenal may seem dubiously portentous, Berger does not wear his inadequacy as a badge of false modesty, at least not to the extent that Agee does. Rather, the author of *G.* frankly scrutinizes his efforts to limn others' experiences. Even in his ostensibly more analytical than imaginative writing, Berger demonstrates that the ethical exigencies of criti-

cism or documentary can be made more manifest via aesthetic devices, from the startling similes that accentuate his essays on art and politics, to the poignant vignettes of encounters between doctor and patients that precede his hardheaded logic in *A Fortunate Man*, to the poems and fragmented storyline and snippets of dialogue that complement his rigorous argument in *A Seventh Man*. In that book, inveighing against capitalist dependence on migrant labor, Berger justifies his figurative moves: "Yet necessarily the language of economic theory is abstract. . . . Metaphor is needed. Metaphor is temporary. It does not replace theory."[24] Of these lines, Geoff Dyer complains, "The terseness of his prose lapses into an inverted rhetoric of understated grandiloquence. There is a pomposity of brevity as well as of loquacity. Full stops salute the passing of each sentence."[25] If Berger is prone to pompous brevity, then Agee, who hoped "to suggest or approximate a continuum" by experimenting with the "maximum-suspended periodic sentence,"[26] can be accused of pompous loquacity. Notwithstanding their rhetorical predispositions to understatement or overstatement, both redeem themselves by remaining fiercely attentive to the distortions and insufficiencies of their own undeniable gifts with words.

How do they turn their verbal talents toward the troublesomely vague and abstract goals of seeing reality and telling truth? Throughout their writings, especially in their collaborations with or reflections on practitioners of the visual arts, Agee and Berger both traffic in abstractions and seek to concretize them through specific illustrations that might make their meanings less elusive. For them, seeing encompasses that which is discerned not only by the eyes but by the other sensory organs, as well as by the faculties of reason, memory, imagination, and empathy. Likewise, to their minds, the instrument of telling might be a camera (or a piano or a paintbrush) instead of a pen. Depending on the user, Agee notes in his 1946 essay for Helen Levitt's *A Way of Seeing: Photographs of New York* (1965), the camera has a singular power either "to develop and to delight" or "to defile and to destroy" the sense of sight.[27] According to Agee, those few photographers who rise above their mechanism's ill uses refrain from artiness while aiming "to perceive the aesthetic reality within the actual world."[28] Berger, too, is loath to consider picture-taking as

a fine art. Indeed, he rather blandly deems photographs "no closer to works of art than cardiograms."[29] Berger makes this comparison to refute the more prevalent and, in his judgment, mostly misleading one between photographs and paintings. Both drawing and painting, he posits in *Another Way of Telling*, translate visible entities into established pictorial languages; every mark or stroke on paper or canvas is entirely "mediated by consciousness" and informed by a systematic visual grammar.[30] By contrast, "photography has no language of its own,"[31] and so it merely quotes from whatever appears before the lens by recording traces of light onto film, no matter how culturally constructed the process of framing, printing, cropping, and displaying the pictures may be. Even if photographic quotations are fairly "weak in intentionality,"[32] Berger speculates that exceptional photos of unknown subjects can be more moving than those of loved ones because they fulfill the desire for revelation intrinsic to all acts of looking, prolonging the meaning of a frozen moment by illuminating correspondences to the viewer's past experiences. Thus, while downplaying the artistry in photographs, he hypothesizes that they might be artfully arranged in sequences or montages to forge a narrative form akin to the workings of memory.

For all his theorizing about photography, Berger, like Agee, subscribes to unsurprising propositions that the best photographs are made through intuition, not intellection, and that the maker's eye is decisive to their truthfulness. Both writers question the truth-telling pretensions of photographer Margaret Bourke-White, whose popular book *You Have Seen Their Faces* (1937), an exposé of southern sharecropping coauthored with Erskine Caldwell, in part instigated the angry iconoclasm of *Famous Men*. In one of its appendices Agee reprints a newspaper profile of Bourke-White in which she postulates that an assortment of pictures about a given situation furnishes the squarest truth because photography is more objective than writing. In *Another Way of Telling*, Berger cites a similar statement by Bourke-White. Despite granting that he admires her photographs and those of her contemporaries who "helped to alert public opinion to . . . the degree of rural poverty in the United States in the 1930s," Berger contends: "Yet to believe that what one sees, as one looks through a camera on to the experience of others, is the 'utter truth'

risks confusing very different levels of the truth."[33] He asks rhetorically, "[H]ow does a photograph tell the 'utter truth' about a man's experience of hunger or, for that matter, his experience of a feast?"[34] Lacking its own language, the photograph therefore lacks the agency to interpret and defend itself. However, "as soon as photographs are used with words, they produce together an effect of certainty, even of dogmatic assertion,"[35] at once seeming to authenticate ideological positions and to confirm the irrefutability of photographic evidence. Consequently, says Berger, "in public the ambiguity of photographs is hidden by the use of words which explain, less or more truthfully, the pictured events," even though the subjective correspondences suggested by these events may be "too extensive and too interwoven to enumerate very satisfactorily in words. (One cannot take photographs with a dictionary.)"[36] Yet one cannot readily parse photographs without a dictionary. Berger proposes that, kept apart from words, "photographic ambiguity . . . could offer . . . another way of telling" about human experience,[37] but he nonetheless relies on words to clarify how this means of communication might operate. Agee likewise goes on writing in spite of misgivings over his medium's duplicity and inexactness. In *A Way of Seeing*, though wanting to evade an explicit "attempt to discuss the 'meanings' of the photographs," he realizes that "we are all so deeply caught in the tyranny of words, even where words are not needed, that they have sometimes to be used as keys to unlock their own handcuffs."[38]

Paralleling these writers' uneasy captivation with photography, their collaborators are attracted to yet chary of language for its sweeping yet abstracted representations, its tyrannical yet liberating capacities. Inspired by their associations with Agee and Berger, Evans and Mohr value writing as a counterpart to their self-taught craft, but they adhere to image-making as their primary way of seeing reality and telling truth. Even though Evans took up the camera to pursue aesthetic aspirations, while for Mohr ethical ones were paramount, tensions between witness and artistry (as with those between verbal and visual expression) are nevertheless regular features of both photographers' careers.

Like Evans, who flirted with youthful literary ambitions, Mohr did not set out to be a photographer but came to learn the trade slowly yet

deftly on his own. Also like Evans, though differing in receptiveness toward their respective institutional affiliations, much of Mohr's later productivity was tied to political bodies with photographic units that hired them to document relief programs but allowed them to transcend publicity shots. In 1949, while serving as an International Red Cross delegate on a mission to aid Palestinian refugees,[39] Mohr procured a camera and started to keep a pictorial notebook for the weekly letters he had promised his father. "I discovered that in one or two minutes I could say more about my work and environment than in pages and pages," he relates, so Mohr stopped writing and just sent pictures home.[40] Back in Europe he studied painting in Paris, where Evans had studied literature a quarter-century earlier, but friends persuaded Mohr to hone his photographic aptitude. Establishing himself as a freelancer based in Geneva, many of his subsequent forays with the camera were commissioned by branches of the United Nations, focusing on humanitarian crises and development issues. Although Mohr has always been ambivalent about rifts between global policies and local traditions revealed by his assignments, he was never as standoffish with his sponsoring organizations as Evans was with the Farm Security Administration, under whose auspices he took some of his finest photographs, including those used in *Famous Men*. Having sworn to himself that he would "never make photographic statements for the government," Evans aloofly protected his artistic freedom while on the staff of this New Deal agency, provoking his dismissal in 1937.[41]

Indicative of Evans's self-assurance, he typically minimized textual apparatuses around his pictures whenever they appeared in book form.[42] Prior to any words, even to the title page, *Famous Men* opens with his uncaptioned photographs: thirty-one in the first edition, sixty-two in the second. For the latter he also added an appreciation of his deceased collaborator. Despite the import of these contributions, in hindsight Evans felt he had "come into too much prominence on the tail of Agee's genius."[43] Awed by his friend's prose, albeit disapproving of Agee's unbridled subjectivity, Evans refused to assist him in editing the manuscript.[44] Their ways of seeing on the page would thus conform to their independent ways of witnessing in Alabama, where, as Evans remem-

bered, "[W]e worked intensely, separately. I didn't see much of Agee. He was working all day, interviewing and taking notes, and I was photographing. . . . We left each other alone."[45]

Mohr says something comparable about his longstanding partnership with Berger: "[W]e work together, but first each one is doing his own work."[46] Of *A Fortunate Man*, Mohr recalls that they each tried to do too much at first, such that Berger reacted violently on viewing several hundred of Mohr's prints, exclaiming that a single shot could outstrip the representational force of many words yet, at the same time, setting aside more than half of the photographs for being overly arty.[47] Berger corroborates Mohr's tale of mutual noninterference and eventual compromise, reflecting that in their books they "have needed a shared sense of measure in order to create pages which flow. . . . What so often checks any flow, when images and text are used together, is tautology."[48] This sense of measure—of verbal and visual ingredients being mixed proportionately, following a flexible trial-and-error recipe—infuses their pages with a dual flavor of surety and improvisation. Berger compares their manner of making *A Seventh Man* to "a concoction" by two chefs in a kitchen "with about ten pots on the stove all the time," he and Mohr dipping into them to sample "different juxtapositions of pictures with different bits of text," deciding which ones fit together most tastefully and least repetitively.[49] The hybrid dish they finally cooked up is seasoned with the sophisticated formal play of a lively conversation between writer and photographer. *Another Way of Telling* enriches their dialogue as they partially swap roles; Berger includes a few of his snapshots, and Mohr contributes some of the writing. "I often feel the need to explain my photos, to tell their story," Mohr comments. "Only occasionally is an image self-sufficient."[50] As opposed to Evans's preferences, Mohr therefore willingly surrounds his pictures with proximate text.

The people Agee and Berger write about, as with those Evans and Mohr photograph, tend to be poor. To what extent are these artists wary that their innate responsiveness to underclasses might color their ways of seeing individuals? Berger proclaims his "gut solidarity . . . with the underprivileged,"[51] yet Agee frets over the "inverted snobbery" of his "automatic respect and humility toward all who are very poor."[52] How,

then, do they adjust their presuppositions about poverty after facing and at times befriending members of downtrodden groups? Moreover, as witnesses who constantly keep an eye on aesthetic possibilities, how do they confront their rights and responsibilities to represent those whose experiences may have been underrepresented or misrepresented? Grappling with such questions requires them to invent ethically accountable forms with which to depict and assess the poor's hardships, fortitude, and praiseworthiness.

Neither Agee nor Evans, though each abhorred social injustice, ever regarded his creative aims as reformist, believing that uplift was not the purpose of art. "I do have a weakness for the disadvantaged," Evans confessed, "but I'm suspicious of it. I have to be, because that should not be the motive for artistic or aesthetic action."[53] Both he and Agee worried that an overweening respect for the poor might lead to spurious likenesses of them, shot through with mawkishness, or else to facile pleas for their socioeconomic betterment. To circumvent utilitarian advocacy, Agee sprinkles *Famous Men* with jests at liberal reformers.[54] As for falling prey to sentimentality, the photographer always prided himself on maintaining disinterestedness toward his subjects, no matter the depth of their misery,[55] but the writer found it harder to stay detached, often descrying virtues in the indigent presumed to be absent among the comfortable. Hence his adulation of unintended beauty in the farmers' houses, clothes, faces, and gestures.[56] In a piece about Brooklyn drafted while he was still tinkering with his tenant book, Agee scans ethnic neighborhoods and surmises "that all street and domestic art is talented and powerful in proportion to poverty and disadvantage of blood."[57] Similarly, he lauds Levitt's photographs of poor people, perceiving in their dress and behavior "more spontaneity, more grace, than among human beings of any other kind," whereas "weeds and cactuses" outnumber flowers in the soil of higher classes.[58] Agee's inverted snobbery reappears here, impelling him to exalt the vivacity of the poor over the aridity of the rich, just as he had idolized destitute sharecroppers in spite of his self-imposed injunctions against such involuntary esteem.

Unlike Agee and Evans, Berger and Mohr are not as apprehensive that partiality for one class might undermine their aesthetic judgment

or their ethical alignment. Thus they more openly side with the poor while striving to unite witness and artistry. In *Another Way of Telling*, Mohr recounts a railroad journey across Java. While other passengers ignored the sprawling humanity outside the closed windows, he could not bear to look away from the "squalid poverty" of a slum on the outskirts of Jakarta, which struck him, like other shantytowns he had seen the world over, as the "tragedy of a city smothered by the daily influx of peasants trying to live somewhere."[59] The countryside they had deserted was direly impoverished. As the tracks wound into the hills, Mohr saw "emaciated children running barefoot the length of the train," begging for handouts.[60] Haunted by their unheeded entreaties, on the return trip, ensconced behind his camera at the window, he photographed these children, hoping that pictures, "the only homage I could offer them," might release him from his obsession with their desperate hunger.[61] Since neither Mohr nor anyone else gave them any alms, however, his aesthetic solution does not truly mitigate his ethical horror, as he signifies by titling this subsection "A Doubtful Exorcism." Berger likewise doubts whether ethics and aesthetics can ever be harmonized in representations of the poor, but he never doubts his loyalty to the disempowered, arguing that "we can only make sense of art if we judge it by the criterion of whether or not it helps men to claim their social rights."[62] This credo energizes not only his essays and documentaries but also many of Berger's fictional portrayals, from the embattled peasants of *Into Their Labours* to the evicted squatters in *King* (1999) to the undaunted prisoner in *From A to X* (2008). As a storyteller he has channeled multifarious voices of the poor while refusing to countenance "the revolting complacency which accepts poverty as an ordained component of the human condition."[63] Infuriated that in consumer economies "the modern poor are not pitied—except by individuals—but written off as trash,"[64] Berger demands a cross-class camaraderie that will support them in claiming their legitimate social rights.

Empathy with those who endure poverty, sparked by artistic investment in their liveliness and moral indignation at their wretchedness, ranges across the human spectrum for Agee, Evans, Berger, and Mohr, extending to urban as well as rural inhabitants. But the works that bind

these cosmopolitan collaborators most notably either take place in the countryside or chart the fates of people forced to abandon the land. In short, the authors' attraction to the poor dovetails with their anxiety about modernization. For the two writers especially, the folkways of agricultural laborers or peasant villagers offer a revitalizing alternative to their own disenchantment with metropolitan society. Agee recognizes within himself "essentially 'peasant' as against urban feelings,"[65] while Berger avers that "after years in a city, a man can fall in love with a mountain village and decide to build a cabin there."[66] Rusticating to so-called "backward" communities devoid of "civilized" trappings, they shy away from their countervailing enthusiasm for modern enticements.

Although Agee resided almost all of his adult years in New York City, he always felt pulled toward the country. As Evans recollected in 1960, "Backcountry poor life wasn't really far from him, actually. He had some of it in his blood, through relatives in Tennessee."[67] The Knoxville native's "variable" accent thus "veered towards country-southern" to ingratiate himself with the Alabama tenants.[68] Whereas the more genteel Evans preferred to sleep at a hotel in their county seat, Agee "sweated and scratched with submerged glee" on their farms, thrilled to have fled "the whole world of high-minded, well-bred, money-hued culture."[69] Throughout his life he sought to escape Manhattan and connect with rural settings reminiscent of his paternal grandparents' place, retreating to the New Jersey countryside to recapture his Alabama excursion and later purchasing a farm near Hillsdale, New York, where he would be buried. Yearning to fathom if not resurrect his tragically shortened bond with his father, whose demise in a car wreck while driving between his rural birthplace and Knoxville would trigger Agee's posthumously published novel *A Death in the Family* (1957), he wrote to his psychoanalyst that his father, even though he "emerged into a bugging mediocrity, in the city, never lost his love or allegiance towards the country."[70] Agee's own passion for the land, while rendered most extravagantly in *Famous Men*, crops up across his literary terrain, from the early poem "Ann Garner" (1928) to the late fable "A Mother's Tale" (1952). After his freshman year at Harvard he bummed around in the countryside and tried his hand at farm work, "hauling and scooping grain" on a migra-

tory harvest crew in the Great Plains, experiences he fictionalized in undergraduate stories.[71] Furthermore, presaging the ardor for rural themes often expressed in his book and film reviews,[72] Agee's *Fortune* articles on the Tennessee Valley Authority, a drought in the Dakotas, regional painters, and rustic customs like cockfighting all attest to his nostalgic predilection for "the lonely rural stretches which are still America": unmodernized geographic pockets that he could cherish "until some remote time when the nation turns wholly urban."[73] For him this pastoral sanctuary was centered in the South, the region he refers to as "this colossal peasant map" in *Famous Men* (8).[74]

Few followers of the first half of Berger's career, which revolved around high art, urban culture, and radical politics, could have predicted that he too would "turn peasant," forsaking the maelstrom of modernity to relocate among relatively primitive people, upholding their authentic relations to nature, place, labor, animals, and one another.[75] However, Berger's rural proclivities are rife in his earlier work. His art criticism, for example, hails Gustave Courbet, Jean-François Millet, and Vincent van Gogh for their intense identification with the peasantry.[76] By contrast, in *The Success and Failure of Picasso* (1965), Berger argues that eschewing the peasant worldview the Spanish painter had grown up beside precipitated his moral and artistic bankruptcy. Wishing to avert the trap he thought Picasso had fallen into by losing touch with his subjects after moving to France, Berger started to look farther afield for his own subjects, aware that, away from one's homeland, "you either feel increasingly exiled as time passes, or increasingly absorbed by your adopted country."[77] The seeds for this shift were planted, though, by Berger's return to England for his initial project with Mohr. Preparing the ground for their later immersion in peasant life, *A Fortunate Man* is suffused with views of forested landscapes and observations on village mores, as they trace Dr. Sassall's ties to a poor rural community where he presses his patients to be as hardy as the Greek peasants he had treated in World War 2. Traveling around mainland Europe, meanwhile, Berger and Mohr empathized with millions of foreign laborers —from Greece, Turkey, Spain, Portugal, Italy, Yugoslavia, and former overseas colonies—who propped up the Continent's advanced postwar

economies. *A Seventh Man* condemns this exploitative system without faulting the workers for seeking to better their lot by migrating abroad. While collaborating on this book, the authors became interested in the villages these migrants left behind. Resolved to bear witness to their vanishing culture, the writer, frequently visited by the photographer, resettled among the Alpine peasants featured and fictionalized in *Another Way of Telling* and *Into Their Labours*.[78]

Whether living with the rural poor for four weeks, as Agee did in west central Alabama, or four decades, as Berger has now done in southeastern France, both extol marginalized farmers for exemplifying a way of life at odds with consumerism. Agee's briefer stay with his subjects may make his fellowship with them appear more contrived, but he cleaves to them with zealous imaginativeness in part to compensate for a cleavage with his caste that runs as deep as Berger's. Reacting against middle-class values that constricted the writers' childhoods[79] and incited their lifelong assaults, Agee reproves "the inability of the benevolent bourgeois to understand the very poor,"[80] and Berger lambastes "the injustice, hypocrisy, cruelty, wastefulness and alienation of our bourgeois society."[81] Though diverging in tactics, their cultural criticism shares this target, from Agee's satirical pieces on orchids and tourists[82] to Berger's polemic against the abuses of European art in *Ways of Seeing* (1972).[83] Repulsed by capitalism's pitiless moneygrubbing, they find themselves rejuvenated by contact and communion with hardscrabble farmworkers.

Although neither writer ever joined the Communist Party, their animus toward the rich is rooted to differing degrees in Marxist ideology. While Agee was an irresolute revolutionist who therefore redoubled his artistic exertions, Berger remains a staunch socialist for whom the duties of art bolster those of politics. But to neglect Agee's politicization, or to overstress Berger's, is to misconstrue both their maturity and their malleability. Berger may seem more politically mature and Agee more politically malleable, but each evinces an intellectual's contrariness. Accordingly, they caution that revolutionary doctrines must be weighed against historical contingencies, that the fight to abolish inequalities can be stymied by internal quarrels, that Marxist solidarity with manual workers does not necessarily embrace the rural poor, and that class

struggle should not negate the merits or idiosyncrasies of individual experience.

Agee's most hotly politicized period, followed by his steepest withdrawal from politics, coincided with his writing of *Famous Men*. Its text, in fact, discloses his shift, during the five years he spent composing it, from a radical leftism to an anarchic individualism, from declarations of Communist principles to denials that they can be practically implemented.[84] As with his ambivalence about art when assaying actuality, Agee's convoluted feelings toward communism stem from a disparity between what he believes would benefit humankind and what he perceives to be the real workings of politics. Irritation over this discrepancy wells up in one of the four dozen proposals he tossed off soon after beginning his "Alabama Record." Plans for an "Anti-communist manifesto" start out bizarrely pro-Communist but quickly switch to conjecture on current deficiencies in leftist agendas.[85] Although he never wrote this contradictory manifesto, Agee obliquely alludes to it in an epigraph for *Famous Men*, paraphrasing the rallying cry of *The Communist Manifesto* yet undercutting it in a footnote that short-circuits any factional attachments. His political equivocations are a consequence of his personal experiences and his artistic temperament, both of which reroute him toward an autonomous aestheticism that nonetheless unexpectedly enunciates an ethical standpoint. During the mid-1930s, disgusted with commerce after "three years of exposure to foulness through *Fortune*,"[86] Agee forecast a class war in which "inevitably, government and capital stand together against labor."[87] Aspiring to stand with laborers, he drafted a number of darkly humorous proletarian poems—most of them later excluded from and only recently restored to his canon—advocating the violent overthrow and replacement of state-backed liberal capitalism by a bucolic utopia.[88] Assigned to research sharecropping shortly after penning these topical verses, Agee was set to prove his proletarian sympathies. He initially sought out labor organizers with contacts in Alabama and planned to analyze the efforts of southern unions as well as government agencies to ameliorate conditions among cotton farmers.[89] Agee's sojourn in the South, however, culminating in his passionate identification with three

particular tenant families, edged him away from partisan movements of any stripe, toward a pessimistic, individualistic outlook. By 1938 he deemed himself "essentially an anarchist" and "a frenetic enemy against authority"; in 1940 he pronounced paradoxically: "If I weren't an anarchist I would probably be a left-wing conservative."[90] Agee's perplexity over politics turned him back toward his gift for poetics, as his activism took the shape of a complex literary ethics and modernist aesthetics rather than a direct call for working-class revolution.

Berger's more consistently engaged and trenchant political writing originally appeared in the Communist press, but his "reservations about the party line in relation to the arts" prevented him, as with Agee, from becoming a member.[91] Committed firstly to creativity, Berger's concern for its societal function then spurred him to adopt adamant political convictions. "Far from my dragging politics into art," he asserted in 1953, "art has dragged me into politics."[92] Parallel to Agee's barbs at the New Deal for its patronizing of the poor, Berger professes himself "immune to the apologetics of liberals. Liberalism is always for the alternative *ruling* class: never for the exploited class."[93] Molding "a pocket of resistance"[94] to neoliberal economic globalization and indiscriminate wars against terrorism, Berger's essays and fictions have commiserated with the "undefeated despair"[95] of indigenous or dispossessed peoples, such as the Zapatistas and the Palestinians, leading him to reaffirm in the twenty-first century that he is "still amongst other things a Marxist."[96] His ideology, however, as hinted at by the "other things" constituting his eclectic perspective, has never been rigidly conventional. Calling himself "a bad Marxist" in 1984, he expounded on his "aversion to political power whatever its form."[97] For Berger, lived experience is much more valuable than conformity to revolutionary mandates. "Marxism cannot draw a line under the centuries' experience of the poor and thus close the account," he maintains, "as if thereafter this experience were no more than an anomaly."[98] Since the mid-1970s, Berger's Marxism has been anomalous due to his concentration on the peasantry instead of the proletariat. In *A Seventh Man* he disputes a notorious passage from *The Communist Manifesto*, which pays little heed to the wisdom of subsistence farmers. Berger alleges: "About the idiocy of rural life Marx exaggerated," in that "he overestimated the capacity of urban rationality, and

judged the village by the standards of the city."[99] Berger's peasant trilogy delivers a thorough rejoinder to metropolitan judgments. Villagers "do not *play roles* as urban characters do," he remarks in *Pig Earth*; they harbor few personal secrets "not because they are 'simple' or more honest or without guile," but because the space for deceitfulness and ostentation is restricted by their plainspoken, pragmatic dealings with their neighbors.[100] Todd Gitlin comments on Berger's risky ideological deviation: "For orthodox Marxism as for capitalism, peasants are momentary obstacles on the speedway to the rational future. The upshot has been either neglect or a romanticism in which urban intellectuals turn Marx's slogan on its head, celebrating the happy genius of rural life."[101] Mostly avoiding such facile celebrations, yet infusing his tales with romantic elements, Berger's unorthodox *Into Their Labours* redresses the disregard of peasants in the Marxist imagination.

Agee and Berger temper their political viewpoints with religious or spiritual impulses that motivate them to represent their subjects less as distressed socioeconomic victims than as sacred beings. Not only do both authors draw on holy writ for the titles of their major works, but they exercise prophetic ways of seeing that ascribe mystical properties to mundane substances. Their books resonate as elaborate praise songs to the rural poor, aesthetically apotheosizing those whom they ethically embed in the earth. Agee, looking into the eyes of a tenant farmer in *Famous Men*, discerns the "angry glory . . . of a furious angel nailed to the ground by his wings, or however else one may faintly designate the human 'soul'" (83). Berger's clairvoyant narrator in *Lilac and Flag* (1990), his trilogy's third volume, gives her blessing to "all the poor of the past and all the poor of the future, among whom there are many who go straight to heaven, if you want an old woman's opinion."[102] Indeed, in Berger's own estimation, most of the poor, by virtue of their resilience in adversity, are worthy of salvation, so that he, like Agee, is liable to forgive them their sins. Whereas Berger's moral imperatives and ardent quest for social justice are chiefly secular, however, Agee's notion of saintliness is an idiosyncratic slant on Christian beliefs, as fervent yet contrary as his short-lived Communist persuasions.

Echoing Agee's caveats about his inchoate writing style, film criticism, and politics, his self-characterizations as a religious amphibian,

amateur, and anarchist may conceal his serious engagement with spirituality. Although he drifted away from institutional religion in adulthood, much of Agee's work exudes a sanctified aura evoking his formidable Anglo-Catholic rearing.[103] Even when wavering in his faith, he retained "the religious consciousness"[104] that patterns his art and permeates his correspondence with Father Flye, not least during those years when Agee was also most politically conscious. Christ's teachings, he believed, were absolutely antithetical to the status quo, but they had been softened to accommodate "people with less spiritual energy," who failed to endorse their potential destructiveness to "the world as it is."[105] While apocalyptic messages reverberate in Agee's mid-1930s poetry, promising the poor's collective inheritance of a pastoral realm, he prophesied meager room for meliorating action through existing political or religious channels. Just three months before his trip to Alabama, Agee conflated these domains in "an intended sort of Christian-Communist morning hymn, as sung probably in America."[106] Imploring the "hundred million ruined souls" of his countrymen to awake from their spiritual malaise and shed their poisonous greed, he hoped they might learn "[t]he love of Jesus and the mind of Marx."[107] This merger of Christian compassion and Communist vehemence seeps into *Famous Men*, despite Agee's renunciations therein of church and party ties. At heart, his text is "an independent inquiry into certain normal predicaments of human divinity" (viii), or, as he makes clearer in an earlier draft, "an enquiry into human divinity, beset by certain normal circumstances of disadvantage."[108] Since his readers are unlikely to be as acquainted with material disadvantages, Agee would apprise them that living with privations is not abnormal for most humans, nor does it preclude such persons from sharing divine attributes. Borrowing some of the book's structure from Catholic liturgy, he presents several biblical extracts and derives his ironic, exhortatory title from an apocryphal hymn (Ecclesiasticus 44) honoring past generations of "famous" (closer to "pious" in the original Hebrew) men. Among the ancestors deserving of praise, according to this panegyric, are not only eminent personages but also those who left no memorial yet whose righteous deeds and steadfast seed shall not be forgotten. Agee's full "Title Statement" cunningly links himself, as one

who has "recited verses in writing," to his unheralded subjects, in effect establishing a literary "covenant" that "their glory shall not be blotted out . . . but their name liveth for evermore" (361).

Just as Agee rouses the reader to join him straightway in exalting unfamous farmers, so Berger invites imaginative participation in his peasant trilogy. He too invokes scripture for its overall title, taken from the Gospel of John: "Others have laboured and ye are entered into their labours" (4:38). The context is Christ's passing through Samaria, whose tribes were scorned by the Jews as inauthentic observers of the Torah. Metaphorically adapting an agrarian adage, Jesus counsels his disciples to reap the ripe fields others have sown, gaining converts by entering into their spiritual labors. Likewise in a foreign land, witnessing to marginalized people, Berger's title secularizes Christ's charge through his robust involvement in their physical labors. Rather than proselytizing, Berger himself seeks to be converted to their ethos. "The best way to get to know peasants," he says, "is not by talking but by doing things, working together."[109] His willingness to work alongside them has not only deepened his knowledge of the many tasks they perform—planting, digging, calving, milking, haying, feeding, herding, butchering, cheesemaking—but has also enabled him to gather in their talk and store away fodder for his storytelling. While his focus on materiality is congenial with his politics, he does not shirk his characters' inner lives. Certain critics have thus labeled him "a spiritual materialist" or "a romantic Marxist."[110] Around the time he was finishing *Into Their Labours*, the writer himself acknowledged his apparent paradoxes in an essay evaluating the 1989 collapse of Communist regimes across Eastern Europe. Since 1789, the economic basis of both bourgeois capitalism and its socialist opposition has vitiated religious values, yet Berger argues that "the spiritual persisted" through the implicit faith of "transcendent visionaries" who set their sights on a classless society.[111] Embracing this surrogate for religion, Berger also puts his faith in romanticism: another persistent if mutable form of spirituality during the previous two centuries. His application of the term can be regrettably loose, but to ignore the romantic strain in his work would be almost as imprecise as to ignore Agee's Christianity and to say simply that they are both spiritually

inclined. Ironically, Agee may be closer than Berger to the Byronic paragon of an unfettered, impetuous romantic, while Berger may be closer to Agee's romanticized conception of an uncompromising saint such as Francis of Assisi.[112] Nevertheless, Berger declares himself a romantic as well as a Marxist, without fussing over this dualism. The respective accents of these philosophies on personal and social dimensions of human experience appeal equally to his spirit. For all its material contours and tragic plots, Berger's trilogy not only chronicles the daily chores, threatened livelihoods, and perilous emigration of mountain peasants but also the dense web of memories spun around their friendships, intergenerational families, and turbulent affairs: the weathering of what he calls "the leather of love" in its second volume, *Once in Europa* (1987).[113] To convey the disruption of traditional communities and displacement of villagers, *Pig Earth* and *Lilac and Flag* both end with magical realist scenes encapsulating the loves and counteracting the losses of the books' resourceful heroes. Berger's incorporation of these fantastic incidents, sewing together spiritual and material fabrics to construct earthbound tapestries of the afterlife, bespeaks his multifaceted vision of reality.

In their roles as witnesses Agee and Berger both broach the hazards of testifying without condescension on behalf of rural dwellers and beleaguered toilers with whom they have initiated relationships. Prior to generalizing about the tenantry or the peasantry, they learn from particular tenants or peasants who happen to be their hosts or neighbors. Earnest about being participants, not just onlookers, the writers vigorously immerse themselves in their adopted agrarian locales. Concerned that the portrayal of friends may dissolve into a betrayal of trust if the representation of poverty implodes into a poverty of representation, they take on their ethical obligations and aesthetic challenges with a gravity of conscience matched by bottomless curiosity.

Written by an artist who gleaned his material as a journalist only to vociferously disavow both art and journalism, *Famous Men* is the impassioned yet cagey testimony of a keen witness who fancies himself a contrite spy. Smitten with his own perceptiveness but ashamed of the espionage required of him, Agee fluctuates between self-inflatedness and self-castigation while observing the conditions of tenant life. Reverently, remorsefully rummaging through the temporarily empty Gudger

house, as if compelled to extend his senses against his will, he remarks, "I am being made witness to matters no human being may see" (114). For whom does Agee bear witness, and to whom does he address his findings? His preamble broods over the circumstances that led him and Evans

> to pry intimately into the lives of an undefended and appallingly damaged group of human beings, an ignorant and helpless rural family, for the purpose of parading the nakedness, disadvantage and humiliation of these lives before another group of human beings, in the name of science, of "honest journalism" (whatever that paradox may mean), of humanity, of social fearlessness, for money, and for a reputation for crusading (7)

Repudiating the principles, profits, and prestige of a profession he worried might eclipse his calling as a poet, Agee prefers to dwell on the coauthors' "human responsibility," on "the strange quality of their relationship with those whose lives they so tenderly and sternly respected, and so rashly undertook to investigate and to record" (8). Although Evans later asseverated, "In making pictures of people no harm is being done to anybody or deception practiced,"[114] Agee feared that their acts of witness were indeed harmful, that even if used artistically instead of journalistically, their visual and verbal records might disfigure the three families they had initially deceived or embarrassed before winning over. This moral qualm induces the book's tender dedication to its protagonists,[115] as well as Agee's uncertainty, littered with scare quotes, about how he should speak of them: "as 'tenant' 'farmers,' as 'representatives' of your 'class,' as social integers in a criminal economy, or as individuals, fathers, wives, sons, daughters, and as my friends and as I 'know' you?" (84). In their particularities, he insists, rather than in their class designation, rest not only the tenants' genuine worth but also his primary fascination with them.

But what might they themselves think of how he chooses to depict them? As individuals whom he hankers to "know" and as "representatives" of an oppressed working class, should not their own quiddities be consulted and their susceptibilities be taken into account before

tackling the problem of giving literary shape to their lives? Would it not be an ethically "obscene" crime to embroider his knowledge of them into an aesthetically ornate representation, just as it would be to knowingly "parade" their unmitigated hurts for readers disconnected from the travails of cotton tenantry? While agonizing over his prose Agee did in fact agonize over those for whom he bore witness. Early in 1939 he guiltily confessed to Father Flye his failure to write in simple language that might be understood by such poorly educated farmers: "The lives of these families belong first (if to any one) to people like them and only secondarily to the 'educated' such as myself. If I have done this piece of spiritual burglary no matter in what 'reverence' and wish for 'honesty', the least I can do is to return the property where it belongs, not limit its language to those who can least know what it means."[116] Chiding himself for his arrogation of actual lives as intellectual property, Agee's metaphor of metaphysical theft is remarkably apt considering how little the tenants own materially. The one thing they can indubitably lay claim to (albeit intangibly) is their sheer existence, but his ethnographic slumming and highfalutin' writing—regardless of how sincerely he might be inquiring into their "human divinity"—threaten to rob them even of their own sense of themselves. Since he can neither banish his literariness nor make reparations for allegorically stealing souls, however, Agee must resort to harrying well-educated readers, reproaching them for their absentee empathy with the hope of activating their dormant consciousness to his subjects' complexity. Ruthlessly policing his representational maneuvers, he swings between doubt and confidence in the efficacy of his mediating performance.

Famous Men shames its assumedly snug audience by announcing: "[T]his is a book about 'sharecroppers,' and is written for all those who have a soft place in their hearts for the laughter and tears inherent in poverty viewed at a distance, and especially for those who can afford the retail price" (12). Counter to this caustic tone, Berger's authorial mediations are as obliging to his readers as he himself is obliged to his subjects. Whereas Agee's multiple introductory feints intentionally complicate more than clarify the subject and insult more than invite the reader, Berger's prefaces and asides strive to communicate transparently.

In *Another Way of Telling*, recapitulating his collaborations with Mohr, he says they always ask themselves, "How can we approach the reader together?"[117] In like spirit, their tales and pictures demonstrate a conscientious joint approach to their subjects, who also collaborate with them by providing constructive criticisms that are woven into the design and content of their books. Mohr's series on the cowherd Marcel and the woodcutter Gaston, for instance, assimilate their photographic preferences. In addition to letting them suggest (as Evans occasionally let the tenants do) the composition of their portraits, Mohr takes note, on showing them his prints, of how they reject certain photos while treasuring ones that attest to their working lives. Berger, too, sets such great store by what his subjects make of their renderings that he seems ready to accept Tolstoy's view, which Agee vacillates over in his 1944 essay "Pseudo-Folk," that peasants are the most reliable interpreters of art,[118] or ready anyway to calculate that they might make up a sizable percentage of his readership. For the 2010 republication of *A Seventh Man*, unfazed that pundits in the mid-1970s had dismissed its interdisciplinary structure for "wavering between sociology, economics, reportage, philosophy, and obscure attempts at poetry," Berger contends that the book has been substantiated by its favorable reception (often in translated editions) among migrant workers, for whom its initial urgency as a sociopolitical treatise meant to boost "international working-class solidarity" has been modified into a more intimate form of address: "a sequence of lived moments" or "a family photo album" for those uprooted or separated by emigration.[119] Elsewhere he recalls a comparable response to his fiction from peasants who have read *Pig Earth*.[120]

To generalize about peasant experience worldwide, that volume's "Historical Afterword" revives an older mode of explicitly linking literary creations to societal trends. Berger points out that during the nineteenth century, to aid the public's comprehension of revolutionary changes, imaginative writers sometimes accompanied a poem or story with an essay denoting how their particular evocation related to universal developments. This practice fell out of fashion during the twentieth century, as literature, rues Berger, "elevated itself into a pure art," though it mostly "degenerated into pure entertainment."[121] Hence he echoes

Agee's disclaimers that *Famous Men* is "not a work of art or of entertainment" (92) but rather "an effort in human actuality, in which the reader is no less centrally involved than the authors and those of whom they tell" (ix). While both writers, being both firsthand witnesses and aesthetic commentators, gainsay the purity of art and the frivolity of entertainment, their positions relative to presumed audiences appear to be incongruous. Berger regrets that authors are no longer guides, serving to instruct as well as to delight their readers, whereas Agee, when not playing bully or sardonically gesturing toward the public's edification, issues postmodernist appeals for self-directed readers capable of finding their own way through his disjointed book, and capable of helping him "make clear some essential coherence in it, which I know is there, balanced of its chaos" (259).

But the tension between steering and stimulating, between imposing set meanings and leaving an array of possible ones available, vibrates throughout all of their writings. As their ways of seeing, whether on their own or in tandem with the photographers, yield a means of praising the rural poor, they debate how insistently to sing these praises. At the heart of their work is the always imperfect yet never forsaken pursuit of triangular fraternity among writer, reader, and subject, encouraging, as Agee summons, the cooperation of all three. Berger the essayist, explaining why he cannot satisfactorily conclude *A Fortunate Man*, may feel oddly constrained to "imagine readers interrupting" him, only to "try to lead" them back to where he is going,[122] but Berger the storyteller, more likely to envision the reader as a companion or even an accomplice in his hunt to identify with others, is therefore likelier to leave many things unstated, because to say too much would be "to overwhelm the reader, instead of allowing space for the reader to collaborate."[123] These "silent connections," as he argues in *Another Way of Telling*, "fuse teller, listener and protagonists into an amalgam" that might be thought of as "the story's *reflecting subject*."[124] With equal love and gratitude but less guilt or agony than Agee, Berger dedicates *Pig Earth* to his many peasant friends, before welcoming the reader to join him as he retraces his journey into the storied depths of their community.

With *Famous Men* as a touchstone, Berger and Mohr's later ways of seeing rural poverty might be viewed as European elaborations on an

American masterwork. Yet in their geographic range, political trenchancy, observational precision, and evocative artistry, *A Fortunate Man*, *A Seventh Man*, and *Another Way of Telling* are not at all derivative but original, refined, and provocative. Moreover, while this photo-textual duo, like their predecessors, deploy modernist artfulness partly to deplore modernization, their praise of peasants, unlike Agee and Evans's, wrestles with the prospect of such people's imminent disappearance. Not just in Europe but around the globe, Berger decries that peasantries are increasingly under threat of destruction due to the pressures of mechanized agribusiness, corporate capitalism, and urbanization. He and Mohr, however, over the course of their three projects, come to empathize ever more acutely and idiosyncratically with remnants of this class of tough survivors. Bringing their reciprocal "sense of measure" to darkroom and writing studio as well as to village and metropolis, they produce "imaginative documentaries" or "narrative dialogues" between pictures and words, suggestively positing how these forms of expression might converse through complementarity, juxtaposition, or montage. Their multimedia combinations and ruminations foster a fresh mode of storytelling aimed at subjectively reconstructing the communal memory of people forgotten or browbeaten by mainstream society.

An early English admirer of *Let Us Now Praise Famous Men*, regretting that it was still unpublished in Britain, recognized that her compatriots, engulfed in a world war, might ask why they should care about "the troubles of a group of peasants thousands of miles away on another continent."[125] American readers in our digitized age might ask the same about the subjects of *A Fortunate Man*, *A Seventh Man*, and *Another Way of Telling*. Yet the reviewer's rebuttal applies just as well to Berger and Mohr's books as to Agee and Evans's opus: "Any representation, any experiment whatsoever, which may shock people into awareness of their responsibility to these undefended ones is of supreme importance."[126] Ethically and aesthetically, the words and images of these witness-artists continue to resound with that shock of awareness, however far removed in time and space.

NOTES

1. John Berger, "Jean Mohr: A Sketch for a Portrait," introduction, *At the Edge of the World*, by Jean Mohr and John Berger (London: Reaktion Books, 1999) 14.

2. James Agee and Walker Evans, Let Us Now Praise Famous Men: *An Annotated Edition of the James Agee-Walker Evans Classic, with Supplementary Manuscripts*, ed. Hugh Davis, vol. 3 of *The Works of James Agee*, gen. eds. Michael A. Lofaro and Hugh Davis (Knoxville: U of Tennessee P, 2015) xvi. Subsequent references to this edition will be noted parenthetically in the text.

3. Critics who do at least mention these pairs of collaborators together include Geoff Dyer, *Ways of Telling: The Work of John Berger* (London: Pluto Press, 1986) 65; Carol Shloss, *In Visible Light: Photography and the American Writer, 1840-1940* (New York: Oxford UP, 1987); W. J. T. Mitchell, "The Ethics of Form in the Photographic Essay," *Afterimage* 16 (January 1989): 8–13; Paula Rabinowitz, "Voyeurism and Class Consciousness: James Agee and Walker Evans, *Let Us Now Praise Famous Men*," *Cultural Critique* 21 (Spring 1992): 168; T. V. Reed, "Unimagined Existence and the Fiction of the Real: Postmodernist Realism in *Let Us Now Praise Famous Men*," *Representations* 24 (Fall 1988): 176.

4. The real surnames of the three families were Burroughs, Fields, and Tingle, but Agee changed them to protect the tenants from the threat of retaliation by landowners who might be angered by the book. For detailed lists comparing the actual names of all the family members and locales to their fictional counterparts, see "Changes of Names of People and Places," Davis, *LUNPFM* 561–63.

5. John Berger and Jean Mohr, *A Fortunate Man: The Story of a Country Doctor* (1967; New York: Vintage, 1997) 109. Sassall's real surname was Eskell. Unlike Agee's pseudonymous roster of "Persons and Places" in *Famous Men*, Berger neither mentions this change in *A Fortunate Man* nor indicates precisely where the volume takes place: the Forest of Dean, in rural Gloucestershire, near the Welsh border. In my interview with him on 14 October 2011, he claimed to have remained mum on these matters, less to keep them secret than to avoid the impression of having made "a kind of promotional book for that particular doctor," which not only would have subverted the authors' intentions but also "would have been disapproved of by the medical profession" in Britain. Nevertheless, Dr. Eskell's true identity and the location of his practice were found out soon enough, and he was subsequently visited by medical students and young general practitioners interested in learning from him.

6. John Berger, personal interview, 14 Oct. 2011. Berger remarks, "I enormously admire Agee as a writer and as a critic and of course Walker Evans as a master." Besides having been inspired by the "wonderful example" of their photo-textual collaboration in *Famous Men*, Berger adds of Agee, "I read quite a lot of his writing about film, as well, because his mind interested me a great deal."

7. James Agee, *Letters of James Agee to Father Flye*, ed. James H. Flye (1962; New York: Ballantine, 1971) 230–31.

8. John Berger, *Pig Earth* (New York: Pantheon, 1979) 196. The second and third volumes are *Once in Europa* (New York: Pantheon, 1987) and *Lilac and Flag* (New

York: Pantheon, 1990). Berger's trilogy was issued in one book as *Into Their Labours* (New York: Pantheon, 1991).

9. James Agee, *Film Writing and Selected Journalism*, ed. Michael Sragow (New York: Library of America, 2005) 34.

10. *Letters of James Agee to Father Flye* 49.

11. James Agee, "A Project for a Poem in Byronics, John Carter," *The Collected Poems of James Agee*, ed. Robert Fitzgerald (Boston: Houghton Mifflin, 1968) 80.

12. Michael A. Lofaro and Hugh Davis, eds., *James Agee Rediscovered: The Journals of* Let Us Now Praise Famous Men *and Other New Manuscripts* (Knoxville: U of Tennessee P, 2005) 189.

13. *James Agee Rediscovered* 51.

14. For two superb accounts of the process by which Agee has been mythologized as a tragic poet, apart from any measured consideration of his actual writings, see Hugh Davis, "'Death of a Poet': The Agee Myth and the Agee Canon," *The Making of James Agee* (Knoxville: U of Tennessee P, 2008) 1–25; and the introduction to Alan Spiegel's *James Agee and the Legend of Himself: A Critical Study* (Columbia: U of Missouri P, 1998) 1–20.

15. John Berger, *Pages of the Wound: Poems, Drawings, Photographs, 1956–96* (London: Bloomsbury, 1996) n. pag.

16. John Berger, *And Our Faces, My Heart, Brief as Photos* (New York: Pantheon, 1984) 95.

17. *And Our Faces* 95.

18. *And Our Faces* 96.

19. *And Our Faces* 21.

20. James Agee, "Plans for Work: October 1937," *The Collected Short Prose of James Agee*, ed. Robert Fitzgerald (Boston: Houghton Mifflin, 1968) 137–38.

21. Agee, "Plans for Work" 133.

22. John Berger, *G.* (1972; New York: Pantheon, 1980) 80.

23. *G.* 135.

24. John Berger and Jean Mohr, *A Seventh Man: A Book of Images and Words about the Experience of Migrant Workers in Europe* (1975; London: Verso, 2010) 45.

25. Dyer, *Ways of Telling* 149.

26. Agee, "Plans for Work" 145–46.

27. James Agee, introduction, *A Way of Seeing: Photographs of New York*, by Helen Levitt (1965; Durham: Duke UP, 1989) vii. A glance at the titles of Berger's books—*The Look of Things, About Looking, The Sense of Sight*—indicates his similar preoccupation with visual perception. Although he does not mention the influence of Agee's phrase "a way of seeing"—which first appears in *Famous Men* (198) and then in his introduction to Levitt's photographs—Berger's *Ways of Seeing* and *Another Way of Telling* uncannily echo this expression.

28. Agee, introduction, *A Way of Seeing* viii.

29. John Berger, "Understanding a Photograph," *The Look of Things*, ed. Nikos Stangos (1972; New York: Viking, 1974) 179. This is the title piece of Berger's recently

collected writings on photography: *Understanding a Photograph*, ed. Geoff Dyer (London: Penguin, 2013).

30. John Berger and Jean Mohr, *Another Way of Telling* (1982; New York: Vintage, 1995) 93.

31. *Another Way of Telling* 96.

32. *Another Way of Telling* 90.

33. *Another Way of Telling* 98.

34. *Another Way of Telling* 98.

35. *Another Way of Telling* 91.

36. *Another Way of Telling* 128, 125.

37. *Another Way of Telling* 92.

38. Agee, introduction, *A Way of Seeing* xiii.

39. Mohr later supplied the photographs that prompted Edward W. Said's text in *After the Last Sky: Palestinian Lives* (1986; New York: Columbia UP, 1999). As an exile from Palestine vicariously accessing his homeland, Said seems both inspired and perturbed by Mohr's pictures, so that their two mediums compete for representational authority throughout the book. For his part, Mohr remarks in the introduction, the concept of exile ceased to be abstract during his boyhood in Geneva in the late 1930s, when his father, a German citizen opposed to Nazism, requested and received Swiss naturalization for their family. After reporting again on Red Cross operations in the Middle East, accompanied by Berger on one trip, Mohr published another book on the troubled region in conjunction with a retrospective on his work: *Side by Side or Face to Face: Israelis and Palestinians: 50 Years of Photography* (Geneva: Labor et Fides, 2003).

40. Jean Mohr, personal interview, 21 Oct. 2011.

41. Walker Evans, *Walker Evans at Work* (New York: Harper & Row, 1982) 112. Evans made this vow shortly before taking a job with the Resettlement Administration—later Farm Security Administration (FSA)—in 1935. Despite his aversion to "photographic chores" and insistence on compiling a "pure record" not to be used for propaganda, Evans did occasionally take "project shots" for the agency that align with "shooting scripts" furnished by its director, Roy Stryker. As for the photographs eventually published in *Famous Men*, technically Evans made them through the sponsorship of Time, Inc., which borrowed his services from the FSA for *Fortune*'s sharecropping article, with the agreement that the magazine would have rights of first publication (rights not acted on, since the piece was never printed) but that the negatives would then be housed in the FSA file.

42. See, for instance, Evans's self-contained portfolios at the rear of Carleton Beals's *The Crime of Cuba* (Philadelphia: Lippincott, 1933) and Karl A. Bickel's *The Mangrove Coast* (New York: Coward McCann, 1942), as well as the catalogs for two exhibitions of his work at the Museum of Modern Art: *American Photographs* (1938) and *Walker Evans* (1971). Lincoln Kirstein wrote an afterword for the former, while John Szarkowski provided an introduction for the latter. And in 1940 Agee drafted an introductory note for Evans's subway portraits, taken with a concealed camera,

a selection of which was finally published as *Many Are Called* (1966; New Haven: Yale UP, 2004). On the design and reception of these volumes, see John T. Hill, "The Exhibition, the Book, and the Printed Page," *Walker Evans: Lyric Documentary* (Göttingen: Steidl, 2006) 28–39.

43. *Walker Evans: Photographs from the* Let Us Now Praise Famous Men *Project*, ed. William Stott and David Farmer (Austin: University of Texas Humanities Research Center, 1974) n. pag.

44. See Lincoln Caplan, ed., "Walker Evans on Himself," *New Republic* 13 Nov. 1976: 25.

45. Evans qtd. in Bill Ferris, *Images of the South: Visits with Eudora Welty and Walker Evans* (Memphis: Center for Southern Folklore, 1977) 32.

46. Mohr qtd. in Paul Willis, "The Authentic Image—An Interview with John Berger and Jean Mohr," ed. Philip Corrigan, *Screen Education* 32–33 (1979/1980): 28.

47. Jean Mohr, personal interview, 21 Oct. 2011. According to Mohr, Berger particularly objected to certain "aesthetic pictures" which "tried to describe the landscapes and the moods of the sky and details of nature," although the writer wound up selecting several such shots for the book's opening images. In total, *A Fortunate Man* includes seventy-five of Mohr's photographs.

48. Mohr and Berger, *At the Edge of the World* 14–15.

49. John Berger, personal interview, 14 Oct. 2011. Notwithstanding this fanciful analogy, the collaborators actually covered the floor with photos and walked around rearranging them to test for desired effects, a process that Berger and Mohr again followed in *Another Way of Telling* when constructing a series of pictures over 140 consecutive pages. Entitled "If Each Time . . . ," this sequence is meant to reflect imaginatively (not journalistically) on a peasant woman's life.

50. Berger and Mohr, *Another Way of Telling* 42.

51. Berger qtd. in Geoff Dyer, "Ways of Witnessing: Interview with John Berger," *Marxism Today* Dec. 1984: 36.

52. *Letters of James Agee to Father Flye* 116.

53. Evans qtd. in Shloss, *In Visible Light* 190.

54. As one example, Agee facetiously claims to have written *Famous Men* so that readers "may feel kindly disposed toward any well-thought-out liberal efforts to rectify the unpleasant situation down South" (12). On Agee's adversarial artistic ideals and antagonism toward social reform, see Michael Augspurger, *An Economy of Abundant Beauty:* Fortune *Magazine and Depression America* (Ithaca: Cornell UP, 2004).

55. While galvanized by and celebrated for his documentary work during the Depression, Evans nonetheless saw his objective realism (exemplified by a frontal approach to neglected subjects) as an aesthetic rather than an ethical enterprise. Both in Alabama and elsewhere, he assumed the severity of dispassionate documentation yet incorporated a paradoxically transcendent element of unselfconscious lyricism, which imbues his style with clarity and beauty while diminishing its instrumentalist overtones. In a quotation reproduced in *Walker Evans at Work*, the photographer

reflects on his portraits of Cuban dockworkers: "Those people have no self-pity. They're just as happy as you are, really" (82). In another indication of his cautiousness against sentimentality, what might be Evans's most searing image of destitution—that of a despondent woman and three ragged children sprawled on a Havana doorstep—is simply captioned "Family," as it appears in *The Crime of Cuba*. For further comment on this ironically understated representation of poverty, see Jefferson Hunter, *Image and Word: The Interaction of Twentieth-Century Photographs and Texts* (Cambridge: Harvard UP, 1987) 40.

56. For differing views on Agee's ethical dilemmas in aestheticizing the farmers' poverty, see Jeffrey J. Folks, "Agee's Angelic Ethics," *Agee Agonistes: Essays on the Life, Legend, and Works of James Agee*, ed. Michael A. Lofaro (Knoxville: U of Tennessee P, 2007) 73–84; Gavin Jones, *American Hungers: The Problem of Poverty in U.S. Literature, 1840–1945* (Princeton: Princeton UP, 2008); Jesse Graves, "A Blind Work of Nature: The Ethics of Representing Beauty in *Let Us Now Praise Famous Men*," *Agee at 100: Centennial Essays on the Works of James Agee*, ed. Michael A. Lofaro (Knoxville: U of Tennessee P, 2012) 93–106.

57. Agee, "Southeast of the Island: Travel Notes," *The Collected Short Prose of James Agee* 185. This piece was commissioned but rejected by *Fortune* in 1939 and first published under the title "Brooklyn Is" in *Esquire* in December 1968.

58. Agee, introduction, *A Way of Seeing* xii.

59. Berger and Mohr, *Another Way of Telling* 73.

60. *Another Way of Telling* 73.

61. Jean Mohr, personal interview, 21 Oct. 2011. He could not give the children anything tangible because the train's windows were bolted shut. While this factor might excuse him from a moral obligation to provide them with actual succor, Mohr remains disturbed by the ethics of witnessing their suffering, especially since he was the only one aboard the train who seemed to notice them. Perhaps the other passengers, as native Indonesians, were inured to and thus likely to shrug off such sights, whereas Mohr, as a foreigner, could not help but stare. He emphasizes this difference in perspectives through his exchange with a local art student who offers him the window seat and assures him that the countryside they will pass is beautiful, but then keeps his eyes askance when the children appear beside the train. While Mohr's premeditated decision to photograph them on the ride back could be interpreted as an exploitative act of voyeurism, he does so not just to salve his conscience but also to enlighten the world to their plight through publication of the images. The privileged Western viewer can hardly avert a reaction of mixed guilt and pity upon seeing the skeletal children midstride with pleading faces and outstretched arms beyond the edge of the window frame in *Another Way of Telling*.

62. John Berger, introduction, *Permanent Red* (1960), rpt. in John Berger, *Selected Essays*, ed. Geoff Dyer (New York: Pantheon, 2001) 9.

63. John Berger, "Sicilian Lives," *The Sense of Sight*, ed. Lloyd Spencer (New York: Pantheon, 1985) 264. This piece was written as a foreword to a book of tales collected by Danilo Dolci. For Berger's further thoughts on storytelling by and among the

poor, see his "Ten Dispatches about Endurance in Face of Walls," an afterword to a collection of stories by Andrey Platonov, rpt. in John Berger, *Hold Everything Dear: Dispatches on Survival and Resistance* (New York: Pantheon, 2007) 97–106.

64. John Berger, "The Soul and the Operator," *Keeping a Rendezvous* (New York: Pantheon, 1991) 234.

65. Agee qtd. from an undated letter to his psychoanalyst Frances Wickes in Davis, *The Making of James Agee* 209.

66. John Berger, *A Painter of Our Time* (1958; New York: Pantheon, 1989) 26. This line from his first novel not only unwittingly foreshadows Berger's mid-1970s move to the French Alps but also reflects his sentiments in the mid-1950s. Although *A Painter of Our Time* is mainly set in London, he wrote a substantial portion of it while living in rural Gloucestershire, the region he later explored with Mohr in *A Fortunate Man*.

67. Walker Evans, "James Agee in 1936," foreword, *Let Us Now Praise Famous Men*, by James Agee and Walker Evans (1941; Boston: Houghton Mifflin, 1960) xi.

68. Evans, "James Agee in 1936" ix.

69. Evans, "James Agee in 1936" xi. Notwithstanding his more detached personality and aristocratic sensibility, the photographer later claimed that he too had "an understanding and love for that kind of old, hardworking, rural, southern human being" (Evans qtd. in Ferris, *Images of the South* 31).

70. Agee qtd. in Davis, *The Making of James Agee* 209. On tensions between city and country in Agee's autobiographical novel, see Victor A. Kramer, "Urban and Rural Balance in *A Death in the Family*," *James Agee: Reconsiderations*, ed. Michael A. Lofaro (Knoxville: U of Tennessee P, 1992) 104–118. For a reconstruction of the book from manuscript materials, making for a very different version from the one edited by David McDowell in 1957, see James Agee, *A Death in the Family: A Restoration of the Author's Text*, ed. Michael A. Lofaro, vol. 1 of *The Works of James Agee* (Knoxville: U of Tennessee P, 2007).

71. Agee qtd. in Laurence Bergreen, *James Agee: A Life* (New York: Dutton, 1984) 66. This account of his agricultural employment comes from a 1929 letter he sent to Dwight Macdonald from Oshkosh, Nebraska. Although Agee was apparently a lousy farmworker, who fessed up to stabbing himself in the heel with a pitchfork, his summertime sojourn as hitchhiker and manual laborer yielded the raw material for two short stories: "Death in the Desert" (1930) and "They That Sow in Sorrow Shall Reap" (1931), both originally published in *The Harvard Advocate*.

72. The book reviews are now collected in James Agee, *Complete Journalism: Articles, Book Reviews, and Manuscripts*, ed. Paul Ashdown, vol. 2 of *The Works of James Agee* (Knoxville: U of Tennessee P, 2013). Agee's review of two "Sharecropper Novels" for *New Masses* (8 June 1937), a year after his own sharecropping research, let him contemplate how the circumstances he had witnessed in the South might be given artistic structure. Despite deeming both novels to be failures, Agee lauds George W. Lee's *River George*, about black croppers in Tennessee, for its sensory "documentation of deep-country," and Louis Cochran's *Black Earth*, about white croppers in Mississippi, for supplying "something of their house and its furnishings, something of their

relationships, of the struggle between generations, something of the vacuum into which they are thrust by poverty and exploitation" (519). Endeavoring to illumine more than "something" of the lives of poor exploited farmers, Agee would spurn fictionalization and quest toward an assiduous reproduction of actuality in *Famous Men*, which swayed his reaction to these novels as well as those he began reviewing for *Time* in 1940. His attraction to rural settings and southern subjects is evident in reviews of such books as George W. Ogden's *There Were No Heroes* (421–22), James Still's *River of Earth* (424–25), William Faulkner's *The Hamlet* (434–35) and *Go Down, Moses* (461–63), Erskine Caldwell's *Trouble in July* (431), W. J. Cash's *The Mind of the South* (450–52), Thomas Wolfe's *The Hills Beyond* (455), and Brainard Cheney's *River Rogue* (473–74). Before completing his tenant volume, Agee also weighed in on another agriculturally-oriented photo-textual collaboration: *An American Exodus: A Record of Human Erosion* (1939) by Dorothea Lange and Paul Taylor. While rating Lange's photographs and Taylor's text superior to those of Bourke-White and Caldwell in *You Have Seen Their Faces*, Agee demurred at how Lange and Taylor (as did Bourke-White and Caldwell) affixed quotations beneath the pictures, which exposed the "tearjerking inherent in dialect re-used by sophisticates" (427). Anxious to avoid such maudlin effects, he not only would agree that Evans's photographs be printed uncaptioned in *Famous Men* but would also hesitate to utilize dialects picked up during fieldwork within his sophisticated text, galled that the southern "tenants' idiom has been used ad nauseam by the more unspeakable of the northern journalists" (276).

With similar doses of spleen and approbation, Agee's film reviews contain his sharpest and warmest critiques of art springing from folk sources. His inaugural column for *The Nation*, rpt. in *Film Writing and Selected Journalism*, ed. Sragow, defers specifying Agee's regret over "ninety-nine feet in every hundred" of John Ford's adaptation of *The Grapes of Wrath* (35). Two years earlier, after its 1940 release, Agee had worked up notes on the film, ostensibly about why it bothered him. In what would become his customary tarnish-then-applaud—or, conversely, commend-then-belittle—manner, this incomplete piece, published in *James Agee Rediscovered*, gestures toward "long efforts . . . on film esthetics and on critical ethics" in order to elucidate the picture's "encyclopedia of flaws, substandards, inadequacies, self-deceptions," only to highlight the moments he most liked in it (140–43). Irked as much by its popularity as its unreality, Agee leverages his disappointment with its impostures as a "documentary" film into a wider grievance with leftists (and, as he typically adds, liberals) who appropriate artworks while condoning their aesthetic blunders. Glaring among such missteps, he alleges, is the acting in *The Grapes of Wrath*, yet Agee foresees the hoodwinked response of Okies upon viewing their portrayal: "[I]t is unhappy to reflect how many farmers, watching these high-paid, earnest, cruelly insulting oafs embody their self-dream, will be completely flattered of their reality" (142). This unkind charge, partly rescinded by his esteem for Jane Darwell's carriage as Ma Joad, stems from Agee's caprice that farming folk remain unmodernized. His exactingness toward what he judges valid embodiments of reality, and his vigilance against

fraudulent ones, which are contradictorily debated throughout *Famous Men*, likewise pervade two later *Nation* reviews about agrarian life, reprinted in *Film Writing and Selected Journalism*. Outwardly like his study, except set in Texas rather than Alabama, Jean Renoir's *The Southerner* (1945) showcases a family of cotton tenants. While appreciating the movie's atmospheric cinematography, Agee gripes, perhaps recalling his own exhaustive inventories of farm work and clothing: "The heart of this kind of living is work, and the picture should have made the work as immediate to the watcher as to the worker in all its methods, meanings, and emotions. It offers instead, mere token shots of work; and in these, too often, the clothes aren't even sweated" (195). Even more disconcerting, he claims, is the film's careless miscasting of actors to play rural southerners, which proves "how massively misguided, and how swarmed with unconscious patronage, the whole attitude of the theater has always been toward peasants" (196). *Farrebique* (1947), by Georges Rouquier, comes closer, thinks Agee, to honoring without patronizing this holiest of subjects for him, subordinating lavish dramatization to careful documentation of life on a French farm. Pleased even so that the director "is infinitely more than a mere documentor, that his poetic intelligence is profound, pure, and vigorous" (342), Agee hails Rouquier's movie as

> one of the finer works in the whole great line of rural art which extends backward through Van Gogh and Brueghel to the *Georgics* and to the *Works and Days*. It combines the cold deep-country harshness of Hesiod with a Vergilian tenderness and majesty; and its achievement is wholly of our time, through that reverence for unaltered reality which can be translated into a work of art only through the camera. (345)

Farrebique, as Agee acclaims it in *Letters of James Agee to Father Flye*, manages "without actors or a fictional story" to render farm life as "agricultural poetry" (174), much as he and Evans do in *Famous Men*.

 73. James Agee, "Cockfighting," *Fortune* 9 (Mar. 1934): 90–95, 146, reprinted in James Agee, *Complete Journalism*, ed. Ashdown, 118. See also Agee's articles "Tennessee Valley Authority," *Fortune* 8 (Oct. 1933): 81–97, reprinted in *Complete Journalism*, 77–90; "Drought," *Fortune* 10 (Oct. 1934): 76–83, reprinted in *Complete Journalism*, 187–90; "T.V.A.: Work in the Valley," *Fortune* 11 (May 1935): 93–98, 140–53, reprinted in *Complete Journalism*, 197–222; "U.S. Art: 1935," *Fortune* 12 (Dec. 1935): 68–75, reprinted in *Complete Journalism*, 264–71. Prefiguring his more direct collaboration with a visual artist in the sharecropping assignment, Agee's piece on the 1934 drought blistering the middle third of the continent and his 1935 survey of contemporary American painters both mull over visual framings of agricultural subjects, as he not only contributed general remarks but also captions to images which are omitted in *Complete Journalism*. His account of the drought relies not on firsthand observations but on photographs by Margaret Bourke-White, whom he would hold up for mockery in *Famous Men*. In this article, albeit beholden to her documentation, Agee is already pushing back with his words. Her pictures of scorched farmland, emaciated animals, and worried farmers merely serve as springboards for

his melodramatic, poetically allusive captions. For example, between shots of starving cattle and skinned carcasses left to rot on the parched ground, he quotes from an ode by Keats and a motet by Carissimi, thus aestheticizing this act of vicarious witness. Similarly, in his commentary on the American painting scene, Agee's words again cut against the images they are supposed to be supporting. Although admiring the ingenuity of Joe Jones, whose series on wheat encodes subtle tributes to Communist defiance, Agee is troubled by a trend he detects among left artists: "the concern of their generation with humanity as humanity, rather than as a diversity of individuals. . . . There are no longer men: there is Man. And Man is a heroic, pathetic, exploited, self-sacrificing, beaten, rising figure seen at a great remove" (266). Agee's preference for distinct personalities over types, for specific men over Man, would dictate his intimate scrutiny of tenant farmers. His disquietude with universalized radical paintings, like his distanced riffs on Bourke-White's drought photos, motivates him to examine in person (and to reexamine through Evans's portraits) the faces of particular individuals from the three families whose trust he covets.

74. Although Agee only uses the term "peasant" a handful of times in *Famous Men*, he clearly (if perhaps erroneously) considers the tenant farmers to be American equivalents of that marginalized class of agricultural laborers designated as the peasantry in other parts of the world. On the book's dynamic constructions of space and evocative descriptions of the land, see Christoph Irmscher, "'Muscles of Clay': James Agee's Southern Landscapes," *Southern Landscapes*, eds. Tony Badger, Walter Edgar, and Jan Nordby Gretlund. Transatlantic Perspectives 7 (Tübingen: Stauffenburg Verlag, 1996) 127–41.

75. For urban puzzlement and leftist disaffection with Berger's midcareer makeover, see Gerald Marzorati, "Living and Writing the Peasant Life," *New York Times Magazine* 29 Nov. 1987: 38–39, 46, 50, 54; Fred Pfeil, "Between Salvage and Silvershades: John Berger and What's Left," *TriQuarterly* 88 (1993): 230–45; Charity Scribner, "Second World, Second Sex, and Literature on the European Left," *Comparative Literature* 55.3 (Summer 2003): 217–28. And for Berger's essays contrasting villagers to urbanites and distinguishing peasant from bourgeois habits, see "The Eaters and the Eaten," *The Sense of Sight* 27–32; "Why Look at Animals?" *About Looking* (1980; New York: Vintage, 1991) 3–28; "The Suit and the Photograph," *About Looking* 31–40; "The Theatre of Indifference," *The Sense of Sight* 68–73.

76. See Berger's "The Politics of Courbet," *Selected Essays* 63–64; "Courbet and the Jura," *About Looking* 141–48; "Millet and Labour," *Selected Essays* 61–62; "Millet and the Peasant," *About Looking* 76–85; "The Production of the World," *The Sense of Sight* 276–81. In addition to these painters, Berger has celebrated photographers whose work features peasants, such as Paul Strand, August Sander, Marketa Luskacova, and Sebastião Salgado. See, in Berger's *Understanding a Photograph*, ed. Dyer, "Paul Strand" 43–48; "The Suit and the Photograph" 34–42; "Christ of the Peasants" 106–110; "A Tragedy the Size of the Planet" 169–76. In other essays Berger also muses on the efforts of peasants themselves to make art from lives wrought on the land. See "The Primitive and the Professional," *About Looking* 71–75; "The Ideal Palace," *Keep-*

ing a Rendezvous 82–91; "The White Bird," *The Sense of Sight* 5–9; "The Storyteller," *The Sense of Sight* 13–18.

77. John Berger, *The Success and Failure of Picasso* (Harmondsworth: Penguin, 1965) 15. On the exilic experience in Berger's life and early work, see Nikos Papastergiadis, *Modernity as Exile: The Stranger in John Berger's Writing* (Manchester: Manchester UP, 1993).

78. For his shedding of urban manners and gradual induction into the rural community on visiting and photographing Berger's peasant neighbors, see Mohr's vignette "Sommand, Haute Savoie, France 1979: Père Nicoud," in their *At the Edge of the World* 130–32.

79. In a notebook entry published in *James Agee Rediscovered*, Agee explicates why *Fortune*'s sharecropping assignment appealed so much to him: "My father was of mountain people who were tenant farmers. My mother was Michigan born, raised in the south; she was of middle-class, somewhat cultivated, small capitalists. My father died when I was six and though I spent some lucky years in a mountain school most of my life had been middle-class. I have always more resented this fact than not, and have to a degree felt cheated and irreparably crippled of half or more than half of what I am" (13). Agee's resentment leads him not only to identify intensely with the Alabama tenant farmers as paternal surrogates who might restore the rural self he felt robbed of, but also to mock those of substantial means as haughty, materialistic, stultified, timorous bores. This entry also adumbrates a class tension at the heart of *A Death in the Family*. While he stresses the agrarian heritage of his father's kinfolk in the hills north of Knoxville, the writer's paternal ancestors included doctors, lawyers, and teachers in addition to generations of farmers. On his mother's side, Agee's grandfather Joel Tyler was a progressive businessman who moved from Michigan to Tennessee and dabbled in land speculation before establishing a company that manufactured tools for cutting marble. The "mountain school" Agee refers to is St. Andrew's, on the Cumberland Plateau near Sewanee, where he felt lucky to meet Father Flye. Having gone on from there to Phillips Exeter Academy and then Harvard University, Agee became tied more securely and fretfully to the cultured, middle-class ethos of his maternal relatives, among whose distant English forefathers he counted both Edmund Grindal, a sixteenth-century archbishop of Canterbury, and Wat Tyler, a fourteenth-century leader of a doomed peasant revolt (see *James Agee Rediscovered* 326).

As for Berger's split from the bourgeoisie, which would eventually lead to his romance with the peasantry, at the age of sixteen he ran away from St. Edward's, a severely authoritarian boarding school in Oxford. In London he enrolled at the Central School of Art, but his studies were interrupted by two years of service in the British army. Refusing the officer's commission his social background entitled him to, Berger stayed on as an instructor at a recruitment camp near Belfast, where he first came into significant contact with working-class men. In London again after the war, he resumed his education at the Chelsea School of Art.

80. Agee qtd. from an unpublished 1945 manuscript in James A. Crank, "Racial Violence, Receding Bodies: James Agee's Anatomy of Guilt," *Agee at 100* 58.

81. Berger, preface, *Permanent Red* (1979), rpt. in *Selected Essays* 4.

82. See "U.S. Commercial Orchids," *Fortune* 12 (Dec. 1935): 108–14, 126–29, rpt. in Agee, *Complete Journalism* 272–84; "Six Days at Sea," *Fortune* 16 (Sept. 1937): 117–30, rpt. as "Havana Cruise," *Complete Journalism* 292–306.

83. John Berger, *Ways of Seeing* (London: British Broadcasting Corporation and Penguin Books, 1972). Originating as a series of BBC television programs, this influential book was conceived partly as a retort to Kenneth Clark's magisterial *Civilization* (1969; Harmondsworth: Penguin, 1982). Whereas Clark acclaimed the timeless authority of Western art and architecture, Berger attacked the hierarchical tradition of the European oil painting for its mystification of history, objectification of women, glorification of property, and appropriation through advertising, all enabled or exacerbated by the mass reproduction of images. *Ways of Seeing* comprises seven untitled essays, alternating between four that consist of both words and pictures and three that employ only images. "These purely pictorial essays," notes Berger, "are intended to raise as many questions as the verbal essays" (5). He and Mohr would carry this practice further in both *A Seventh Man* and *Another Way of Telling*.

84. For instance, in *On the Porch*, penned in 1937 and printed in *Famous Men* without revisions (other than some contradictory footnotes) that might have retracted or qualified Agee's earlier political stances, he proclaims, "I am a Communist by sympathy and conviction," then adds, "I am under no delusion that communism can be achieved overnight, if ever" (201). Another section, Agee's 1939 reply to a *Partisan Review* questionnaire, restates his allegiances only to disavow them: "I am most certainly 'for' an 'intelligent' 'communism'; no other form or theory of government seems to me conceivable; but . . . I feel violent enmity and contempt toward all factions and all joiners," due to a determined "effort to be faithful to my perceptions" (289).

85. See Agee, "Plans for Work: October 1937," *The Collected Short Prose of James Agee* 140.

86. *Letters of James Agee to Father Flye* 89.

87. *James Agee Rediscovered* 54.

88. On Agee's brief but fervid radicalism, concealed by Robert Fitzgerald's editorial suppression of his proletarian poetry, see Davis, *The Making of James Agee* 27–50. Many of these poems are available in *James Agee Rediscovered* thanks to the recovery efforts of its coeditors Lofaro and Davis. Most date from the first few months of 1936, during a sabbatical from *Fortune* that Agee spent mainly in Florida, just before the magazine sent him back south in search of sharecroppers. Agee's endorsement of insurrection, fused with utopianism, is especially fierce in poems such as "Millions Are Learning How," in *A New Anthology of Modern Poetry*, ed. Selden Rodman (New York: Modern Library, 1938) 346; "Rhymes on a Self-Evident Theme," printed in Davis, *The Making of James Agee* 258–59; "[Marx, I agree]," qtd. in Davis, *The Making of James Agee* 41; "[Hold on a second, please]," *James Agee Rediscovered* 231–33; "Collective Letter to the Boss," *James Agee Rediscovered* 241–43; "Fight-Talk," *James Agee Rediscovered* 233–39. Cast in pungent couplets addressed to a down-and-out working-class man, "Fight-Talk" satirizes New Deal agricultural acts for

cutting down on planting wheat
Lest anyone should overeat;

...

And plowing under extra cotton
To prove the tenant's not forgotten (235)

Departing from the revolutionary rhetoric and pastoral visions intermixed in Agee's other poems, however, this acerbic pep talk concludes with a sardonic plea to reelect President Roosevelt and perpetuate the New Deal: "So pledge allegiance once again / To Franklin and his merry men" (239), no matter their efficacy at assuaging the nation's economic woes during the Depression.

89. For an incisive assessment of Agee's political evolution while researching and writing about tenant farmers, see Davis, *The Making of James Agee* 144–51. Of the two unions founded in the 1930s to protect the welfare of southern agricultural laborers, often in the face of white vigilante violence, the Socialist-linked Southern Tenant Farmers Union was most active in Arkansas, and the Communist-supported Sharecroppers Union was based in Tallapoosa County, Alabama. For an impassioned defense of the former union as an indigenous, interracial organization rising up against repressive plantation owners, see Howard Kester, *Revolt among the Sharecroppers* (New York: Covici, Friede, 1936). The latter union mainly recruited black farmworkers whose earlier attempts to organize had been broken up by a rash of attacks and arrests. Although Agee seems to conflate these unions in *Famous Men*, saying that he discussed "what the tenant farmer could do to help himself out of the hole he is in" (348) with George Gudger, who may have "at least heard of the union" (313), the writer was well aware of efforts by both unions and other organizations to agitate on behalf of sharecroppers. As confirmed by notebook entries in *James Agee Rediscovered*, he not only attended political meetings in New York sympathetic to their plight but also tried to locate Bob Smith and Beth Mitchell (pseudonyms for Communist Party members with connections in Alabama) immediately after *Fortune* handed him the tenant assignment. A fellow traveler of the party who now had "a chance to see more than I otherwise could have short of learning how to be of use as an organizer," Agee was particularly keen on investigating activities of "the straight communist Sharecropper's Union" (13–14). In addition to portraying a specific farm family, he thus originally intended to complete two other reports: "the second a generalized piece, a big fatassed analysis of the situation and of cotton economics and of all Governmental efforts to Do Something about It, . . . and the third a straight union piece, starting with inch-by-inch process of a couple of organizers opening up new territory, leading that on through night-riding et cetera, and mushrooming it into a history of both unions" (14). Similarly, see *Letters of James Agee to Father Flye* for a letter dashed off the day he received his instructions, in which Agee details everything the article was to cover, including "Govt. and state work; theories & wishes of Southern liberals; whole story of the 2 Southern Unions" (94). Hardly any of these matters, however, wound up in the book that emerged from Agee's journey. With

his performance diverging widely from his intentions, and with his depoliticizing embrace of actuality, *Famous Men* mushroomed in other directions.

90. *Letters of James Agee to Father Flye* 100, 105, 128.

91. Berger qtd. in Dyer, "Ways of Witnessing" 37. Despite the proletarian solidarity expressed in many poems recuperated in *James Agee Rediscovered*, Agee thought the "Sweet anodyne" of "hewing closely to / The Party Line" was escapist (217), and he crudely mocked the Communist Party for its callow artistic manias:

> Numerous Leftists find The Dance
> Grounds for going off in their Leftist pants
> As for me I think a fart
> In a typhoon stands a better chance as art (216)

92. John Berger, *New Statesman* 4 Apr. 1953: 400.

93. Berger, preface, *Permanent Red* (1979), rpt. in *Selected Essays* 4.

94. John Berger, "Correspondence with Subcomandante Marcos," *The Shape of a Pocket* (New York: Pantheon, 2001) 233.

95. Berger, "Undefeated Despair," *Hold Everything Dear* 13–25.

96. Berger, "Ten Dispatches About Place," *Hold Everything Dear* 127.

97. Berger qtd. in Dyer, "Ways of Witnessing" 37.

98. Berger, "Sicilian Lives," *The Sense of Sight* 264.

99. Berger and Mohr, *A Seventh Man* 40.

100. Berger, *Pig Earth* 10.

101. Todd Gitlin, "*Pig Earth* by John Berger," *New Republic* 20 Sept. 1980: 40.

102. John Berger, *Lilac and Flag: An Old Wives' Tale of a City* (London: Granta, 1990) 154.

103. Not only are many of the poems in *Permit Me Voyage* steeped in religious language, but Agee's two longest works of fiction, *The Morning Watch* (1951) and *A Death in the Family*, draw respectively upon his stern tutelage at an Episcopal boarding school and the clash of pietistic and atheistic sensibilities among his family members.

104. Agee qtd. in *Religion and the Intellectuals* (New York: Partisan Review, 1950) 14.

105. *Letters of James Agee to Father Flye* 101.

106. *Letters of James Agee to Father Flye* 91.

107. Agee, "[Now the steep and chiming coasts]," *James Agee Rediscovered* 231.

108. *James Agee Rediscovered* 153.

109. Berger qtd. in Marzorati, "Living and Writing the Peasant Life."

110. Dyer, *Ways of Telling* 134; Papastergiadis, *Modernity as Exile* 35.

111. Berger, "The Soul and the Operator," *Keeping a Rendezvous* 231–32.

112. For a cautionary critique of Agee's unrestrained romanticism in defying conventions and glorifying iconoclastic artists as well as unsung farmers, see Jeffrey J. Folks, "James Agee and the Culture of Repudiation," *Agee at 100* 37–51. In an epistolary aside that, if secularized, could pertain to Berger's fierce stances on art and politics, Agee remarks, "Francis of Assisi seems to me violently to have restored ideas

of Jesus: of complete disregard for the structures of the world or of living as it was" (*Letters of James Agee to Father Flye* 101).

113. John Berger, *Once in Europa* (New York: Pantheon, 1987) xi.

114. Evans qtd. in Leslie Katz, "Interview with Walker Evans," *Art in America* 59.2 (Mar.-Apr. 1971): 84.

115. The published dedication of *Famous Men* reads: "To those of whom the record is made. / In gratefulness and in love" (v). In a draft of the dedication, Agee named each member of the three tenant families, dedicating the book to them "in friendship and gratitude," before adding, "To all human beings whom they represent; and to a future fit for them" (788).

116. *Letters of James Agee to Father Flye* 117.

117. Berger and Mohr, *Another Way of Telling* 83.

118. See James Agee, "Pseudo-Folk," *Partisan Review* 11 (Spring 1944): 219–223. This cheeky diatribe on the "bourgeoizified" folk tradition lampoons the hyperbolic primitivism and artificial language of black musicians and white writers who effect, he says, "a lowering or full dismissal of ethical and moral standards" through "esthetically execrable" amalgamations of classical and folkloric content (219, 222, 220). That Agee's own work might indulge in such admixtures does not seem to perturb him, or remains repressed out of his desire to sustain conflicting ethical and aesthetic benchmarks. "Tolstoy's opinion that the one reliable judge of art was a clean old peasant has never convinced me, but it has strongly moved, interested and unsettled me," he equivocates. "But thanks to our nominal democracy and to the machines for universal manure-spreading"—bourgeois advertising, that is—"the 'peasants' themselves, the sources of folk art, are if possible even more dangerously corrupted than the middle-class audience" (220). Rehashing a key theme (the perception of beauty as both a fruit and a pitfall of class privilege) from his own tome on peasants, Agee's whim that they stay uncorrupted by all aspects of modernity (modernism no less than modernization) cancels out his intuitive attraction to the idea that they may be the most trustworthy arbiters of artistic taste. While "Pseudo-Folk" sounds off on almost every imaginable genre (from jazz to soap operas) of modern art, its recommendations on literary uses of ordinary folk are, like Agee's previous comments on books about the rural poor, most self-revealing of his approach to portraying them. Thus he censures John Steinbeck's *The Grapes of Wrath* (1939), lumping it in with the puzzlingly "snobbish, affected and anti-human" disgracefulness of "the 'talk-American' writer, the Common Man as normally represented in left-wing, liberal and tory fiction alike, and the pseudo-Biblical diction which chokes so much of our writing once we try to 'dignify' the vernacular" (221). This accusation of inverted snobbery—precisely what he himself felt the need to guard against when writing *Famous Men*—may in part be colored by bitterness over the commercial success of Steinbeck's book versus the flop of his own. Incriminating the novelist and his ilk for their unintentional travesties of the rural poor, Agee holds out hope for a more judicious use of colloquial speech.

119. Berger and Mohr, *A Seventh Man* 7–8.

120. See Berger's remarks in Dyer, "Ways of Witnessing" 38.

121. Berger, *Pig Earth* 195–96.

122. Berger and Mohr, *A Fortunate Man* 164–65.

123. John Berger, personal interview, 14 Oct. 2011.

124. Berger and Mohr, *Another Way of Telling* 285–86.

125. Anna Kavan, "Selected Notices," *Horizon: A Review of Literature and Art* 9 (April 1944): 285.

126. Kavan 285.

"In the Service of an Anger": Let Us Now Praise Famous Men and the American Civil Rights Movement

James A. Crank

When James Agee and Walker Evans's massive photo-text, *Let Us Now Praise Famous Men*, first appeared in print in 1941, the response was dismal. Most of the literary world either ignored the book or marked it as a poorly written contribution to America's increasingly waning obsession with its rural poor. Part of the lackluster response might be explained by a sense of intellectual fatigue surrounding the project's subject matter; after all, *Famous Men* was not really a unique project for the decade. Many magazines, artists, photographers, and writers were all compelled by America's poor sharecroppers and tenant farmers in the 1930s. To cite only the best known example, it was during the same summer in 1936 when Walker Evans and James Agee spent three months in Hale County, Alabama, ostensibly to produce an article for Henry Luce's *Fortune* magazine on the plight of the southern sharecropper, that Erskine Caldwell and Margaret Bourke-White were also traveling throughout the South to capture the "faces" for their own photo-text.

While *You Have Seen Their Faces* (published in 1937) and *Famous Men* both explored the same subject during the same summer, the two books could not have been more different. Caldwell and Bourke-White approached their text as a combination of conventional genres, somewhere between protest novel and storybook, while Agee and Evans hoped to create a multimodal, new kind of art that mined the emotional depths of every facet of documenting the sharecropping experience, including, as a matter of course, their own feelings of guilt and helplessness as "spies" for an unimaginative, calloused magazine audience. Although Caldwell and

Bourke-White were interested in exploring and explicating the entire region, Agee and Evans instead narrowed their focus to three representative families. *You Have Seen Their Faces* was "published to near universal acclaim in November, 1937,"[1] while *Famous Men* could not find a publisher until late in 1941. Although *Famous Men* was virtually ignored, Erskine Caldwell and Margaret Bourke-White's book sparked intense debate across the nation. Reviewing *You Have Seen Their Faces* in *The Southern Review*, Donald Davidson wrote, "The facts indicate a highly complex situation; and Mr. Caldwell could do nothing with a complex situation. He wanted it simple and stark. He made it simple and stark[.] . . . [Caldwell] wants an uprising. He is a Marxian, who has learned nothing from Stalinized Russia."[2] But no one seemed upset by Agee and Evans's ideology. The lack of a mention in *The Southern Review* is also curious: if Davidson had found in Caldwell a southerner corrupted by his Communist sympathies, one openly antagonistic toward the upper and middle classes, someone who masked his criticisms through the guise of a documentary about sharecroppers, why would not the critic similarly be outraged only four years later when *Famous Men* was released? After all, one of the book's epigraphs is a version of the (in)famous Marx dictum, "Workers of the world unite—you have nothing to lose but your chains," and Agee's tone throughout the introduction is nothing short of pugilistic, bitter, and sarcastic. *You Have Seen Their Faces* feels tame compared to the "fight" Agee agitates for throughout his book.

And yet *Famous Men* failed to either impress or provoke anyone, save literary critics and reviewers who found the book an insulting mess. John C. Cort was not alone in marveling over Agee's tortured prose. In his review for *Commonweal*, he writes, "[T]he real interest of the book . . . is a study of its author, who—for my money—is in a much more tragic condition than any exploited sharecropper." Rather than focusing on the tenant farmers whom Agee and Evans had attempted to document with pathos and authenticity, Cort instead describes an author who contained both "the most confused intellect and set of emotions that have come down the pike in several moons."[3] As Agee predicted, his book was an abysmal failure: it went quickly out of print and marked the beginning of the end for Agee at *Fortune*. For his own part, Agee felt the purposeful ignorance of his book a fitting conclusion to his failure

as an artist; he had hoped his publisher would print the typeface on newsprint so that it might decompose more rapidly than paper. Indeed, as Hugh Davis notes in *The Making of James Agee*, in 1953, "just twelve years after its publication, the printing plates for *LUNPFM*, virtually unknown outside of those who knew Agee himself, were melted down as scrap metal during the Korean War: Agee's desire . . . was nearly fulfilled in spirit, if not in fact."[4] The book had disintegrated, quite literally, from popular imagination.

By the time his posthumously published *A Death in the Family* won the 1958 Pulitzer Prize for Fiction, James Agee was beginning to find a new audience. Two years later, *Famous Men* was rereleased to a new decade, one that, the Agee mythos would argue, was ready to receive it as it was meant to be read, as a vicious indictment of America's disingenuous, manufactured empathy for the disenfranchised. And even before its rerelease, *Famous Men* had achieved a kind of mythic, cult quality; the few versions of the 1941 book still extant were passed around college campuses, especially in the Northeast. Bruce Jackson remembers being a freshman at Rutgers in 1960 and hearing of other students' adoration of the book and how it invited a kind of spiritual awakening. Not surprisingly, the appeal of the book came, in part, from its opacity: "[P]eople talked of it as if it were the Grail: brilliant, redemptive, universally inaccessible."[5] Once it was rereleased, however, the book became a legitimate phenomenon with young, college-aged students, who were simultaneously delighted and befuddled by the experience of reading it; teenagers and twenty-somethings approached *Famous Men* as a sort of complex, high-modernist hybrid: half documentary, half Gertrude Stein poetry with a self-effacing and intractable, prosaic vernacular all its own.[6] *Famous Men* especially appealed to college students in the North whose thoughts were beginning to turn southward, to the suffering and disenfranchisement of poor, southern African Americans: Agee's sincere effort at crafting a humanist documentary spoke to their white privileged baby boomer guilt, a perspective that desired relevance in the broadening world of the 1960s. Many of those northern university students would eventually travel south as "Freedom Fighters" and civil rights workers. During their time working for the rights of African Americans, they would take their affection for Agee and his challenging

book with them and integrate his meditations into the ethos of their movement.

The successful 1960 rerelease of *Let Us Now Famous Men* is unequivocally connected with the beginnings of what would later be codified as the American civil rights movement. The book spoke directly to the turbulent decade's troubled relationship with racial politics, disenfranchisement, and economic empowerment. Jackson recalls that much of the rerelease's impact came from the unrest of that time. He writes,

> The psychiatrist Robert Coles tells of black and white Civil Rights workers in the South in the early sixties carrying [*Famous Men*] as a bible or a talisman. My friend Charles Hainie [*sic*], who was one of those Civil Rights workers, said, "We grew up in a world where it wasn't all right for men to be emotional about things. Women could, but we didn't know how. Agee taught us it was ok to feel. All those feelings of his about intruding into people's lives, it was important for us to know that it was ok for us to have those feelings. We went into people's houses when we did voter registration. That book taught us how to go into someone's house."[7]

Unsurprisingly, *Famous Men* appealed mostly to male civil rights workers who felt themselves emotionally invested in ways that were in danger of being read as not just anti-masculine, but also as effeminate. Male civil rights workers found Agee's own emotional investment with his poor sharecroppers a correlative to their own deep concern for the southern African American.

Jackson and Hainine's recollections of *Famous Men*'s appeal to civil rights workers' emotional lives are not unique. Indeed, much of the success of the rerelease of the text (both within the academy and outside of it) comes from reading Agee's book as a rubric for how (white) privilege might successfully engage with multiple species of disenfranchisement. Jeanne Follansbee Quinn describes *Famous Men*'s appeal as deriving in part from its methodology for dealing with issues of representation; she writes, "The book achieved iconic status among civil rights workers in the 1960s because it suggested to sympathetic whites a model for approaching disenfranchised Southern blacks, an appropriation of Agee

and Evans's text that I believe underscores their insight into the compensatory nature of identification."[8] Many civil rights advocates felt *Famous Men* was a book that taught the central components of successful engagement for civil rights workers in the South. Matt Herron notes,

> The book is practically a teaching text for the approach (best articulated by Bob Moses) that SNCC [Student Nonviolent Coordinating Committee] adopted in working with Mississippi people: respect local people and their intuitive wisdom and their power to help themselves. The respectful attitude of Agee toward his sharecropper family is part and parcel of SNCC's philosophy, and is nowhere better stated than in Agee's work. . . . It was a tremendously influential book that changed peoples' behavior, my own included.[9]

Similarly, Staughton Lynd found that the spirit of *Famous Men* "was alive in the Freedom Schools (which I directed) in the summer of 1964. . . . Agee and Walker rescued the oral history of ordinary people. Second, implicit in that methodology was faith in the capacity of ordinary people to do extraordinary things."[10] Though Agee and Evans's book does not seem to be "officially" taught in the Freedom Schools or at the SNCC, it was certainly an unofficial textbook of the movement, a kind of methodological theory that complemented the practical work being done on the ground. *Famous Men* was all the more compelling because it had to be sought out; one did not read it, one became initiated into its teachings.

For any serious scholar of James Agee or *Famous Men*, how the American civil rights movement transformed Agee's failure of a book into a kind of humanist bible is a curious thing. Despite how it occurred, the actual success of the rerelease cannot be disputed: the 1960 version of *Let Us Now Praise Famous Men* went on to sell around sixty thousand copies and has become one of the most widely discussed texts of the Great Depression; in terms of contemporary appeal, it has even begun to eclipse more conventional works like *The Grapes of Wrath* (1939), not to mention its contemporary rival, *You Have Seen Their Faces*, which has now been virtually forgotten.[11] But this success does not come without

questions: what was it about Agee's text that spoke to the decade? How was *Famous Men* subsumed as a book of racial enlightenment when Agee's own engagement with race (when extant at all) is troubling to say the least.[12] And, perhaps most difficult to answer, in what way does the 1960s reception of *Famous Men* speak to a readership that had moved beyond the strictures of modernism and into the play and openness of high and postmodernism? While I doubt the possibility of arriving at a single reason for *Famous Men*'s popularity, thinking broadly about the way Agee's book was first received by civil rights workers and later sanctioned as an official text of the movement, despite its obvious problems with subjectivity, identification, and motive reveals much about the universality of the work.

Beyond a methodology for approaching poverty and disenfranchisement, *Famous Men* would offer civil rights workers a persona with which to identity. As workers traveled south to volunteer for jobs they felt important to the cause, they felt as though they were intruding on real people's lives and deliberately upsetting a fragile balance that, while oppressive, was familiar and comforting. Ambivalence over the messy work of voter registration and marching for equality—simultaneously disrupting and damaging the familiarity of oppressed people's lives all in the name of good intentions—reminded workers of Agee's conflicted perspective over his investment in his own project of representation. In *Silent Voices: The Southern Negro Woman Today*, for example, Josephine Carson recalls an instance of visiting with an African American voter in Atlanta in the mid-1960s; the woman is pushed at her, "as if she were an object. 'She'll talk to ya.' His tone is sweet, paternal toward me. I feel dreadful, hysterical. Why no protest? I have invaded; yes, this whole work is an invasion. Yes, I know that it is an invasion. Obscene—that is how it felt to James Agee to live with and observe innocent hosts who floundered, starved, and grappled for decency in the splintered ruin of their lives."[13] Carson finds in Agee a partner who is similarly disturbed by the emotional ambivalence of trying to help without really knowing how. *Famous Men* clearly resonated with civil rights workers who felt conflicted by their task of transforming the South through engagement with real people dealing with issues of poverty and disenfranchisement. Mary King remembers that her identification with disen-

franchised African Americans through her work on the Student Non-violent Coordinating Committee in the 1960s came almost solely from an engagement with Agee and Evans's book: "I did not pity the poor with whom we worked. One reason for this lies with a book that Casey and I were studying: *Let Us Now Praise Famous Men*, a record of southern cotton-tenant families in the 1930s, written by James Agee and with photographs by Walker Evans which looked at the plight of three tenant families in the Deep South."[14] If for no other reason than it offered an approachable, humanistic ethos to engaging with issues of poverty and disenfranchisement, *Famous Men* became central to civil rights work in the South.

Civil rights workers who express affection for Agee and Evans's book also foreground the connection between their own experiences and Agee's voice in *Famous Men*. Such a connection might not be surprising, for, while much of the book is inscrutable, one clearly identifiable feature is the clarity of voice, Agee's self-tortured, angry, and defeat-riddled articulations of his process of representation. Voice was central to Agee's fashioning of a new aesthetic throughout *Famous Men*; Agee thought of his project as a new artistic endeavor in which both the documented and documenter share equal weight. As a consequence, Agee deliberately did not remove his own thoughts, anguish, terror, and joy from the text. And *Famous Men*'s multivocality is one of its defining characteristics.[15] The voice Agee fashions is critically aware (even hyperaware) of his own failure of communication, for he found that, in writing of the poor farmers, he had created a book that was crucially unsuccessful in uniting his reader to any truth of poverty; despite his best intentions, he communicated mainly his own sense of frustration and hopelessness. The owning of his failure becomes emblematic of the kind of work Agee sees as emerging from the scorched earth of the modern American novel. "In a novel, a house or person has his meaning, his existence entirely through the writer," he writes. "Here, a house or a person has only the most limited of his meaning through me: his true meaning is much huger. It is that he *exists*, in actual being, as you do and as I do."[16] Later, he speaks directly to the farmers themselves about his difficulty in representing them. In a section marked "COLON," he explains that he cannot turn them into characters in a novel any more than he can "document" their

lives for a magazine: "[H]ow am I to speak of you as 'tenant' 'farmers,' as 'representatives' of your 'class,' as social integers in a criminal economy, or as individuals, fathers, wives, sons, daughters, and as my friends and as I 'know' you?"[17] Art limits Agee's ability to humanize and sustain his moral agenda because it denies the farmers an actual space in real life. Agee acknowledges that he wishes his account could be "globular. . . . [E]ighteen or twenty intersected spheres. . . . [T]he heart, never, center of each of these, is an individual human life."[18] Unlike the exploration of his own past personal tragedies, Agee cannot turn the farmers' lives into lyrical poetry and pretty art.

Agee's tortured vocalization of the responsibility he felt toward poor, white tenant farmers deeply resonated with civil rights workers who were themselves traveling to the Deep South, ostensibly to do the same kind of work that Agee had hoped to accomplish. Howard Zinn notes that among the volunteers traveling as part of the Freedom Summer of 1964, many "mentioned the book as one of their influences on them. It seems natural to me that young people learning about poor Southern whites, and working with poor Southern blacks, would see that on all one continuum, of concern for the injustice of a system, which is based on both class and race opression."[19] Unlike Erskine Caldwell, who had decided to "invent" stories for the real farmers he met in 1936, Agee approached the white sharecropper with reverence and awe. Instead of fashioning narratives for the poor, white southerner that sentimental-ized or manipulated his perspective, Agee deified his sharecroppers. Despite (or perhaps because of) Agee's obsession with the poor, rural white farmers, civil rights workers found in his admiration a similar connection to their own feelings for the people they were coming to help. Emmie (Schrader) Adams compares Agee's sincere love for his subjects with her own interest in poor southerners; she writes that [Agee and Evans] "seemed like a lost fragment of their generation whose message reverberated with ours; the dignity that they found in their subjects, the things they admired in them, their wisdom, their strength, etc."[20] Agee had presented the poor, white southerner as a model of both Christian and secular beauty, a figure to be worshipped, a vessel through which he might come to understand his own personal worth. His preoccupation

with their value drew comparisons to the workers' feelings for those they came to help. Casy Hayden writes that *Famous Men* was compelling precisely because of

> Agee's capacity to actually get his love for these people out there where you could feel it. Perhaps it was the fact that he really did love them, as we did love the people we were working with. Really love them. To love the least of them. It wasn't done, you know. Not really. It would be like writing in love of homeless people. . . . It was a language, a form for what we knew interiorly, where we went when we sang in the churches. It was that legitimizing, that resonant. The fact that it was about whites made it ever better, because we knew we transcended race, that our love wasn't about race, but was more basic, more huge.[21]

Consequently, the book inspired a quasi-religious awe; it became a transcendent text of enlightenment. Hayden tells us, "I carried this book around with the two work shirts and the one pair of jeans, the same size as my old Bible, for which it was the replacement. We passed it around like cigarettes, like bread and wine."[22]

However, *Famous Men* also spoke to an anger burning deep within the movement. Students, civil rights workers, and revolutionaries were attracted to Agee and Evan's text and its tone of outrage and fury, a tone for which they had endless sympathy. Chris Routledge of *The Guardian* recently noted that even now, seventy-five years later, "what appeals most about the book is its anger."[23] In the 1960 reissue of *Famous Men*, readers found the "anguished self-questioning prose" of James Agee and the "uninflected, seemingly styleless photographs"[24] of Walker Evans to be a sophisticated and intricate attack on not simply the social order of the South but also on the very idea of representing poor, disenfranchised southern folk. Agee indicted everyone in his book: himself, the reader, the publisher, and the landowners of the South. Included in that attack were the purveyors of exploitation and sensationalization at the expense of the southern poor: magazine editors, ineffectual liberal audiences, and armchair moralists. There is little doubt that Agee was attacking his

predecessors, Caldwell and Bourke-White, the latter being excoriated in one of *Famous Men*'s many appendices for being wildly out of touch with the poverty she documents. But Agee was also attacking a system of oppression that necessitated his very involvement in the project at all. He writes of his and Evans's project as "the virulent, insolent, deceitful, pitying . . . running and searching . . . of two angry[,] . . . youthful intelligences in the service of an anger and of a love and of an undiscernible truth, and in the frightening vanity of their would-be purity."[25]

Civil rights workers' attraction to what is clearly neither a text of racial enlightenment nor a call to revolution and action might be explained by Agee's purposeful romanticization of his task in the book: he defines his goal as a kind of angry and anguished attempt to do something, anything, even if the end result is, finally, indiscernible. That voice, the rhetoric of searching intractability and failure in the face of a palpable rage, is one that the civil rights worker understood, adopted, and celebrated. In his preamble to the book, Agee's anger is clear. He questions the intentions of everyone involved with the story, including *Fortune* (the magazine that had sent Agee to do the work for an article), himself, and the reader:

> It seems to me curious, not to say obscene and thoroughly terrifying that it could occur to an association of human beings drawn together through need and chance and for profit into a company, an organ of journalism, to pry intimately into the lives of an undefended and appallingly damaged group of human beings . . . for the purpose of parading the nakedness, disadvantage and humiliation of these lives before another group of human beings.[26]

For the civil rights worker, Agee's anger was not just political posturing; Todd Gitlin also finds in it "something far more idiosyncratic & interesting" than a typical leftist attack on the machinations of capitalism and workers. It had in it the sincerity of an inexplicable rage, he explains: "I was attracted by Agee's honesty as he wrestled around in moral quandaries & identified with the honesty at least as much as by the politics. The writerliness, the moral charge, the confrontation with the reader's

ease—it was all of a piece to me."[27] Howard Zinn similarly concludes that it was not a political sensibility that civil rights workers shared with the text, but more a call to rebellion:

> There was not much of a connection with the politics of the Thirties, in my opinion, because although the situation of the poor was especially bad in Thirties, that seemed only an extension of their permanent condition in any period. Rebelling against the complacent fifties? I don't think that was a conscious thought. Against the complacency they saw around them in the Sixties—that's more likely, a complacency which they were then to have a part in upsetting.[28]

Agee's furious tone, his attempt to renegotiate that anger into a sincere humanism, and the ultimate failure of his vision all spoke to civil rights workers' perspective on their work, their view of the project in which they were engaged as the task of their generation.

By the end of Agee's introduction, virtually no one is left unscathed, save the subjects, the "undefended" poor, rural farmers whom Agee praises. Agee's authorial tone is not inviting; it is deliberately antagonistic, but his antagonism connects with self-defeat. Even seventy-five years later, the book seems to be an indictment of itself, a plea for commonality that knew it could not connect with anyone. Agee chastised the magazine for sponsoring such a story, the reader for buying into its voyeurism, and, indeed, the author for creating it. In short, his antagonism was so divided that it seemed impossible to localize it to a specific group. And yet, by the end of his book, it becomes clear that Agee is not really interested solely in documenting and defining an "unimagined existence," but is instead involved in a very personal project, one that he hopes will help define his worth as an artist and as a human being. He writes to his spiritual mentor Father Flye that he felt "terrific personal responsibility toward [the] story" and had "considerable doubts of my ability to bring it off; [and] considerable more of *Fortune*'s ultimate willingness to use it as it seems (in theory) to me."[29] Later, he confided that to do the story right, he would have had to take on

[t]he whole problem and nature of existence. Trying to write it in terms of moral problems alone is more than I can possibly do. My main hope is to state the central subject and my ignorance from the start . . . well, there's no use trying to talk about it. If I could make it what it ought to be made I would not be human.[30]

The final aesthetic—that of a professional project of representation that morphs into a personal project of identification and self-discovery—mirrors the trajectory of the civil rights worker. Sue Thrasher remembers that *Famous Men* created, for her, a perspective on poor, white southerners that actively changed her vision of who she was:

> I think I was also just beginning to articulate to myself—not out loud to others—my growing consciousness around class. During the civil rights movement, I was often surrounded by middle class white students who seemed to think it was romantic to move into rural poor communities and live on almost nothing. I knew it was not romantic. But I wasn't yet ready to speak of class. Poor whites, at the time, were also associated with redneck racists. It was all a bit confusing.[31]

Civil rights workers found their voice in Agee's, and they sensed in his personal discoveries their own changing perspectives. Agee's move from anger, to responsibility, to ecstatic spiritual revelation, to personal discovery, to defeat, to the acknowledgement of the impossibility of his project had deep connections to the work and the world of the civil rights worker in the South in the mid-1960s.

Famous Men's eventual success stems not from Agee's initial goal of exposing the unimagined existence of sharecroppers but instead from an articulation of a specific historical moment in American culture that his text ultimately predicts: Agee's setting and subject (poor, white Alabamians) are transformed in the decades between the initial publication and its reissue—from a source of fascination to a subject of anxiety—and Agee's own position as insider-outsider recalls the same ambiguity of the civil rights worker, who also experiences ambivalence

toward the white southerner and his perspective. In fact, it might not be an overstatement to claim that our understanding of *Famous Men* as a high-modernist self-referential documentary (metadocumentary? mockumentary?) comes largely from its contextualization with the American civil rights movement and the connections between Agee's voice and the voices of the thousands of workers who wanted to make a difference but felt crucially impotent and, often, mired by a paralyzing anger and outrage.

In understanding the way(s) in which *Famous Men* impacted the civil rights movement (and especially, crucially, the Freedom Summer of 1964), it is useful to imagine all the spaces that Agee's text opened for practical applications for confronting disenfranchisement, all couched in a simultaneous acknowledgment of the futility of a task of enfranchisement within a corrupt and exploitative system of power (a system that privileged white, middle-class identities such as Agee's and the majority of civil rights workers, even as both worked to undermine and expose their positions of power). Read in concert with the civil rights movement, one can see how Agee's voice and perspective are adopted by white, liberal intellectuals agitating for civil rights, even though Agee never consciously published his thoughts about political rights for African Americans.[32] Despite its obvious limitations, though, *Famous Men* offered a voice for the movement that continued to be foundational throughout the lives of civil rights workers. Matt Herron concludes,

> Like most great books, *Let Us Now Praise Famous Men*, [*sic*] has more than the simple power to inspire, it can direct men and women to action, and may change their lives. It certainly influenced the politics and probably the actions of SNCC people; for me, it shaped my life as a communicator. I haven't read the book in years, but I carry it inside of me—as important an influence as any I know.[33]

The transformation of James Agee's failure of a 1930s documentary to a successful text of 1960s racial enlightenment effectively revises *Famous Men*'s rhetoric of failure into an ethos for a movement that brokered

ambivalence and relativism as it fought to give voice to those it felt were exploited.

What is particular interesting, finally, about civil rights workers' interest in Agee's text is that it is not the voice of the disenfranchised that workers felt the book isolated, promoted, and celebrated, but their own voices, cynical, deeply conflicted, and unquenchably furious. The book becomes not a means to understand the unknowable world of their subjects but a vessel through which civil rights workers might understand their own perspective and rearticulate their own struggle; it is a way to hear their story echoing back to them through Agee's tortured voice. *Famous Men* becomes for them a prioritizing (and awkward romanticizing) of their own struggle. That civil rights workers found themselves the central hero of Agee's story is what made the book so compelling to them, and it is largely because they hear their voices articulated through his that *Let Us Now Praise Famous Men* endured far beyond what James Agee had ever dreamed, predicted, or, indeed, even wanted.

NOTES

1. Alan Trachtenberg, foreword, *You Have Seen Their Faces*, by Erskine Caldwell and Margaret Bourke-White (Athens: U. of Georgia P, 1995) v.

2. Donald Davidson, "Erskine Caldwell's Picture Book: A Review of *You Have Seen Their Faces*," *Contemporary Southern Prose*, ed. Richmond Croom Beatty (Boston: D. C. Heath and Co., 1940) 275–276.

3. John C. Cort, rev. of *Let Us Now Praise Famous Men*, by James Agee and Walker Evans, *Commonweal* 12 Sept. 1941: 500.

4. Hugh Davis, *The Making of James Agee* (Knoxville: U of Tennessee P, 2008) xii.

5. Bruce Jackson, "The Deceptive Anarchy of *Let Us Now Praise Famous Men*," *The Antioch Review* 57.1 (Winter 1999): 38.

6. Like Stein's poetry, *Famous Men* presents its reader with unadorned catalogs, lists of objects, and barren descriptions of items found in dressers or on tables; the poetry comes from an engagement with the beauty of the mundane, an aesthetic that clearly influenced Agee throughout *Famous Men*.

7. Jackson 41.

8. Jeanne Follansbee Quinn, "The Work of Art: Irony and Identification in *Let Us Now Praise Famous Men*," *Novel: A Forum on Fiction* 34.3 (Summer 2001): 344.

9. Sarah Barrash, "Correspondence Regarding *Let Us Now Praise Famous Men* and Mississippi Freedom Summer," Box 1, Folder 1, MS, John C Hodges Library,

1995–1999, University of Tennessee. My sincerest thanks go to Sarah and her help crafting this article; her suggestions and permission to quote from her correspondence were both critical to me and my essay. I should also like to thank the University of Alabama and their financial support for my travel to Knoxville, TN, in December of 2013. I am especially indebted to the Research Grants Circle (RGC) and The College Academy of Research, Scholarship, and Creative Activity (CARSCA) for funding me for this particular visit to the archive.

10. Barrash, Box 1, Folder 1. Because the archive consists of a series of letters between Barrash and the civil rights leaders, there are few specifics on dates, locations, and projects or initiatives. The letters are general explanations of workers' engagement (and lack of) with Agee and Evans's text. Many of the workers responding to Barrash's questions would have been working largely in Mississippi between the years 1963–1968. But some of them would have been working throughout the South (i.e., Alabama, Georgia, and Tennessee, too). It is clear from a reading of the archive that Agee and Evans's book had a broad appeal to those working for civil rights, despite their location. Whether in Mississippi, or the larger South, *Let Us Now Praise Famous Men* was an important touchstone for civil rights workers.

11. The Wylie Agency (who holds the copyright for the James Agee Trust) reports that *Famous Men* has sold around 35,000 copies since 2001. Meanwhile, the University of Georgia launched a recent small-run of *You Have Seen Their Faces*, which had been out of print prior to 1995.

12. For a discussion of Agee's engagement with matters of race in *Famous Men*, see James A. Crank, "Racial Violence, Receding Bodies: James Agee's Anatomy of Guilt" *Agee at 100: Centennial Essays on the Works of James Agee*, ed. Michael A. Lofaro (Knoxville: U of Tennessee P, 2012) 53–74.

13. Josephine Carson, *Silent Voices: The Southern Negro Woman Today* (New York: Delacorte Press, 1969) 28.

14. Mary King, *Freedom Song: A Personal Story of the 1960s Civil Rights Movement* (New York: William Morrow, 1987) 139.

15. See James A. Crank, "'A Piece of the Body Torn Out by the Roots': Failure and Fragmentation in *Let Us Now Praise Famous Men*," *Mississippi Quarterly* 62.1 (Winter 2008–2009) 163–17.

16. James Agee and Walker Evans, Let Us Now Praise Famous Men: *An Annotated Edition of the James Agee-Walker Evans Classic, with Supplementary Manuscripts*, ed. Hugh Davis, vol. 3 of *The Works of James Agee*, gen. eds. Michael A. Lofaro and Hugh Davis (Knoxville: U of Tennessee P, 2015) 11. Subsequent references to this edition will be noted as Davis, *LUNPFM*.

17. Davis, *LUNPFM* 84.

18. Davis, *LUNPFM* 84.

19. Barrash, Box 1, Folder 1.

20. Barrash, Box 1, Folder 1.

21. Barrash, Box 1, Folder 1.

22. Barrash, Box 1, Folder 1.

23. Chris Routledge, "Let Us Now Praise James Agee" *The Guardian* 11 Jan. 2008, date of access <http://www.theguardian.com/books/booksblog/2008/jan/11/letusnowpraisejamesagee>.

24. Trachtenberg vii.

25. Davis, *LUNPFM* 8.

26. Davis, *LUNPFM* 7.

27. Barrash, Box 1, Folder 1.

28. Barrash, Box 1, Folder 1.

29. James Agee, *Letters of James Agee to Father Flye* (New York: George Braziller, 1962) 92.

30. *Letters of James Agee to Father Flye* 105.

31. Barrash, Box 1, Folder 1.

32. While much of Agee's thoughts on African American enfranchisement and civil rights in America lay hidden in his journals and letters to Father Flye, he did pen a short essay entitled "America Look at Your Shame," which was discovered and later published by Michael A. Lofaro and Hugh Davis in the relaunch issue of *The Oxford American*. In the piece, Agee explores his own thoughts on racial discrimination against the backdrop of his paralyzing, ineffectual white guilt. See James Agee, "America, Look at Your Shame!" *Oxford American* 43 (Jan.-Feb. 2003): 35–39.

33. Barrash, Box 1, Folder 1.

Ruses and Ruminations:
The Architecture of *Let Us Now Praise Famous Men*

Caroline Blinder

> Upon the leisures of the earth the whole home is lifted before the approach of darkness as a boat and as a sacrament.[1]

> Every spirit builds itself a house, and beyond its house a world, and beyond its world a heaven.[2]

This article takes as its starting point the "Shelter" section from *Famous Men*, in which the abodes of the individual sharecropper families are outlined, dissected, and ultimately set out to be, according to Agee, no less than "the altar of God" (104). My aim is to examine how the architectural ordering of the sharecroppers' homes, the positioning of the houses in the landscape, their interior architecture, and the objects placed therein become the catalyst for a lengthy series of poetic investigations into the sacred nature of the quotidian and the everyday. Through a detailed look at primarily Agee's writing, the idea of an American architecture as synonymous with a distinctly vernacular fortitude emerges. This fortitude becomes a way to define an almost pastoral condition, a condition paradoxically contingent on the lack of economic progress in the South rather than the sharecroppers' desire for it. For Agee, in particular, this becomes a way to allegorize writing, photography, and, indeed art, as always contingent on what surrounds them. By focusing again and again on the physical parameters of the sharecroppers' lives, Agee appropriates Emerson's dictum from "Nature"—"What is a farm but a mute gospel?"[3]—admonishing the reader to really see *and* feel what is present in "a house made from the ground up" (150). For Agee, to immerse oneself in the architecture of these structures is to "realize for a

little while at a time the simultaneity in existence of all of its rooms in their exact structures and mutual relationships in space" (150). A catalyst for what Agee calls "a kind of building-dream" (150), architecture in the "Shelter" section becomes yet another way for Agee to play out his desire for immersion and separation, both physically and psychologically, from the sharecroppers. Ultimately, Agee uses the "Shelter" section as a way to sacramentalize the sharecroppers' surroundings and as a way to render his own presence in the house equal to that of the penitent seeking salvation. In this sense, rather than see Agee's religiosity as contrary to a more secular interest in the sharecroppers, reading parts of the "Shelter" section as a series of sacramental rites allows us a deeper understanding of Agee's style, a style based on faith as much as documentary rigor.[4]

Attentive to precise descriptions of the physical world *and* laboring with an ingrained sense of its inevitable limitations, the interior architecture of the sharecroppers' homes is thus another indicator of how space is used both metaphorically and structurally as a framing device for the writer and photographer's vision. For Agee and Evans, the pre-industrial nature of the objects in the rooms, the design and decorative impulses discernible there, are all indicative of the lyrical potential of lives lived in humility and toil, and as such, redemptive in ways impossible for Agee to enumerate. *Famous Men* constitutes, among many things, an exercise in the difficulties of commenting on an environment whose austerity in material terms paradoxically proves its value as a subject in artistic terms. Even more paradoxically, Agee oftentimes takes the humble architectural dimensions of the sharecroppers' homes as proof of their status as religious sites, what he at varied moments calls altars, tabernacles, and recessional spaces, worthy of poetic representation and of the adulation of the poet-writer. If adulation entails both the excessive fawning over something and the praise given to something divine, then Agee's descriptions fluctuate between the two, collapsing the boundaries between outright adulation and a more fetishistic interest in the materiality of the sharecroppers' lives.

Agee's awareness of his position as social and intellectual interloper in this context is made all the more visible by Walker Evans's measured and unapologetic photographs of the interiors of the sharecroppers' homes. The fact that Evans did not stay with the families for any extended pe-

riod, and only came into contact with them for photographic purposes, seems particularly crucial and an indicator of Evans's possibly more professional if no less invested attitude to the project at hand. The issue is thus not whether Agee *felt* more for his subjects than Evans, but how Agee's writing is led by a documentary ethos that cannot be divorced from his ethical anxieties. How to render the actual economic repercussions of the sharecroppers' poverty becomes, in other words, secondary to the idolization of their homes. Not until near the very end of the "Shelter" section does Agee admit that "they live in a steady shame and insult of discomforts, insecurities, and inferiorities, piecing these together into whatever semblance of comfortable living they can, and the whole of it is a shark nakedness of makeshifts and the lack of means" (170).

The reminder of "the lack of means" underlying the Gudger, the Woods, and the Ricketts' houses is inserted into the "General Habitability" section long after we have gone through the Gudger house in detail. In this respect, it is a recuperative measure, in many ways, rather than an intrinsic part of the detailed exposition of individual rooms, their dimensions, and usage. Agee's decision to only peripherally remind the reader of the lack that lies at the heart of these lives not only renders the project more lyrical, but the social purpose also becomes in a curious way incidental. And Agee makes it clear at several key moments why he does not want to stress the dismal functionality of the homes:

> It is my belief that such house as these approximate, or at times by chance achieve, an extraordinary "beauty." In part because this is ordinarily neglected or even misrepresented in favor of their shortcomings as shelters; and in part because their aesthetic success seems to me even more important than their functional failure; and finally out of the uncontrollable effort to be faithful to my personal predilections. I have neglected function in favor of aesthetics. (164)

In this context, the architecture of the sharecroppers' homes, the descriptions of the outer structure, the walls, and their materials, emblematizes both a state of transition for Agee and a state of desired

immersion. Agee, who is trying to come to terms with the fact that he will always be at some distance from his subject matter, can only hope to approximate some semblance of nearness, some sense of being able to embody what he seeks to document. As such, Agee's decision to focus on the "beauty" rather than functionality of the homes is a much more serious affair than what he surreptitiously calls a "personal predilection"—it is, in fact, an attempt to be genuinely integrated into the homes he describes. The problem, as amply illustrated prior to the "General Habitability" section is that the houses are, indeed, too beautiful; they can be admired, but the task of inserting them into a wider socioeconomic context is—as Agee intimates from the very onset—doomed:

> Here I must say, . . . what I can hardly hope to bear out in the re-
> cord: that a house of simple people which stands empty and silent
> in the vast Southern country morning sunlight, and everything
> which on this morning in eternal space it by chance contains, all
> thus left open and defenseless to a reverent and cold-laboring spy,
> shines quietly forth such grandeur, such sorrowful holiness of its
> exactitudes in existence, as no human consciousness shall every
> rightly perceive, far less impart to another . . . (112)

As always with Agee, the problem is how to impart the "holiness" of a structure whose beauty relies on its very vulnerability. By the time the reader gets to the "Shelter" section we know that Agee considers himself a "cold-laboring spy," albeit a reverent one. Here, Agee promises, the actual eternal proof of the "grandeur" of human existence will finally be shown. With equal presumption, Agee establishes his own eye as somehow beyond mere "human consciousness," a move akin to a much more Emersonian notion of the poet's eye than to any documentary version of objectivity. Likewise, it is no coincidence, as Agee will remind us over and over again, that he *sees* the most when the structures are vacated, when they—and he—are left alone without the distractions of their occupants. Agee wants them to "stand empty and silent in the vast Southern country morning sunlight" so that he may spy in peace (112). On the one hand, Agee, in seeking to get to grips with the documentary task, tries to move unhindered between interior and exterior spaces, be-

tween the actual physical circumstances of the sharecroppers' lives and their spiritual potential while, on the other hand, he employs a rhetoric of indexicality and typography that seems to hinder this very process. As witnessed at the end of the "Shelter" section, the only thing Agee can do is move the writing in the direction of something that renders the boundaries described oblique and permeable; only in this way will he be able to render his desire for immersion and integration. The most expedient and lyrical way for Agee to achieve this is by configuring the architecture of the sharecroppers' homes in religious terms, promising, as the subtitle of the section itself indicates, that he will "go unto the altar of God" (104).

> On the bureau shelf, the mantel, the table and one wall, objects: small simple and varied: which, the only adorned or decorated creatures of this room, bestow upon its nakedness the quality of an altar. (132)

Imbedded into Agee's move through the Gudgers' home are a series of ritualistic moments, designed in some measure to pave the way toward the "Altar" section and the "Tabernacle." In keeping with the desire to combine the indexical methodology of an archivist at work with something recognizably spiritual, the outline that preempts the "Shelter" section lists every room of the house, the significant pieces of furniture, their exact positioning, but then ends with "Recessional and Vortex" (106). Appearing midway through the section, the "altar" is the mantle and desk by the Gudgers' fireplace, upon which sits the "white china swan, profiled upon the north" (135). This very swan reappears at the end of the "Shelter" section where it, like a compass, with its "hidden needle holds it course" (178). Like the tabernacle, another spot designated as emblematic of the sacred and the secular simultaneously, the altar consists in equal measure of the Gudgers' attempts to prettify their surroundings, of personal mementos, photographs, and advertising reminiscent of better times, and of things that are too delicate—glass and porcelain—to be of functional use. Without Agee's perambulatory movements through the house, we would not be prepared for this table drawer to be anything special, and it is largely because of the ritualistic

procedures that preempt the introduction of the altar and tabernacle that this works. As Agee begins his move through the house, following the departure of the family, which initiates the "Shelter" section, he takes "warmed water from the bucket", anoints himself, and with the "same knowledge, along with the coldness, the adoration, the pity, the keen guilt at the heart" remembers George Gudger's labor (115).

If Agee proceeds to name the home "this tabernacle upon whose desecration I so reverentially proceed" (115), it is to ritualize both his own endeavor and his shame. Much has been said about the possible ramifications of Agee's modernism, its taint in some ways by his guilt over how to render the sharecroppers, but in this instance the "Shelter" section becomes a form of literary transubstantiation and a way for Agee to navigate his own anxieties. In other words, Agee can only move on, despite his forebodings, through a process of consecration, a process enabled by taking what appears to be simply the unadorned and the ordinary as the starting point for a transmutation of the everyday. There are of course similarities here between Evans's ability with his camera to portray things as they are and, at the same time, through the process of photography to change them from one substance into another. In fact, this sense that there is alchemy at work is partly what constitutes Agee's fascination with Evans's photographic abilities. However, rather than look at the two processes in comparative terms, I am interested here in how Agee employs a very discursive sense of religious rhetoric, what some might call a secularized and modernist implementation of religious terminology toward different ends.

In the Eucharist, the conversion of bread and wine into the body and blood of Christ is enabled despite the appearance of bread and wine remaining, and Agee's vision of the sharecroppers shares something with this very central idea of transubstantiation. In fact, what worries Agee may be that the mortality of the sharecroppers, their vulnerability, the inadequacy of their shelter, is strangely secondary to an architecture that speaks of perseverance, of survival, and of a timelessness born out of generations of toil: "[T]his square home, as it stands in unshadowed earth between the winding years of heaven, is, not to me but of itself, one among the serene and final, uncapturable beauties of existence" (112). The process of rendering this "timelessness" is partly what Agee

seeks to idealize through a description of the sharecroppers' interiors as holy spaces and their personal objects as vessels for a process of transmutation that can only be signified as religious.

While the rhetoric employed by Agee is undoubtedly marked by his Anglican upbringing it is also—in line with a decidedly modernist use of the vernacular—tempered and accentuated by something more akin to an Emersonian vision of nature. Moving about a nearly bare storeroom, Agee examines how the house is "made from the ground up . . . every inch of this open to the eye as it is within one of these rooms" (151). It is, once again, the sense of naked transparency that fascinates Agee, for whom "all these things, each in its place, and all in their relationships and in their full substances, be, at once, driven upon your consciousness, one center" (151). The possibility of an instantaneous illumination, a dissolution of boundaries through the collapse between interiority and exteriority in the house, is clearly described by Agee as a form of epiphany (151).

For Agee, to describe both this sense of transition and of immersion simultaneously, the homes of the sharecroppers must become organic embodiments, living, breathing entities in themselves. It is no coincidence that the permeability of the floor, the roof, the walls is accentuated not so much as a sign of the makeshift nature of the structures, but as indicative of a desired nearness to nature. More importantly, in line with an Emersonian tradition, it is the idea of nature as a spectacle that confirms our own divinity. Not dissimilar to Emerson's transparent eyeball, Agee describes himself as a " bodyless eye," a "disembodied consciousness . . . that stands in an open platform of floor, not walls nor roof: and in a fluttering of hammers and with wide quiet motions from all sides of this consciousness, . . . their edges join in a stitching of nails" (150). The state described by Agee here exemplifies the at times muddled mixture of Emersonian transcendentalism and contemporary psychology that plays out in *Famous Men*. Here is a state in which the writer (and photographer for that matter) are the lens for the refractions of a nearly cosmic state of being, and yet also an indication of a desperate attempt to solidify the temporal. Agee's lyricism contains a multitude of literary references impossible to deal with sufficiently— but the casket-like sense of closure, of a vestment made out of wood,

bears similarities to William Faulkner's *As I lay Dying* (1930), the living entombment of the narrative voice a metaphor for both martyrdom and death.[6]

Like Emerson, Agee's invocation allows him to establish the homes and the ways in which they are placed in the landscape as proof of some preordained plan. For Agee, things are in their space for distinct reasons, the joined edges of walls are nailed together for a purpose just as the swan upon the altar turns just so toward north and not south. This tendency to take the physical aspects of the land as entry points into a wider metaphysical study of humanity's position is, of course, not unproblematic. If Agee's moral dilemma is how to render the actuality of the lives he describes in terms that will spur political action, then the language of transcendence not only removes the section from any sense of realpolitik, but also sets it firmly within a much more speculative sphere.

Agee's conundrum, proving that despite destitution and economic restrictions these homes carry a spiritual weight that far supersedes their practical application, nonetheless allows him to pursue a decidedly modernist interest: how to chart the inevitable collapse between private and public that modernity brings. As Jacques Ranciére argues in "The Cruel Radiance of What is (Hale County, 1936–New York, 1941)," "It is only possible to account for these lives and their place in the world, however slightly, by going beyond the significant relation between the particular and the general towards the symbolic relation of the part to the unrepresentable whole."[7]

For Ranciére, rather than read Agee as engaged in a postmodern collapse of meaning, we should see him as embracing the impossibility of his task in an ethical sense: "Because each thing, each object, each part of the house has to stand convincingly as a consecrated object as well as a 'scar' indicative of the social ramifications and causes of the poverty described, Agee can only make sensible at the same time both the beauty present at the heart of misery and the misery of not being able to perceive this beauty" (253).

In Agee's case, the fact that, "[t]o those who own and create it, this 'beauty' is however irrelevant and undiscernible" (165) is therefore, in the end, of no consequence to the process before him.[8] In the "Tabernacle"

section, Agee's stealth as a "spy" in the home comes to the fore as he riffles through the private possessions kept hidden in the "tabernacle" drawer, possessions that possibly attest to the loss of an infant, used baby dresses, objects that render the sacred, the passing of time, both tangible and more ephemeral. If "tabernacle" is an apt term for a structure that harbors the actual proof of the existence of God and acts as the locus for something spiritual, it is also a form of sanctuary from the harsh conditions externally that the farmers cannot escape.[9] Agee is well aware of the tabernacle's archaic, Judaic meaning as something temporary, a dwelling place that can be transported easily because of its construction and out of necessity in a diasporic sense. If Agee labors throughout to articulate this sense of religious presence, it is not to render the religious sensibilities of the sharecroppers themselves, but rather his own emphatic plea. We may be tempted to read this portrayal as a renewed reverence toward the sharecroppers, but it could just as well be a plea for a reading of his writing as a sermon. Standing before the altar, Agee consecrates the objects he perceives, giving himself all the more reason to list them painstakingly in their detail.

One may rightly argue that this reading of Agee, as taking upon himself the prophetic mantle of a priestly figure, undermines his very intention. After all, if the shelter is akin to a tabernacle, an altar for the administering of something holy, it complicates an equally important reading of the homes as sites of trauma, the trauma of immanent and psychological displacement, the fear of homelessness in the face of agrarian failure, and so forth—issues that would have been very real and potential factors for the sharecroppers described. And yet, as sites of trauma, as emblems of something left behind by modern society, Agee and Evans insist on carefully delineating these families as timeless, unchanged, not only by market forces and industrialization, but also by successive generations giving birth, living, and dying. Despite the vermin and the dirt, the homes are markedly beautiful; they are steadfast, protective, and ultimately lyrical in the photographs by Evans. A paradox is therefore at work as Evans, with an unwavering confidence, photographs the interiors with a sense of proportion and structure that is more akin to the painted interiors of Charles Sheeler.[10] In these terms, Evans's aesthetic is noticeably marked by a sense of the objects' cubist

and still life potential, rather than as symptomatic of poverty and lack. A longer and more in depth discussion of Evans's aesthetic in this context would be useful, but in this instance it is worth considering some of the differences in how objects are photographed compared to Agee's descriptions of them.

For Agee, writing of the selfsame objects offers the possibility of rendering their actual olfactory texture, their tactile qualities, things that prove some connection between life and spirit. In fact, it is the very sign of usage, the fact that they have unmistakably been used, the salve missing from a jar, the teeth from a celluloid comb, that make them corporal versions of the occupants to whom Agee so wishes to get close. To think of the "Shelter" section in terms of an alignment between the corporeal and the spiritual is a tall order, but Agee's circling around these objects in ways that are both fetishistic and reverent seems too systemic, too sought out, to be accidental. On a more ironic level, Agee's awareness that one of the hardships endured by the occupants is precisely a lack of privacy is foregrounded in his own surreptitious inspections of their closets, chests, and private drawers.

Agee, to some extent, plays out this paradox by establishing himself as the outsider, the one in exile, the one searching for shelter. In doing so, Agee, perhaps inadvertently, inserts himself into a much longer lineage of modernist writers for whom the condition of modernity plays itself out as a permanent state of exile. Rather than mark the idea of exile through its connection to hardship and lack, however, the ruinous nature of the sharecroppers' lives provides Agee the exiled writer with a purpose. If Agee the writer is searching for a sense of rootedness, lineage, and belonging then the "Shelter" section is Agee's opportunity to rethink what "home" means once it is partitioned into its constituent parts.

If Agee labors under the romantic idea of the dilapidated and the used as somehow charged with history in ways that are more potent than their modern, urban counterparts, he also markedly establishes the agrarian as a somewhat primitive counterpart to such ideas. Strangely, but perhaps fittingly, the final part of the "Shelter" section, entitled "Recessional and Vortex," is a barnyard overview of the animals living at and surrounding the Woods' land. These are also, tellingly, creatures that

have escaped the lens of Evans, for whom animals constitute the antithesis to the gravitas he affords his human portraits.

On the one hand, Agee may thus be supplying the extraneous materials that make up the landscape around the architectural center, and in which Evans has no interest; on the other hand, there is something jarring between the brutal husbandry described and the religious connotations of a "Recessional."

Part of the answer lies in the importance of Evans's images that throughout, by verifying the existence of the structures historically, provide Agee with visible historical, social, and economic contexts. We know because of Evans's images that people occupy these "shelters," that the empty rooms have real inhabitants. As such, the focus on architecture— as seen through the eyes of both Agee and Evans—becomes a way to articulate something solid on a wider level as well as a way to articulate what we might call the enigma of modernity's relationship to the past, its desire to make new, to recreate and construct, whilst maintaining the strength and meaning of the original structure. In his desire to engage forcefully with his surrounding, Agee wants to immerse himself in the homes of the sharecroppers, and yet he is painfully aware that he is in a space that he, as the writer of the text, is simultaneously creating. The barnyard section renders in no uncertain terms the non-human, and crucially, the proximity of the non-human to what has hitherto in the "Shelter" section been described in near sacred terms. Perhaps, Agee is acknowledging the one space in which he is unequivocally an outsider.

As always, Agee wants to inscribe questions regarding the nature of aesthetic experience in circumstances where one might not expect to find it. The homes of the sharecroppers, with their modest use of decoration, with no superfluous or excess detail, seem to prove that very little can say a great deal. They are also conduits for his own attempts to recuperate not only the sharecroppers' pasts but also his own. If Agee's memories of being literally sheltered by the sharecroppers' homes strikes a cord on a deeper metaphysical level, it is partly because the homes signify not only a physical link between the past and the present in terms of their decidedly non-urban, non-modern outlook, but they also enable Agee to adopt the perspective of the child looking back and ahead in time. In the section entitled "The Room Beneath The House," Agee

creates a psychological typography in which a recurrent image appears, that of Agee crouching or hiding under something, reenacting the perspective of the child: "There in the chilly and small dust which is beneath porches, the subtle funnels of doodlebugs whose teasing, of a broomstraw, is one of the patient absorptions of keeling childhood" (123). In his role as the "adopted" child of the sharecroppers, Agee looks outward on the working sphere of adulthood and inward on the "meditation space of childhood" (124).[11] In actual terms, the "room beneath the house," the meditative space, is simply the crawl space under the porch; for Agee, however, it constitutes a temporary safe haven from the inevitable disappointments of entering adult life, a luxury of which the sharecropper children, who all work, know little.

I do not mean to imply that Agee deliberately adopts an infantile position, simply that he gravitates toward those liminal spaces, in an architectural sense, that allow for unhindered observation. Likewise, buildings acquire historical meaning, not just because they may some day disappear from the "New South," but also because they mediate between the present and the past in ways similar to that other mediator, the writer. For the adult Agee, the perspective of the child is a seminal part of this process; it is both an attempt to regain a past innocence and an acknowledgement of its inevitable loss.

Agee's search for an alignment between the actual internal and external shapes of the homes and the documentary imagination of the writer is, as he is well aware, impossible. Nonetheless, if vernacular architecture bears the marks of its own production, or in other words is intrinsically connected to the culture from which it emanates, then the documentary perspective in outlook and function shares a strong kinship with it. In this respect, it is not a question of eliminating the barriers between literature and architecture; it is about using architecture as a way to occupy a particular space within the text, just as the room beneath the house constitutes both an actual and a psychological space for contemplation. The structure of the "Shelter" section bears witness both to the ethnographic purpose of the descriptions, the painstaking moving from room to room, the elaborate descriptions of how the walls are put together, the descriptions of how the pine is colored by its contact with the elements, the sun, darkness, rain, etc., and

it bears witness to Agee himself, engaged in trying to be an objective and subjective writer simultaneously.

The idea of the interiors as sacred spaces, conveyed in naming the "Altar," the "Tabernacle," and the "Recessional and Vortex" subsections that conclude the "Shelter" section, is a way to work around the dilemma of how to occupy space in the midst of creating it. By turning the site into a sacred location, Agee partly becomes the supplicant who on his knees enters, penitent and humble, whilst seeking to illuminate the sacred nature of the inhabitants. Thus, it is perhaps fitting that Agee names the last section a "recessional," despite the incongruity of the animals described. It indicates that not only is the site holy, but it is also a site of communion and celebration, a site for meeting and renewal —a site where a recessional might take place. Unlike the processional that begins a wedding in traditional terminology, the newly married couple leads the way during the recessional, followed by the wedding party. The term is also used to describe a hymn that accompanies the exit of the clergy and choir after a service. Ironically, but undoubtedly deliberately by Agee, the term "recessional" can also describe a period of economic recession, thus combining the economic destitution of the sharecroppers with something that should be a celebratory moment, such as a wedding. "Recessional" can also mean a form of vortex, or an uncontrollable spiraling movement, so that the terms "recessional" and "vortex" invoke two contradictory movements simultaneously. While the first recessional movement is that of an orderly, ritualistic procession, the other emanates from a natural phenomenon, a chaotic movement of uncontrollable force. If the open ending of the "Shelter" section appears to hover on the edge of something ritualistic, as well as disordered, it is indeed a recessional vortex, a fitting ending to an intense devotion at risk,always,of spiraling out of control.

Agee's link between the economic recession that ensured his presence in the households in the first place and the contradictory sense of something celebratory, a religious event even, epitomizes the dichotomy outlined thus far.

On the one hand, the religiosity of Agee's language serves a philosophical and spiritual purpose first and foremost, but, on the other hand, it also allows for the architectural dimension to function as a metaphor

for the sharecroppers as sacred embodiments of something divine. The repercussions of this constitute uncomfortable territory, even for Agee, who seems to balk at the sacrilegious implications of his own language and yet simultaneously cannot do anything but embrace it.

One of the ways in which Agee tries to circumvent this dichotomy is by returning repeatedly to an aesthetic in which symmetry or the attempt at symmetry in the building of the houses, their doors and windows, renders them comprehensible, ordered, and self-contained. Indeed, at first glance, Agee and Evans are impressed by an overwhelming sense of symmetry: "Where we stand, square toward the front, the house is almost perfectly symmetrical. Its two front walls, square, balanced, each of a size, cloven by a hallway; the lifted roof; at center of each wall, a square window . . ." (117).

Given the structure of the homes, the most common being the hallway intersecting two parts of the house with each end open to the back and front, the structural symmetry, as John Dorst points out, may trick us into thinking that "one can understand this building, and by implication the lives it encloses, at a single glance."[12] However, once these moments of absolute symmetry are intersected by Agee's "disembodied consciousness," rendering, as Dorst puts it, "the material reality of the house from a dematerialized perspective" (54), the symmetry becomes yet another way to juxtapose the spiritual with the material, the outer frame with its inner content. These moments are crucial, for they remind us of Agee's attraction to the collapse between interiority and exteriority, not just the collapse between interior and exterior spaces in the architectural structure itself, but also in a form of writing seeking to render the inner emotional space of the occupants as well as their outer social circumstances. As Linda Wagner-Martin puts it: "The structure of the work repeats the uneasiness of its tone. The book appears in some ways to be like a house itself—forthright, forthcoming, with the more public and intellectualized matter given at the outside, arranged in layers around the seminal core of human life."[13] Nonetheless, as Wagner-Martin notes, in the end: "Inner penetrates outer; outer is but a threshold to the inner concerns. Rather than a boxlike structure, Agee's house of fiction becomes a vortex, a single center of focus" (46).

The construction of the house, with its view through the front to the back, the typical dogtrot house, not only adds to the recessional sense of the spaces as entry and exit points, it also renders a view of the private as somehow open. To achieve this effect, Agee is once again prepared to forego a critique of the structural lack that such a structure might imply. As he admits, "The aesthetic beauty achieved here, at the cost of a functional lack, is the beauty of unforeseeable metamorphoses, the conjunction of life's randomness with random vegetation, climate and makeshift instruments" (254). Here, the idea of the home as the opposite of symmetrical, random, and makeshift is not just about being left behind by modernity, it is also a way to prove that that which appears lacking is in fact richer in its lyrical implications. Rather than subordinate all parts of the structure to one dominant architectural principle, it is the random nature of the repairs, the weathered pine, and the encroaching vegetation that makes them beautiful.

This romantic urge toward the idealization of a hybrid, part manmade, and part organic construction can be discerned throughout *Famous Men*. And it is there, partly, in Agee's reluctance to articulate any discernably coherent political standpoint in *Famous Men* overall. As the twentieth century began to focus in earnest on structures built for functionality, work, and streamlined habitation, the structures in Agee's "Shelter" section resist the instinct toward commodification forcefully and unapologetically. Agee makes it clear that this is not the sharecroppers' choice, but rather the combined outcome of economic privation and an inability, he insinuates, to accept the changes necessary for survival. These are attachments that Walker Evans renders with a seemingly neutral eye, and much more could be said about how this eye operates in conjunction with Agee's lyrical prose. What this investigation has sought to do, in some measure, is to look at how Agee inserted the architecture of the "Shelter" section into a distinctly religious rhetoric designed to elevate the sharecroppers. In this context, Agee's fascination with the obsolete nature of certain artifacts in the homes, the makeshift nature of the materials and build, allows for new meanings and sites for contemplation to emerge. We, however, and not the sharecroppers, are privy to Agee's contemplation as he moves through the shelters, and it is

meant for us to recognize what he designates as sacred existence. Thus, on a very obvious level, it is clear that the interpretation of various architectural forms affects Agee and Evans's relationships to their ostensible subjects in *Famous Men*, yet it is how these forms operate as containers of individualized hopes, fears, and aspirations rather than class and region that fascinates Agee above all. We may then read Agee's use of architecture as a literary shortcut designed to both authenticate his surroundings and to make the homes investigated something larger than life. The extent to which the architectural form of *Famous Men* is about that *other* inhabitant, namely Agee himself, is illuminated in his emotional investment in the house. It lies squarely in the vision of a writer seeking to sacramentalize the spaces about which he wrote. We may critique Agee's descriptions of the privations encountered in these spaces, and we may even critique Agee's possibly naïve faith in the Christ-like existence of the sharecroppers themselves. Nonetheless, as a site for the contemplative reveries of a writer seeking his own salvation, the "Shelter" section is the most appropriate of locations.

NOTES

1. James Agee and Walker Evans, Let Us Now Praise Famous Men: *An Annotated Edition of the James Agee-Walker Evans Classic, with Supplementary Manuscripts*, ed. Hugh Davis, vol. 3 of *The Works of James Agee*, gen. eds. Michael A. Lofaro and Hugh Davis (Knoxville: U of Tennessee P, 2015) 178. Subsequent references to this edition will be noted parenthetically in the text.

2. Ralph Waldo Emerson (1803–1882), US essayist, poet, philosopher. "Nature," (1836; 1849) in *The Portable Emerson*, ed. Carl Bode (New York: Penguin, 1982) 49.

3. Emerson, "Nature" 29.

4. Definitions of transmutation include: a visible sign of an inward grace, especially one of the solemn Christian rites considered to have been instituted by Jesus Christ to symbolize or confer grace. The sacraments of the Protestant churches are baptism and the Lord's Supper; the sacraments of the Roman Catholic and Greek Orthodox churches are baptism, confirmation, the Eucharist, matrimony, penance, holy orders, and extreme unction.
—something regarded as possessing a sacred character or mysterious significance.
—a sign, token, or symbol.
—an oath; solemn pledge.

5. The Merriam Webster definitions as above.

6. For more on the connection between Agee and William Faulkner, see Mick Gidley, "Ontological Aspects of *Let Us Now Praise Famous Men*: Death, Irony, Faulkner" *New Critical Perspective on James Agee and Walker Evans: Perspectives on* Let Us Now Praise Famous Men (New York: Palgrave Macmillan, 2010) 21–41.

7. Jacques Ranciere, "The Cruel Radiance of What is (Hale County, 1936—New York, 1941)," *Aisthesis: Scenes from the Aesthetic Regime of Art*, trans. Zakir Paul (New York: Verso, 2014) 250.

8. While churches figure in the first half of *Famous Men* as backdrops for external events that are equally religious in their implications, the fact that no photographs or actual descriptions of the interiors of churches are in the book seems crucial. Unlike Margaret Bourke White and Erskine Caldwell's *You Have Seen Their Faces* (1937), which contains a series of images of church interiors, as do many other photo-textual projects of the 1930s, *Famous Men* seems adamant about avoiding actual sites of religious practice.

9. Tabernacle: a tent sanctuary used by the Israelites during the Exodus.
— *Archaic*: a dwelling place, a temporary shelter.
— A receptacle for the consecrated elements of the Eucharist.
— An ornamental locked box used for reserving the Communion hosts.
— A house of worship; *specifically*: a large building or tent used for evangelistic services.

10. Charles Sheeler (July 16, 1883–May 7, 1965) was an American painter and photographer. He is recognized as one of the founders of American modernism and shared an apartment with Walker Evans in New York during their formative years.

11. Agee's interest in childhood is a permanent fixture in most of his writing, from *A Death in the Family* to the fearful consequences of loss in *The Night of the Hunter* to his 1942 introduction to Helen Levitt's photographs of children on the streets of Manhattan in *A Way of Seeing*, the presence of childhood is used as the most potent of metaphors for innocence and the inevitable loss of it.

12. John Dorst, "On the Porch and in the Room: Threshold Moments and Other Ethnograhic Tropes in *Let Us Now Praise Famous Men*," *New Critical Essays on Let Us Now Praise Famous Men*, ed. Caroline Blinder (New York: Palgrave Macmillan, 2010) 53.

13. Linda Wagner-Martin, "*Let Us Now Praise Famous Men*—And Women: Agee's Absorption in the Sexual," *James Agee: Reconsiderations*, ed. Michael A. Lofaro, (Knoxville: U of Tennessee P, 1992) 46.

Famous Men by the Numbers:
An Analysis of the Evolution
of James Agee's "I" from *Cotton Tenants*
to *Let Us Now Praise Famous Men*

Michael A. Lofaro

Let Us Now Praise Famous Men is often noted as the most experimental of James Agee's prose texts, the hardest to interpret, a work of genius, and of initial failure. While the publication of its source text, *Cotton Tenants*,[1] is too recent to elicit much criticism, the transformation is a dramatic one. Such a conclusion is more than understandable given that *Cotton Tenants* was written in 1936 for *Fortune* magazine for a business audience and *Famous Men*, while grounded in the previous text, was published in 1941 and written seemingly as a jumping-off point for Agee as a personal artistic manifesto for and about himself, a work of social criticism, and as the first major piece of prose of three works (*The Morning Watch*, 1950/1951; *A Death in the Family*, 1957/2007)[2] in which he attempts to come to grips with who he is, should be, and may never be.[3] As the author ages, his narrators' ages regress in his works from his twenty-six- to thirty-one-year-old present in *Famous Men*, to his past—a middle schooler in *The Morning Watch*, to a child in *A Death in the Family*—and his prose, while nearly always artful and oftentimes lyrical, becomes more accessible to the general reader; he moves consciously to reach a wider audience not only in prose but also in his movie reviews and essays, and his screenplays, both adapted and original.[4] In examining *Famous Men*, perhaps Agee's most complex and indulgent work, it seems fruitful to see how he spun his self-inquiring, critical tale of himself both into and out of *Cotton Tenants*.

The elusive nature of *Famous Men* is notorious. It so confounded librarians that it was cataloged under sociology, literature, photojournalism, history, philosophy, music, and even agriculture. It is perhaps

ironic that the methodology of this essay draws on yet another field and is undergirded by a preliminary comparative statistical analysis of the two texts in an attempt to trace James Agee's changes in constructing *Famous Men* from *Cotton Tenants*. The main tool is a comparative word frequency analysis using Taporware.[5] Some overarching results of the analysis reveal this initial profile of the works:

TABLE 1.

	FM	CT
Unique words:	12030	5491
Total words:	131041	32066
Words that occur once:	6019	3228
Words that occur twice	1890	846
Highest word frequency:	7872	1949
Average words frequency:	10.8919	5.8387

This general analysis reveals that *Famous Men* has approximately four times as many words as *Cotton Tenants*, four times the word frequency, and approximately double the number of words that are unique, that occur only once, and that occur twice. A more particular analysis using Taporware also provides a relative ratio of word frequency in the texts to give a more accurate measure of actual usage when evaluating the much longer *Famous Men* in terms of *Cotton Tenants*. For example, a ratio of 1.0011 is produced for the word "rain," which appears 45 times in the 131,041 of *Famous* Men and 11 times within the 32,066 words of *Cotton Tenants*. A ratio of 1 suggests an equality of usage between the texts in regard to "rain." In general, the higher the relative ratio of the texts, the more difference that exists between them.

While acknowledging *Cotton Tenants* as the seedbed for *Famous Men* in this comparative process, the present study in the main focuses upon words that are statistical outliers to elicit the most profound differences and the extent of change that occurred in the evolution of the texts, above and beyond the differences one might rightly suspect exist

between *Famous Men*, produced essentially according to Agee's own vision but eliminating all those words banned in Boston at the publisher's demand,[6] and *Cotton Tenants*, written in theory for *Fortune* magazine and its readership. It seems likely, given the length of *Cotton Tenants* (32,066 words), that Agee may have already had some intention of expanding his work. The 30 articles that he published in *Fortune* from 1932 to 1937 ranged in approximate size from 290 words (a piece on "Glass" in January 1935) to 12,600 (a piece entitled "T.V.A.: Work in the Valley" in May 1935), with an average length for his published work in the magazine of about 4,300 words.[7]

To verify the significance of the highest and lowest relative ratios, the comparative data that produced the ratio between usage in *Famous Men* and in *Cotton Tenants* are also subjected to the additional statistical scrutiny of a "Z Test Calculator for Two Population Proportions," a two-tailed test set at 99% or better significance.[8] Those words that are not significant at that high level are omitted from all the lists below to increase accuracy. Words unique to each text will be subsequently examined as will words deemed "common" by Taporware. *Famous Men* is Text 1; *Cotton Tenants* is Text 2 (See Table 2).

The words noted are those with the highest relative ratio that also meet the test for 99%+ significance. The words "surface" (33/1; 8.0751) and "boards" (33/1; 8.0751) are excluded from the chart because, although they have a higher relative ratio than "hope," they do *not* meet the test for 99% or higher significance, due to the fact that they have only 1 occurrence in *Cotton Tenants*. The next 15 words after "hope" that do meet the test (in decreasing value of their relative ratio) are "wall" (115/6; 4.6901); "odor" (57/3; 4.6493); "high" (51/3; 4.1599); "thin" (67/4; 4.0987); "upon" (172/11; 3.8263); "woods" (105/7; 3.6705); "above" (69/5; 3.3769); "light" (161/12; 3.2831); "art" (67/5; 3.2790); "part" (131/12; 3.2056); "door" (65/5; 3.1811); "wood" (91/7; 3.1811); "kind" (71/6; 2.8956); "night" (91/8; 2.7835); and "body" (99/9; 2.6917); all are excluded from Table 2. What is apparent is the overwhelmingly personal nature of the narrative *Famous Men* has become for Agee. "I," "my," and "me" are 3 of the top 5 words in terms of the combined relative ratio/significance test and occur 2,049 times to 26 times in *Cotton*

Tenants. A case additionally might be made to include "am" in both the combined relative ratio/significance and occurrence categories. While the personal nature of *Famous Men* is of course obvious to any reader, the true extent of this evolution and its dominance in that work would likely pass unnoticed without the present comparison.

TABLE 2.

Words	Text 1 counts ratio	Text 1 relative	Text 2 counts	Text 2 relative	Relative (text1/text2)
am	137	0.0010	0.0000	1	33.5238
I	1424	0.0109	0.0005	15	23.2304
my	333	0.0025	0.0002	5	16.2972
lifted	49	0.0004	0.0000	1	11.9903
me	292	0.0022	0.0002	6	11.9088
knew	47	0.0004	0.0000	1	11.5009
soft	43	0.0003	0.0000	1	10.5221
talking	42	0.0003	0.0000	1	10.2774
trees	39	0.0003	0.0000	1	9.5433
gray	39	0.0003	0.0000	1	9.5433
slowly	38	0.0003	0.0000	1	9.2986
edge	38	0.0003	0.0000	1	9.2986
spread	37	0.0003	0.0000	1	9.0539
narrow	37	0.0003	0.0000	1	9.0539
toward	106	0.0008	0.0001	3	8.6461
hope	63	0.0005	0.0001	2	7.7082

Reversing the Taporware analysis and placing *Cotton Tenants* as Text 1 and *Famous Men* as Text 2, and again excluding all those words that do not meet a 99%+ significance in the two-tailed "Z Test Calculator for Two Population Proportions," demonstrates a different emphasis on Agee's part. The chart is extended to 19 rather than 16 words because of the 8 words that have the same relative ratio (5/1; 20.4062) and the fact that "landowners" is synonymous with "landlord's." (See Table 3.)

TABLE 3.

Words	Text 1 counts ratio	Text 1 relative	Text 2 counts	Text 2 relative	Relative (text1/text2)
doctor	12	0.0004	0.0000	1	48.9748
meals	9	0.0003	0.0000	1	36.7311
Elizabeth	9	0.0003	0.0000	1	36.7311
cornbread	9	0.0003	0.0000	1	36.7311
buttermilk	8	0.0002	0.0000	1	32.6498
William	7	0.0002	0.0000	1	28.5686
charge	7	0.0002	0.0000	1	28.5686
meetings	6	0.0002	0.0000	1	24.4874
cash	6	0.0002	0.0000	1	24.4874
cancer	6	0.0002	0.0000	1	24.4874
pneumonia	5	0.0002	0.0000	1	20.4062
occasional	5	0.0002	0.0000	1	20.4062
neighbors	5	0.0002	0.0000	1	20.4062
Lily	5	0.0002	0.0000	1	20.4062
landlord's	5	0.0002	0.0000	1	20.4062
fry	5	0.0002	0.0000	1	20.4062
chicken	5	0.0002	0.0000	1	20.4062
canned	5	0.0002	0.0000	1	20.4062
landowners	13	0.0004	0.0000	3	17.6846

Most apparent from these results is the reportorial specificity of the words used in *Cotton Tenants* in terms of the highest relative ratio and 99%+ significance versus those of *Famous Men*. *Cotton Tenants* contains first names ("Elizabeth," "William," "Lily"), broad class references ("doctor," "landlord's," "landowners," and "neighbors" might also warrant inclusion), and concrete nouns ("meals," "cornbread," "buttermilk," "meetings," "cash," "cancer," "pneumonia," "chicken"). The only word on the comparable list for *Famous Men* that would fit in any of these three groups is "trees," a finding that reinforces both Agee's conversion

of his source text from an objective, concrete work of journalism to one far more subjective and nuanced and also conveys his dramatic imposition of himself and his theories (his use of "I," "my," and "me") upon *Cotton Tenants*.

Using the "common word" analysis that Taporware can provide upon the words that are unique to each text creates charts that expectedly focus upon names, since Agee kept the actual first and last names of his subjects for *Cotton Tenants* but changed them in *Famous Men*. The top sixteen unique words in both texts are listed in Tables 4 and 5.

TABLE 4.

Words	Text 1 count—*Cotton Tenants*	Text 1 relative
Burroughs	68	0.0021
Tingle	49	0.0015
Floyd	27	0.0008
Tingles	26	0.0008
Moundville	20	0.0006
Allie	16	0.0005
Lucile	13	0.0004
line	12	0.0004
Frank	10	0.0003
fields	10	0.0003
Charles	10	0.0003
doesn't	9	0.0003
Burroughs'	9	0.0003
Ruth	7	0.0002
Mary	7	0.0002
Ida	7	0.0002
bee	7	0.0002

TABLE 5.

Words	Text 1 count—*Famous Men*	Text 1 relative
Ricketts	90	0.0007
Gudger	90	0.0007
center	77	0.0006
stood	66	0.0005
george	58	0.0004
car	56	0.0004
myself	45	0.0003
Louise	39	0.0003
rear	37	0.0003
standing	36	0.0003
Annie	33	0.0003
hung	32	0.0002
brown	32	0.0002
window	31	0.0002
touch	31	0.0002
stone	31	0.0002

Limiting the list to 16 words does eliminate names in each work: "Tingles,'" "Ruby," "Minnie," "Laura" ("Laura Minnie Lee" is one person) in *Cotton Tenants* (all at 6/.0002) and "Emma" from *Famous Men* (30/.0002). The charts thus yield 265 occurrences of proper names in *Cotton Tenants* (this figure includes the 6 mentions of the possessive "Tingles'" as a variant of "Tingles") and 303 ("Ida Ruth" is one name) in *Famous Men*. Since this relative ratio is 3.5896 and it is significant at 99%+, these calculations likewise support the far greater specificity of *Cotton Tenants* and its focus upon its titular subjects. Similar analysis of Agee's "I" in *Famous Men* (the "I," "my," and "me" of the first table, plus the "myself" of the last) yields 2,094 occurrences versus 26 for *Cotton Tenants* for a relative ratio of 20.0000 and likewise a significance of 99%+. These figures continue to underscore the fact that the objectivity of

Cotton Tenants gives way to the personal, subjective nature of *Famous Men* as Agee transforms his project into a book infused with himself.

Arranging the Taporware analysis by word count also produces interesting data, both in terms of word count and relative ratio. In Table 6 *Cotton Tenants* is Text 1, *Famous Men* is Text 2, and the chart reproduces the 45 common words most frequently used. The "Z Test Calculator for Two Population Proportions" is not applied in this instance due to the

TABLE 6.

Words	Text 1 counts	Text 1 relative	Text 2 counts	Text 2 relative	Relative (text1/text2)
children	82	0.0026	0.0012	162	2.0658
cotton	82	0.0026	0.0010	134	2.4974
work	76	0.0024	0.0016	215	1.4426
like	72	0.0022	0.0020	259	1.1345
little	64	0.0020	0.0025	327	0.7988
time	64	0.0020	0.0016	210	1.2438
field/s	63	0.0020	0.0001	19	13.5321
year	54	0.0017	0.0005	71	3.1040
day	53	0.0017	0.0006	78	2.7731
good	51	0.0016	0.0011	143	1.4555
half	51	0.0016	0.0008	109	1.9095
white	48	0.0015	0.0013	172	1.1389
people	46	0.0014	0.0005	66	2.8444
just	45	0.0014	0.0010	133	1.3808
tenant	42	0.0013	0.0005	68	2.5207
tenants	42	0.0013	0.0002	22	7.7913
man	40	0.0012	0.0008	106	1.5400
money	39	0.0012	0.0004	55	2.8939
clothes	37	0.0012	0.0004	53	2.8491
winter	37	0.0012	0.0002	26	5.8078
house	36	0.0011	0.0017	223	0.6588
summer	35	0.0011	0.0003	41	3.4839
country	34	0.0011	0.0006	81	1.7131

TABLE 6. (cont.)

Words	Text 1 counts	Text 1 relative	Text 2 counts	Text 2 relative	Relative (text1/text2)
years	34	0.0011	0.0005	69	2.0110
human	33	0.0010	0.0011	143	0.9418
family	33	0.0010	0.0006	78	1.7266
land	32	0.0010	0.0006	84	1.5547
families	32	0.0010	0.0002	25	5.2238
small	31	0.0010	0.0011	150	0.8434
quite	30	0.0009	0.0006	74	1.6545
food	30	0.0009	0.0003	44	2.7826
life	29	0.0009	0.0006	76	1.5573
men	29	0.0009	0.0005	68	1.7405
mrs	29	0.0009	0.0005	59	2.0060
got	29	0.0009	0.0004	56	2.1134
far	28	0.0009	0.0009	112	1.0203
make	28	0.0009	0.0007	95	1.2029
landlord	28	0.0009	0.0001	18	6.3484
child	27	0.0008	0.0005	66	1.6696
say	26	0.0008	0.0009	114	0.9308
black	26	0.0008	0.0007	96	1.1053
old	26	0.0008	0.0006	78	1.3604
come	26	0.0008	0.0005	64	1.6580
corn	26	0.0008	0.0003	35	3.0317
negro	24	0.0007	0.0002	22	4.4522

numbers of words excluded from the total count of words in each work. The relative ratio, however, is still an effective tool.

To illustrate the transformation between texts with just a few examples, this table documents a higher emphasis in *Cotton Tenants* upon time (though not the word "time" itself) and upon seasons through a greater relative use of "year" (54/71; 3.1040), "day" (53/78; 2.7731), "winter" (37/26; 5.8078), "summer" (35/41; 3.4839), and "years" (34/69; 2.0110); upon class through "tenant" (42/68; 2.5207), "tenants" (42/22; 7.7913), and "families"

(32/25; 5.2238), a category and trend that emerged as well in the comparative relative ratio/significance chart previously noted above; upon race through "negro" (24/22; 4.4522); and a somewhat greater emphasis upon the young through "children" (82/162; 2.0658), among other possibilities.[9] To rephrase these results, it seems significant to ask why Agee consciously or unconsciously deemphasized these areas in writing *Famous Men*, for each and all have seemingly given way before the barrage of Agee's relentless "I."

Famous Men is more than the sum of its numbers, just as Agee's authorial intention is more than a twentieth-century recapitulation of Emerson's "transparent eyeball." The numerical analysis of his words, however, reveals much about textual evolution in the present test case and points the way toward other possible investigations, not only of the areas noted above, but also of larger topics, such as the underlying synergy between his three major autobiographically based texts. The use of computer-driven analytical tools provides a modern analog to the train that Agee describes in his first journal for *Famous Men*: "This train was going South. It was into the South it was taking me. . . . I was being drawn into a particularly good opportunity to try to see, [what] was the farthest and commonest, most unanswerable questions of human and earthly and universal destiny, human art, human life."[10] Analytical methodologies will not allow us to answer these "unanswerable questions" that so preoccupy *Let Us Now Praise Famous Men*, but they do give us another way in which "to try to see."

NOTES

1. First published as James Agee and Walker Evans, *Cotton Tenants: Three Families*, ed. John Summers (Brooklyn, NY: Melville House, 2013); in this article I use the scholarly edition of *Famous Men*, which includes *Cotton Tenants*. See appendix 2 in James Agee and Walker Evans, Let Us Now Praise Famous Men: *An Annotated Edition of the James Agee-Walker Evans Classic, with Supplementary Manuscripts*, ed. Hugh Davis, vol. 3 of *The Works of James Agee*, gen. eds. Michael A. Lofaro and Hugh Davis (Knoxville: U of Tennessee P, 2015) 565–646. Henceforth cited as Davis, *LUNPFM*.

2. For *Famous Men*, see note 1. That text reproduces the 1941 first edition and describes and contains the modifications made in the 1960 edition. James Agee's

The Morning Watch was first published in the Italian journal *Botteghe Oscure* (vol. IX) in 1950 in Rome and in book form in 1951 (Boston: Houghton Mifflin). His *A Death in the Family* appeared in 1957 (New York: McDowell, Obolensky) and as vol. 1 of *The Works of James Agee*: James Agee, A Death in the Family: *A Restoration of the Author's Text*, ed. Michael A. Lofaro (Knoxville: U of Tennessee P, 2007). These works are all part of a larger plan of Agee's to write an extended multivolume autobiography or biography of himself and his forebears.

3. The topic is a common one in Agee scholarship. My view on Agee as an "agonist," a person defined by an ongoing internal struggle, in his case both in his life and art, is noted in briefest form in the preface to *Agee Agonistes: Essays on the Life, Legend, and Works of James* Agee (Knoxville: U of Tennessee P, 2009) xi–xv.

4. Selections of these works are most readily accessible in *James Agee: Film Writing and Selected Journalism*, ed. Michael Sragow (New York: The Library of America, 2005). A complete scholarly edition of Agee's writing in these fields will soon be available in *The Works of James* Agee as *Screenplays—Volume A—*"The African Queen" and "The Night of the Hunter": *First and Final Screenplays*, ed., Jeffrey Couchman (volumes B and C to follow) and as *The Movie Reviews, Commentary, and Criticism of James Agee*, ed. Charles Maland.

5. Taporware 2.0 is a prototype text analysis tool developed at the University of Alberta that enables users to perform text analysis on HTML, XML, and plain text files over the web. In general, it excludes articles, conjunctions, prepositions, etc., and all words that are not considered "common words" by its standards. See <http://taporware.ualberta.ca/> for more information. I add my thanks to Professor Ashley Maynor of the University of Tennessee Library who made me aware of this program and guided me through its initial use.

6. Davis, *LUNPFM* vii.

7. In the present analyses, I am using the editor's last draft of the texts of *Famous Men* and *Cotton Tenants*. A very few editorial directions to the printer could not be removed and increase the actual totals of the word counts. Also, Taporware itself yielded small variants when the total word count was performed on *Famous Men*. No variance ever occurred in multiple applications for word count in *Cotton Tenants*. The much larger size of the *Famous Men* file may have been the cause, but the variation was always less than 80 words out of the total of 131,041. This figure was deemed insignificant. Also, no variation at all occurred in the count of the words displayed in the charts in this article. For the word counts in Agee's *Fortune* articles, I have used the texts in *Complete Journalism, Articles, Book Reviews, and Manuscripts*, ed. Paul Ashdown, vol. 2 of *The Works of James Agee* (Knoxville: U of Tennessee P, 2013), gen. eds. Michael A. Lofaro and Hugh Davis.

8. My thanks to Lakmal Walpitage, a PhD candidate in Educational Psychology and Research, for his suggestions and initial help with the "Z Test Calculator for Two Population Proportions." See <http://www.socscistatistics.com/tests/ztest/Default2.aspx>.

9. The numbers on "fields" is problematic and not used in this discussion since it refers to land and is also a name in *Cotton Tenants*. Reversing the analysis and using *Famous Men* as Text 1 and *Cotton Tenants* as Text 2 provides no additional notable information.

10. The word "what" is an editorial insertion for clarity. Michael A. Lofaro and Hugh Davis, eds., *James Agee Rediscovered: The Journals of* Let Us Now Praise Famous Men *and Other New Manuscripts* (Knoxville: U of Tennessee P, 2005) jour. 1.1, 4.

"Curious, Obscene, Terrifying, and Unfathomably Mysterious": *Let Us Now Praise Famous Men* and Cultural Freakery

Erik Kline

> It seems to me curious, not to say obscene and thoroughly terrify-
> ing, that it could occur to an association of human beings drawn
> together through need and chance and for profit into a company,
> an organ of journalism, to pry intimately into the lives of an un-
> defended and appallingly damaged group of human beings, an
> ignorant and helpless rural family, for the purpose of parading
> the nakedness, disadvantage and humiliation of these lives before
> another group of human beings. . . . All of this, I repeat, seems to
> me curious, obscene, terrifying, and unfathomably mysterious.
>
> <div align="right">James Agee,

> Let Us Now Praise Famous Men,

> "Preamble"[1]</div>

The rich body of criticism that *Famous Men* has received points to the fact that critics, like Agee himself, are drawn to the book because, as a project in representation and an experiment in formal technique, it *is* curious, obscene, terrifying, and mysterious. The book's diverse criti-cal reception speaks to its complexity, and the burgeoning field of freak studies can offer a particularly illuminating mode to expand and refig-ure these interpretations of *Famous Men* and its textual-historical sig-nificance. Broadly, the discipline examines the history of freak shows as well as the anxious function of the bodies exhibited for voyeuristic spectators. While critics have variously addressed the voyeurism present throughout the book,[2] the ways in which this voyeurism intersects with the rhetoric and phenomena of the American freak show remain unex-plored. Yet, as freak studies reminds us, any sort of receptive voyeur-ism demands an equal, reciprocated signification through productive exhibitionism, and, in *Famous Men*, Agee and Evans transform their

documentary project into an exhibition of "an undefended and appall-ingly damaged group of human beings." Agee's characterization of the book—and, I would argue, its subjects—as "curious, obscene, terrify-ing, and unfathomably mysterious" only emphasizes the parallels to the presentational modes associated with freak shows, and the goal of this essay is to understand how the book tacitly borrows the strategies and rhetoric of freak shows as a means to exhibit human and cultural aber-ration, southern victims of abject poverty, for a wider public. In doing so, *Famous Men* extends the cultural phenomenon of the freak show, which was losing social prominence during Great Depression years, into textual form.

Famous Men received rather lukewarm reviews when it was pub-lished seventy-five years ago. It was not until the 1960s that the book gained traction as a work of art. True, the 1960s ushered in a time of new aesthetic modes, and the proto-postmodern style of *Famous Men* inter-sected well with the decade's current trends in artistic experimentation. The renewed interest in the book during this time, however, also speaks to its freakish characteristics. As a historical moment that celebrated rather than condemned human alterity, the 1960s and its various coun-tercultures championed what had previously been considered curious and obscene, and, as such, the outcasts of 1930s America could, how-ever superficially, be understood as figures of identification rather than castigation. Indeed, "freak" had become an "honorific title" during this period with young dissidents celebrating "freaking out."[3] That freakish reclamation occurred simultaneously with revived interest in *Famous Men* should not be seen as merely coincidental. The concurrent inter-ests also suggest that the presentational mode throughout the book does contain freakish qualities, qualities that had been on the wane and re-ceived as poor taste during the Depression years.[4]

Composed in a moment of literary and cultural crisis, *Famous Men* simultaneously questions what representation should do and what hu-mans should be. Evans and Agee's exploration, of course, grounds much literature, but the book's unique composition and self-aware anxiety, both vacillating between the abstract and the visceral, magnifies these aesthetic and humane dilemmas. With a long Transatlantic history and commercially popularized by P. T. Barnum's exhibitions of human curi-

osities, the freak show similarly provided spectators with an immediate, visceral presentation of human aberration that, in turn, provided audiences with an abstract questioning of humanness. Because of shifts in the nation's commercial, medical, and ethical paradigms, the freak show's presence declined as an avenue for human (re)presentation in popular American culture in the 1930s.[5] As Rachel Adams points out in *Sideshow U.S.A.*, however, "as actual freak shows were evicted from popular culture, their representational currency multiplied," and the presentation of people as freaks picked up in other areas of culture.[6] Despite Agee's reticence about using this curious and obscene sort of presentation, the epigraph of this essay signals that *Famous Men* continues the tradition of freak exhibitions and their function in the American cultural imagination.

At the same time of the freak show's decline in popularity, an ethnographic interest in impoverished victims of the Great Depression, especially in rural geographies, became a popular subject of the national imagination.[7] Folklore critic James S. Miller argues that this interest came from "the desire to limn the nation's derelict spaces for vestiges of its most vividly ruined (material and human) antecedents,"[8] a desire permeating *Famous Men* and reflecting the artistic impulse to present new objects of cultural anxiety. *Famous Men* combines these two cultural events—the decline of the freak show and the rise of Depression-era ethnography—and in its form and content demonstrates their convergence. In response to the Great Depression, the tenant farmers became, in essence, the new embodiment of freakery: while the term "freaks" is historically always in flux,[9] freaks themselves "function as magnets to which culture secures its anxieties, questions, and needs at any given moment."[10] By responding to the Depression and contributing to the extension of human freakery, Agee and Evans present to their audience rural Alabaman subjects who are deformed by cultural expectation and economic exploitation, ambiguously human in their otherness as they become depersonalized objects. While the signification of freaks continuously shifts, enfreakment broadly entails the embodiment of the "intolerable abject . . . [and] cast off refuse" of culture,[11] a particularly resonant description for Evans and Agee's tenant farmer, whose labor begets "privation" and a "wasted life" (265). Moreover, comprised of photographs, thick

description, and prose that is at once lyrical, fragmented, and strained, *Famous Men*'s form is as much a textual curiosity as are the human curiosities it presents.

One of the central reasons we continue to revisit *Famous Men* is its form. Evans's untitled photographs blur realism and grotesque artistic modes; Agee writes in a simultaneously lyrical and jarring prose. Together the photographer and writer create a textual object difficult to define, and such difficulty in assigning generic distinctions resonates with freaks' resistance to categorization. James Andrew Crank, in examining the book's recurring fracture and failure (modifiers not incongruent with the enfreaked body, a failure at normalcy often due to fractured expectations), calls the book a "bloated and schizophrenic work."[12] In an attempt to create a new category that *Famous Men* might encompass, postmodernism critic T. V. Reed calls the book "one of the strangest texts in the American canon," and, in characterizing the range of aesthetic and disciplinary modes, suggests it as composed of "richly textured crazy quilts."[13] These categorical attempts combine physical (bloated, textured) and mental (schizophrenic, crazy) deviance to convey structural and stylistic oddity. As these critics suggest, the structure and style demand attention; audiences—new and returning—are often enthralled and disoriented in experiencing the book. The project is indeed mysterious, and this mystery is what makes the book so fascinating and so troubling. Like the freakish body, we are drawn to its deviance. Agee's bizarre yet beautiful style throughout the volume causes our continuous revisiting of the text, and just as a freak body collapses expectations of normal bodies and lacks a neat category of its own, *Famous Men* similarly collapses expectations of literature (or whatever label is attached to it), evading generic categorization. Because of these aesthetic pressures, *Famous Men* offers an entry point in understanding not only what it means to present enfreaked subjects, but also to enfreak a textual object itself.

Agee demonstrates his awareness of his and Evans's unorthodox text, an awareness that contributes to the fashioning of blurred representation. Commenting on the nonlinear fragmentation of the book, he tells his reader, "[Y]ou mustn't be puzzled by this, I'm writing in a

continuum" (54), an intimation which suggests a necessary, if not purposeful, disorientation of the audience. The nonlinearity occurring as a continuum, fragmentation coupled with wholeness, opens up questions of expectation in the narrative mode. Indeed, Agee admits, "[N]othing I might write could make any difference whatever. It would only be a 'book' at best" (11). The book he would like to "write" would be visceral abjection, "[a] piece of the body torn out by the roots" (11), suggesting that fragmented embodiment is central to Agee's understanding of his subjects. Crank suggests that such a project is a "direct confrontation with disconnection itself" and that by "settling for the structure of a 'book,' Agee had already admitted defeat."[14] I would add that, because of this confrontation and defeat, the book reflects the difficulty of definition when confronting an enfeaked body on stage. As just a book, *Famous Men* appears as a body—a bound volume—of words and images with meaning beyond the confines of predetermined genre much like an ambiguous body with meaning beyond predetermined ontology. The only ontological exploration such a confrontation can carry, Agee states, is visceral, not verbal; he likens his intention to the pain in listening to Beethoven or Schubert, to "jam your ear as close into the loudspeaker as you can get it and stay there. . . . Concentrate everything you can into your hearing and into your body" (13). Such an experience cannot be "pretty" or "beautiful. . . . It is beyond any calculation savage and dangerous and murderous to all equilibrium in human life as human life is" (13–14). Because this intention transcends the scope of the written word, the work necessarily becomes encumbered, even violent, and the book's style imitates an unknowable friction embodied in its subjects.

It is because of these very difficulties in representation that *Famous Men* deconstructs literary modes and fails to humanize the subjects on display. Because of a failure in *representing* their lives or experiences, Agee and Evans can only resort to *presenting* them. The presentation culminates in the "record in the body," which conveys expansive meaning "of being, of truth, of conscience, of hope, of hatred, of beauty, of indignation, of guilt, of betrayal, of innocence, of forgiveness, of vengeance, of guardianship, of an indenominable fate, predicament, destination,

and God" (9). The book, then, becomes a venue to present bodies that in turn might represent larger philosophic quandaries within them. By compounding such various, even contradictory, dilemmas of humanness in the body, the authors reflect the anxiety manifested by the freak, and as readers progress through *Famous Men*, the text unfolds much like the disorienting spectacle of the freak show.

Readers first encounter the enfreaked bodies of *Famous Men* through Evans's photographs, before the textual narrative even begins. This initial encounter is entirely visual, emphasizing that the subjects of the book are something that must be seen to be wondered at. Because it occurs before verbal exposition, this section of the book functions much like the bannerline posters and ballyhoo outside of freak shows, presentational strategies to entice the audience and capture veracity. Most people, regardless of social class, "have been willing to pay for the privilege of viewing [human oddities],"[15] and while people were "fascinated" by the opportunity to see such corporeal otherness, most "remained skeptical."[16] Thus, promoters had to persuade potential customers to enter the tent of the sideshow. They did this through the bannerline and the ballyhoo, which consisted of talkers enticing an audience against a backdrop of large print posters—the text of the banners subordinated by the images on them—as most people accepted the truth-value of a photograph.[17] One or two freaks often performed outside the tent to assure customers that real freaks were indeed inside.[18] The photographic sequence, then, assures the veracity of the "exhibits" inside the book. Evans's photographs provide an invitation in their vivid depiction of real people in abject environments, and his particular aesthetic suggests a deliberate performative function in the iconography of his photographs.

Because the photography appears before any text, it is important to recognize that what it presents is as yet nameless, undefined. We see only bodies and things. The movement of the photographs—portraits, landscapes, and action shots appearing side by side—only contributes to their subjects' ambiguity. The portraits move inexplicably from that of the relatively human to the grotesque, heightening the affective immediacy of and ambivalence to the subjects involved. Because of the movement, the series mimics the juxtaposition of aberration and nor-

mal encompassed in freak portraiture itself.[19] Moreover, with the land-scapes, the photography moves between town and country, demonstrating the removal of the farmers from the audience's recognizable world. This removal, in turn, casts the farmers as something other, abject, and approachable only outside the relatively comfortable environment of modern public life.

This movement continues to distance the identity of the people contained in the portraits. Notably, the first photo we see is of a land-owner—a rather confident demeanor on his face and in his upright posture signals considerable difference from much of the portraits that follow. He appears in jacket and tie, which quickly makes him more identifiable to the spectators. Being the first photograph of the series, it sets up a standard by which the audience can measure themselves, for the people in following portraits are strikingly less human. The viewers go on to see on the next facing pages a man and woman in more ragged

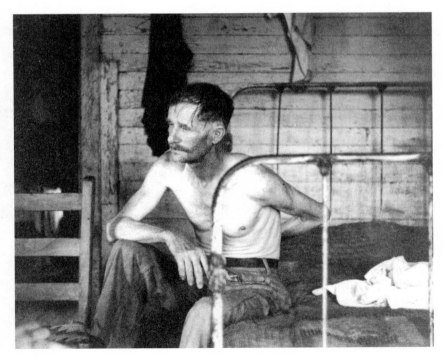

Figure 1.

and dirty clothing. His face is not clean-shaven; she bites her lower lip with something between discomfort and confusion. The adults continue to get more grotesque and their bodies more emphasized, perhaps best encapsulated by a single plate's two photos of a man who appears like a living skeleton, a common sideshow exhibit. Still, as the photos make clear, his inhuman thinness correlates directly to his impoverished living conditions. Hair greasy and eyes distant, he looks out from a dilapidated bed. In the first photograph he looks up, alert, but in the one below (*Figure 1*) he leans over with arm behind his back, his face seemingly wincing in pain, presumably from his labor. Collectively, these photographs signal to the audience that the subjects must be seen to be understood, that these are humans stuck in dilapidated bodies housed in dilapidated homes, and that this dilapidation—their freakishness—is bound up in historical circumstance and exploitation. This relativity reinforces to the audience the fluidity of freakish bodies, heightening both the wonder and pity we attach to them.

The photos continue and often reinforce the idea of the otherness of subjects on display. We see a boy with eyes and mouth only half-open, suggesting a feeble-mindedness later explicitly expressed by Agee, followed by an even younger child who is dirty, barefoot, ragged (*Figure 2*). This younger child sits next to a disembodied leg (also raggedly clothed) and foot (also bare) to heighten its diminutive stature and emphasize the malnourishment of its body. I say "it" purposefully; the child is too young to identify gender, and its clothing, something between a shirt and a dress, reflects the androgyny so common in many sideshow acts. This androgyny actually characterizes many of the children's portraits, which suggests the inherited freakishness that Agee assigns them later in the text. The malnourished, androgynous child becomes most haunting in one photograph of a child on the floor covered in fraying cloth (*Figure 3*). Its legs and an arm stick out, but otherwise the body is unidentifiable. Inverting the armless or legless wonders of the freak show, this body has appendages with no discernable torso or head, marking corporeal fragmentation. The two photographs preceding and following this one display the homes themselves and the objects inside; this photograph appears between them with the body bordered by the

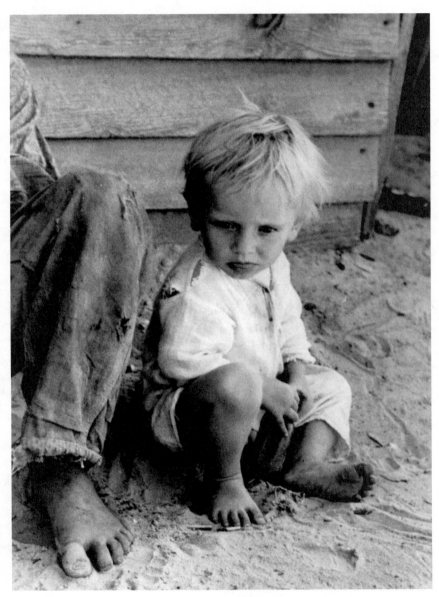

Figure 2.

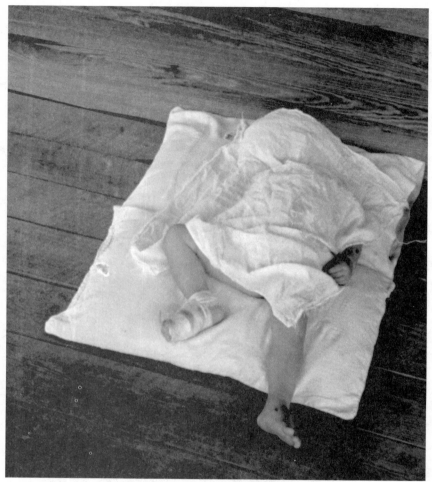

Figure 3.

same wooden floorboards, emphasizing its inertia. Like the static ob-
jects in the surrounding photos, it is just a thing that appears on this
stage, more like a prop than a child. Finally, the cloth itself, and how it
lies, appears much like a shroud; coupled with the stillness of the body,
the photograph distorts the very life of the subject contained. Thus, in
a single photograph, we see how Evans's technique often breaks down
the very identifiers used to assign normalcy. The body in this photo-

graph blurs male/female, whole/fragment, human/object, and dead/alive distinctions.

No doubt these photographs are, in a haunting way, beautiful, and much of their beauty results not only from their dilapidation and ambiguity, but from their intimacy as well. This intimacy, however, often carries overtones of both spectacle and the grotesque. The audience sees this conflation in a family portrait in which the subjects return the spectators' gaze with a solemn, distant, almost emotionless demeanor (*Figure 4*). The only emotionally active body in this photo is the child in his father's lap. At the center of the photograph, the boy becomes its focal point. Perhaps unaware of his condition, he seems unable to sit still as he appears moving outward while his father tries to contain him. Most notably, the father's restraint lifts the boy's shirt, revealing his genitals to the audience. That Agee will later characterize "the purpose of parading the nakedness, disadvantage and humiliation of these lives before another group of human beings" as curious, obscene, terrifying,

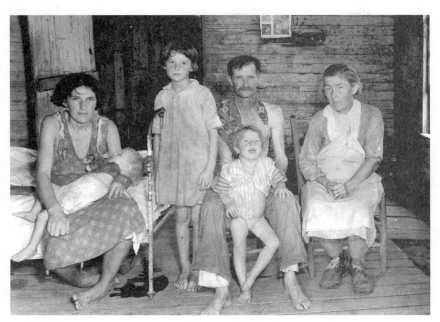

Figure 4.

and mysterious, only amplifies these various modifiers because here, quite literally, that is precisely what Evans does. Wholly, the photographic series strips the families of voice and agency, relegates their meaning to their seeable bodies, which in turn reinforces their function as freakish spectacle. What follows in the book is largely a meditation on this meaning, a question of humanness for the farmers, the audience, and the author alike, paralleling the enfreaked body as a site of awe, pity, and wonder.

While Agee states an equality between the photos and the narrative (viii), the paratextual location of the photography is significant. That "LET US NOW PRAISE FAMOUS MEN," the first words of the book, appear in bold print facing the final photograph of a surreal series tells its audience that they are now inside. Like the ballyhoo, what preceded this title page was a preview of what is staged in the show itself, the text of the book. The title itself suggests the collaborative function of the freak show, one that demanded equal participation from the spectators and the spieler; usually silent, the freaks were a site of otherness verbalized by the spieler and internalized by the spectator. The title of the book, appearing where it does, offers a kind of invitational imperative—"Let Us"—underscoring a dynamic interplay, and the command provides agency to everyone but those on display, "Famous Men." They are, instead, subordinated to passive figures that receive gaze and meaning, "Praise," from those presenting and those watching. More, the title's temporal immediacy, "Now," tells the audience that the preceding photographs do not yet warrant praise or any kind of assigned meaning; they offer a glimpse of what is to come. Although they are equally significant to the overall performative success of the show, the photographs do not entail the kind of prolonged signification of what is contained inside; only after they are finished can audiences *now* begin to understand the curiosities on display. Appearing where it does, the title tells us the show can begin.

The farmers' lives are just as anchored to the visceral as the style and structure of the work itself. At its foundation, the freak show functioned on a corporeal premise: that its subjects are defined by their body and evaluated by their deviance from the norm, an evaluation based on cul-

tural expectations and performance. This bodily definition and deviant evaluation is central in Agee's understanding and exposition of the tenant farmers. Witnessing freaks "fires rich, if anxious, narratives and practices that probe the contours and boundaries of what we take to be human,"[20] a phenomenon central to Agee's anxiety in defining the farmers. Further, the freak show needs a platform for this viewing and evaluation, the stage. Agee builds this stage textually, and in the section "Colon," he simultaneously questions the verbal platform on which he displays his subjects while verbally defining them by an internal otherness manifested by their bodily aberration. Importantly, this section is subtitled "Curtain Speech" (81), a metatextual reminder that this book, like any show, is a performance. As this section describes the performative meaning of the farmers—their importance to the identity of their spectators—it recalls the freak show's spiel, picking up the commentary of the preamble in which Agee calls the tenant families an "appallingly damaged group of human beings," telling the audience what they are witnessing and why it is important.

During this metatextual spiel, Agee defines the farmers' humanity by means of their physiology when he says, "The heart, nerve, center of each of these, is an individual human life" (84), but these individual lives essentially function as a site of difference, an event for the audience to understand their own normalcy and agency. Agee tells his audience that the creation of these lives is "an aberration special to one speck and germ and pollen fleck of this planet" and that "all this difference is circumstance, physical and mental," reminding them that though these farmers are the "most frightful in known creation, of human existence," their otherness is situational (84–85). Echoing the rhetoric of the freak show, Agee uses this spectacle of difference to reinforce the spectators' normal identities and to remind them that this normalcy is tenable, a major reason that witnessing freaks can be so terrifying. Despite pleading the families' humanness, he strips them of this humanity at the moment of their exhibition. In a verbal gesture of presenting a dehumanized object, Agee says, "*Here* at a center is a *creature*" (91, my emphasis). As creatures, they are relegated to a limited personhood whose meaning is created through voyeuristic interpretation. Continuing, he explains

that these creatures are unlike himself and the spectators, who are specifically human: understanding the exhibit "is a human effort which must require human co-operation" (92). Agee provides human agency to himself and his audience, for they get to define the creatures on display, who, because of their textual and symbolic position, cannot define themselves.

As a whole, "Colon" is a meditation on the meaning of the farmers' lives and livelihoods, a "purpose toward truth, into the living eyes of a human life" (83). By linking his purpose to eyes, Agee immediately yokes truth to the visible, measurement to the seen. Throughout the section, Agee weaves the corporeal with all of its resonant assumptions, a "texture of sorrowful and demented flesh" that "[dwells] in the woodlands and dead clays in bestial freedom or in servitude" (85). Through this aberrant corporeality, the farmers become both exoticized and aggrandized to their spectators, two primary modes of presenting freaks,[21] and as voyeur of the grand and exotic, Agee delimits their humanity. He describes their returning gaze with "the eyes of a trapped wild animal, or of a furious angel nailed to the ground by its wings" (83). With this description, he assigns the families a kind of transcendent primitivism linked to a romanticized feralness, an ambiguous otherness that must be trapped, nailed, and exhibited for any hope of the audience's understanding.

As the speech unfolds, the families increasingly resist comprehension, as Agee remarks on the almost impossible task to contain them in words. He laces this section—and the entire book—with his anxiety of semantic deficiency, underscoring the very otherness of his subjects by his inability to adequately represent them with language. He explains to the farmers that the "particularities that each of you is that which he is . . . are exactly themselves beyond designation of words" (84). He believes that text is not an avenue for the families' characterization, that it removes them—as trapped wild animals or violently grounded angels—from their natural environment, imposing an invasive environment upon them. As a historical or imperial criterion for the "civilized," written language becomes this imposed environment. In displaying exoticized acts, show organizers would often create a set to both simulate

the authenticity of the freaks' wildness and negotiate the environmental collision of that wildness with the outside "civilized" space. In *Famous Men*, verbal description is the fabricated stage on which Agee exhibits the families' primitive simplicity. As its stage, he litters the text with diction that separates it from restrained, refined, and civilized modernity. He says those on this stage "may fairly designate the human 'soul,' that which is angry, that which is wild, that which is untamable" (83). The implication here is that although beyond adequate definition, the farmers must be semantically contained, for they indicate to the audience what they are underneath the tempering of modern life.

The freak show negotiated space by more than just a stage, however. Whether at a dime museum or in the tent of a traveling sideshow, a freak show was always separated from its outside environment, enclosing the spectators with a suffocating immediacy with those on display. Upon entrance, viewers were confronted with several exhibits that solidified their cognizant separation from their comfortable world of normalcy. In *Famous Men*, this moment occurs in the section "At the Forks," when Agee and Evans find themselves at a fork in the road surrounded by "nothing but woods" (28), a spatial signal of their departure from civilization. Lost, the two ask for directions from three people on a porch, the first real exhibit of the book's continuous presentational enfreakment. Like the families in his curtain speech, Agee defines these locals almost entirely by a simultaneously exotic animalism and transcendent aggrandizement. This combination is perhaps most concise when Agee describes the woman's eyes with "the splendor of a monstrance" (29), literally a vessel of holiness but with a phonetic overtone of the teratological, the monstrous.

Agee further combines the exotic with the aggrandized with the older man on the porch, who is at once a savage child and "a hopelessly deranged and weeping prophet" (29). As the book's first exhibit, Agee layers this man with language of an enfreaked body, extending the limits of the ambiguous human. While Agee says he is likely fifty years old with a "thorny beard," he is also "almost infantine" with a face "seamed and short as a fetus" (29). Physically he is "small-built and heavy jointed" but moves "like a little child." Agee expounds this enfreakment by

animalizing him, exhibiting his actions like the wild man act who "would look ferocious" and "grunt or pace the stage, snarling [and] growling." [23] The older man similarly paces between Agee and the porch where the woman speaks to him "as if he were a dog masturbating on a caller" (31). With this seemingly odd simile, Agee ascribes the man both with the likeness of an animal as well as an inability for the restraint one might expect in civilized company. With a "gnashing mouth," the man does not speak human language but "[says] fiercely *Awnk, awnk*,"what Agee describes as the "loud vociferation of a frog" (30–31). Indeed, Agee removes his human intellect altogether—reducing him to bestial, bodily function—when he says of him, "[H]e was just a mouth" (31).

The man's parallels with that of a wild man act continue as Agee and Evans leave the exhibit. In the car, Agee looks back to see that "[t]he older man was on the dirt on his hands and knees coughing like a gorilla" (32). While freak scholars almost always discuss these exhibits in terms of racial and cognitive enfreakment,[24] Agee's depiction throughout this episode highlights the fact that such enfreakment occurs not just by the people on display, but also by the way they are presented. As Adams notes in her own exploration of continued freakery in American culture, "Freaks are produced not by their inherent differences from us, but by the way their particularities are figured as narratives of unique and intractable alterity."[25] In creating a narrative to exoticize the Deep South for the American public, Agee reduces this man to barely human. While we can read this presentation with its suggestions of mental disability, Agee elides such language, reinforcing a manufactured narrative that dehumanizes the man in favor of creating a spectacle for his audience. In doing so, he buttresses an anxious, impoverished—but still human and civilized—national identity against a depiction of primitive abjection.

The anxiety attached to the old man in "At the Forks" occurs because Agee collapses normative understandings of humanness through him; he is neither human nor animal, young nor old. Freak critic Elizabeth Grosz argues such ambiguous embodiment that resists dominant binary identity constructions unifies most freak exhibits and explains audiences' ambivalent response to them.[26] Thus, popular freak show attrac-

tions like hermaphrodites and bearded women defy the female/male binary, conjoined twins the singular/nonindividuated subjects. [27] While "freak" connotes a kind of catch-all for the unidentifiable and encompasses a wide range of perceived abnormality,[28] understanding the ways in which *Famous Men* collapses perceived parameters of humanness serves to demonstrate how the book reifies various common exhibits. Acts that collapse the adult/child binary, such as "dwarfs" and "pinheads" (microcephalics), recur throughout the book. Sometimes these instances are explicit, as when he prescribes the infant Squinchy with a "dwarf body" (60). The collapsing of age occurs with the adults as well; at one point, for example, Agee says Emma "is rather a big child" (51). Pressing on the discomfort of the childishness contained in her adult body, Agee comments on it being "sexual beyond propriety to its years" (51). More often than not, however, this characteristic seems just below the surface. All of the subjects are in some ways always children, evident in Agee's description of legacy and its perpetuation of poverty (48–49). Moreover, the innocence—or, more derisively, simplicity—that the book consistently attaches to its subjects suggests a childishness that their circumstances will not allow them to outgrow. The adults, forced to perpetual labor, remain mentally childlike; the actual children, with demand for their physical labor, become bodies of adult expectations. Indeed, assigning childish traits to his subjects occurs so often that, late in the book, Agee criticizes himself for having a "[b]ad case of infantilism" (313). In the consistent characterization of his subjects as both (or neither) adult and child, Agee underscores the blurring of boundaries encapsulated in the farmers, which are always wrapped up in material and corporal conditions. By doing so, he presents the subjects as curiosities to examine, pity, and marvel.

The book frequently ties these freakish qualities—whether childish, animalized, or some other ambiguity—to its latent criticism of unfettered capitalism (a criticism evinced in Marx's epigraph). Although Agee describes his subjects as childlike, he often links these descriptions directly to their economic exploitation, and in doing so, suggests to his audience that their subordinated humanity, their freakishness, results not from inherent, natural qualities, but from historical

circumstance. By linking their alterity with their labor, he extends the rhetoric of the freak show to national anxieties during the Great Depression, telling his audience that an economic system responsible for the salient suffering of the period actually degrades its victims, like freaks, to the point of being barely human. With Emma, for example, although he begins with her childishness, he links her body directly to economy: "She is a big girl, almost as big as her sister is wiry, though she is not at all fat: her build is rather that of a young queen of a child's magic story who throughout has been coarsened by peasant and earth living and work" (51). He continues this characterization beyond the individual, suggesting that the abjection of the farmers is a collective reality, that the abnormality contained in one spirals outward with successive generations. Agee links the farmers' legacy of perpetual childishness to their historical conditioning:

> A man and a woman are drawn together upon a bed and there
> is a child and there are children:
> First they are mouths, then they become auxiliary instruments
> of labor: later they are drawn away, and become the fathers and
> mothers of children, who shall become the fathers and mothers of
> children. (48)

Agee equalizes the characterization of the farmers between being adults, children, passive bodies, and laboring tools. While the latent critique of systemic economic exploitation is obvious, Agee's juxtaposition of it with bodily function and generational infancy makes the critique fashioned more as a spiel of humanness, or lack thereof, than of capitalism generally. Like many people with visual markers of difference, these farmers are made freaks from their birth and their inherited economic and bodily struggle. However, like freaks on a stage, these farmers are made freaks by the specific presentation Agee gives them, reminding the audience that though inherited, this freakishness is not inherent, but created.

This presentation continues (indeed, is expounded) with Agee's successive exhibitions of the Ricketts, Woods, and Gudgers. Each family has

already been introduced to the audience not only through Evans's photographs and Agee's preamble, but also in the "Persons and Places" section at the beginning of the book, which lays out the families like a cast of characters one might find on a playbill, suggesting their performative function. Miller argues that Agee "confess[es] his desire to penetrate and exhibit" the lives of the tenant farmers,[29] a desire that at once works to decode their ambiguous otherness—penetrate it—and present it to an audience for all to see. While it would be impossible to catalog the various instances in which Agee exhibits his subjects specifically through their bodily otherness, it is worth noting the mode of this exhibition in part two of *Famous Men*. Throughout most of the book, but emphatically in this section, the subjects are voiceless, a key component of the freak show.[30] Instead of providing the families with a voice (when he does, it is usually free and indirect, filtered through his own), Agee represents them through titled exhibits of their livelihoods, such as "Work", "Education", and "Clothing." In all of these sections, the families are almost entirely silent, relegating their meaning not to their verbal expression of their experiences, but to their bodily performances of them. These exhibits also emphasize, through general subject and meticulous detail, that these performances are all inflicted by the economic system they inhabit. By presenting the families this way, Agee transforms the families from agents to subjects, which textually represents their socioeconomic condition but also formally stages their silent objectification for the audience.

Although Agee seeks to humanize the families' lives and identities, he seems deftly aware of his intention's failure. Agee consistently wrestles with his anxiety of failed representation, one that transforms tragedy to spectacle. Lamenting his inability to humanize his subjects, he reminds his audience about the people he presents, spieling about their meaning. He says of George Gudger,

> The one deeply exciting thing to me about Gudger is that he is actual, he is living, at this instant. He is not some artist's or journalist's or propagandist's invention: he is a human being: and to what degree I am able it is my business to reproduce him as the human

being he is; not just to amalgamate him into some invented, literary imitation of a human being. (194)

That Gudger's personhood, socially devalued and materially impoverished, *excites* Agee is, if not troubling, at least telling. As exciting, Gudger becomes an object of selfish, voyeuristic wonder. Furthermore, Agee's reflection recognizes that he actually *has*, to some degree, amalgamated this human being into a signifying imitation. Although Gudger is not Agee's "invention," the textual presentation of him throughout the novel is. Because Agee feels compelled to remind his audience of the humanness of Gudger as a person, he signals that the intended humanizing of his presentation has failed.

Do not take Agee's anxiety in his representation of the families lightly, and keep in mind that it is more than a mimetic meditation of a distant experience. Understanding *Famous Men*'s enfreaking representation of the tenant families is more than a critique of a book that receives consistent acclaim for an apparent sympathetic and humanizing depiction of marginalized Americans. It reflects a real, felt response from the families it presents. In 1986, journalist Dale Maharidge and photographer Michael Williamson sought out the later Gudger, Ricketts, and Woods generations and documented their findings in *And Their Children after Them*. Equally as tragic and beautiful as *Famous Men*, albeit in a different style, the book reflects the families' lives after *Famous Men*, lives largely ignored by a public that had moved on from their exhibit. Despite continuing some troubling descriptions of "backward" families,[31] as a critical project of its own, *And Their Children after Them* does reflect different family members' awareness of and sensitivity to the public display of themselves, their parents, and their grandparents in *Famous Men*. Junior Gudger, eight when Agee and Evans first visited his family, "fume[s]" over *Famous Men*'s "brutal portrayal" of his family, understandably resentful that "journalists came and paraded his family's poverty for all the world to see."[32] The fallout for the Ricketts is worse, as Maharidge describes that they were "the butt of jokes all over the county in 1936, and some still are today."[33] Maharidge explains that Margaret, twenty in *Famous Men*, and her son John Garvrin continue to cooperate

with their own exhibition "because they are ignorant of why any human would want to cause them any harm, to hold them up to ridicule, to be gawked at like zoo creatures."[34] Maharidge demonstrates here that the tradition commercialized by Barnum and manifest in *Famous Men* is not dead. As Adams, Thomson, and others indicate, it only adapts to new social environments, and, as these various spectacles show, this voyeuristic site of awe and pity, horror and entertainment, for some necessarily comes at the expense of an exploitative exhibition of others.

Although critics sometimes overlook this failed representation, Agee demonstrates his awareness of it throughout. In a bizarre sequence near the end of the book, he compels himself to counteract this anxiety by the degradation of his own body. By forcing himself to the visceral torture of fleas and bedbugs in sleeping at the Gudger home (343–46), Agee suggests that his own understanding of the farmers' lives can only come through a kind of masochism, mimicking in his own way the performing freaks of self-inflicted bodily violence. Because of this self-punishment, coupled with a stylistic beauty, critics often succumb to the valorization of Agee himself. I cannot argue with the book's merit or Agee's sympathy; *Famous Men* is indeed beautiful in its representation of lived experiences, and Agee is sympathetic in the awareness of his failure yet relentless pursuit to expose these experiences. It is because of this admiration that we continue to revisit the text, but this admiration should not overshadow the lives of the Woods, Ricketts, Gudgers, or any other victim of poverty Agee and Evans present on a stage for us to see. As Agee himself understood, the project is curious, obscene, terrifying, and unfathomably mysterious. Against Agee's wishes, audiences sometimes forget that the lives contained in the book—beyond Agee himself—are human beings who existed and exist. For me, that they existed roughly twenty miles from where I write this essay only emphasizes the immediacy of their existence. Because of this immediacy and this lived experience, it is important to recognize at its seventy-fifth anniversary the personhood embodied in *Let Us Now Praise Famous Men* and understand the continued resonance of the enfreakment it portrays.

NOTES

1. James Agee and Walker Evans, Let Us Now Praise Famous Men: *An Annotated Edition of the James Agee-Walker Evans Classic, with Supplementary Manuscripts*, ed. Hugh Davis, vol. 3 of *The Works of James Agee*, gen. eds. Michael A. Lofaro and Hugh Davis (Knoxville: U of Tennessee P, 2015) 7–8. Subsequent references to this edition will be noted parenthetically in the text.

2. See particularly Paula Rabinowitz, "Voyeurism and Class Consciousness: James Agee and Walker Evans, *Let Us Now Praise Famous Men*," *Cultural Critique* 21 (Spring 1992): 143–70.

3. Leslie Fiedler, *Freaks: Myths and Images of the Secret Self* (New York: Simon and Schuster, 1978) 14.

4. See particularly Fiedler 300–319; and Rachel Adams, "From Sideshow to the Streets," *Sideshow U.S.A.: Freaks and the American Cultural Imagination* (Chicago: Chicago UP, 2001) 138–58, for explorations of freakery during the 1960s.

5. Robert Bogdan, "The Social Construction of Freaks," *Freakery: Cultural Spectacles of the Extraordinary Body*, ed. Rosemarie Garland Thomson (New York: New York UP, 1996) 23

6. Adams 2.

7. James S. Miller, "Inventing the 'Found' Object: Artifactuality, Folk History, and the Rise of Capitalist Ethnography in 1930s America," *Journal of American Folklore* 117.466 (Oct. 2004): 374–75.

8. Miller 374.

9. Adams *2–4*.

10. Rosemarie Garland Thomson, "Introduction: From Wonder to Error— A Genealogy of Freak Discourse in Modernity," in Thomson, *Freakery* 2.

11. Adams 7.

12. James Andrew Crank, "'A Piece of Body Torn Out by the Roots': Failure and Fragmentation in *Let Us Now Praise Famous Men*," *Mississippi Quarterly* 62.1 (Winter-Spring 2009): 163.

13. T. V. Reed, "Unimagined Existence and the Fiction of the Real: Postmodernist Realism in *Let Us Now Praise Famous Men*," *Representations* 24 (1988): 156, 161.

14. Crank 165, 164.

15. Ronald E. Ostman, "Photography and Persuasion: Farm Security Administration Photographs of Circus and Carnival Sideshows, 1935–1942," in Thomson, *Freakery* 121.

16. Ostman 121.

17. Ostman 122.

18. Ostman 126.

19. Adams 115. See Adams, "Freak Photography," *Sideshow*, 112–37. chap. 5, for examinations of photographic representations of freaks and how these techniques continue in modern photographic art.

20. Thomson, "Introduction," *Freakery* 1.

21. Robert Bogdan, *Freak Show: Presenting Human Oddities for Amusement and Profit* (Chicago: U of Chicago P, 1988) 104–5.

22. Adams 28–29.

23. Bogdan 103–105.

24. Agee continues this mode of enfreakment in the following section, "Near a Church," where he characterizes the African American woman "like a kicked cow scrambling out of a creek, eyes crazy" and her movement as "a running not human but that of a suddenly terrified wild animal" (35).

25. Adams 56.

26. Elizabeth Grosz, "Intolerable Ambiguity: Freaks as/at the Limit," in Thomson, *Freakery* 57.

27. Grosz 59–63.

28. Adams 10.

29. Miller 385.

30. See Fiedler 274–99, who argues that the freaks' silence contributes to the spectacle of the freak show and further reinforces a power structure that removes agency from those on display in favor of the spieler and the audience.

31. Dale Maharidge and Michael Williamson, *And Their Children after Them: The Legacy of* Let Us Now Praise Famous Men: *James Agee, Walker Evans, and the Rise and Fall of Cotton in the South* (New York: Seven Stories, 2004) 164.

32. *And Their Children after Them* 139–42.

33. *And Their Children after Them* 170.

34. *And Their Children after Them* 170.

The "True Fact about Him":
The Conflict of Art and Nature
in James Agee's *Let Us Now Praise Famous Men*

Jeffrey Folks

In his depiction of the southern sharecropper, James Agee aspires to move beyond conventional art in order to record the "true fact about him,"[1] yet his ability to do so, as he readily admits, is limited by his own imaginative capacity and that of his audience. The obstacles standing in his way include the familiarity of the subject (the sharecropper had become "faddish" in the thirties, and so laden with stereotypical images), politics (the sharecropper was a primary target for New Deal reform), and, above all in Agee's case, aesthetics. Even as he proclaims the priority of life over art, Agee embraces a romantic ethos that positions "Agee the writer" above the sharecropper subject matter and so restores art to its superior position in relation to nature. *Let Us Now Praise Famous Men* is far more artful than Agee admits. His exploration of tenant life is above all the product of Agee's extraordinary artistic ambition to produce a wholly original and hugely evocative work of art.

Despite his aspiration to a variety of photographic art that would be as unadorned, honest, and direct as possible, Agee in fact adheres to a very different and far from naturalistic aesthetic, though one familiar within the long tradition of romanticism. As a late romantic, Agee attempts to press the boundaries of authenticity to their furthest ends, straining against convention to meld his art with nature, to be "at one" with his tenant subject, and to break down all barriers between nature and self. This aesthetic of authenticity is familiar from any number of romantic writers, most especially Percy Bysshe Shelley, to whose politicized nature poetry Agee's own return to nature bears a great deal of similarity. Like many late romantics, however, Agee brings to the romantic tradition an

untenable and self-defeating ambition to arrive at ultimate authenticity, an ambition absent even in Shelley. The idea of the artist merging with his tenant subject—a bare, empty, abject territory, to say the least—is akin to emotional and artistic suicide. Since authenticity of the degree that Agee seeks can never be obtained, the end must always be frustration or abnegation. From this point of view, *Famous Men* was a tortured meditation on his own death-in-life, a condition that mirrored the uncompromising radicalism of his aesthetic.

In *Famous Men* Agee clarifies his aesthetic as he flatly rejects realism and naturalism as simply forms of "documentary" and then proceeds to formulate a credo for his own writing based on the figure of the prose writer as "poet." In contrast to all the complaisant and simplifying writers of journalism and conventional prose, this serious artist aspires to an impossibility: the ideal that words can "embody," not merely "describe" (192). Despite the futility of the task, this poet figure "continually brings words as near as he can to an illusion of embodiment" (192). Such art "accepts the most dangerous and impossible of bargains and makes the best of it" (193). This approach, for Agee, is the highest artistic ambition, and it is what distinguishes his sharecropper narrative from that of all of his contemporaries. Thus, Agee was perhaps the only prominent writer of his generation who accorded the rural poor the dignity of taking their condition seriously as the subject for high art.

His attempt was not entirely successful, nor perhaps even appropriate. James Seaton analyses just such an artistic dilemma as Agee faced in his recent book, *Literary Criticism from Plato to Postmodernism*. In Seaton's terms, Agee's aesthetic falls within the familiar tradition of Neoplatonic art, a tradition that underlay the modernist movement that in turn helped shape Agee's aesthetic. Within this tradition, critics "have agreed that ordinary people were hopelessly mired in illusion, but . . . that art and literature properly understood can lead adepts to spiritual heights from which the concerns of everyday life would be revealed as mere trivialities."[2] The ordinary affairs of actual human beings, which in the context of twentieth-century American society would equate with the everyday life of the middle class, appear unimportant in comparison with the Neoplatonist's ambition to press art toward some ultimate

insight or key to existence. The danger of this position, as Seaton makes clear, is not just the likelihood of a sort of elitist disdain for ordinary affairs but also the tendency of such a radical pursuit of truth to connect Neoplatonist art with radical and often violent ideologies. In Agee's case, the ideology that comes to mind is nihilism. Agee almost never speaks in support of conventional political activity—to do so would violate his underlying despair of anything making a difference within the ordinary realm of affairs—though he fiercely supports the idea of the individual's withdrawal from society and his right of self-determination.

Agee's political view, to the extent that he had one, was at odds with the reform ethos of most of his contemporaries and most certainly with that of the Roosevelt administration. Agee mocked the idea of reform in part because it did not accord with his romantic image of the tenant class as permanently degraded and detached from the bourgeois ethos of respectability. In *Famous Men* Agee devotes several pages to a scathing attack on the work of Margaret Bourke-White, among the best-known photographers of the rural poor in the 1930s. What Agee most objected to in her work, aside from the obvious staging of the subject matter, was the sense of appropriation for personal or political advantage, and normally for both. As Agee writes, Bourke-White "spent months" in the South "bribing, cajoling, and sometimes browbeating her way in to photograph Negroes, share-croppers and tenant farmers in their own environments" (411). Bourke-White's photographs of the rural poor had made her a wealthy celebrity, but they failed to reveal anything but the surface of tenant life. From Agee's perspective, the New Deal itself involved the same failing: with its efforts to transfer crop support funds to the tenants, albeit through the hands of often less than scrupulous landowners, it treated only symptoms and showed little interest in the sharecroppers as human beings. Even as tenantry becomes a "stylish" subject for writers and politicians alike, the tenants "will suffer and be betrayed at the hands of such 'reformers'" (168). Like John Steinbeck's *The Grapes of Wrath*, a propagandistic novel that made the case for greater federal aid for the Dust Bowl migrants, programs administered through the Agricultural Adjustment Administration and other newly created bureaucracies often failed because of their lack of knowledge of

or sympathy for the tenant class. In any case, if the sharecroppers are to be reformed, made over into tidy little candidates for the middle class, they would hold no interest for a writer like Agee. Indeed, they would become just what he most despises: aspirants to the bourgeoisie. Thus, Agee repeatedly reassures himself that the croppers, for psychological, social, and even genetic reasons, can never be "reformed" into the middle class. They have been so utterly desensitized by their existence that it is "unlikely" they will ever benefit from assistance. Their life, as Agee says at several points as he explores the Gudger cabin, is "inhuman" (153), but this status in a certain sense is as Agee wants it to be. Agee had been seeking all his life for an alternative to the bourgeois malaise, and in his few short weeks in Alabama he believed that he had found it.

Clearly, he had not, because the tenants whom he conjures up in *Famous Men* are neither "representative" (vii), as he claims at the beginning, nor believable in their own right. Agee's tenants are, however, *necessary* to his art, because they complete the Neoplatonic equation of artist, nature, and transcendent reality. They are the earthly portal by way of which the artist arrives at a higher truth. Thus, in his portrait of George Gudger, Agee includes far less of the mundane reality—next to nothing, for instance, about the labor that Gudger actually performs or about his use of what leisure time he has—than the "true fact about him . . . that he is exactly, down to the last inch and instant, who, what, where, when and why he is" (188). It is this *essential* but extraordinarily abstract and inexpressible truth about the tenants that Agee aims to convey, and it is a truth that invariably discovers beauty, innocence, and even holiness in their lives. Ironically, however, the strenuous pursuit of the "true fact" in the interest of art carried Agee further and further away from the psychological and economic realities of sharecropping. It is unlikely that the Gudgers would ever have used the word "holy" or "divine" to describe the primitive conditions in which they live, nor is it likely that any human being would wish to remain in those conditions.

Agee's attempt to portray tenant life as sublime is perhaps the most puzzling quality of *Famous Men*. It is a crucial aspect of the book and is intimately related to the assumption that the tenants have been so dehumanized as to share almost no qualities in common with mainstream

society: they are both utterly beyond and utterly above bourgeois existence. Agee goes to great lengths to make this point, and yet the preponderance of evidence suggests he was mistaken. When one compares Agee's account with the evidence of historical records, memoirs, and photography, the sharecropper that Agee conjures up seems more a product of imagination than a real human being. It is not so much the physical circumstances, about which Agee can be as exacting in his depiction as Evans in his photography, that Agee misrepresents, as it is the character and motive of his subjects. The evidence suggests that Agee was especially prone to misrepresent the class aspirations, religious experience, and sexual morality of the tenants.

Perhaps the most striking quality of Agee's narrative, and one that has less to do with the author's art or politics than with his temperament, is the pervasive hopelessness and despair in which he casts his subject. It is a quality that connects Agee himself with the subject he is addressing as his spiritual desperation finds its analogue in the physical conditions of the tenants. In the extraordinary section entitled "Colon," Agee traces the development of a human being, whether a tenant or one of "the two billion now alive" or Agee himself, from the defenseless innocence of infancy through the cruel "pain of generations upon generations unnecessarily crucified" (84). The extremity of Agee's despair is apparent in his description of childhood as "the years of [the child's] very steepest defenselessness" so that "by the time he is five or six years old, he stands at the center of his enormous little globe a cripple of whose curability one must at least have most serious doubt" (91). From that point on, his life is a death-in-life filled with exploitation, repression, and impoverishment. While Agee seems to speak of, and at one point to, the three tenant families, he is at once speaking of all human beings and of Christ, whose crucifixion suggested but failed utterly to express the suffering of mankind. Finally, Agee declares that it is "beyond my human power" to reveal the entirety of suffering even for the small group of tenants with whom he has taken up. The failure of life for the tenants draws an immediate declaration of failure from Agee. He is not, he says, an artist or an entertainer: he is simply a human being calling for "co-operation" (92) from his readers so that the extent of human suffering will be registered.

If one believed, as Agee did, that the condition of the tenants, along with that of most of humanity, was hopeless, then the appeal for cooperation of this sort would make sense. The question is, in the context of the twentieth century and particularly in relation to the tenant class, whether Agee's despair had an objective basis. Were the tenant children whom he encountered actually "little slit graves of angelic possibility" (91), or were they, like most American children born in the first half of the twentieth century, on a pathway to material and cultural advancement?

One aspect of the "real" tenant that Agee dismissed entirely was the potential for class mobility, yet by the end of the 1960s the tenant system in the South had withered away, due in part to mechanization and to opportunities that the expanding wartime economy had opened up. As Joseph P. Ferrie writes in "The End of American Exceptionalism? Mobility in the U.S. Since 1850," "[S]ons of farmers were nearly twice as likely to get white collar jobs in the twentieth century as in the nineteenth."[3] Between 1930 and 2000, a period that encompasses the potential lifespan of most of the tenant children in *Let Us Now Praise Famous Men*, US per capita GDP grew from less than $6,000 (in 2009 dollars) to just under $40,000.[4] Many of those who had been tenants would live to see their children enter the middle class, and some, like the family Dan Morgan traces in *Rising in the West*, would achieve prominence. In his study of the Tatham clan, Morgan notes that "the children of [migrants] Ruby and Oca had energy and confidence, and as they improved their status, they developed an outlook that was distinctly middle-class."[5] A crucial point, however, was that as migrant workers the Tathams already possessed "the common bonds of family and beliefs" that contributed so vitally to their rise.[6] It was not that they were transformed into another species through the good graces of assistance or charity: they had always possessed the shrewd intelligence, aptitude for hard work, and ambition to achieve success once the opportunity arose.[7] This success is a very different future from what Agee imagines for the three tenant families in *Famous Men*.

Even within the text of *Famous Men*, one finds Agee's writing straining against credulity as realities threaten to intrude. This is the case in his representation of the moral virtue, or lack of it, in the tenant women. Agee's fantasies, especially the idea that more than one of the tenant women (and several of the female children) are sexually attracted to

him, seem particularly out of place. By a roundabout logic, however, they fit the overall structure of the book. It is crucial for Agee to believe that the tenants are incapable of ever becoming chaste and respectable bourgeois. For his own reasons Agee needs to suppose that the tenant women are promiscuous. Otherwise, the nightmare scenario looms that the tenants are merely temporary victims of circumstance who are essentially no different in their aspirations, abilities, and tastes than the rest of Americans. That being the case, Agee's entire worldview falls apart. If the tenants truly aspire to prosperity, cleanliness, education, and respectability, that scenario leaves Agee marooned on his own private island of rebellion, hostility, and spite. Instead of being a heroic artist serving the poor and abused, Agee becomes simply a talented bohemian: a romantic who has appropriated the tenant subject for his own personal reasons.

There are other ways in which Agee's account does not accord with that of credible social historians. As is apparent from numerous photographs in the vast archives of the Library of Congress, tenant women attempted to maintain a degree of cleanliness and order even in the midst of abject poverty. Among the 270,000 Farm Security Administration (FSA) photographs housed in the American Memory Collection, a large number reveal the efforts of tenants to cling to a dignified way of life even in the midst of dire poverty. A photograph by FSA photographer John Vachon (#1211) shows farm families of apparently modest means sitting in front of the courthouse in Tahlequah, Oklahoma, in July 1939. All of these individuals are well groomed, dressed in clean clothes, and seated in a dignified manner, though on the ground. Moreover, they appear to constitute intact nuclear families.[8] A photograph by Russell Lee (#1224) records a group of farmers "eating pie at a pie supper in Muskogee County, Oklahoma, in February 1940." This revealing photograph shows young men in white shirts wearing ties among older residents with decent coats, hats, and dresses.[9] Much the same impulse toward cleanliness and respectability underlies Annie Mae Gudger's embarrassment at possessing only "very old and broken shoes which were twice too big for her" (225).

Curiously, FSA photographs of Alabama tenants, even those taken by Walker Evans himself, do not reveal the same degree of destitution

evinced in either the text or photographs of *Let Us Now Praise Famous Men*. A photograph of "Joe Handley, tenant farmer and part of his family" taken by Arthur Rothstein in 1937 shows a clean, simply dressed but respectable family seated in the breezeway of their home. Interestingly, even the small children are wearing shoes.[10] A 1935 photograph of a "farm woman in conversation with relief investigator, West Virginia," by Walker Evans records a clean and well-dressed woman along with a clean, well-groomed boy, possibly her son.[11] The contrast with Evans's photographs of the three tenant families in *Let Us Now Praise Famous Men* suggests that the photographs in the Agee and Evans book were carefully posed and selected to reinforce a particularly negativistic view of the sharecropper.

As Agee himself admits, the tenant families in *Famous Men* possessed clean clothes, which they reserved for Saturdays in town or for Sunday church-going, yet these clothes do not appear in Evans's photographs published in the book. Rather, the focus of the photographs, and of the narrative, is on the dirt, infestation, and excrement in which the tenants live. "[T]he laundry is almost never done," Agee writes, "and beyond their faces and hands the people, and their clothing and bedding, and their pans and dishes, and their house, are generally by standards other than their own insanely or completely dirty" (160). Morgan presents a very different picture of tenant life: the tenant families that he investigates are entirely as self-respecting and ambitious as other Americans. As he writes, "After the war, very few people suggested anymore that the men and women who had come from Oklahoma to California in the 1930s were 'of the lower fringe of humanity.'"[12] That view, that the tenants were temporary victims of transient economic forces, is corroborated by Caroline Henderson, one of the most influential Dust Bowl writers of the era. Even as she reports the dreadful conditions of struggling farmers, Henderson stresses "their habitual capacity for keeping at work in spite of failure and loss, their lifelong training in facing hard facts, their comparative adaptability, and their opportunities under normal conditions to produce at least a great part of their own necessities of life."[13]

Little is recorded in *Famous Men* concerning the religious practices of the tenants, and yet numerous accounts confirm that church atten-

dance, Bible reading, and prayer were essential elements of tenant life. As Morgan notes, the fundamentalist Protestant religion favored by most southern tenants "generally was viewed with a mixture of disdain, amusement, and concern by the New Deal bureaucracy . . . as well as by intellectuals and writers." [14] In *The Grapes of Wrath*, for example, Steinbeck suppresses all mention of religion in connection with the Joads, with the exception of their irreverent neighbor, Jim Casy, a lapsed preacher converted to secular humanism. For his part, Agee imposes a dismissive and mocking attitude toward Christianity. Even the title of the book is a subversive reference to the Bible's straightforward celebration of "great men," those men of righteousness and faith who are, in effect, the pillars of their communities. In his account, Agee cynically implies that such men (that is, the landowners) are hypocrites who are exploitative or at the very least uncharitable toward those in need. Among the tenants themselves, a range of opinion toward such men must have existed, but the tenant system, with clearly defined rules and procedures, had existed for decades in the South, and within this system the role of the landowner had always been paternalistic. The landowner hired and fired, allotted acreage, extended credit, kept accounts, and collected a share of the crop at settlement. With his relative wealth and authority, he was a target of resentment for Agee, as he was for liberals such as Jerome Frank, Margaret Bennett, Adlai Stevenson, John Abt, Lee Pressman, and Alger Hiss in the AAA, but perhaps not so much for the tenants themselves whom Agee, of course, deems the true "great men" in his book.

Underlying the social mobility and conventional values of the tenant class was an important truth: far from being an alien and dehumanized being unlike the mass of Americans, the tenant was simply an ordinary human being, no different from any other, though temporarily disadvantaged by economic conditions. In this respect, Agee echoes a mistake familiar among writers and politicians of the era: the idea that an unchanging group of families had always constituted the southern tenant class. Nearly all New Dealers, particularly those most inclined toward reform, can be said to share the view of Aubrey Williams, head of the National Youth Administration, that "destitution in the rural South was chronic, that most farmers' incomes had never been com-

mensurate with the prices of necessities, and consequently, even in the 'prosperous' 1920s the region had the poorest schools, health facilities, and public services." [15] In reality, as Mertz points out, only recently had large numbers of white southerners descended into tenancy: the "total number of sharecroppers in the South" had risen in each of the five decades before 1930,[16] and the numbers had risen sharply during the 1920s as a result of collapsing farm prices. On the Southern Plains a similar deterioration had taken place: the percentage of tenants in the farming population had risen from 32% in 1920 to more than 50% in 1930.[17] The myth that there had existed a large and static class of shiftless and lazy poor whites was just that, a myth. Considerable numbers of tenants in the 1930s had recently owned farms of their own, while much larger numbers could claim parents or grandparents as landowners. There had never existed a large, permanent class of white tenants in the South.

Another contemporary misreading echoed in *Famous Men* is the idea that the "sharecropper problem" resulted from mechanization. In this connection, the most influential work of the 1930s was Pare Lorenz's film, *The Plow That Broke the Plains*, a film funded by the Resettlement Agency wherein Lorenz crystalized the view that the tenant class had been displaced from their sustainable agrarian existence by the intrusion of machines such as the tractor and the mechanical harvester. This romanticized film, endorsed by FDR as "a modern tool of government,"[18] fueled several New Deal schemes to restore diversified agriculture to both the Great Plains and the South (for example, through the creation of collectives practicing subsistence farming). The underlying assumption was that prior to mechanization, the rural poor were largely self-reliant outside the capitalist system. This description, of course, had never been the case since southern farmers had always planted cash crops of tobacco and cotton. Associated with this idea was the notion that mechanization had promoted an overpopulation of rural areas. Many serving in the Department of Agriculture supported the idea of relocation of tenant families off the land and of returning the land to its primitive condition. In the South, FDR's policy of price adjustment via crop controls resulted in the removal of large numbers of tenants from the land as an average of forty percent of farmland lay fallow.[19] The displacement

of the rural poor reached crisis proportions in the mid-1930s, a highly publicized issue that Agee never mentions in *Famous Men*.

Unlike the majority of writers of that era, Agee's perspective was essentially apolitical. Agee evinced no interest in the particulars of New Deal assistance programs, programs that, as Conrad notes in reference to a study in *Social Forces*, "had failed miserably to help sharecroppers and low-class tenants."[20] Although he supported the general goal of greater assistance, Agee found that sharecropper conditions mirrored his own anarchistic rejection of conventional social norms, and so he voiced no interest in changing these conditions. The gratification that Agee gained from his two-month stay in Alabama was clearly connected with his sense of having stripped himself of what he considered to be pretension and inauthenticity. Having shed the carapace of civilized existence, he had arrived at the essence of existence. In the silence of the summer night, miles from even the smallest hamlet, Agee writes, "I can tell you anything within realm of God . . . and that what so ever it may be, you will not be able to help but understand it" (45). Like so many in the romantic tradition, Agee equated an escape from society with access to visionary powers.

Agee's stay with the tenants seemed to present him with an extraordinary opportunity of a spiritual and artistic nature. Unlike the New Deal planners, who worked to implement agricultural parity, land redistribution, and farmer cooperatives, Agee spent little time considering assistance, largely because he had convinced himself that the existence of the tenants was superior to that of mankind within society. Like the New Dealers, Agee viewed the tenants as humans of a different order than himself, but unlike them, he saw no reason to improve their lot. The tenants represented what Agee aspired to be and fantasized of being for the rest of his life, whether through his devastating and unshakable memory (or reconstruction) of childhood loss, recollections of a severely monkish adolescence at boarding school in Tennessee, or fantasies of civilization devastated by nuclear war.[21] While he might seem to be making the case for government assistance, Agee was at the same time, and to a greater degree, insisting that the elemental nature of tenant life was something beautiful, sublime, and even holy, and that he

was a disciple of their way of life. The irony, of course, is that every one of the southern tenants would have leapt at the chance to enjoy the privileges that Agee had been afforded and that he continued to enjoy, even as a low-level employee of *Fortune*. There is no indication in the text of *Famous Men* that any one of the tenants views his or her poverty with anything but loathing and disgust.

As Agee notes, the tenants are perplexed by the arrival of Agee and Evans, this pair of sophisticated visitors who seem to have landed from another planet. The tenants extend what hospitality they can, but it seems unlikely they shared Agee's own assessment that "they were my own people . . . and we all felt right and easy with each other and fond of each other" (56). Not only was Agee different, but he also seemed incapable of registering the tenants' most basic aspirations toward greater security, comfort, and education. He overlooked the central fact that the tenants aspire to be included in the mainstream of the American middle class. Still, indications of this fact slip into the text of *Let Us Now Praise Famous Men*, including the effort of Annie Mae Gudger to "beautify" the cabin in which she and her family live, the effort to maintain a clean environment, the respect for hard work and aspiration for better pay, and the educational aptitude of ten-year-old Louise Gudger. What Agee stresses is something quite different: the apparent lack of aspiration toward a better life, the mental limitations or dehumanized state of nearly all the tenants, the early aging of all the adults, the inevitability of decline, and the elemental sexuality of the women and even of children. In sum, Agee's treatment of the tenants is remarkably reductive. He wishes to exclude them from the mainstream of American society so as to "save" them from respectability.

While the New Deal writers and artists falsified their depiction of the tenant class for their own political purposes, Agee falsified his writing in the interests of a very different mission: the discovery of a compelling vehicle for the artistic expression of his own sense of despair. In his approach to the three tenant families, Agee found it necessary to impose his nihilistic assumptions on a class of people whose moral perspective was actually quite different from his own. In terms of every significant element of their lives—the sanctity of marriage, devotion to

children, the virtue of labor, striving for financial security, patriotism, educational aspiration, cleanliness, and orderliness—the tenant class in general held beliefs that Agee despised. As Morgan wrote of the Okie migrants entering California, "They weren't a bunch of hoboes. They were decent people. But how would anybody know? The truck looked a wreck. . . . They had stubby beards and looked worn out."[22] Too often, Agee presents the appearance of the tenant families, their ramshackle homes, and their pitiful possessions in similar terms, but even as he assigns a quality of "holiness" to them, he fails to credit their everyday decency and conventional morality.

Ultimately, what distinguished Agee's treatment of the tenant class was that he brought to the task the sensibility of a serious artist, though that of a tortured, radicalized, and self-destructive romantic. The resulting work was unique, enigmatic, and unfaithful to its subject, but it was nonetheless a work of art that strove neither for documentary realism nor for propagandistic effect. What Agee attempted in *Let Us Now Praise Famous Men* was at once the oddest and most subversive of strategies: a rejection of both the prevailing opinion of liberal reform and the demands of a more traditional naturalistic mode of writing. What he sought was to bring the sensibilities of high art to the lowest social order. The result was both a slap in the face and an appeal to both the progressive artists and reviewers who aligned themselves with every faddish innovation as well as to the reformers who manipulated the sharecropper subject for political ends.

Most of all, *Let Us Now Praise Famous Men* was a reflection of Agee's determination to forge an art form that would express his radical sense of hopelessness. In the sharecroppers Agee found a proper analogue for his own spiritual desperation, though by imposing this condition on the subject of the rural poor, he distorted the actual nature of tenant life. The attempt to create a work of high art out of the most barren, ugly, and offensive materials was from the start a futile undertaking, as Agee must have appreciated, but it was necessary as an attempt to confront his sense of calamity and doom. The result was neither heroic nor entirely successful. Like so much of Agee's career, *Let Us Now Praise Famous Men* was a failure, but a failure on a grand scale.

NOTES

1. James Agee and Walker Evans, Let Us Now Praise Famous Men: *An Annotated Edition of the James Agee-Walker Evans Classic, with Supplementary Manuscripts*, ed. Hugh Davis, vol. 3 of *The Works of James Agee*, gen. eds. Michael A. Lofaro and Hugh Davis (Knoxville: U of Tennessee P, 2015) 188. Subsequent references to this edition will be noted parenthetically in the text.

2. James Seaton, *Literary Criticism from Plato to Postmodernism: The Humanistic Alternative* (New York: Cambridge UP, 2014) 2.

3. Joseph P. Ferrie, "The End of American Exceptionalism?: Mobility in the U.S. Since 1850," Oct. 2004, Northwestern U, [2/14/2015] <http://faculty.wcas.northwestern.edu/~fe2r/papers/Exceptionalism.pdf>.

4. Catherine Mulbrandon, "Long-Term Real Growth in US GDP Per Capita 1871–2009," *Visualizing Economics* 8 Mar. 2001, [2/14/2015] <http://visualizingeconomics.com/blog/2011/03/08/long-term-real-growth-in-us-gdp-per-capita-1871-2009>.

5. Dan Morgan, *Rising in the West: The True Story of an 'Okie' Family in Search of the American Dream* (New York: Vintage, 1992) 321.

6. Morgan 321.

7. In *And Their Children after Them* (New York: Pantheon, 1990), Dale Maharidge and Michael Williamson trace the lives of Agee's three tenant families and their descendants from 1936 through 1986. What they discover among the children and grandchildren of Agee's destitute sharecroppers is a remarkable range of success and failure (including the suicide of Maggie Louise Gudger at age 45 and the relative success in life of her daughter and grandchildren). Maharidge and Williamson confirm the fact that sharecropping died out by the 1970s. Among the 128 direct descendants of the three tenant families, none are engaged in tenant farming.

8. John Vachon, "Tenants sitting in front of the Tahlequah, Oklahoma, courthouse in July 1939," *Photographs of Oklahoma*, FSA, Oklahoma Dept. of Libraries Online, 2015, [2/14/2015] <http://www.odl.state.ok.us/oar/resources/fsa/>.

9. Russell Lee, "Group of farmers eating pie at a pie supper in Muskogee County, Oklahoma, in February 1940," *Photographs of Oklahoma*, FSA, Oklahoma Dept. of Libraries Online, 2015, [2/14/2015] <http://www.odl.state.ok.us/oar/resources/fsa/>.

10. Arthur Rothstein, "Joe Handley, tenant farmer and part of his family," 1937, FSA/OWI Collection, Library of Congress, [2/14/2015] <http://www.loc.gov/pictures/collection/fsa/item/fsa2000006781/PP/>.

11. Walker Evans, "Farm woman in conversation with relief investigator, West Virginia," 1935, FSA/OWI Collection, Library of Congress, [2/14/2015] <http://www.loc.gov/pictures/collection/fsa/item/fsa1997019501/PP/>.

12. Morgan 151.

13. Caroline Henderson, *Letters from the Dust Bowl*, ed. Alvin O. Turner (Norman: U of Oklahoma P, 2001) 118.

14. Morgan 126.

15. Paul E. Mertz, *New Deal Policy and Southern Rural Policy* (Baton Rouge: Louisiana State UP, 1978) 225.

16. Mertz 29.

17. Vance Johnson, *Heaven's Tableland: The Dust Bowl Story* (New York: Farrar, Straus, 1947) 144.

18. R. Douglas Hurt, *The Dust Bowl: An Agricultural and Social History* (Chicago: Nelson-Hall, 1981) 61.

19. David Eugene Conrad, *The Forgotten Farmers: The Story of Sharecroppers in the New Deal* (Urbana: U of Illinois P, 1965) 76.

20. Conrad 81.

21. See James Agee, *A Death in the Family: A Restoration of the Author's Text*, ed. Michael A. Lofaro (Knoxville: U of Tennessee P, 2007); *The Morning Watch* (Boston: Houghton Mifflin, 1951); and the screenplay "The Tramp's New World," published in John Wranovics, *Chaplin and Agee: The Untold Story of the Tramp, the Writer, and the Lost Screenplay* (New York: Palgrave McMillan, 2006).

22. Morgan 55.

The Cinematic Eye of James Agee
in *Let Us Now Praise Famous Men*

Jeffrey Couchman

Walker Evans is a hard act to follow. Ever conscious of the quietly revealing photographs that open *Let Us Now Praise Famous Men*, James Agee confronts the reader of his text with the limitations of language. "If I could do it," he announces in a well-known passage, "I'd do no writing at all here. It would be photographs; the rest would be fragments of cloth, bits of cotton, lumps of earth, records of speech, pieces of wood and iron, phials of odors, plates of food and of excrement."[1] Many pages later, he returns to his theme: "Words . . . are the most inevitably inaccurate of all mediums of record and communication" (191). The camera, on the other hand, is "incapable of recording anything but absolute, dry truth" (189). The point is open to debate, but the statement underlines an essential idea in *Famous Men*: the moral imperative to present a true picture of three tenant families in Alabama. Because odors and excrement might not be feasible between the covers of a book, Agee compensates for the inadequacy of words by using an excess of words in an array of styles. Amid the free verse and prose poetry and reportage (barely a start for a list of literary forms in the book), Agee employs language that mimics motion-picture devices. By creating his own moving camera eye within his literary text, Agee conveys photographic truth through a lens different from that of Evans's still camera. Differing visual perspectives reveal one way in which the book's photographs and text are, as Agee puts it in his preface, "mutually independent." At the same time, the dual approaches bear out Agee's paradoxical idea that the same images and words are "fully collaborative" (viii). The very contrast of Evans's still photography and Agee's cinematic prose heightens their interdependence.

In American literary history, the phrase "camera eye" is familiar from John Dos Passos's trilogy *U.S.A.* (1937), which, like *Famous Men*, is an epic work with an eclectic form.[2] Ironically, chapters titled "The Camera Eye" in *U.S.A.*, despite their vivid imagery, are neither photographic nor cinematic. Dos Passos's "camera" might be considered an introspective eye, because the chapters are written in a literary, stream-of-consciousness style:

> it was like the Magdeburg spheres the
> pressure outside sustained the vacuum within
> and I hadn't the nerve
> to jump up and walk out of doors
> and tell them all to go take a flying
> Rimbaud
> at the moon[3]

Sections in *Famous Men* that could be headed "The Film Camera Eye" are interested in recording an external reality. With his lifelong devotion to cinema, however, Agee knew that film's externalizations can lead to internal truths.

When *Famous Men* appeared in 1941, Agee had published two film treatments, "Notes for a Moving Picture: The House" (1937), an unsettling stream of surrealistic visions, and "Man's Fate" (1939), a section from the 1934 novel of the same title by André Malraux.[4] (A treatment is a description of a film's action with little or no dialogue.) The works help to illuminate the purpose of Agee's cinematic mimesis in *Famous Men*. Tom Dardis calls the published pieces "cinematic 'closet dramas,'" intended to be read and not used as literal guides for screen productions.[5] (Agee would write other film treatments, including "Bloodline" (1951), a post-Civil War drama for Twentieth Century-Fox, in which he carefully describes how his stories are to play out onscreen.)[6]

"Closet drama" is a good description of "Notes for a Moving Picture." Despite the visual qualities of the treatment, Agee's primary concern is the sound and rhythm of his prose. For example, Agee offers the following picture of smokestacks and sky:

Then, sighted up the lengths of sunstruck stacks as along rifles: a smokeless stack, which in one second discharges smoke in a crisp white flower: another; another; two-together; pause; another; pause; another.

Back to the broad-air picture, with the risen columns, in still air, mushrooming, beginning to merge.[7]

"Man's Fate" is more truly a film narrative. Its imagery and assembly of shots are influenced by such Russian filmmakers as Sergei Eisenstein and Aleksandr Dovzhenko. In a note at the end of the treatment, Agee even mentions Dovzhenko's *Arsenal* (1929) as a model for the sort of "dynamic" editing he has in mind.[8] Agee's chief concerns in "Man's Fate" are sound within the film and pictorial tableaux. Here he describes the prison yard in which wounded Chinese prisoners are waiting to be murdered:

The strong deep iron bell of a clock: a granular quality of vibration. Sound only.

Square-shot, a little below centre, from outside, of the closed guarded door of the prisonyard: motionless but not a still. Seen through thin drizzling fog and darkness descending but maximum sharp focus; the drizzle holding the same rhythm as that of the bell-vibration.[9]

Cinematic moments in *Famous Men* are in the vein of Agee's two treatments: they are meant to be read, never filmed. The rhythm of the prose is as important as the filmic presentation. Yet portions of the book that evoke cinema are generally more active than "Notes for a Moving Picture" and "Man's Fate." In one of the few critical pieces to look at film technique in relation to *Famous Men*, Caroline Blinder writes about the way Agee's cinematic lens becomes "a metaphor for how to animate, rather than merely capture, the lives of the sharecroppers."[10] To illustrate her point, she studies Agee's exploration of the Gudgers' empty house. Blinder's observation about animating the tenants' lives applies to passages throughout the book. Agee often draws on film grammar to generate a sense of immediacy and to create a truly moving picture.

In "A Country Letter," Agee describes how to walk from the house where the Gudgers are sleeping to the house where the Ricketts live. In film terms, he employs a tracking shot, as though a camera is moving from place to place. He does not rely entirely on description; he retains a chatty authorial voice. In this context, however, the speaker has the quality of a narrator speaking voice-over on a film soundtrack. He is like a commentator in a travelogue, pointing out sights and offering helpful explanations:

> Leave this room and go very quietly down the open hall that divides the house, past the bedroom door, and the dog that sleeps outside it, and move on out into the open, the back yard, going up hill: between the tool shed and the hen house (the garden is on your left), and turn left at the long low shed that passes for a barn. Don't take the path to the left then: that only leads to the spring. (63)

When viewing an Evans photograph in *Famous Men*, the viewer may have a tactile sense of wood or clothing, but one still remains primarily an observer, standing outside the frame, peering into a room or across a field. The second-person point of view in Agee's travelogue places the reader in the scene. In a sense, the reader becomes the camera, moving out of the house and along the paths. Moreover, each reader becomes one of the Gudgers, Ricketts, or Woods, experiencing the landscape in a visceral way, because this is how the tenants walk from house to house:

> . . . but cut straight up the slope; and down the length of the cotton that is planted at the crest of it, and through a space of pine, hickory, dead logs and blackberry brambles (damp spider webs will bind on your face in the dark; but the path is easily enough followed); and out beyond this, across a great entanglement of clay ravines, which finally solidify into a cornfield. Follow this cornfield straight down a row, go through a barn, and turn left. There is a whole cluster of houses here; they are all negroes'; the shutters are drawn tight. (63)

In the next lines, Agee breaks away from the tracking shot. He writes, "You may or may not waken some dogs: if you do, you will hardly help but be frightened." He describes the animals "bellowing in the darkness," people waking up, "their heads lifted a little on the darkness from the crackling hard straw pillows of their iron beds." In film terms, Agee cuts to shots of the awakening people. Words that follow, still in second person, are, however, novelistic. Agee imagines feelings within the reader, a stranger to the countryside: "the knowledge of wakened people . . . overcasts your very existence, in your own mind, with a complexion of guilt, stealth, and danger" (63).

He then eases the reader back into the mobile shot:

> But they will quiet.
> They will quiet, the lonely heads are relaxed into sleep; after
> a little the whippoorwills resume, their tireless whipping of the
> pastoral night, and the strong frogs; and you are on the road, and
> again up hill, that was met at those clustered houses. (63–64)

Agee's cinematic techniques in *Famous Men* at times point toward the screenplays that he would write in subsequent years. (His first script, *The Blue Hotel*, was written in 1950.)[11] The soundtrack that Agee constructs in the passage above is echoed in his first draft for *The Night of the Hunter* (1954), which is based on a novel by Davis Grubb.[12] A boy on the run from a psychopathic preacher is hiding with his sister in a hayloft. He looks out on a nighttime landscape and hears the voice of the preacher singing a hymn in the distance. Grubb's sound palette, which includes dogs and a whippoorwill, must have struck a familiar chord in the author of *Famous Men*. The following passage from Agee's screenplay draws on descriptions from page 201 of the novel:

> . . . and now we hear . . . the yelling of the farm dogs the voice
> disturbs; . . . and now too the voice from our own farm is added,
> near and wild.
> [A few scenes later, Preacher passes out of view.]
> His voice continues, fading. . . . Our dog quits. . . . Other voices,
> other dogs, at varying deep distances, die off into pure silence. A

little of this exquisite silence; then the whippoorwill resumes, but half-heartedly now, shyly, as if abashed.[13]

One can see that even when Agee writes a screenplay, he includes novelistic details like "exquisite silence" or a whippoorwill singing "shyly." In *Famous Men*, Agee's literary voice (note "floated cotton" below) mingles with cinematic movement in the approach to the Ricketts' house. The camera, still climbing the hill, pans (that is, swivels on a horizontal plane) back and forth across the landscape:

> . . . pines on your left, one wall of bristling cloud, and the lifted hill; the slow field raised, in the soft stare of the cotton, several acres, on the right; and on the left the woods yield off, a hundred yards; more cotton; and set back there, at the brim of the hill, the plain small house you see is Woods' house, that looks shrunken against its centers under the starlight, the tin roof scarcely taking sheen, the floated cotton staring.(64)

Agee's poetic prose stirs an emotional response. Yet the mobile composition of the scene adds its own resonance. Rising to panoramic heights, the reader becomes one with the land and sky. Semicolons, sometimes followed by the coordinating conjunction "and," create an effect of continuous camera movement, as opposed to cuts from image to image. Agee pictures the "lifted hill," which melds into "the slow field" as it comes into view. You, the camera, look left, right, and left again.

Movement ceases for the final picture. The camera eye gazes at the Woods' house, small now in the distance below the stars, beside the "floated cotton," and the house becomes a vision of the Woods themselves, small and isolated against vast forces. The cinematic framing of the landscape carries us to a sympathetic understanding of human beings.

Agee's metaphoric image of the "shrunken" house is a sharp contrast to the direct representations in Evans's photographs. Evans trains his camera on, to adapt a phrase from *King Lear*, "the thing itself."[14] A picture of a worker picking cotton, which appears in the 1960 edition of *Famous Men*, does not invoke grand ideas ("Man's Endless Toil," let us say).[15] The angle behind the woman emphasizes the bent back and the worker's in-

tense focus on the rows of plants. It is an image of individual labor at a particular moment in the sun.

Evans also shows little interest in vistas of the sort that Agee provides in his sweeping views left and right from the top of a hill. Evans generally prefers to move in close and observe such things as the dark entryway of a school or boots left out on red clay. Even when Evans widens his angle, for a shot of a mother and child crossing a yard, for example, his positioning accentuates details in the image: the bare feet of the figures, broken slats on a wooden structure, and shadows that add a natural beauty to the scene.[16]

When Agee devises his own close shots, they often include movement that engenders emotion more overt than anything found in an Evans still life. For example, Evans photographs a fireplace, a portion of a wall, and a handful of decorative and utilitarian items. These include a calendar with an illustration of a woman in a hat, an open locket, and a pair of shoes on a low shelf.[17] The sparse collection is inherently affecting. Evans, however, downplays emotion with a frontal composition that emphasizes an overall geometry—the straight edges of the fireplace and the symmetry of objects within his frame. Agee depicts the same objects, though he adds others to exhibit a composite of possessions in the Gudgers' house. He may pause to describe details in each image, but the constant reframing of the display, whether understood as a pan or a series of shots cut together, keeps his scene moving:

> A calendar, advertising ——'s shoes, depicting a pretty brunette with ornate red lips, in a wide-brimmed red hat, cuddling red flowers. The title is Cherie, and written twice, in pencil, in a schoolchild's hand: Louise, Louise.
>
> A calendar, advertising easy-payment furniture: a tinted photograph of an immaculate, new-overalled boy of twelve, wearing a wide new straw hat, the brim torn by the artist, fishing. The title is Fishin.'
>
> Slung awry by its chain from a thin nail, an open oval locket, glassed. In one face of this locket, a colored picture of Jesus. . . . In the other face, a picture by the same artist of the Blessed Virgin. . . .

Torn from a child's cheap storybook, costume pictures in
bright furry colors. (136)

Agee's progression places the reader in the room, a visitor actively engaged in sequential scrutiny of the items on the wall. In the steady revelation of belongings strung randomly together, each new object is an epiphany. The cumulative effect is a sense of reverent joy in these everyday things. That effect is heightened by a climactic image that transcends the others as a mark of time and a remembrance of family: "At the right of the mantel, in whitewash, all its whorlings sharp, the print of a child's hand" (137).

In another close view—of George Gudger in a kind of medium close-up—Agee effectively mimics a different type of camera movement for cumulative effect. He describes George Gudger dressed for a Sunday. Each piece of clothing appears in a separate paragraph; the steady progress upward mirrors the tilt (a movement up or down on a vertical plane) of a stationary camera:

Long bulb-toed black shoes: still shining with the glaze of their
first newness, streaked with clay.

Trousers of a hard and cheap cotton-wool, dark blue with narrow gray stripes; a twenty-five-cent belt stays in them always.

A freshly laundered and brilliantly starched white shirt with
narrow black stripes.

A brown, green, and gold tie in broad stripes, of stiff and hard
imitation watered silk.

A very cheap felt hat of a color between that of a pearl and that
of the faintest gold, with a black band. (209)

Agee's slow tilt up is similar to a moment in the shooting script for *The Night of the Hunter*. The children running from the evil preacher have been found in a meadow by a farm woman named Rachel Cooper. A dramatic moment of revelation begins with a close-up of the boy, John:

His eyes go down to her feet. He, and we, start to examine her
from foot to head; for this is our heroine at last.

CLOSE TILTING SHOT—RACHEL

. . . from JOHN's eye-level. We TILT SLOWLY UP her height. She wears man's shoes, heavy with mud; a rough skirt; a shapeless sweater hangs over her shoulders; she is in her middle sixties and wears a man's old hat.[18]

In *Famous Men*, the reader has seen George Gudger from various perspectives by the time Agee describes him in his Sunday best. Agee's upward tilt, however, is an act of discovery. It is as though the reader is seeing Gudger for the first time. Like Rachel Cooper, he remains still for our steady, moving gaze. The shoes are new, yet already "streaked with clay." Pants, belt, imitation silk tie, and hat are cheap, yet the pants are striped in a fashionable way, Gudger's shirt is clean and starched, and the hat, in its coloring, has a dash of elegance. All this one sees in a continuous vision that is touching without being sentimental. At the end of the tilt, Gudger stands before us as a man of pride and dignity.

For a description of Mrs. Gudger on a Saturday, Agee uses yet another technique. He turns to rapid film editing to give us a burst of images. In his filmic portrait of Mrs. Gudger, Agee's "shots" are a kind of montage. The word is used here in the sense worked out by Russian filmmakers of the 1920s: shots juxtaposed in startling ways to generate an emotion or an idea greater than any image on its own. For example, here are several shots from Eisenstein's shooting script of *Battleship Potemkin* (1925). The body of the revolutionary leader, Vakulenchuk, is on view in Odessa. Townspeople have gathered to mourn, while sailors from the *Potemkin* row toward shore (brackets around the word "Rower's" are in the original):

CU [close-up] Vakulenchuk.
A handkerchief raised to a face.
A hand dropping a copper coin.
Hands crumpling a cap.
Oars dipping towards the water.
[Rower's] arm movement (beginning of stroke).
Oars hitting the water.
[Rower's] head bending forward.[19]

The shots are not cut together in a continuous manner. Isolated images and multiple perspectives combine to express a sense of grief and urgency.

In a similar way, Agee's swift editing builds up a picture of Mrs. Gudger. For this sequence, Agee moves his camera eye in. Each image, except for those in the final paragraph, is a close-up:

> Face, hands, feet and legs are washed.
> The hair is done up more tightly even than usual.
> Black or white cotton stockings.
> Black lowheeled slippers with strapped insteps and single buttons.
> A freshly laundered cotton print dress held together high at the throat with a ten-cent brooch.
> A short necklace of black glass beads.
> A hat.
> She has two pairs of stockings. She sometimes goes barelegged to Cookstown, on Saturdays, but always wears stockings on Sundays. (210)

The images of Mrs. Gudger do not follow one another in a logical order (from foot to head, for example). Four different views are combined in the first one-sentence paragraph. The sequence of shots in that line begins with the face, moves down to the hands, jumps all the way to the feet and up to the legs. Agee then cuts to Mrs. Gudger's hair, back down to her legs for two different images (black stockings, white stockings), to her feet, and finally to her dress. The images relate specific information: Mrs. Gudger is clean, her hair is tightly bound, her laundered dress is neatly decorated with a brooch, her entire outfit is topped with a hat. The hat feels like a culminating image. Agee, however, returns once more to stockings and legs, images accompanied by narration, to tell us that Mrs. Gudger always wears stockings on Sunday. Because the pictures flash by in an unpredictable order, each one stands out all the more distinctly. Yet together they form an overall impression of a trim, dignified woman that no single image could fully convey. On the next page, Agee says that Mrs. Gudger "is keenly conscious of being carefully dressed, and

carries herself stiffly" (211). One hardly needs that description because Agee's cinematic presentation has already revealed essential aspects of the woman's nature.

The tilt shot of Gudger and the montage of his wife create analytical views that differ from Evans's photographic portraits, in which the subjects, whether seen in close-up or in full view, are complete beings. Agee's cinematic effects break Gudger and Mrs. Gudger into parts while simultaneously reassembling those parts to comment implicitly on each figure. Evans is not interested in commenting on his subjects. As William Stott puts it, "Evans does not 'expose' the reality he treats, he reveals it— or better, he lets it reveal itself."[20] Evans photographs family members standing or sitting, alone or in groups, gazing out at us with eyes that we interpret as we will.

In the layout of his photographs, Evans also generally avoids authorial commentary, though as Alan Trachtenberg points out, the landowner in the first photograph is "a figure whose afterimage pervades the whole sequence. He is the unshakable reminder of the governing *system*: private property, absentee landlordism, and exploitative tenancy."[21] Otherwise, Evans does not display his photographs in a disquieting or ironic design. His arrangement has the familiar appearance of a family snapshot album. In contrast, Agee's entire text is built up of surprising juxtapositions. A poem is followed by cinematic prose in which the reader journeys to the Ricketts' house. That external action is followed by a plunge into dreams and interior monologue ("O, we become old; it has been a long, long climb. . . . How were we caught?"). From those inner thoughts, Agee cuts to Jesus delivering the Beatitudes from the Sermon on the Mount, a leap that might offer comfort after the sorrows and questions of the monologue or might instead raise doubts about the certainty of Christ's words (62–68). One might say, then, that Russian montage in *Famous Men* is not limited to cutting within a passage. The constantly shifting perspectives throughout the book produce a flux of emotion and meaning. No single view can tell the full truth. The whole becomes greater than any individual part.

Agee also employs a type of montage familiar from Hollywood films: a sequence of shots ranging over space and time that are linked together, often through dissolves. (In a dissolve, one shot fades out while another

simultaneously fades in.) Agee provides a good example of a montage in the first draft for *The Night of the Hunter*. He writes a sequence to cover a day in the children's flight down the Ohio River in a small boat. Excerpts from the twenty-four hours are as follows:

LONG SHOT—BOAT AND RIVER
From across the river, near water level, we see the boat settle into its downstream drift. . . . The sun is rising.
TWO-SHOT—JOHN AND PEARL
. . . they are gobbling down berries, and their mouths are stained.
LAP-DISSOLVE TO:
DOWN-SHOT—BOAT AND RIVER—NOON (HELICOPTER)
The water is dazzling silver in noon light; the boat enters the shot at top screen center and leaves at lower screen center. . . .
LAP-DISSOLVE TO:
MEDIUM SHOT—BOAT AND RIVER—POST-SUNSET
We shoot from water level towards the shore and the fallen sun; the boat enters from our right, medium close; it and the children are in near-silhouette.[22]

In *Famous Men*, Agee opens part 3 of "A Country Letter" with words that create a montage of greater scope, one that implicitly sets the tenant families amid vast global currents:

Spired Europe is out, up the middle of her morning, has brought her embossed cities, her front of country snailed with steel;

the Atlantic globe is burnished, ship-crawled, pathed and paved of air, brightens to blind;

shoulder clean shoulder from their hangar, Brazil and Labrador; flash flame;

from stone shore, bluff browed tree, birds are drawn sparkling and each plant: erects upon his root, lifts up his head, accepts once more the summer. (69)

This passage, especially the first two paragraphs, reverberates with the sound of Hart Crane's poetry (*The Bridge*, for example: "And Thee, across the harbor, silver-paced / As though the sun took step of thee").[23] Nevertheless, the literary language carries us with cinematic sweep across Europe, over the Atlantic, down to Brazil, and up to Labrador. The bright, flashing images of cities and ships and countries establish a high, traveling perspective (like the helicopter shot in *Night of the Hunter*'s montage). Although a space separates each paragraph, the reader does not jump suddenly from picture to picture. Agee fashions smooth transitions that suggest dissolves in a film. Semicolons, coupled with unindented paragraphs that do not capitalize initial words, ease us into new visions and maintain the forward flow of the scenes. In the final paragraph, Agee moves from macrocosm to microcosm by descending from his long shots to steadily closer shots of a shore, a tree, birds, and plants bursting through the earth.

In the next lines, which are quoted below, Agee crafts another transition, this time using a colon after the phrase "once more the summer." In effect, he dissolves from plants to human beings rising in the morning. The first line repeats the final words quoted above. Every plant

> erects upon his root, lifts up his head, accepts once more the
> summer:
>
> and so must these: while the glistening land drives east: they
> shall be drawn up like plants with the burden of being upon
> them, their legs heavy, their eyes quiet and sick, the weight of the
> day watching them quietly from the ceiling, in the sharpening
> room. (69)

Agee uses a simile ("they shall be drawn up like plants"), but he goes beyond merely stating a likeness. He dramatizes his comparison of people and plants in striking pictures. Each plant "erects upon his root," and the people rise, "their legs heavy, their eyes quiet and sick." Alongside his verbal device, Agee creates a visual simile of a type used in, for example, *Fury* (MGM, 1936). The film, directed and co-written (with Bartlett Cormack) by Fritz Lang, dissolves from three women

gossiping in a store to a flock of chickens clucking. Lang's dissolve equates the women and hens. Agee's transition makes a poignant contrast. The plants rise with a kind of sexual excitement to accept a season of thriving life. The humans rise in sluggish sickness. Agee's visuals give concrete meaning to his evocative words, "the burden of being upon them."

To describe burdened people rising, Agee uses plurals ("they" and "their"). Yet the imagery is so specific that it is hard not to see a single pair of legs or feet. Naturally, one thinks of a Gudger or a Woods or a Ricketts:

> . . . they will lift; lift—there is no use, no help for it—their legs
> from the bed and their feet to the floor and the height of their
> bodies above their feet and the load above them, and let it settle
> upon the spine, and the width of the somewhat stooped shoul-
> ders, the weight that is not put by. (69)

From those medium close shots of a body getting out of bed and standing to face the day, Agee, in his next words, cuts to a long shot that contains multitudes:

> . . . and are drawn loose from their homes a million upon the
> land, beneath the quietly lifted light, to work. (69)

The jump in scale is startling. Through Agee's cinematic movement, the three tenant families of *Famous Men* become part of a mass, part of the national calamity that is the Great Depression.

For his part, Evans has little interest in placing the tenant families in a large, historical context. In the 1941 edition of *Famous Men*, he includes three photographs beyond pictures of the families and their homes: a street lined with parked cars, a shot of abandoned stores, and a remote building identified as "Mayors [sic] Office."[24] In the 1960 edition, he adds more images of southern life, including African-American men in front of a barbershop and a wider scene of a railroad depot with tracks curving into the distance.[25] For the viewer, who has no idea that the un-captioned pictures range across towns in Alabama and Mississippi, the photographs remain local. It seems that Evans has not strayed far from

the terrain of the tenants. Any social or political ideas are contained implicitly within Evans's specific, concrete images.

The contents page of *Famous Men* identifies Evans's intimate assembly of people and places as "Book One." Agee's expansive text is "Book Two." The titles emphasize how the two books are, to quote Agee again, "mutually independent," each with its distinctive way of seeing the Gudgers, the Ricketts, and the Woods. Ultimately, however, the collision of photographs and words ties the books together, so that the two parts do indeed become "fully collaborative" (viii). Summarizing differences between Evans's still photography and Agee's cinematic writing will help to clarify ways in which the creators complement one another.

Evans remains the outside observer. The viewer stands with him, gazing on faces or rooms or buildings with a calm reserve. Agee, restless and inquisitive, thrusts the reader into fields, into rooms, even into drawers. The reader becomes a firsthand participant in the lives of the tenants, moving through their spaces, seeing what they see. The different viewpoints work together to weave a complex overall picture of the tenant families. The range of perspectives is more revealing than either an entirely external position or a relentlessly interior vision could be.

In his quiet observation, Evans withholds comment. Morris Dickstein points out that the photographer "insistently shoots head on, at chest height or eye level, as if to establish a clear parity between the subject and the viewer."[26] Evans thus allows one to have private interaction with people and places in the photographs and to draw one's own meaning from the pictures. Agee's probing eye and continuous narration analyze the families and interpret the images that he conjures up in his text. The book is that much richer for sometimes leaving the reader to contemplation and at other times bringing in a passionate, provocative guide to the tenants' world.

Evans stays grounded in the specifics of that world. He offers no metaphoric visions or grand overviews of the people or the farms. Agee now and then pulls back to see the people in relation to the land or to place them in a national and, at times, global perspective. Thus one experiences the Depression in an immediate, highly personal way, while also feeling the breadth and depth of the disaster.

The potent synthesis of photographs and words in *Famous Men* becomes all the more evident when viewed alongside the volume *Cotton Tenants: Three Families*, published in 2013. The book prints Agee's original essay about the tenant families, which *Fortune* rejected in 1936. Images selected from a Walker Evans album at the Library of Congress, *Photographs of Cotton Sharecropper Families*, accompany Agee's piece.[27] Sometimes the photographs embedded in the text relate directly to the words that surround them. A photograph of two African-American children staring into the camera, for example, is included in an appendix titled "On Negroes."[28] At other times, the photographs have no explicit connection to the immediate text. A shot looking into a kitchen is inserted between pages describing Allie Mae Fields.[29] The interior of a church appears amid descriptions of the Tingle children.[30] (Agee's original piece uses the actual names of the families: Fields, Tingle, and Burroughs. In *Famous Men*, Agee renames them Woods, Ricketts, and Gudger.)[31] At least once, image and text are juxtaposed to create the sort of dual vision—intimate and expansive—that one finds in *Famous Men*: Floyd Burroughs' work shoes appear beside Agee's broad discussion of a "civilization which . . . puts a human life at a disadvantage."[32] For the most part, however, the pictures and the words collaborate only in the sense that they both document the lives of cotton tenants. In the end, the book presents a fine piece of journalism periodically interrupted by fine photographs.

Agee's more straightforward journalistic approach to his subject in *Cotton Tenants* further underscores the complexity of *Famous Men*. Agee probes very little into the nature of his assignment, does not swivel from one literary form to another, and never pushes his prose into the realm of cinema.

A vibrant description of the landscape in *Cotton Tenants*, for example, does not suggest a tracking shot: "About in the middle of its land as among tough distorted petals the Burroughs house stands, about halfway down one hill, facing across its bare stumpy yard (in which blooms one small pink planted flower) that westward face of the hill which smothers in woods and ends in the wandering of a coffee-colored and malarious creek."[33] (Compare that passage to the more active descriptions in *Famous Men* quoted above on pages 300–302.)

In chapter 2 of *Cotton Tenants*, "Shelter," Agee describes objects on a wall and on pieces of furniture, but he keeps the images in one long paragraph, thus minimizing a sense of camera movement or film editing, and he concludes with commentary in a literary vein. Compare the following with the multiple paragraphs in *Famous Men* quoted above on pages 303–304:

> A tinted photograph of a neat, new-overalled, clean country boy fishing. Title: Fishin.' Torn from a child's book, costume pictures in furry colors. . . . Slung by its chain from a nail: a cheap locket depicting Jesus Christ and the Blessed Virgin, with their respective hearts exposed. . . . On a table: a green glass bowl in which sits a white glass swan. On the dresser: a broken china rabbit; a china bulldog and litter of china pups—Lucile was given them last Christmas. . . . For one of the mantels Mrs. Burroughs designed out of white tissue one of those scissored stretches of paper lace which children so enjoy making. But she has just about given up trying to make the house pretty.[34]

Agee also describes Allie Mae Fields' clothes, while at the same time commenting on her demeanor, in a single paragraph and not in a series of one-line cinematic images. See above, page 306, to compare the picture of Mrs. Gudger in *Famous Men* with the following observations:

> Her dress, whichever one it may be, began as a cheap cotton print for best and has been washed, worn, sunned, and sweated into something more faint and sad and finelooking. . . . For town or Sunday, she puts on, newlaundered, one of the two or three dresses she would conceivably wear except at home; a fragile lavender straw hat, small and misshapen and worn on her shy graven head with sorrowful, clumsy, and ridiculous grace; black flatheeled slippers; and sometimes cotton stockings.[35]

In the years following *Fortune*'s rejection of "Cotton Tenants," Agee came to believe that words were not enough to tell the truth about "North

American cotton tenantry as examined in the daily living of three representative white tenant families" (viii). At the same time, he enlarged his sense of what words can achieve. *Let Us Now Praise Famous Men* evolved from that contradiction. Although he says in his preface that "the immediate instruments" for the Agee-Evans examination "are two: the motionless camera, and the printed word" (viii), Agee generates so many types of language in *Famous Men* that one might say his "printed word" subdivides into several instruments, not the least of which is a motion-picture camera. As Agee expanded his conception of "Cotton Tenants" (the "limited" story of his original essay, for example, became an "inquiry into certain normal predicaments of human divinity"),[36] he liberated his language from the confines of magazine journalism and sent his words tracking, panning, tilting, and cutting from image to image. Together with Evans's still photographs, Agee's exuberant pictures in motion help to project the many-sided views of the tenant families and their world that are the very core of *Famous Men.*

Postscript: The Vertov Connection

This addendum is related to Agee's creation of film devices in that it suggests another way in which cinematic ideas inform *Famous Men*. The concept of montage is not the only idea from Russian film history embedded in the book. Agee's text has a kinship with the theory and practice of the documentary filmmaker Dziga Vertov. In the 1920s, Vertov (born Denis Kaufman) was the spokesperson for a group of filmmakers that included his wife and editor, Elizaveta Svilova, and his brother and cameraman, Mikhail Kaufman. He called the group *Kinoglaz* ["Kino-eye" or "Cinema-eye"], which also became the term for his theoretical method.[37] It should be understood that Vertov, as he explains in titles at the start of his film *Man with a Movie Camera* (VUFKU, 1929), is interested in "creating a truly international absolute language of Cinema based on its total separation from the language of Theatre and Literature."[38] There is a certain irony in linking his techniques to Agee's literary production. Yet parallels between Vertov and Agee in their approach to documentary are striking.

"The weakness of the human eye is manifest," Vertov says in a 1923 manifesto for his group. "We affirm the kino-eye with its own dimensions of time and space."[39] The kino-eye achieves truth deeper than that seen by the human eye, a truth "through the means and possibilities of film-eye, i.e., *kinopravda* ['film-truth']."[40]

Agee almost sounds like a member of Vertov's group when he refers to the camera as "an ice-cold, some ways limited, some ways more capable, eye." The camera is "like the phonograph record and like scientific instruments and unlike any leverage of art, incapable of recording anything but absolute, dry truth" (189). (This quotation puts words cited at the start of the essay in their full context.) Agee's fascination with film suggests that the word "camera" in his pronouncement is not limited to still photography.

In notes for an article not published in his lifetime, Vertov develops his ideas: "Kino-eye makes use of every possible kind of shooting technique: acceleration, microscopy, reverse action, animation, camera movement, the use of the most unexpected foreshortenings—all these we consider to be not trick effects but normal methods to be fully used."[41] Many of these effects, and more, are on display in *Man with a Movie Camera*, the quintessential Vertov film. To record events during a day in a city's life, Vertov uses such devices as a split screen, superimpositions, unusual camera angles, and erratic camera movements (swaying, handheld shots in a beer hall create a drunken effect). His cinematic manipulations probe and analyze the nature of reality and allow the viewer to see everyday events in new ways.

Agee's text for *Famous Men*, which seems capable of holding, to use Vertov's words, "every possible kind" of literary technique, shares the spirit of kino-eye. Agee moves easily from analytic prose to bursts of cinematic imagery, and he readily shifts from a lyrical style to matter-of-fact description or from narrative scenes to a listing of objects in a drawer so that he can view the tenant families from various unexpected angles. Like Vertov, Agee embraces experimental techniques as something more than "trick effects." For example, on page 67 he interrupts Annie Mae's inner monologue with these marks:

((?)) :)

This is not arbitrary play with punctuation. As Paula Rabinowitz says, the marks indicate "sonic rhythms, the anguish of unfulfilled desire, . . . charting what cannot be said, absence."[42]

Vertov's *Man with a Camera* is as much about the nature of film as it is about life in a Russian city. His cinematic devices do not let us sit back comfortably and watch scenes of daily life pass by. We never forget that we are watching a film. At times, Vertov literally thrusts the camera at the viewer. He also shows the cameraman at work in many of the sequences. An editor onscreen cuts the very film we are watching. We look at frames on a strip of *Man with a Movie Camera*—still images of children laughing—and then the children are in motion, and we understand that our cinematic "reality" is mere optical illusion.

Agee, with his stylistic shifts and play with language, also calls attention to his text as text. He, too, lays bare the mechanics of creation. Throughout the book, alongside the tenant families, we see James Agee the writer. In a section titled "Intermission: Conversation in the Lobby," Agee even includes his replies to a questionnaire from *Partisan Review* on "Some Questions Which Face American Writers Today" (283–90).

A contrast in tone between Vertov's reflexive imagery and Agee's reflexive words is worth noting. Vertov is witty and playful. Shortly before the drunken camerawork mentioned above, the cameraman rises up out of a glass of beer. Near the end of the film, a camera tripod, through the use of stop-motion cinematography, walks into the frame and takes a bow. Agee reflects on (or rather, agonizes over) the nature of his book and the difficulty of writing about the tenant families. "It seems to me curious, not to say obscene and thoroughly terrifying," he says, "to pry intimately into the lives of an undefended and appallingly damaged group of human beings" (7). In a long rumination on language and truth, he tells the reader, "Make no mistake in this, though: I am under no illusion that I am wringing this piece of experience dry" (195). Still, differences in tone aside, Vertov and Agee are both intent on being truthful about the process by which they arrive at a true picture of the subject at hand.

It may well be, however, that Agee never consciously modeled his work on Vertov's ideas. Agee does not mention Vertov in his film reviews, though he speaks highly of other Russian filmmakers. "Men like

Eisenstein, Dovzhenko and Pudovkin," he believes, made "some of the greatest works of art of this century."[43] Dovzhenko and Eisenstein are also mentioned in *Famous Men*, during a satirical diatribe about the trivialization of art: "Dovschenko's *Frontier* is disliked by those who demand that it fit the Eisenstein esthetic" (12). Agee was a friend of the preeminent Russian film historian Jay Leyda. Although *Man with a Movie Camera* was not readily available in the West for decades, Leyda writes of seeing the film at the Museum of Modern Art in 1930 and being dazzled by it.[44] According to Laurence Bergreen, Leyda and Agee screened Russian films together at the Museum of Modern Art.[45] It is at least possible that the two of them watched Vertov's work.

Famous Men, as William Stott explains in convincing detail, has little in common with other documentary writing of the 1930s.[46] Agee's language and form have been tied to diverse literary forebears, but his text also resonates with ideas from 1920s documentary cinema.[47] John Wranovics, author of *Chaplin and Agee*, points out that "Agee envisioned [*Famous Men*] as a literary analogue to a documentary film, its images provided by Evans."[48] The main section of the present essay, however, suggests that Agee, too, crafts film images for the book. Examining his motion-picture devices, not to mention the entire text of *Famous Men*, through Vertov's kino-eye truly highlights the pervasive force of Agee's cinematic instincts and affords a fresh perspective on the all-encompassing method that Agee employs to document as fully as possible the lives of three tenant families in Depression America.

NOTES

1. James Agee and Walker Evans, Let Us Now Praise Famous Men: *An Annotated Edition of the James Agee-Walker Evans Classic, with Supplementary Manuscripts*, ed. Hugh Davis, vol. 3 of *The Works of James Agee*, gen. eds. Michael A. Lofaro and Hugh Davis (Knoxville: U of Tennessee P, 2015) 11. Subsequent references to this edition will be noted parenthetically in the text, and abbreviated in the notes as Davis, *LUNPFM*.

2. John Dos Passos, *U.S.A.* (New York: Modern Library, 1937). Linda Wagner-Martin states that Agee's text draws on "devices and themes from the high-modernist experimentation" of Dos Passos (as well as William Faulkner and Thomas Wolfe). Linda Wagner-Martin, *"Let Us Now Praise Famous Men*—and Women: Agee's

Absorption in the Sexual," *James Agee: Reconsiderations*, ed. Michael A. Lofaro, Tennessee Studies in Literature 33 (Knoxville: U of Tennessee P, 1995) 44.

3. Dos Passos, *The 42nd Parallel*, vol. 1, *U.S.A.*, 303.

4. James Agee, "Notes for a Moving Picture: the House," *New Letters in America*, ed. Horace Gregory (New York: Norton, 1937) 37–55, rpt. in *The Collected Short Prose of James Agee*, ed. Robert Fitzgerald (Boston: Houghton Mifflin, 1968) 149–73; James Agee, "Man's Fate," *Films: A Quarterly of Discussion and Analysis* 1.1 (Nov. 1939): 51–60, rpt. in *Collected Short Prose* 203–17; André Malraux, *Man's Fate* (*La condition humaine*), trans. Haakon M. Chevalier (New York: Modern Library, 1934).

5. Tom Dardis, *Some Time in the Sun* (New York: Scribner's, 1976) 225. In 1946, Agee published another "closet drama" treatment called "Dedication Day" in *Politics* 3 (Apr. 1946): 121–25, rpt. in *Collected Short Prose* 103–17.

6. "Bloodline," typescript, MS-2730, Box 8, Folder 9, James Agee and James Agee Trust Collection, Special Collections Library, University of Tennessee (hereafter cited as Special Collections).

7. Agee, "Notes for a Moving Picture" 37.

8. Agee, "Man's Fate" 60. Among Eisenstein's landmark films are *Battleship Potemkin* (Goskino, 1925), *October* (Sovkino, 1928), and *Alexander Nevsky* (Mosfilm, 1938). Dovzhenko's films include *Arsenal* (VUFKU, 1929), *Earth* (VUFKU, 1930), and *Frontier* (GUKF, 1935).

9. Agee, "Man's Fate" 51.

10. Caroline Blinder, "Animating the Gudgers: On the Problems of a Cinematic Aesthetic in *Let Us Now Praise Famous Men*," *New Critical Essays on James Agee and Walker Evans: Perspectives on* Let Us Now Praise Famous Men, ed. Caroline Blinder (New York: Palgrave Macmillan, 2010) 145.

11. *The Blue Hotel*, adapted from the short story by Stephen Crane, was written for Huntington Hartford. The script was never produced, though it was eventually adapted by Joseph Hurley for a half-hour episode of the television program *Omnibus*, directed by Fred Carney, ABC, 25 Nov. 1956.

12. James Agee, "The Night of the Hunter," typescript of first-draft screenplay, 1954, MS-2730, Box 4, Folder 29, Special Collections; Davis Grubb, *The Night of the Hunter* (New York: Harper, 1953). The film, *The Night of the Hunter*, directed by Charles Laughton, was released by United Artists in 1955.

13. Agee, "Night of the Hunter" 209–10.

14. The words are from Lear's speech to Edgar, disguised as poor Tom the madman (3.4.97–99): "Ha! Here's three on 's are sophisticated; thou art the thing itself. Unaccommodated man is no more but such a poor, bare, forked animal as thou art." William Shakespeare, *King Lear*, ed. Claire McEachern (New York: Pearson, Longman, 2005). The passage is in the same scene as Lear's "Poor naked wretches" speech, which Agee uses as the first of three epigraphs in *Famous Men*.

15. The photograph is number 15 in the 1960 edition: "Lucille Burroughs Picking Cotton." Davis, *LUNPFM* 951–53, includes a comparative chart of photographs that appeared in the 1941 and 1960 editions of the book.

16. All three photographs mentioned in this paragraph are from the 1960 edition. The school photograph is number 58, "Glean Hill School, Alabama." The boots are number 14, "Floyd Burroughs' Work Shoes." The mother and child are number 16, "Mrs. Burroughs Takes in the Milk."

17. This photograph, "Fireplace and Wall Detail in Bedroom of Floyd Burroughs' Cabin," is number 8 in the 1941 edition and number 9 in 1960.

18. James Agee, *The Night of the Hunter*, in *Agee on Film*, vol. 2, *Five Film Scripts by James Agee* (New York: McDowell, 1960) 327. Although director Charles Laughton did not take a screen credit, he was deeply involved in the creation of the shooting script. For a detailed discussion of the Agee-Laughton collaboration, see Jeffrey Couchman, *"The Night of the Hunter": A Biography of a Film* (Evanston: Northwestern UP, 2009) 72–97.

19. Jay Leyda, ed., *Eisenstein: Three Films*, trans. Diana Matias (New York: Harper, 1974) 23. For simplicity, shot numbers that appear along the left margin have been left off. The shots listed are 64–71. To read a detailed explanation of montage and various ways in which shots can collide, see Sergei Eisenstein, *Film Form: Essays in Film Theory*, ed. and trans. Jay Leyda (New York: Harcourt, Harvest, 1949) 45–83.

20. William Stott, *Documentary Expression and Thirties America* (New York: Oxford UP, 1973) 268–69.

21. Alan Trachtenberg, "Walker Evans's Contrapuntal Design: The Sequences of Photographs in the First and Second Editions of *Let Us Now Praise Famous Men*," in Blinder, *New Critical Essays* 74.

22. Agee, "Night of the Hunter" 197–98.

23. Hart Crane, *The Bridge* (1933; New York: Liveright, 1970) 1.

24. The photographs are number 29, "County Seat of Hale County (Greensboro, Alabama)," number 30, "Abandoned Stores, Advance, Alabama," and number 31, "Moundville, Alabama, Mayor's Office."

25. The men outside the barbershop are number 55, "Sidewalk in Vicksburg, Mississippi." The depot is number 59, "Railroad Station, Edwards, Mississippi."

26. Morris Dickstein, *Dancing in the Dark: A Cultural History of the Great Depression* (New York: Norton, 2009) 101.

27. James Agee and Walker Evans, *Cotton Tenants: Three Families*, ed. John Summers (Brooklyn, NY: Melville House, 2013). Davis prints Agee's eighty-eight-page typescript of "Cotton Tenants" in appendix 2, *LUNPFM* 565–646.

28. Agee and Evans, *Cotton Tenants* 208. The photograph is captioned "Negro Children."

29. *Cotton Tenants* 61–63. The photograph is captioned "Part of the Kitchen."

30. *Cotton Tenants* 54–56. The church photograph is uncaptioned.

31. Davis includes a comparative list of names in appendix 1,"Changes of Names of People and Places," *LUNPFM* 561–63.

32. *Cotton Tenants* 34–35. The photograph is captioned "Burroughs' Work Shoes."

33. *Cotton Tenants* 68.

34. *Cotton Tenants* 76–77.

35. *Cotton Tenants* 107, 116. The description of Allie Mae is interrupted by eight pages of photographs, which include family portraits, Bud Fields' house, and rows of Burroughs' cotton.

36. *Cotton Tenants* 37; Davis, *LUNPFM* viii.

37. Annette Michelson, ed., *Kino-Eye: The Writings of Dziga Vertov*, trans. Kevin O'Brien (Berkeley: UP of California, 1984) 5, 12.

38. Dziga Vertov, *Man with a Movie Camera*, 1929, DVD, Kino, 2003.

39. Michelson 16.

40. Michelson 41.

41. Michelson 88.

42. Paula Rabinowitz, "'Two Prickes': the Colon as Practice," in Blinder, *New Critical Essays* 127.

43. James Agee, *Agee on Film: Criticism and Comment on the Movies* (1958; New York: Random House, Modern Library, 2000) 185. The first name in the list quoted is printed "Einstein," but clearly "Eisenstein" is intended. See note 8 for information about Dovzhenko. The third filmmaker mentioned is Vsevolod Pudovkin, who directed such films as *Mother* (Mezhrabpom-Rus, 1926), *The End of St. Petersburg* (Mezhrabpom-Rus, 1927), and *Storm over Asia* (Mezhrabpomfilm, 1928). Tom Dardis has an interesting discussion about Dovzhenko's importance to Agee and his influence on Agee's screenwriting (223–24).

44. Michelson xxii; Jay Leyda, *Kino: A History of the Russian and Soviet Film*, 3rd ed. (Princeton: Princeton UP, 1983) 251–52.

45. Laurence Bergreen, *James Agee: A Life* (New York: Dutton, 1984) 181.

46. Stott 290–314.

47. David Madden points to one literary ancestor when he writes, "Some readers call *Let Us Now Praise Famous Men* the *Moby-Dick* of nonfiction." See David Madden, "The Test of a First-Rate Intelligence: Agee and the Cruel Radiance of What Is," in Lofaro, *James Agee: Reconsiderations* 35. James Ward Lee lists other influences: "I recognize all the echoes of Hopkins, Blake, e. e. cummings, Archibald MacLeish, Faulkner, Joyce—all the Modernist gods." See comments of James Ward Lee, "*Let Us Now Praise Famous Men* Panel," *Remembering James Agee*, eds. David Madden and Jeffrey J. Folks, 2nd ed. (Athens: UP of Georgia, 1997) 109.

48. John Wranovics, *Chaplin and Agee: The Untold Story of the Tramp, the Writer, and the Lost Screenplay* (New York: Palgrave, 2005) xxviii.

"James with the Ironically Titled 'LUNPFM'"

Paul Ashdown

A syndicated crossword puzzle clue appeared in the *Village Voice* and other publications on December 23, 2013: *James with the ironically titled "LUNPFM."* The timing of the clue suggests the puzzle's author was familiar with *Cotton Tenants: Three Families*, the original *Fortune* article that evolved into *Let Us Now Praise Famous Men*, or, evidently to those in the know, *LUNPFM*. With the article's appearance in book form in May of 2013, Agee had renewed currency three years before the seventy-fifth anniversary of *Famous Men*'s publication.[1]

The clue alludes to a conventional interpretation of the title and book. Biographer Laurence Bergreen said Agee chose the title "to emphasize with savage irony the obscurity of the three families about which he had written." Malcolm Jones, reviewing *Cotton Tenants: Three Families*, expanded on this interpretation: "When Agee chose his book's title from a passage in the *Apocrypha*, he was being ironic, since his subjects—Alabama tenant farmers—were not only not famous but ignored, neglected, marginalized, and scorned by the rest of the nation."[2]

Jones added: "Sometimes irony breeds upon itself, and this is one of those instances." The tenants had achieved "ironic immortality," becoming icons not only of the Depression, but also of the whole idea of poverty in America. Few places in the United States have been "more pawed over" or "fired more imaginations" than rural Hale County, Alabama, a county of about 25,000 residents in 1936. What could be more ironic? Jones might have noted that much ruminating about that "pawed over" place occurred in Frenchtown, New Jersey, where Agee wrote much of *Famous Men* in 1938.[3]

The Mists of Irony

But what do we mean by irony? And what did Agee mean? D. C. Muecke, a noted Australian scholar of "ironology," warned that attempting to understand irony is like trying to gather mist. Irony is "elusively Protean" and constantly evolving. Definitions, accordingly, abound, ever more specialized. At its most elemental irony involves "the art of saying something without really saying it," and "a contrast of 'appearance' and 'reality.'" In an essay about *Famous Men*, Jeanne Follansbee Quinn offered this definition:

> Irony describes a doubleness in which what is said diverges from
> what is meant, creating a tension that communicates information
> and, more importantly, an attitude toward its subject. Because it
> depends on recognizing the difference between what is said and
> what is meant, irony requires a context in which readers interpret
> and impute ironic meaning.[4]

Agee was aware of irony from an early age. He described his first school friends as "ironic, intelligent, 'pariah' types." At seventeen, he praised author Robert Nathan's "irony tempered with compassion" in a review of the novel *The Fiddler in Barly* published in the *Phillips Exeter Monthly*. "He never dissects a soul, with the cold detachment of, say Sinclair Lewis; rather, he sits patiently, and watches that soul unfold like a flower," Agee wrote. Beginning at Exeter, and continuing during his years at Harvard, Agee wrote most of the often ironic poems published in *Permit Me Voyage* in 1934. As editor of a *Harvard Advocate* parody of *Time* in 1932, Agee spoofed the news magazine's faux Latinate style and its brisk, fact-crammed, authoritative sections assembled by editors rewriting newspaper articles mined for rich, albeit inconsequential, detail processed into compelling stories. Newsmakers were physically described through clever compound adjectives inspired by the *Iliad*. The editorial artifice condensed information while appearing to give it meaning and relevance for the middle-class, Philistine reader through omniscience. The overall tone could be harsh, sneering, even caustically ironic. The parody included a mock review of *De Bello Gallico* in the *Time* style: "Oldish, bald, determined, Julius Caesar, well known world

traveler and all around army man, now number one Gaulman, has entered the literary lists with a first book."[5]

In a *Harvard Advocate* review of T. S. Matthews's account of the Judd Gray-Ruth Snyder murder case, a tabloid sensation of the 1920s, Agee said Matthews had written an earnest American tragedy "with full literary consciousness," and with "the courage to keep the language completely dull," by using the "barren idiom and vocabulary" of Gray's journal, a style devoid of wit, beauty, or irony. In contrast, Ring Lardner, a writer of idiom, had "never employed the language in the narration of pure tragedy, tragedy cleansed of all satiric, ironic, or humorous tarnish." Rather, he "connects tragic irony and insane humor; and he is savagely *un*-literary."[6]

In 1936, soon after *Fortune* assigned him the story that became *Famous Men*, Agee told Father James Flye that he found Franz Kafka's *The Castle* "full of terrific ambiguities and half-lights, a certain amount also of irony, but on the whole very far above [*sic*. the] altitude of irony." A year later, having read Ambrose Bierce's *The Devil's Dictionary*, he wrote Father Flye: "Irony and savage anger and even certain planes of cynicism are, used right, nearly as good instruments and weapons as love, and not by any means incompatible with it; good lens-wipers and good auxiliaries."[7]

In 1939, commenting favorably on the article "Snobbery on the Left" by historian Dixon Wecter in an issue of the *Atlantic Monthly* sent by Father Flye, Agee added his own criticism to the ironic use of ambiguous words. "What hell is worked, for instance, under banner of such words as 'love,' 'loyalty,' 'honesty,' 'duty,' and their opposites; what are the different meanings of the word 'pride'; which seem most destructive of evil and why and how; which may not be; which are not; which are 'obligatory,' 'constructive,' and for 'good?'" He replied to a letter from Father Flye regarding certain "offending words or phrases" from the *Famous Men* manuscript. Agee then was in strained discussions with Harper & Brothers, which had declined to publish *Famous Men* unless Agee removed some language the publisher considered obscene. Agee felt it possible "to be quite as foul mouthed using a euphemism or an aseptic or so called scientific word as the word in general vulgar or forbidden use. . . . It is not a restoration of words of themselves I care for but a restoration of

attitudes or 'philosophy' of which all words are gruesomely accurate betrayals." He plead guilty to "a variable and at times very coarse taste or judgment," but said he could not recall "having groogled or leered or smirked since I was in the cheap-irony stage at about fifteen."[8]

Incontinent Irony

This "cheap-irony stage" probably owed something to those "ironic, intelligent, 'pariah' types" Agee said were his first friends. Muecke identified "schoolboy sarcasm" as one expression of youthful irony. Agee saw something more when he reviewed A. E. Housman's *A Shropshire Lad* for *Time*. He said Housman never outgrew his adolescence in his work. "At their weakest, his emotions had the innocent, arrogant self-pity, the horribly magnanimous sentimentality, the incontinent irony, of which extreme youth is capable."[9]

Agee's own incontinent irony, self-pity, and sentimentality was on full display in the letters he wrote to Father Flye during the time he was working on *Famous Men*. He wrote that the book was "all done but a few pages, which I'm finishing a great deal too slowly. I feel almost nothing about it, pro or con, except a wish to be done with it, a sense of serious gaps in it, and a knowledge that it is 'sincere' and that I made no attempt to take an easy way on it. But so much more is clear or pretty clear in the head that becomes weak and confused when I try to write it." He was "full of a good many kinds of anxieties . . . pulled apart between them so that I'm seldom good for much." A few months later he felt "cold, sick, vindictive, powerless and guilty against the world." He conveyed an ambivalence toward the project, writing that "between the wish to take vengeance on myself and on 'Harpers' and 'the world,' and the wish to do the best I can, and feelings of hopeless coldness and incompetence, I can't even feel much anger, far less anything better."[10]

In another letter he described how his lack of self-discipline, his melancholia, his "habit of thinking emotionally, and its alternative *accidia* (all these doubtless interactive) makes a fair amount of my living numb and a certain amount of it hell." He earlier had said he felt he was "disintegrating and 'growing up,' whatever that means, simultaneously, and

that there is a race or bloody grappling going on between the two in my head and solar plexus." If Housman was prone to "incontinent irony" by Agee's lights, then so was Agee himself.[11]

Journalism and Irony

Agee's attack on journalism in *Famous Men* was directed at its presumptions, including its abuse of irony. He scorned journalism's complacency and its shallowness. Its "primal cliché," he said, was that answers to the traditional questions introduced by the journalist's who, what, when, where, why, and how could not convey "more than the slightest fraction of what any even moderately reflective and sensitive person would mean and intend by those inachievable words, and that fraction itself I have never seen clean of one or another degree of patent, to say nothing of essential, falsehood." Journalism, he claimed, was inherently dishonest, "a broad and successful form of lying." Misplaced irony was part of the deception. Agee's article on the tenant farmers was to have been part of *Fortune*'s Life and Circumstances series. A previous article in the series—not by Agee—had featured Gerald Corkum, a paint sprayman at an auto plant who was a working-class "Success Story" as evidenced by an ironic photo of "The Corkum Library," a newspaper, magazine and a dictionary, on a living room table.[12]

Journalists, according to Muecke, are inclined to find irony in "coincidences or when there is a very small margin between success and failure in a matter of great moment." Philip Howard, a London *Times* reporter and editor writing about troublesome words, chided dilatory journalists desperate to find compelling beginnings and angles to their articles. *Ironically* is used incorrectly to mean a coincidence or curiosity, "an all-purpose introductory word to draw attention to every trivial oddity, and often to no oddity at all." So, for example, it is just a coincidence, and not ironic, that the city mayor died on his birthday, but it is whimsically ironic that a church in the city caught fire during a "burning of the mortgage" ceremony, or that the police chief's car was stolen as he was giving a speech boasting that crime was on the wane. Journalistic irony "generally serves for sarcasm or ridicule, in which laudatory expressions

in fact imply condemnation or contempt," according to Howard, and is aimed at "an imagined exclusive inner circle who are in the joke, while profane outsiders who are being mocked are mystified."[13]

After the publication of *Famous Men* in 1941, Agee wrote a letter to *New York Times* critic Ralph Thompson taking exception to Thompson's review of the book. He said the review showed the "journalist's-malice-aforethought." He objected to Thompson's referring to him as "Harvard-bred," an ostensibly laudatory descriptor Agee said was "used with a skilful journalist's pleasure in tilting words to discolor, yet stay safely within purely factual, legal truth." He chided the writer for his "smooth, misrepresenting tricks."[14]

In his own journalism Agee sometimes commented on the use of irony by others in politics, business, culture, and other journalism. He noted in an early *Fortune* article that a charity event for servants hosted by their carriage trade employers had been ridiculed in the press as "the Butlers' Ball." In "U.S. Ambassadors," also written for *Fortune*, he observed that President Franklin Roosevelt was a man of daring "mixed with humor and with irony," and the idea of appointing Jesse Isidor Straus as ambassador to Germany, "which would have been in itself a daring and ironical statement of U.S. opinion of Nazi Germany—could very well have been among his thoughts." Straus, the president of R. H. Macy & Co., and a Roosevelt campaign booster, was appointed ambassador to France, however.[15]

Agee could sometimes use irony to good effect. In writing an obituary of Henry Ford for *Time*, Agee saw his subject's Puritan disdain for luxury and beauty to be at odds with his creation, the Model T Ford. "That it has, incidentally, a unique kind of ugly beauty beside which the would-be beauties of most other cars are shown up as the silliest kind of ostentation, is an irony which doubtless Mr. Ford never intended," but which Agee relished. He noticed that Ford's body was taken to the cemetery in a Packard hearse rather than one of his company's own vehicles. He wrote a *Time* article about a "vanity press" publisher so unscrupulous that he "even published one man's book on how to make money as an author." In another *Time* article, Agee reported that a Long Island library asked "informed people" to list of the "most influential" books of the last half century, indicating he doubted the judges were informed

or the selections important. The first peaceful autumn in Europe after the Second World War was also "the first autumn of the atomic age," he pointed out in a *Time* news roundup, having warned two months earlier that the bomb "rendered all decisions made so far, at Yalta and at Potsdam, mere trivial dams across tributary rivulets."[16]

By the time Agee was writing what would become *Famous Men* after he returned to New York from Alabama in 1936, he had started to recoil from cheap irony and journalism, when he found it used to patronize the poor and titillate the voyeur. This attitude is most evident in several book reviews Agee wrote for the Marxist journal *New Masses*. The first was a review of Herbert Asbury's *The French Quarter*. Asbury had written sensational exposes for H. L. Mencken's *American Mercury*, the *New York Herald,* and the *New York Tribune* in the 1920s and then published true crime books such as *Gangs of New York: An Informal History of the Underworld* in the 1930s, all in what Agee called "the tradition of the mid-twenties liberal literary journalist."[17]

Agee suspected Asbury enjoyed gawking at the New Orleans demimonde as would readers "to whom 'slums' mean 'low-life,' and to whom 'slums' and 'low-life,' particularly of the past (which somehow is always more 'picturesque' and 'colorful' than the present) are 'amusing' or even 'fascinating'; who relish synonyms like bagnio, bordello, etc.; and such wordage as 'a troupe of ten exquisite strumpets.'" They would find vicarious delight in reading "'case histories' of prostitutes who happened to be especially 'colorful,'" and the feeling of being "in the know as they read in some detail of the intimate relationships between vice and municipal politics." The "facts" in the fact-laden book, however, were not worth the trouble, even to the intended readership, "a subsection of the sub-intellectuals of the middle class which is conditioned to enjoy what it offers and which is still numerous enough to support it," the same audience Agee derides so thoroughly in *Famous Men*.[18]

Agee said readers of the novel *Black Earth* by Louis Cochrane would get a detailed

> picture of one of the more 'upright' and 'respectable' types of
> white sharecropper families—a family half sucked into the self-
> deceptions of the class next above it. You will get something of

their house and its furnishings, something of their relationships, of the struggle between generations, something of the vacuum into which they are thrust by poverty and exploitation. You will also get the perspective of the town where their landlord lives; and something of the true nature of their relationship with this 'good' type of landlord.

Even more revealing was the "painful conviction that grows on you that nearly everything he writes of has actually happened," after which "the whole account takes on a new and really large value; you sit in on the trouble, and a whole year's life, of a family you would probably care to know all you can about." The review included some of the same criticism Agee in *Famous Men* leveled against Erskine Caldwell and Margaret Bourke-White's *You Have Seen Their Faces*, an earlier photojournalistic book on tenant farming.[19]

His challenge in *Famous Men* was to strip away the filter of both fiction and duplicitous journalism to show that what "actually happened" happened, and that the sharecropper "exists, in actual being, as you do and as I do, and as no character of the imagination can possibly exist." And not just as "respectable" subject matter you might care to know about, but also "an undefended and appallingly damaged group of human beings, an ignorant and helpless rural family." Journalism, even with all its limitations, at least affirmed that a sharecropper like George Gudger "is exactly, down to the last inch and instant, who, what, where, when and why he is . . . flesh and blood and breathing, in an actual part of a world in which also, quite as irrelevant to imagination, you and I are living."[20]

Irony in Famous Men

The assumption that Agee intended an ironic title conditions our reading of *Famous Men*. John Hersey's introduction to a new edition of *Famous Men* in 1988 claimed the "children" of the 1960s who discovered the book during the civil rights and antiwar movements were "delicately tuned to Agee's irony and idealism and guilt." What kind of irony were

they tuned to, and what were its limits? Was the text ironic as well as the title?[21]

Agee had planned to use the title for an earlier manuscript, a long short story, subsequently lost, that he described in his October 1932 application for a Guggenheim Fellowship. The story contained what he called "a verse passacaglia," perhaps an experiment in repetition and variation of a theme, anticipating some of the structure of *Famous Men*. He used a verse taken from Psalm 126 for another early story, *They That Sow in Sorrow Shall Reap*, and occasionally derived titles and epigraphs from carols, psalms, prayers, poems, and popular lyrics in his journalism, scripts, and poetry. Of *Famous Men's* title he said little, except to write his friend Robert Fitzgerald opaquely in December 1940 that he did "thoroughly regret using the subtitle [*Famous Men*] as I should never have forgotten I would." In the book, he said the "subtitle" was actually the title of the first volume of a larger, multivolume work to be called *Three Tenant Families*. But "further work as may be done" was a "deception," permitting "prominence to the immediate, instead of the generic, title." *Cotton Tenants: Three Families* may be part of the "generic" work Agee never completed.[22]

Agee's use and awareness of irony in *Famous Men* is complex. In the "Work" section, he describes the sharecropper family as a "force, without irony," existing for work. He details the relationship he and Evans developed with Bud Woods, "the shrewdest and wisest" of the tenants, sharing with him "a reflective and skeptical cast of mind," and given to "long and guarded, ironic yet friendly slowdrawling talks" in which he spoke "seditious truths in naïve elaborations of irony." In the "On the Porch" section, Agee and Evans hear "masterful irony" in the enigmatic orisons of two foxes, who, like "two masked characters" irrelevant to the action on a stage, "had sung, with sinister casualness, what at length turned out to have been the most significant, but most unfathomable, number in the show; and had then in perfect irony and silence withdrawn."[23]

In his notes, drafts and unused chapters, Agee observed that the Burroughs (Gudger) family lacked both humor and irony, although he saw in Hale County "strong knottings of irony, pity and hopelessness. A

particular craziness about the South." In a letter he wrote Evans while he was working on the book in May 1938, Agee said he had done "an entirely different kind of start which I like but which is not good enough and not right: very dense and heavily loaded irony that reads too much like a series of exercises in same. But I have a feeling I'm getting toward a good beginning."[24]

Early in *Famous Men*, Agee used quotation marks as he had in the book reviews and in his letters to Father Flye to signify the irony in such words as "artist," "life," "scientific," "literature," "political," and "religion." He flagged as many as eleven words on a single page to emphasize the incontinent irony in "honest journalism" and other forms of public discourse. Another cluster of such words, "tenant," "farmers," "representatives," "class," "know," "successfully," and "soul," appear later in the book to introduce the section he titles "Colon." Perhaps his sharpest ironic jibe is the epigraph he uses to introduce the "Money" section, quoting Franklin Roosevelt: "You are farmers; I am a farmer myself."[25]

But his general use of irony as "lens-wipers" in *Famous Men* was much more ambitious. Agee used irony to overthrow the documentary and journalistic tropes he questioned in *Fortune* magazine and books like *You Have Seen Their Faces* and *The French Quarter*, although irony rarely overwhelms the text. Jeanne Follansbee Quinn explains in a perceptive study how Agee's romantic irony demanded a self-conscious engagement, an awareness of the presumptions of 1930s documentary realism. Readers were to understand their own complicity in exploiting the sharecroppers by viewing them as passive, sentimental objects rather than subjects with agency. The sharecroppers were not just failed strivers excluded from the middle class, as Caldwell and Bourke-White would have them, nor were they journalistic human interest material to be pitied by voyeuristic readers. They were active, heroic human beings, not social categories. Their few possessions were not without inherent grace and harmony. Agee intentionally destabilized the text to challenge readers to share the limitations and consequences of their engagement with the sharecroppers through a dialectical process grounding an ethical stance. His irony required multiple perspectives, a comparative reading of texts and "things," which he all but hurled at the readers. Understanding the context revealed the "doubleness" of perception.[26]

And how very natural this perspective was for Agee. Those who knew him best, like Robert Fitzgerald, said it became "almost tedious to hear Jim examining all sides of a question, all sides turned out to be unsatisfactory in the end; and they did, of course. He was right." John Huston remembered that in Agee there was a "kind of genius—a dialectic that would discover its point, its purpose. In those long nights of talks you felt that in these conversations there was an attempt on Jim's part to reconcile divergent opinions, to find common ground." Father Flye said Agee "could weigh different angles from which one might view a situation, and say, 'Yes, this is so, but we must take account of this other fact also.' And to some persons he would be exasperating. They would think, Make up your mind and say yes, yes. And he would say, 'Yes, I accept this, but on the other hand there is this that you must be thinking of also.'"[27]

Ecclesiasticus and the Apocrypha

The Apocrypha, the source of the *Famous Men* title phrase, is an anthology of books the early Christian church accepted from the Greek version of the Old Testament, but which had been excluded from the Hebrew canon. Most were written after the last books of the Hebrew Bible and the first writings compiled in the New Testament, thus providing an important junction between the testaments. Ecclesiasticus, the word meaning "church book" in Latin, is called in its complete form The Wisdom of Jesus the Son of Sirach, and is one of the books of the Apocrypha. The work was written in Hebrew by a scribe and teacher called Ben Sira in Jerusalem about 180 BCE, and translated into Greek in 117 BCE. Ben Sira offers practical and spiritual instruction to a student seeking answers to important questions.[28]

As in all translations, the original meaning may be shifted, however slightly, and that is one of the difficulties with the King James translation Agee knew. The line he quotes, the first verse in chapter 44, is *Let us now praise famous men, and our fathers that begat us.* These famous men are identified in the subsequent poetic narrative as wise and venerated rulers and leaders, prophets, poets, and composers, able, wealthy, and peaceful men, "the glory of their times." The famous men are

revisited in a chronological sequence, the generations, or ancestors, of the Jewish people. The phrase translated as famous men in English means, in Hebrew and Syriac, "men of piety," and the sense of the entire line is *Let me now sing the praises of men of piety, of our fathers in their generations.* They are contrasted with forgotten men, who, though having no memorial, nonetheless were merciful, righteous, and pious. Their progeny, therefore, have "a good inheritance," and remain "within the covenant," and "their glory shall not be blotted out."[29]

By quoting the first fourteen verses of chapter 44 at the conclusion of *Famous Men,* Agee ostensibly intends the title as something more than just a conveniently catchy leftover phrase that had been in his mind at least since he contemplated using it as the title of his verse passacaglia. He also quotes the Lord's Prayer, the Beatitudes and some psalms from the *Book of Common Prayer.* It is important to understand Ecclesiasticus as a type of wisdom literature in order to make sense of both the title and the longer excerpt. Such collections of epigrams, maxims, and aphorisms are intended to instruct the young in ethics, communal values, and theological concerns. They are not intentionally ironic, although some phrases have been seen as such.[30]

Church of England theologian William O. E. Oesterley, one of the foremost authorities on Ecclesiasticus, notes its similarity to Proverbs, both books interpreting wisdom broadly to include:

> cunning, craft, caution in word and act, business capacity, aptitude in craftsmanship, cleverness, discernment, self-control, discretion, learning, wise dealing, right living, all culminating in the fear of the Lord. For behind all there is a religious background in so far that every form of wisdom is seen to be a gift of God, varying indeed in content and scope, but yet a divine endowment.... To [Ben Sira] worldly wisdom is the same in kind, only less in degree, as divine wisdom; the indissoluble connection between religion and everyday life is thus assumed, and is illustrated on every page of his book.[31]

This wisdom, however, is presented in a form that expands the earlier recitation of proverbs into what begins to look like an essay written by

a man with "a profound knowledge of human nature" offering a commentary on daily life as he found it, "a wonderfully clear insight into the social conditions of his time." According to Oesterley, Ben Sira anticipates the viewpoint of the Sadducees, the party that later denied the existence of life beyond death, in opposition to the Pharisees, after the Maccabean wars sometime around 125 BCE. Immortality, for Ben Sira, came in being remembered, both for famous men and those "who have no memorial," through their piety and good name.[32]

Agee knew the title phrase *Let us now praise famous men* from his Anglo-Catholic upbringing in Knoxville, his participation in services there at St. John's Episcopal Church, at the St. Andrew's School Chapel near Sewanee, Tennessee, and at the Cowley Monastery in Cambridge, Massachusetts, near the Harvard campus. The All Saints' Day liturgy includes readings from Ecclesiasticus 44:1–15, in his time taken from the Apocrypha in the King James Bible.[33]

All Saints' Day has been celebrated in the Western Christian tradition on November 1 at least since the eighth century, although commemorations of saints and martyrs are much older. All Souls' Day, traditionally observed on November 2, was designated as a day to remember the vast congregation of faithful believers who are "unknown in the wider fellowship of the Church." In the Anglican tradition, All Souls' Day is called the Commemoration of All Faithful Departed. The collect, or prayer, for All Saints' Day encourages the faithful "to follow thy blessed saints in all virtuous and godly living." The reading from Ecclesiasticus is an appropriate text through which to incorporate the spirit of both All Saints' and All Souls' as long as one does not consider the hoped for intercommunion of the living and the dead in Christ to be at odds with Ben Sira's pre-Sadducean denial of immortality, perhaps an ironic juxtaposition.[34]

Robert Coles thought Agee's decision to use *Let Us Now Praise Famous Men* as the primary title rather than *Three Tenant Farmers* was significant because the "reader is told, right off, that he or she must contend with a moral narrative, with a literary sensibility intent on irony, rather than with a more standard sociological study." That might be true if readers knew where the phrase came from and what it meant, and could find their way through the mists of irony. *Apocrypha* means in

Greek, after all, "hidden things." Allie Mae Burroughs, "The Mona Lisa of the Depression," told an interviewer that her son liked *Famous Men* because his father Floyd (George Gudger) was called "famous," which, thanks to Agee and Evans, he and Allie Mae ironically were, but not in quite the way they intended.[35]

Agee's title phrase, without the liturgical and textual context, implied little more than that the sharecroppers were not famous men, and that any "praise" given them would be ironic. Moreover, he warned readers early on that praise given these "famous men" would be shallow and ultimately pointless.

> Wiser and more capable men than I shall ever be have put their findings before you, findings so rich and so full of anger, serenity, murder, healing, truth, and love that it seems incredible the world were not destroyed and fulfilled in the instant, but you are too much for them: the weak in courage are strong in cunning; and one by one, you have absorbed and have captured and dishonored, and have distilled of your deliverers the most ruinous of all your poisons.

The admonition owed less to Ecclesiasticus and more to Jesus's cry, "O Jerusalem, Jerusalem, thou that killest the prophets, and stonest them which are sent unto thee"; Agee listed Jesus, along with William Blake, among the "unpaid agitators" he introduced in his "Persons and Places" section. In Agee's formulation, the "prophets" are tamed, domesticated, or forgotten.[36]

Agee does not describe the sharecroppers as pious, however. In *Cotton Tenants: Three Families*, Agee reported that the sharecroppers in the area could not support a church but sometimes met for hymn singing and preaching in an abandoned shack. While none were "especially religious," they believed in God. Their religion seemed to be based on a fear of death and a primal fear of storms. In *Famous Men*, Agee describes a locket containing an image of the Sacred Heart of Jesus and the Blessed Virgin hanging by a nail in the Gudger home. Agee thought the Protestant Gudgers were unlikely to understand the Catholic iconogra-

phy. Bud Woods "understands the structures and tintings of rationalization in money, sex, language, religion, law, and general social conduct in a sour way." In a footnote, Agee commented on the severe Sunday clothing of "a large class of sober, respectable, pious, mainly middle-aged negroes."[37]

Kimberley Patton has examined the symbolic language Agee used to describe the life of the sharecroppers in religious terms, despite his own ambivalence toward certain Christian doctrines. She views *Famous Men* as "an anguished testimony of religious faith destroyed by unexpected attendance upon the monotonous and soul-wrecking experience of others." She praises the book's "paradoxical marriage of faith and despair, its stark willingness to dwell between contradictory opposites without trying to resolve them," as well as its literary elegance "framing a horrific struggle with theodicy—by remembering the words of the *Book of Common Prayer*." She locates irony in the fragility of the lamp-lit home that shelters the sharecroppers from the dark void that threatens to engulf them like the sea. Their home is afloat on that sea and lifted in consecration, preserving them against the "hostilities of heaven." Even as they are drawn into this sanctuary, however, their security is tenuous, limited by the anarchy of time.[38]

Because Agee took the title and concluding verses from Ecclesiasticus, it is tempting to assume some ironic congruence between *Famous Men* and Ben Sira's Wisdom. But Ben Sira offers advice on such matters as raising children ("He who loves his son will whip him often"); charity ("Do not avert your eyes from the needy"); manners ("Do not interrupt when another is speaking"); hospitality and security ("Do not invite everyone into your home, for many are the tricks of the crafty"); debt ("Whoever builds his house with other people's money is like one who gathers stones for his burial mound"); etiquette ("If you are seated among many persons, do not help yourself before they do"); after-dinner speeches ("Speak, you who are older, for it is your right, but with accurate knowledge, and do not interrupt the music"); and treatment of slaves ("Yoke and thong will bow the neck, and for a wicked slave there are racks and tortures").[39]

The Fabric of the World

Agee and Evans offer no such advice, nor do they have a plan of action or solution for the problem of tenant farming, which shifted risk from capital to labor after the Civil War. Neither could their project address the larger issue, what Agee called "the whole problem and nature of existence," although the noun *existence* or some form of the verb *to exist* occurs eighty-two times in the book. Rather, the work is, in the words of William Stott, "a book of doom and desperate resignation." Coles asserts that Agee had little interest in preaching to others even though *Famous Men* is a self-flagellating moral document. "No one is going to read it and know what is the right thing to do." Agee's many heroes at the end of *Famous Men* are "a small consolation to any social activist or reformer who wants to go *do* something—say, about those awful schools in the South, among other places in this country." Moreover, Agee questions again and again what right any "reformer," especially the authors, have to interfere. Agee's original manuscript, *Cotton Tenants: Three Families*, was a more explicit brief for the reform of a structural economic and social problem, but not *Famous Men*. Agee is a preacher in the former, a prophet in the latter.[40]

Coles sees that much of Agee's skepticism about reformers in *Famous Men* places him and Evans among those

> who struggle with ironies and paradoxes galore, including the terrible ones that the more we expose and denounce the blatant evils of this world, the more we become a prominent part of the very world in which that evil seems to flourish, and so we get rewarded and become (speaking of ironies) "famous men" because we have highlighted the lives of a "them" (even if called "famous men"), and so it goes.[41]

When writing about farmers, Ben Sira was equally disinclined to offer remedy, contrasting the drudgery of their labor to the intellectual labors of scribes, who have the leisure to become wise:

> How can one become wise who handles the plow,
> and who glories in the shaft of a goad,

who drives oxen and is occupied with their work,
and whose talk is about bulls?
He sets his heart on plowing furrows,
and he is careful about fodder for the heifers.

Nevertheless, the work of the farmer, the artisan, and the smith maintains "the fabric of the world," even if no one asks for their counsel or holds them in high esteem. In an earlier verse Ben Sira says that anyone's death brings an end to sorrow, "but the life of the poor weighs down the heart." In this respect, the books are congruent. Yet Ben Sira is being neither ironic nor satirical. His wisdom is about acceptance and piety, not reform.[42]

Proverbs of Hell

Near the end of *Famous Men*, in his "Notes and Appendices" section, Agee offers a different kind of wisdom by quoting William Blake's "Proverbs of Hell" from *The Marriage of Heaven and Hell*. This poem comes closer to the wisdom of *Famous Men*. Blake's provocative proverbs may be the kind of paradoxical irony Agee intended for the revolutionary book that he insists is not what it seems, a deception, a swindle, an insult perpetrated by spies. While preparing the book, he had told Father Flye that he was suspicious of his "over-frequent use in writing of the name of God or of William Blake." But he did not stop.[43]

Like *Famous Men*, *The Marriage of Heaven and Hell* is a singular work, a response to something, variegated in style and often perplexing in intention. Scholars have noticed affinities between "Proverbs of Hell," Ecclesiasticus, and other wisdom literature, but find important differences. The wisdom literature generally counsels caution and restraint in the face of temptation, while Blake's proverbs, spoken by the Devil, have been taken to exalt excess and freedom from restraint to encourage self-expressive energy. (Agee includes: "The road of excess leads to the palace of wisdom."[44]) Scholars have asked if the proverbs are to be understood literally or ironically, or as logical contradictions exposing the instability and inconsistency of established values.[45]

Fred Parker asks how seriously one is to take Blake's devilry in light of the text's "insouciant brilliance, the shameless freedoms that it takes, the

whiplash ironies, the delight in parody and exaggeration, the cascade of formal experiment, its fearlessness of assertion, its play of fantasy, its wicked provocations." Parker suggests that the proverbs need not be read as ironic. Rather, "it is also possible to hear the title as ironic, and to read large parts of the *Marriage* as implacably antagonistic." Blake, in a way, plays the Devil's advocate by impersonating him, which is not all that far removed from Agee's obsession with journalistic espionage and impersonation in *Famous Men*. Blake's "Proverbs of Hell" can be read as "paradoxes or counterstatements that set up an unresolved tension between two conflicting ways of seeing. (This is unlike normal proverbs, which typically invite the response, 'how true!')." While *Famous Men* has its own share of "whiplash ironies," it, too, offers paradox and holds perception in tension.[46]

The Life of Irony

In an essay introducing an issue of *Soundings* in 1994, the journal's editor Ralph V. Norman thought the title *Let Us Now Praise Famous Men* "defiantly anti-ironic," a *rejection* of irony. Agee once had asked how one tells the rooted sorrow of a summer evening in Knoxville, Tennessee, in 1915. The question asked in *Famous Men* is how one tells, by proxy, the sorrow of Alabama cotton farmers, a task Norman said took on "a darker texture and importance when it is about the suffering of others in one's own time." Norman was suspicious of the kind of irony that issues from the "learned despisers" who are "apt to make irony the mood and voice for the regard and attention they give any set or combination of their lessers." Their accounts are "riddled with comeuppances," and when Norman claims Agee is anti-ironic, he means he "rejects the cheap irony that blithely assumes it knows where the comeuppances lie."[47]

Agee was no "learned despiser" in *Famous Men*, nor was he in the grip of the cheap irony he condemned. Rather, Agee essentially *lived* the life of irony described by the radical journalist Randolph Bourne in a 1913 essay. For Bourne, irony is a life, not a method. The ironic life has its own affinities with Ecclesiasticus and the wisdom literature, for the ironist "is mad to understand the world, to get to the bottom of other personalities." The ironist's "passion for comprehension" leads to the trans-

parency and truth-seeking to which the good journalist should aspire. A journalist must embrace another's place in the world through a sharing of common humanity. Irony thus becomes "the truest sympathy. It is no cheap way of ridiculing an opponent by putting on his clothes and making fun of him." This condescending ridicule of the poor by *Fortune* and the authors of *You Have Seen Their Faces*, as Agee saw it, was what he was reacting against in *Famous Men*. His response was to live among the sharecroppers, to put on the garments of their existence.[48]

Bourne seemed to anticipate the problem that Agee was guarding against, the "aesthetic taint" to irony that appears to be only skin deep. But the true ironist, according to Bourne, is ironic

> not because he does not care, but because he cares too much. He is feeling the profoundest depths of the world's great beating, laboring heart, and his playful attitude towards the grim and sordid is a necessary relief from the tension of too much caring. It is his salvation from unutterable despair. The terrible urgency of the reality of poverty and misery and exploitation would be too strong upon him.

It almost was too strong upon the young James Agee, who wrote *Famous Men*, with its somewhat less-than-ironic title, in earnest and in irony, because he cared so much for the great beating heart of the world.[49]

NOTES

1. James Agee and Walker Evans, *Cotton Tenants: Three Families*, ed. John Summers (Brooklyn, NY: Melville House, 2013).

2. Laurence Bergreen, *James Agee: A Life* (New York: E. P. Dutton, 1984) 236; Malcolm Jones, "Revisiting James Agee: Discovering the Original *Let Us Now Praise Famous Men*," *Daily Beast* 7 June 2013, 4 Oct. 2014 <http://www.thedailybeast.com/articles/2013/06/07/revisiting-james-agee-discovering-the-original-let-us-now-praise-famous-men.html>.

3. Jones, "Revisiting James Agee." Agee and Alma Mailman lived in Frenchtown through most of 1938 and early 1939. He worked on the book and other projects during this period. See Bergreen 211–27; *Collected Short Prose of James Agee*, ed. Robert Fitzgerald (New York: Ballantine, 1962) 43.

4. D. C. Muecke, *The Compass of Irony* (London: Methuen, 1969) 3–6; D. C. Muecke, *Irony and the Ironic* (London: Methuen, 1982) 44; Jeanne Follansbee Quinn,

"The Work of Art: Irony and Identification in *Let Us Now Praise Famous Men*," *NOVEL: A Forum on Fiction* 34.3 (Summer 2001): 348.

5. James Agee and Walker Evans, Let Us Now Praise Famous Men: *An Annotated Edition of the James Agee-Walker Evans Classic, with Supplementary Manuscripts*, ed. Hugh Davis, vol. 3 of *The Works of James Agee*, gen. eds. Michael A. Lofaro and Hugh Davis (Knoxville: U of Tennessee P, 2015) 939. Subsequent references to this edition will be noted as Davis, *LUNPFM*; James Agee, *Complete Journalism: Articles, Book Reviews, and Manuscripts*, ed. Paul Ashdown, vol. 2 of *The Works of James Agee* (Knoxville: U of Tennessee P, 2013) 411–12, 419; Robert Coles noted the "bitter and gloomy irony" of "Lyrics," the first poem in the collection. Robert Coles, *Agee: His Life Remembered*, ed. Ross Spears and Jude Cassidy (New York: Holt, Rinehart and Winston, 1985) 5; James L. Baughman, *Henry R. Luce and the Rise of the American News Media* (Boston: Twayne, 1987) 40–51.

6. *Complete Journalism* 414–15.

7. James Agee, *Letters of James Agee to Father Flye*, ed. James H. Flye (1962; New York: Ballantine, 1971) 95, 98–99.

8. Bergreen 234–35; *Letters of James Agee to Father Flye* 113–14, 123.

9. Muecke, *The Compass of Irony* 3, 20; Agee, *Complete Journalism* 512.

10. *Letters of James Agee to Father Flye* 118–19, 124–25.

11. *Letters of James Agee to Father Flye* 107, 127.

12. Davis, *LUNPFM* 189–90; William Stott, *Documentary Expression and Thirties America* (Chicago: U of Chicago P, 1986) 262.

13. Muecke, *Irony and the Ironic* 31–32; Philip Howard, *Weasel Words* (New York: Oxford UP, 1979) 98–101. An egregious example of journalistic irony appeared in a November 11, 2014, *USA Today* article (3A) under the headline "Irony Alert: Supreme Court Justices Say Municipal Rulings Need Reasons." "Ironically," of course, the court in recent months had declined to hear numerous cases without explaining why. A use of irony to better effect occurred when a reporter noted the irony of the Army's announcement that it would monitor the long-term health of all veterans exposed to certain chemical weapons in Iraq. An Air Force sergeant injured by a chemical weapon in the United States, however, had not been monitored although his wounds had prompted the Army action after a newspaper investigation. C. J. Chivers, "A Burned Vet, Lapsed Care, Lasting Harm," *New York Times* 31 Dec. 2014; William Flint Thrall, Addison Hibbard, and C. Hugh Holman, *A Handbook to Literature* (New York: Odyssey, 1960) 248–49.

14. Davis, *LUNPFM* 932. The letter may never have been sent. It does not appear among the letters in the Ralph Thompson Papers in the New York Public Library.

15. *Complete Journalism* 112–14, 126–27. The irony is that Straus's Jewish faith would have offended the anti-Semitic Nazi regime. Straus was considered a capable choice, despite his lack of experience in affairs of state.

16. *Complete Journalism* 307–11; 316–22; 342, 572.

17. *Complete Journalism*, 516.

18. *Complete Journalism* 515–16.

19. *Complete Journalism* 519–20; Erskine Caldwell and Margaret Bourke-White, *You Have Seen Their Faces* (New York: Modern Age Books, 1937).

20. Davis, *LUNPFM* 7, 11, 188.

21. John Hersey, introduction, *Let Us Now Praise Famous Men*, by James Agee and Walker Evans (Boston: Houghton Mifflin, 1988) xxxvi.

22. *Collected Short Prose of James Agee* 16, 52; Davis, *LUNPFM* viii.

23. Davis, *LUNPFM* 262, 302, 379, 382.

24. Davis, *LUNPFM* 820, 867, 900.

25. Davis, *LUNPFM* 7, 9–12, 84, 97.

26. Quinn 338–68.

27. Coles, *Agee: His Life Remembered* 50 (Fitzgerald), 166 (Huston), 169–70 (Flye).

28. Daniel J. Harrington, S. J., *Invitation to the Apocrypha* (Grand Rapids, MI: William B. Eerdmans, 1999) 1–2, 78–79; F. L. Cross, ed., *The Oxford Dictionary of the Christian Church* (London: Oxford UP, 1958) 68.

29. Herbert G. May and Bruce M. Metzger, eds., "The Apocrypha," *The New Oxford Annotated Bible with the Apocrypha*, RSV (New York: Oxford UP, 1977) 186; "The Apocrypha," *A New Commentary on Holy Scripture Including the Apocrypha*, eds. Charles Gore, Henry Leighton Goudge, and Alfred Guillaume (New York: Macmillan, 1958) 97.

30. Geddes MacGregor, *Dictionary of Religion and Philosophy* (New York: Paragon House, 1989) 664–65; *The Oxford Dictionary of the Christian Church* 1471; James O. Murray, "The Study of the Apocrypha by the Preacher," *Homiletic Review: An International Magazine of Religion* 31–32 (Aug. 1896): 113.

31. W. O. E. Oesterley, "The Wisdom of Jesus, the Son of Sirach, or Ecclesiasticus," *A New Commentary on Holy Scripture Including the Apocrypha* 79–81.

32. W. O. E. Oesterley, "Ecclesiasticus" 79–81.

33. St. Andrew's School was run by the Order of the Holy Cross, an Anglican Benedictine monastic order founded in 1884. The "Cowley Fathers" belong to the Society of St. John the Evangelist, an Anglican order founded at Cowley, Oxford, England, by Richard Meux Benson in 1866; James Agee, *Selected Journalism*, ed. Paul Ashdown (Knoxville: U of Tennessee P, 2005) xi–xivii.

34. *The Proper for the Lesser Feasts and Fasts Together with the Fixed Holy Days*, 3rd ed. (New York: The Church Hymnal Corporation, 1980) 362–65; J. C. J. Metford, *Dictionary of Christian Lore and Legend* (London: Thames and Hudson, 1983) 20.

35. Coles, *Agee: His Life Remembered* 102; Allie Mae Burroughs quoted in *Agee: His Life Remembered* 121.

36. Davis, *LUNPFM* 12; Matthew 23:37.

37. Summers, *Cotton Tenants* 184–85; Davis, *LUNPFM* 136, 247, 214.

38. Kimberley Patton, "The Whole Home is Lifted," *Harvard Divinity Bulletin* 35.4 (Autumn 2007): n. pag.

39. All quotations from Ecclesiasticus, or the Wisdom of Jesus Son of Sirach, are in *The HarperCollins Study Bible* , ed. Wayne A. Meeks, new RSV (New York: Harper Collins, 1993) 1530–1616.

40. On capital and labor in sharecropping, see Sven Beckert, *Empire of Cotton: A Global History* (New York: Knopf, 2014). *Letters of James Agee to Father Flye* 107; Stott, *Documentary Expression and Thirties America* 313; Robert Coles, *Irony in the Mind's Life: Essays on Novels by James Agee, Elizabeth Bowen, and George Eliot* (Charlottesville: UP of Virginia, 1974) 56–57; on Agee's intentions in *Cotton Tenants: Three Families* see Adam Haslett's, introductory essay, "A Poet's Brief" 13–26; on Agee as prophet, see Paul Ashdown, "Prophet from Highland Avenue: Agee's Visionary Journalism," *James Agee: Reconsiderations*, ed. Michael A. Lofaro (Knoxville: U. of Tennessee P., 1992) 59–81.

41. Coles, quoted in *Agee: His Life Remembered* 83.

42. Meeks 1590–91. The verses quoted are Ecclesiasticus 38:19, 24–26, 34.

43. *Letters of James Agee to Father Flye* 124.

44. Davis, *LUNPFM* 372.

45. Christopher Rowland, *Blake and the Bible* (New Haven, CT: Yale UP, 2010) 89; Stephen Cox, *Love and Logic: The Evolution of Blake's Thought* (Ann Arbor: U of Michigan P, 1992) 89; Fred Parker, *The Devil as Muse: Blake, Byron, and the Adversary* (Waco, TX: Baylor UP, 2011) 64, 77.

46. Parker 64, 77.

47. Ralph V. Norman, "Why Odysseus Wept," *Soundings* 77.3–4 (Fall/Winter 1994): 240; Ralph V. Norman, personal correspondence, 3 Dec. 2013.

48. Randolph Bourne, "The Life of Irony," *Atlantic Monthly* 111 (March 1913): 357–67, rpt. in *The Radical Will: Selected Writings 1911–1918*, ed. Olaf Hansen (New York: Urizen Books, 1917) 134–48; the applicability of Bourne's work to Agee's is suggested by Quinn 350.

49. Bourne, *The Radical Will* 143.

From Cotton Pickin' to Acid Droppin': James Agee and the New Journalism

Michael Jacobs

By now, the idea that James Agee and *Let Us Now Praise Famous Men* prefigured the tenets of the New Journalism is old hat. Over the last four decades, several scholars and journalists have argued that despite Tom Wolfe's grandiose claims to the contrary, the so-called *New* Journalism was anything but, and to prove as much, we are told one need look no further than James Agee and Walker Evans's Depression-era text and picture book on three tenant families.[1] Indeed it is a pervasive (and at times fashionable) argument that Agee's writing in *Famous Men* so effortlessly reflects Wolfe's prescribed features of the New Journalism, which include scene-by-scene construction (and "resorting as little as possible to sheer historical narrative"), the recording of dialogue "in full," the use of third-person point of view, and (most important) the recording of people's *status life*: "everyday gestures, habits, manners, customs, styles of furniture, clothing, decorations, styles of traveling, modes of behavior toward children, servants, superiors, inferiors, peers[,] . . . various looks, glances, poses, styles of walking and other symbolic details that might exist within a scene."[2]

While the connections between Agee's reportage and Wolfe's definition of the New Journalism are obvious, it is nonetheless problematic that many, if not most, arguments positioning Agee's text as a distinct progenitor of this subsequent journo-literary movement largely rely on Wolfe's specified paradigm and only deviate to demonstrate how *Famous Men* transcends the limitations found in Wolfe's literary journalism. Such a limited juxtaposition obscures much more profound connections than can be attributed to Wolfe's prescribed formal elements by

themselves. This essay therefore examines an alternate set of parallels between *Famous Men* and two of Wolfe's first books, *The Kandy-Kolored Tangerine-Flake Streamline Baby* (*Streamline Baby*) and *The Electric Kool-Aid Acid Test* (*Acid Test*). More specifically, in investigating Wolfe's direct criticism of Agee's approach to immersion reporting, rather than exclusively focusing on the aforementioned paradigm, we find unexpected aesthetic and philosophical correlations between the two writers. Central to this connection is the endeavor to *humanize* subjects who, in consequence of sociocultural developments of their respective eras, have been relegated to the status of other.

In his 1973 anthology-manifesto, *The New Journalism*, Tom Wolfe boldly declares that his brand of reportage, and that of like-minded writers, such as Norman Mailer, Truman Capote, Joan Didion, and Hunter S. Thompson, represents nothing less than a coup d'état of literary proportions—a veritable revolution of style, scope, and technique. To establish such a position, Wolfe must posit a creation narrative conclusively disconnected from preceding movements. Within this narrative, close to its center, is a dismissal of all those would-be predecessors who might be mistaken as definitive forefathers of the New Journalism: the Mark Twains, Charles Dickenses, and Stephen Cranes of previous eras. Some do receive greater consideration than others; in light of their "full-bodied," often "novelistic" approach to reportage, for example, writers like John Reed, John Hersey, Lillian Ross, and George Orwell are afforded the honor of "Not Half-Bad Candidates."[3] Others do not fare so well, however. Among those completely *written off* by Wolfe as "The Literary Gentleman with a Seat in the Grandstand" is James Agee.[4]

Though Wolfe concedes that Agee "showed enterprise enough, going to the mountains and moving in briefly with a mountain family"[5]—thus distinguishing him from less adventurous "Literary Gentleman" who shy away from the "tedious, messy, physically dirty, boring, [and] dangerous" legwork at the heart of the New Journalism—he nonetheless finds fault in Agee's "extreme personal diffidence," as well as his writing's provision of a singular narrative point of view: "his own."[6] Considering all that Wolfe has to say on the subject of immersion and point of view, we can infer that Agee's ostensibly limited narrative perspective is, in fact,

a consequence of his diffidence. Put another way, the idea is that if Agee were less timid, he would have probed and prodded his subjects to such an extent as to solicit enough direct testimony to saturate his book with dialogue, therefore providing the bevy of narrative perspectives Wolfe deems vital to effective literary journalism.

While Wolfe is correct in observing that *Famous Men* is short on dialogue, his assertions in this regard seem curious and perhaps a bit ironic as Wolfe, himself, dedicates a considerable amount of text in *The New Journalism* to defending his own work against a similar charge, specifically his use of interior monologue.[7] Additionally, there is the glaring fact that he ignores the role of Evans's photographs as providing at least one more documentary perspective.[8] His criticism of Agee's diffidence moreover strikes even the most casual reader as strange when considering all that Agee reveals of himself in his prose.

Of course, Wolfe's claims are more rhetorical than analytical as they attempt to realize two goals. The first, as has been stated, is to establish a proper creation myth largely independent of preceding literary movements. The New Journalists were, if nothing else, iconoclasts, and by 1973—the same year William Stott published his reverential analysis of *Famous Men* in *Documentary Expression and Thirties America*, Agee and Evans's text had attained an almost deified position among scholars in myriad disciplines. Robert Coles is famously noted as referring to it as a "talisman" for 1960s civil rights workers operating in the South.[9] Indeed, reverence for the text had reached such heights that in some spheres, it had been reclaimed as an authoritative tome or reference book. For example, in a 1966 article from the *California Law Review*, we find a footnote reading, "For a general description of the manner in which the poor are housed, see Agee and Evans, *Let Us Now Praise Famous Men*."[10] Thus if Wolfe is to convince us of the import and newness of the New Journalism, he must challenge both the character and efficacy of canonical (and nearly canonical) works of literary journalism. And while the tone of his dismissal of Agee comes across as a casual afterthought, the fact that he dedicates more ink to *this* "literary gentleman" than any other suggests that he represents a considerable obstacle to the formation of the New Journalism mythology.

Secondly, Wolfe's claims in this section exist as part of a dialogue with detractors, most notably Dwight MacDonald (a longtime supporter and friend of Agee) and Michael J. Arlen, who have challenged both the merit and newness of the New Journalism.[11] Wolfe's boldly radical assertions regarding the New Journalism's supplanting of the novel in literary importance, his brutal satire of William Shawn and the *New Yorker* in earlier pieces written for the *Herald Tribune*,[12] his choices of unusual and often maligned subjects—many of whom were facets of the burgeoning counterculture—and of course his experimental style had all solicited waves of harsh criticism from the journalistic and literary establishment.[13] So while critical reviews of Wolfe's early work abound with shots at his journalistic integrity and artistic ability, we find a general subtext suggesting something else at work: a *cultural* conflict that Wolfe, himself, is all too eager to perpetuate. Many of the New Journalism's early critics were more turned off by the countercultural spirit of the form than they were its journo-aesthetic ideology. Accordingly, their criticisms often point to something much larger than the ostensible emphasis of their respective critiques, such as narrative innovation and journalistic accuracy and efficacy; they introduce a cultural clash that is, in many ways, a microcosm of the generational divide—ideologically speaking—in the Vietnam War era.

The consequence of this discord is that neither side seems to recognize Agee's most profound contribution to Wolfe's New Journalism. More important than the stuff of realism on which all parties of this fracas seem most focused is *humanistic* ambition and the particular aesthetic and rhetorical methods by which Agee and (later) Wolfe seek to reclaim the human dignity of marginalized subjects. Through various devices, most notably the aforementioned recording of "status life," the literary journalism of both writers endeavors to negate otherness, effecting reader-subject identification. Thus just as T. V. Reed observes of Agee, Wolfe, too, posits "several versions or angles of vision on a given object, character, or narrated scene."[14] And through these versions or angles, *Famous Men*, *Streamline Baby*, and *Acid Test* all work to reveal the *human* actuality of their respective documentary subjects, or as Lincoln Steffens once wrote of the ideal in journalism, to report on a subject "so humanly that the reader will see himself in the fellow's place."[15]

Admittedly this observation, while noteworthy, is not enough to position Agee effectively as a significant antecedent of the New Journalism in this context. To accomplish as much, one must closely look at exactly those things Wolfe finds flawed in Agee: his apparent diffidence and *Famous Men*'s seemingly singular point of view. For Wolfe, multiple narrative points of view and a complete *lack* of reportorial diffidence are fundamental constituents to effectual nonfiction storytelling. What's more, they are inextricably intertwined; the use and conflation of varying narrative perspectives—the writer's, the subjects', and the often seamless and dizzying shift between them—is a testament to the writer's bold and extroverted disposition. Or as Wolfe writes in *The New Journalism*,

> I never felt the slightest hesitation about any device that might conceivably grab the reader a few seconds longer. I tried to yell right in his ear: *Stick around!* . . . Sunday Supplements were no place for diffident souls. That was how I started playing around with the device of point-of-view.[16]

When considering all that Agee reveals of himself to the reader of *Famous Men*—feelings of artistic inadequacy, childhood memories of voyeuristic tendencies and dubious sexual proclivities, disquieting fantasies of a prostitute he decides to forego, and his unfiltered sexual desires for the women and girls of the three families—the word "diffident" hardly seems an appropriate description of his documentary method. Nevertheless, Wolfe is not the first person to describe him as such. In "James Agee in 1936," Evans's brief meditation on his friend and collaborator (written in 1960 for the *Atlantic* and used as the foreword in subsequent republications of *Famous Men*), the photographer categorizes Agee's manner of *speaking* as giving "the impression of diffidence" and notes that it was ultimately "his diffidence that took him into" the wary sharecroppers and their families. In both cases, this perceived reticence is positioned as an asset, not a hindrance—a factor in Agee's universal likability and that which helps him win the trust of his sharecropper subjects. More to the point, the legacy of this labeling is seen in a number of books and articles written about Agee in the last fifty years. From

critical analyses of *Famous Men* to magazine articles on the man himself, we find "diffidence" or "diffident" used to characterize both the person and the artist.[17] It is therefore worth considering that Wolfe's critique of Agee relies more on Evans's characterization of the *man* than a thorough contemplation on his work.

All that said, Wolfe's point is not wholly unfounded. With *Famous Men* we find little dialogue or direct testimony, what Wolfe would consider as evidence of Agee putting himself out there and asking probing, provocative questions. William Stott, despite his monumental commendation of *Famous Men*, corroborates this contention, pointing out that Agee frequently articulates the thoughts of his subjects rather than letting them speak for themselves via dialogue and personal testimony. Stott lists a series of "humiliating" confessions, including, "Oh thank God not one of you knows how everyone snickers at your father"; and "He no longer cares for me. He Just takes me when he wants me."[18] This he identifies as perhaps "the chief problem in Agee's text," for it positions the author as every bit as presumptuous and condescending as the exploitative, sensational documentary Agee and Evans sought to counter with *Famous Men*.[19]

Stott's main issue seems to be that these confessions are not accompanied by any "reason to believe them true."[20] However, there is nothing to suggest that through interview and conversation Agee was not privy to such thoughts. Even Wolfe argues that a literary journalist is under no obligation to provide the type of evidence to which Stott refers. In defending his own use of interior monologue (ascribed to the main subject of his piece) in his 1964 story on Phil Spector, "The First Tycoon of Teen," Wolfe addresses the question of how a journalist can "accurately penetrate the thoughts of another person. . . . The answer proved to be marvelously simple: interview him about his thoughts and emotions, along with everything else."[21] So, we might easily assume that Agee has done just that. Such a possibility presents a rich irony, then, for it positions Wolfe as not simply an unknowing defender of Agee, but also an inheritor of his journalistic legacy. What is more, it demonstrates that Agee, diffident or not, has provided his subjects the means by which they can speak for themselves. The difference between his work and that of Wolfe's in this respect is therefore simply a matter of form.

The real problem is that Agee often packages his subjects' sentiments in a voice that does not realistically represent them. And when he does as much, when he uses his profoundly sentimental, lyrical prose to represent the thoughts, words, and feelings of his subjects, the result *can be* construed as "humiliating." Obviously, uneducated tenant farmers and sharecroppers would not describe the depth of their work-induced, coma-like sleep with declarations such as "not thunder nor the rustling worms nor scalding kettle nor weeping child shall rouse us where we rest" (65). But it must be stated that not all of Agee's attempts to give voices to his subjects are shaped in this fashion. At times, he does attempt to cultivate a dialect more faithful to what one might imagine such a subject would possess: "Why is it there can't ever seem to be any pleasure in living? [. . .] Sometimes it seems like there wouldn't never be no end to it, nor even a let-up" (67). This simplified, courser language, accentuated with a subtly placed grammatical error, suggests a very different approach to the representation of the subject's voice. And it works to accomplish two goals. The first, and most obvious, is its attempt to reflect more faithfully the way his subjects speak. The second and more important goal or effect lies in this passage's spatial position within the text itself. It sits just two pages away from the former passage, and thus together they function as bricolage—a juxtaposition suggestive of a greater significance. By placing his voice next to that of his subject, Agee aligns himself with the members of the farm families, a move at the heart of his endeavor to effect empathy in his reader and therefore humanize his subject. It also precedes Wolfe's use of the very same device by three decades.[22]

If Agee still comes off as diffident after sharing his deepest insecurities, fantasies, hopes, and fears, it is perhaps only because he has too much reverence for his subjects to bombard them with prying, condescending questions. What's more, such a seemingly deferential demeanor—that which "takes him into" the homes and hearts of the Gudger, Ricketts, and Woods families—provides the reluctant journalist a degree of access he might never receive had he employed the investigative disposition touted by Wolfe (in many ways diminishing the need to adopt such tactics). Agee sees himself as a "spy," a covert operative, and not simply one within the realm of the sharecroppers. He is also a

subversive entity within the institution of journalism, for as he observes in a poem written to Walker Evans about their mission, they are "Spies moving delicately among the enemy."[23] We see then that his suspicion of conventional journalism, a sentiment he shares with Wolfe, precludes him from acting as Wolfe insists he should. Thus Wolfe's intimation that Agee is incapable of soliciting enough reaction and response from his subjects to generate more narrative points of view seems a dubious assumption.

Contrastingly, the degree to which Agee expresses this reverence represents the very opposite of diffidence as it makes the writer wholly vulnerable, just as his subjects are made vulnerable by the voyeuristic endeavor of their documentarian. While the aforementioned, sexually explicit confessions and assumptions about his subjects appear to reinforce certain notions of class- and gender-based dominance,[24] Agee's intentions and, to a great extent, their effect run antithetically. By making himself vulnerable to his reader, who is presumably of the same educated, bourgeois station, Agee endeavors to achieve that which John Hartsock identifies as the most important facet of literary journalism: the elimination (or, at the very least, lessening) of the documentary subject's status as other.[25]

In a sense, Agee attempts to assume the same "defenseless" constitution as the tenant families, and by doing so, implements his subjectivity as an ontological bridge between reader and subject. By sharing so much of himself, confessing his love and lust, pathos and empathy, awe and reverence for all three families (the Gudgers/Burroughs especially), Agee makes himself perhaps the most vulnerable character in the book. In this act, he aligns himself with people far beneath his, Evans's, and his readers' social stratum. Agee is ultimately a device through which his readers can understand the Gudgers, Woods, and Ricketts to the point of being able to identify with them. This use of the author as a conduit is truly significant, for while Wolfe certainly does not express reverence or vulnerability to the extent one finds in *Famous Men*, in both *Streamline Baby* and *Acid Test* he nonetheless provides momentary—albeit profoundly meaningful—glimpses of a journalist giving in to the allure of his subjects. And this visible admiration for his subjects, when consider-

ing the parallels between his and Agee's documentary methods, makes all the difference.

In *Streamline Baby*, his first collection of previously published New Journalism articles, Wolfe's genuine admiration for many of his subjects is at once overt and profound.[26] In "The First Tycoon of Teen," for example, he refers to Spector as a "bona-fide Genius of Teen."[27] For the writer, Spector is the real thing: a genuine visionary, "the only pure American voice."[28] At times it is difficult to tell if this reverence is truly Wolfe's or that of Spector's entourage, the collective perspective that Wolfe frequently assumes as part of his free indirect discourse. This approach is not unlike Agee's treatment of the myriad cropper family members,particularly in section 2 of "Part One" where, as they sleep, he articulates their dreams and lamentations. Still, Wolfe's explicit admiration for his subjects reveals a sense of vulnerability similar to, though much less potent than, that which Agee implements to humanize his sharecroppers. Unlike Agee, Wolfe is not dealing with subjects far below his socioeconomic status, and thus his subjectivity in this respect is not an attempt to "shed the cloak of privilege"[29] in a class-based context. Consequently, in *Acid Test* he is not above poking fun at Kesey and the Pranksters from time to time, as we see in his irreverent treatment of the Pranksters' general inability to focus on completing their film, which eventually becomes a fragmented monster of endless, out-of-focus footage. But in exposing himself in this way, Wolfe forfeits the privilege of *heedlessness*—of existing beyond the bounds of scrutiny. The documentary subject knows no such place of comfort; therefore Wolfe is, in a sense, shedding the very cloak of which T. V. Reed writes.

This reverence and resulting vulnerability reveal a writer endeavoring to lessen the ontological divide between his subject and reader. And for good reason. Wolfe positions his rich and famous subjects in *Streamline Baby* as misunderstood geniuses who, but for their own talents, bravado, and sheer heroism, would be marginalized to the point of destructive obscurity by the forces of mainstream American culture. The writer therefore endeavors to establish the "value, dignity, and cultural importance of his heroes, to convey each character's vision (and its inherent merit and significance) to a postwar populace largely conditioned

to reject (or at least be wary of) notions, behaviors, and cultural elements beyond the limits of the stifling social conservatism forged in the 1950s"—a social paradigm epitomized by Spector's quoted observation, "Because I'm dealing in rock and roll, I'm, like, I'm not a bona-fide human being."[30]

Wolfe's humanizing reverence is not limited to Spector. It abounds, to some extent, in nearly all of his profiles—at least those appearing in the book's first section, "The New Culture-Makers." In "The Fifth Beatle," he again invokes the word "genius" in reference to rock and roll disc jockey Murray the K.[31] In the title piece of the book, Wolfe positions George Barris and his peers, pioneers in the art of California car customization, as "America's modern Baroque designers."[32] In "The Last American Hero," by far the longest and most reverential piece of the collection, the writer seeks to mythologize his subject, bootleg whiskey runner turned race car champion Junior Johnson, a living legend in his own right long before Wolfe discovers him.

Such esteem is palpable in *Streamline Baby*, but it is ultimately eclipsed by the level of admiration Wolfe extends to his subjects in his subsequent book, *Acid Test*, a profile of iconic American author and consciousness expansion guru Ken Kesey and his followers, The Merry Band of Pranksters. From the very beginning of the text, the writer reveals the profound impression Kesey has made on him. At their first meeting, Wolfe is in awe of his subject's physical prowess and cannot help but focus on his "thick wrists and big forearms," "massive" jaw and chin, and "big neck with a pair of sternocleido-mastoid muscles that rise up out of the prison workshirt like a couple of dock ropes."[33] Before him, Kesey looks like "Paul Newman, except that he is more muscular." This physical appreciation is extended to Kesey's wife, Faye, as well. With her "long sorrel-brown hair" and "radiant, saintly appearance" she becomes "one of the prettiest, most beatific-looking women I ever saw" (23).

Soon, Wolfe's physical and aesthetic appreciation is joined by a spiritual and psychological connection with his subjects. While waiting at the Haight-Ashbury warehouse for Kesey to return from jail, Wolfe becomes almost instantaneously seduced by the Prankster energy, the "mysto steam" that begins "rising in [his] head" (16). This is in response

to the Pranksters' discussion of their leader, a worshipful dialogue that Wolfe first (and only momentarily) sees as "phony." Within a few pages, upon Kesey's entrance, however, the "mysto" graduates to the level of near deification:

> And it is an exceedingly strange feeling to be sitting here [. . .] in this improbable ex-pie factory Warehouse garage [. . .] in the midst of Tsong-Isha-pa and the sangha communion, Mani and the wan persecuted at the Gate, Zoroaster, MADE-HI-OY-MONGAH and the five faithful before Vishtapu, Mohammed and Abu Bekr [. . .] in short, true mystic brotherhood. (27–28)

The subtle transition from skepticism to veneration is important, for it demonstrates an air of humility, the confession of misinterpretation, not unlike what one finds throughout *Famous Men*. Certainly Wolfe does not make himself nearly as vulnerable as Agee in this (or any other) respect. Then again, his subjects are not nearly as "defenseless" as the tenant farmers of Agee's purview. In consequence, Wolfe's is a much more *controlled* projection of his own shortcomings, as mediated by a far less deferential tone than we see in Agee's prose. Still, there are a few instances in which he calls his own prowess as a writer into question, e.g., his early admission of ignorance regarding the San Francisco acid scene or when he naively (and temporarily) aligns himself with the clueless mainstream press.

Perhaps the most important—and humanizing— outcome of the reverence we see in both Agee's and Wolfe's works is that it allows the writers to reclaim their subjects as individuals and not cultural types. And it is here that we find Agee's most salient foreshadowing of the New Journalism. In its first few pages, *Famous Men* reveals itself to be a subversive text—one that, at the very least, violated many points of rhetorical and stylistic protocol observed by *Fortune*, particularly those ascribed to the "Life and Circumstances" series of which it was to be a part. One such violation is the fact that it does not provide a glimpse of an "average" or "representative" tenant farm family, but rather paints a picture of three unique, heterogeneous family units: *multiple* case studies.

Ultimately Agee casts his subjects not as interchangeable representatives of a base socioeconomic stratum, i.e., easily digestible, objectified fodder for the consumption of a middle-class readership, but as unique, autonomous characters. In this way, he not only avoids what William Stott identifies as the "tone of breezy condescension" that defined Life and Circumstances and pervaded the literary journalism of his day;[34] more than that, Agee circumvents the more general, objectifying limitations of documentary to humanize a caste of people largely positioned as other.

Throughout *Famous Men* no routine, possession, idiosyncrasy, sound, odor, gesture, or inferred thought of the farmers and their kin is left unmentioned, and Agee's refusal to make any identifiable choice with regards to the inclusion or exclusion of detail in this context begs the question of ultimate purpose. There are a few salient reasons for such meticulous analysis of these people's lives, but the most important is its ability to delineate differences among his ostensibly identical, ignoble subjects for middle-class readers. One class's perception of another tends to blur distinctions that are otherwise obvious within a certain class. The obscuring of such differences is, in itself, a dehumanizing corollary as it suggests that the individuals of the class in question are interchangeable objects or signifiers. Conversely, the establishment of individuality is inherently humanizing, particularly in modern America where it is perceived as an inherent human right and virtue. *Famous Men* forces its reader to see its unfamiliar subjects as individuals. Hence Agee's observation that "certain individuals are his parents, *not like other individuals*; they are living in a certain house, it is *not* quite like other houses; they are farming certain shapes and strengths of land, in a certain exact vicinity, for a certain landholder [. . .]" (89, italics added).

As a thorough spy, Agee cultivates heterogeneity *within* a "lower class," which to a certain extent facilitates a level of equality among all parties involved in the documentary: documentarian, subjects, and reader. Just as bourgeois readers would recognize differences in their own class, they would see the same in the class to which the Gudger, Woods, and Ricketts families belonged. For Agee then, his readers and subjects share the inherent quality of persons never "to be duplicated, nor replaced" (49).

With this development, *Famous Men* at least partly succeeds in lessening the ontological divide between its readers and subjects because it attempts to close the psychosocial distance separating the two.

This heterogeneity manifests in a variety of ways. In the "Shelter" section of the text, for example, we find three distinctly labeled subsections: "The Gudger House," "The Woods House," and the "Ricketts House." The simple act of delineating a separate subsection for each family demonstrates Agee's desire to have his readers see his subjects as individuals, each possessing their own unique attributes. And this is further highlighted in "Notes," the brief segment that follows, where Agee offers a series of comparisons. Under the subheading, *Relations and averages*, for instance, is the following:

> By location or setting in the land, the Gudgers' house is far false to the average: the land is much too uneven, the house is too remote, the cultivated land of one farm is closely walled in by thick woods. By all this appearance it better suggests a frontier house in 1800 in newly cleared country, or a 'mountaineer's' home, than a tenant's. (165)

By contrast, Agee subsequently shows the reader that the "Woods' and Ricketts' setting is better" (166). Other such comparisons permeate the text. Perhaps the most edifying of these is Agee's explanation of the differences between tenant farmers, like Bud Woods and Fred Ricketts, and sharecroppers, like George Gudger. As with his discussion of setting, Agee, in the "Money" section, highlights the ways in which George Gudger fairs worse economically (if only marginally) than his neighbors:

> Gudger has no home, no land, no mule; none of the more important farming implements. He must get all of these of his landlord. Boles, for his share of the corn and cotton, also advances him rations money during four months of the year, March through June, and his fertilizer. Gudger pays him back with his labor and with the labor of his family. Gudger is a straight half-cropper; or sharecropper. (97)

This is followed by a description of Woods' and Ricketts' more favorable circumstances. While they own neither their homes nor their land, "Woods owns one mule and Ricketts owns two, and they own their farming implements" (97). Such distinctions place Woods and Ricketts in a more fortunate position, for they must surrender only a third of their cotton and a quarter of their corn (compared to half of both for Gudger).

Agee's approach to representation succeeds in identifying differences among people who, because of their common culture and marginalized status, would otherwise appear indistinguishable from one another to a middle-class readership far removed from the tenant farm milieu. Their identities would blur into a single, homogenized form, which was not uncommon in the sensationalism of the day. Agee strives to do the opposite; were he to not, he would remain as ignorant as he professes to be upon one of his first encounters with the farmers: "scarcely knowing you by families apart" (296). And while each family is afforded its own identity in *Famous Men*, it is the Gudgers, the poorest and most tragic group, who are ascribed a distinct identity beyond that which Agee grants the Woods and Rickets—a quality of being simply labeled, "silence."

The Gudger family is indeed defined by its silence, a silence "more deep than starlight" (51). In fact, in direct reference to the Gudgers— the family unit, its individual members, their domicile and possessions, and/or the natural world around them at any given point in the text— the word "silence" and its variations are implemented more than twenty times. And Agee's frequent use of "silence" is significant on a few levels. For one, it emphasizes his romantic ambitions. In the Gudgers, he seeks to cultivate a fleeting, if not lost, pastoral zeitgeist. There is an ineffable holiness to these people and their connection to the earth, despite the fact (or perhaps because of it) that the earth, itself, has been none too kind to them. Thus Agee makes clear the places and unnamable phenomena of human existence that language fails to represent. In its place we experience "such holiness of silence and peace" (45), and "the early light and the cleanness and silence after the rain" (347), and "the speechless, silent, serious, ceaseless and lonely work along the great silence of the unshaded land" (278).

Agee's focus on the silences that define the Gudgers' existence is not solely a device through which he explores his pastoral romanticism, however. As stated, it is also a means of creating distinct and distinguishable qualities among his subjects. The Gudgers are a family largely identified by their silences; such is brought about by the location of their land as it is "not within sight or within a half-mile's walk of any other inhabited house" (107). It is a land populated by "grenbrown" trees "whose silence, different from that of the open light, seems to be conscious and to await the repetition of a signal" (109).

In section III of "Part One," we find the silence of the Gudger household broken by such a signal, but only as a result of being juxtaposed with the goings-on of the Woods and Ricketts. Here Agee will at once effect a commonality among the people and families of his focus and, to a much greater extent, fundamental differences. The scene is marked by *noise* ("the yell of a rooster"—"so valiant a noise"; "skillful birds, who whistle, and beat metals with light hammers"), as well as constant, often "epileptic" motion (71–74). Agee composes a pastiche-like description of breakfast time at each family's house, transitioning from one kitchen to the next, in a sometimes disorienting, but ultimately accessible fashion. For the most part we can clearly identify the kitchen in which we have found ourselves at a given moment, for Agee uses a first or last name. In some instances, however, we find a conflation of actions and thus an inability to determine to whom, specifically, the description refers.

A similar, yet even more fragmented composition is found in the preceding section II of "Part One." Here, as the family members slumber in their respective shared beds, Agee rapidly and seamlessly shifts from one bed to another, one person to another, back and forth, from Ricketts to Woods to Gudger, from George to Fred to Annie Mae to Ivy. He infiltrates their individual unconscious, supposing the colors and contents of their dreams. Each, in one way or another, portrays the loss of an irretrievable way of life, from Sadie Ricketts's diminished childhood "pride and beauty" to George Gudger's "lost birthright, bad land owned, and that boyhood among cedars and clean creeks" (65). Here we see that theirs is a shared misfortune, but not a shared *identity*.

Certainly there is a sameness to the lives of these tenant farmers, their wives, and their children, just as there is a common thread among all

people who inhabit the same land and suffer the same hardships. And yes, Agee does his part to cultivate a common essence, to draw them together under a cohesive, comprehensive human condition. But in his ultimate goal of restoring their humanity, he goes even further in effecting a palpable sense of uniqueness, one that allows his bourgeois readers to see the farmers and their kin as they would themselves: individual people and not a constructed ontological type.

Like Agee, Wolfe endeavors to position Kesey and the Pranksters as individual representatives of an importantly distinctive movement within the growing counterculture. Specifically, he examines key differences between Kesey and company and their supposed forbearers in the consciousness expansion movement: Timothy Leary and his group, the League for Spiritual Discovery. In this analysis he challenges the prevailing, condescending, and objectifying notion in the mainstream press suggesting (or sometimes bluntly stating) that essentially all invested parties of the counterculture practice the same rituals and hold the same ideals.

Halfway through their maiden bus trip, Kesey and his followers point "Furthur" [sic] toward Millbrook, New York, the nerve center of the burgeoning consciousness expansion movement.[35] There sits the palatial compound of Leary and his League. This chapter, titled "The Crypt Trip," marks the first of many moments of disillusionment for the Pranksters. They come to Millbrook for two primary reasons: to feel a kindred connection with the progenitors of their movement and to cultivate a sense of validation—the feeling that what they are doing is, in fact, important and right. However, they leave upstate New York, as do we, the readers, with a fortified sense of estrangement, fueled by the idea that their endeavor is so out there and so original that not even Leary and his followers can comprehend it.

Like the Pranksters, the Learyites are outcasts, having been "hounded out of Harvard, out of Mexico, out of here, out of there" (93). Thus Kesey and company roll into the estate with soaring expectations of unity, understanding, and appreciation. As Wolfe notes, "If there was anybody in the world who was going to comprehend what the Pranksters were doing, it was going to be Timothy Leary and his group" (93). This was, after all, the "Ancestral Mansion" of the Pranksters, a term the Prankster

Babbs initially conjures in earnest but later asserts with an air of sarcasm. When Cassady pulls the bus within sight of the "great gingerbread mansion," the Pranksters enact their usual display of camaraderie and spectacle:

> The Pranksters entered the twisty deep green Gothic grounds
> of Millbrook with flags flying, American flags all over the bus,
> and the speakers blaring rock 'n' roll [. . .] like a rolling yahooing
> circus. [. . .] Sandy Lehman-Haupt started throwing green smoke
> bombs off the top of the bus, great booms and blooms of green
> smoke exploding off the sides of the bus like epiphytes as the lurid
> thing rolled and jounced around the curves. We are here! We are
> here! (93–94)

But to this grand proclamation there is no response. Like many times throughout their journey, the initial pomp and circumstance of the Pranksters' arrival solicits an anticlimactic reaction. Here they are met not with fanfare and not even by Leary, himself. Rather, Richard Alpert, Leary's friend and colleague at Harvard (both were dismissed in 1963), along with two other members of the League, Peggy Hitchcock and Susan Metzner, meet the group outside. In contrast to the Pranksters' "jumping off the bus still yahooing and going like hell," the three Learyites remain cool and, while friendly, seemingly unimpressed (94). In fact, the Pranskers' arrival appears to be a disturbance of sorts as the mannerisms of the welcoming committee members communicate, "We have something rather deep and meditative going on here, and you California crazies are a sour note" (94). From this point forward, the Leary leg of the journey is a disappointment. But it is not so much the cold reaction they receive that spoils this encounter and turns the Pranksters off; rather it is the League's entire approach to consciousness expansion. Herein lies a critical juxtaposition for Wolfe, one that will enable him to counter the homogenizing treatment of the counterculture by the mainstream press.

Despite their intrusion, the Pranksters are treated to a guided tour of the "Ancestral Mansion." As the group moves through the halls and rooms, many of which are adorned with ancient and antiquated artifacts,

we find an adherence at odds with everything for which the Pranksters stand. The Learyites, so far as the Pranksters (and Wolfe) can see, are mired in nostalgia: "They have turned back into that old ancient New York intellectual thing, ducked back into the romantic past, copped out of the American trip" (100). Unlike the New York intellectual's reverence for a "purer, gadget free" France or England, however, Leary and his group turn to a purer, gadget-free "India—the East—with all the ancient flap-doodle of Gautama or the Rig-Veda blowing in like mildew"; hence the discovery of Millbrook's "meditation centers" (or, as the Pranksters call them, "crypts") and the observation that *The Tibetan Book of the Dead* "was one of the Learyites' most revered texts" (95).

Kesey's approach to consciousness expansion exists in stark contrast to that of the Millbrook community. His is an ideology that completely eschews such nostalgia. For one, there is nothing "gadget free" about the Pranksters. Their journey "Further" is documented (and projected) with the use of a formidable cache of recording devices; they are, after all, making a movie. But the use of such devices represents something much more significant than this utilitarian function. It wholly fits within Kesey's notion of the "American trip," an acid-fueled approach to life that embraces the constituents of the here and now. Kesey and his followers have come of age in the Atomic Age. They are products of postwar America and therefore opt to cultivate *new* mythologies within, not in place of, that culture—ergo their identification not with the heroes of epic poetry, but rather the comic book superheroes with which they grew up.[36] And if Batman has taught us anything, it is that gadgets and superheroes go hand in hand.

Examining the disparity between the Kesey and Leary camps is an important device in helping close the ontological distance between reader and subject, for as Agee does with his farmers, Wolfe highlights the distinctiveness of people and groups that would otherwise be conflated by readers and mainstream journalists very much disconnected from the consciousness expansion movement.

Wolfe recognizes a fundamental inability of conventional journalism to deal with the "new forms of expression that were kicking around in that hip world at that moment" (224). And at moments throughout *Acid Test* we see the rumblings of what would only years later become

a fully matured contempt for the mainstream press. Early in the text, Wolfe discusses the "last night" of Perry Lane in July of 1963—the final celebratory gathering before developers, who had bought the land, were to tear down the cottages and build modern homes.[37] He observes that the reporters dispatched to cover the event had come already equipped with "that old cliché at the ready, End of an Era" (48). What they find instead are Kesey and his newly formed Band of Merry Pranksters "high as coons" running about the once tranquil artists' colony, climbing trees and "hard-grabbing off the stars" (48). The idea that the reporters arrive on the scene with preconceived notions of what they will find—"intellectuals on hand with sonorous bitter statements about this machine civilization devouring its own past"—is not the real issue for Wolfe. He is more concerned with the fact that despite witnessing this burlesque, which in no way resembles the scene they anticipate, the reporters nonetheless leave with "the cliché intact," ignoring the actuality before them.

No doubt Wolfe was also responding to conventional journalism's more generally myopic handling of the counterculture—specifically the Hippie phenomenon, which by the time *Acid Test* was published had turned out headlines such as "Dominant Mothers are called the Key to Hippies," as well as content that proclaimed "Villagers are for things. . . . Hippies are for nothing"; "Hippies almost always refer to Negroes as 'Spades'"; and "Hippies like LSD, marijuana, nude parties, sex, drawing on walls and sidewalks, not paying their rent, making noise, and rock 'n' roll music."[38]

Conversely, Wolfe documents the way in which the consciousness expansion movement seduces a host of other subsects of the counterculture, from the "devoted surfing cliques," like the Pump House Gang, to the Berkeley-educated stakeholders of the "student rebellion," many of which, as Wolfe demonstrates, come to embody perspectives in opposition to Kesey's. In this connection, he effects a heterogeneity on par with Agee's treatment of his Alabama subjects.[39]

It is impossible to know if Agee's work in *Famous Men* had a *direct* influence on Wolfe's reportage. Of course he admits to having read the sharecropper book searching for a kindred reportorial method, though professes to have found very little in this vein. Nonetheless, his work speaks for itself. In its endeavor to *humanize* its subjects by lessening the

ontological divide between them and the reader, it positions itself in the same tradition of documentary literature as *Famous Men*. If nothing else, then, one can conclude that Wolfe's dismissal of Agee as a forbearer to the New Journalism is, at best, the wishful thinking of a writer in search of a new journalistic frontier—which is ultimately subverted by the very overt parallels found between his and Agee's documentary modes. Of course, such parallels are not limited to *Famous Men* and the two Wolfe books discussed here. The works of Hunter S. Thompson, Joan Didion, and Michael Herr (to name but a few New Journalists) observe the very same devices of subject heterogeneity and reverence, as well as a general contempt for conventional journalism in its inability to faithfully represent human actuality, examined in this analysis. That said, Wolfe is easily the loudest and most recognizable advocate, or proponent, of New Journalism, not to mention Agee's most visible critic in this context, and therefore the one with whom we must first contend. In doing so, we find not a completely novel approach to narrative nonfiction writing, but rather the progeny of Agee's documentary humanism.

NOTES

1. See Mas'ud Zavarzadeh, *The Mythopoeic Reality* (Urbana, Illinois: University of Illinois Press, 1976); Michael Arlen, "Notes on the New Journalism," *Atlantic Monthly* May 1972: n. pag.; Niall Lucy, "Writing and Experience: *Let Us Now Praise Famous Men, Again*," *Continuum: The Australian Journal of Media and Culture* 5.1 (1991): n. pag.; Norman Sims, *True Stories: A Century of Literary Journalism* (Evanston, Illinois: Northwestern University Press, 2007); Pegi Taylor, "Creative Nonfiction," *The Writer* 15.2 (2002): 29–33; R. Thomas Berner, *The Literature of Journalism: Text and Context* (State College, PA: Strata Publishing, 1999); Stephen Henighan, "The Honourable Oblivion of James Agee," *The Times Literary Supplement* 4 Aug. 2006: n. pag.; Stephen L. Vaughn, *Encyclopedia of American Journalism* (London: Taylor and Francis, 2007).

2. Tom Wolfe and E. W. Johnson, *The New Journalism* (New York: Harper & Row, 1999) 47.

3. *New Journalism* 60–61.

4. *New Journalism* 58–60.

5. *New Journalism* 60. For the purposes of this analysis, we need not make much of Wolfe's inaccuracy in this regard—the fact that Hale County, Alabama, is in fact *not* a mountainous region and therefore the Gudgers were not a "mountain family."

6. Wolfe's general position regarding writers placed in this dubious category (which include D. H. Lawrence, William Hazlitt, and John Dos Passos) is that they

fail to fully engage the actions and lives of those about whom they are writing. Their reportorial observations of a particular person, event, or phenomenon, though quite vivid, never approach the level of immersion he deems worthy of the moniker, New Journalism. As an example, he cites William Hazlitt's famous nineteenth-century sketch of a bareknuckle boxing match, "The Fight." Though a rich and descriptive piece of writing, its observations could "have been as easily observed . . . by any other Gentleman in the Grandstand" (59).

7. In this respect he claims he was erroneously accused of projecting his own perspective onto his subjects.

8. There is much to be said of their function in *Famous Men*, but such an analysis is beyond the scope of this essay.

9. See Bruce Jackson, "The Deceptive Anarchy of *Let Us Now Praise Famous Men*," *Antioch Review* 57.1 (1999): 38–49.

10. Carl Schier, "Protecting the Interests of the Indigent Tenant: Two Approaches," *California Law* Review 54.2 (1966): 670–693. For comparable treatments of *Famous Men* see Kurt H. Wolff, "Surrender and Religion," *Journal for the Scientific Study of Religion* 2.1 (1962): 36–50; Mary Ann T. Randar, "Social Work from a Social Science Perspective," *Social Science* 48.2 (1973): 82–86; Richard M. Zaner, "An Approach to a Philosophical Anthropology," *Philosophy and Phenomenological Research* 27.1 (1966): 55–68; Robert Ascher, "Tin Can Archæology," *Historical Archaeology* 8 (1974): 7–16; Thomas J. Cottle, "Young, Creative and Trapped," *Change in Higher Education* 2.1 (1970): 20–31.

11. See Dwight Macdonald, "Parajournalism, or Tom Wolfe & His Magic Writing Machine," *New York Review of Books* 26 Aug. 1965: n. pag.; "Parajournalism II: Wolfe and the New Yorker," *New York Review of Books* 3 Feb. 1966: n. pag. MacDonald would eventually add a footnote to his original review of Wolfe's work, giving some kudos to the article, "Radical Chic." See also Michael J Arlen, "Notes on the New Journalism," *The Atlantic* May 1972: n. pag.

12. "Tiny Mummies! The True Story of the Ruler of 43rd Street's Land of the Walking Dead!" *New York* 11 Apr. 1965: n. pag.; "Lost in the Whichy Thicket," *New York* 18 Apr. 1965: n. pag.

13. Letters from E. B. White, John Hersey, J. D. Salinger, and a host of other literary heavyweights poured into the *Herald Tribune*'s mailroom, each criticizing Wolfe as a hack sensationalist. Even John Hersey, whose work Wolfe would later cite as part of the "direct ancestry of the present-day New Journalism," was incensed. In a *Yale Review* article, "The Legend on the License" (Autumn 1980), Hersey blames Wolfe for a pervasive journalistic "defect": the common belief among New Journalists and "nonfiction novelists" that "the mere facts don't matter."

14. T. V. Reed, "Unimagined Existence and the Fiction of the Real: Postmodernist Realism in *Let Us Now Praise Famous Men*," *Representations* 24 (1988): 164.

15. Lincoln Steffens, *The Autobiography of Lincoln Steffens* (New York: Harcourt Inc., 1931): 317.

16. *New Journalism* 29–30.

17. See Norman Sims, *Literary Journalism in the Twentieth Century* (Evanston, Illinois: Northwestern University Press, 2008) 178; Kate Webb, "In Praise of Film Writer James Agee," *The Guardian* 10 Dec. 2009: n. pag.

18. James Agee and Walker Evans, Let Us Now Praise Famous Men: *An Annotated Edition of the James Agee-Walker Evans Classic, with Supplementary Manuscripts*, ed. Hugh Davis, vol. 3 of *The Works of James Agee*, gen. eds. Michael A. Lofaro and Hugh Davis (Knoxville: U of Tennessee P, 2015) 66, 68. All page references in the text are to this edition.

19. William Stott, *Documentary Expression and Thirties America* (Chicago: University of Chicago Press, 1986) 303. For Agee and Evans, the epitome of such work was Erskine Caldwell's and Margaret Bourke-White's *You Have Seen Their Faces*.

20. Stott 303.

21. *New Journalism* 47.

22. At one point in his *Streamline Baby* article, "The Fifth Beatle," Wolfe quotes pioneer rock and roll disc jockey Murray the K's on-air, quick-paced radio patter, and then immediately emulates it with a similarly styled paragraph. Here Wolfe has not assumed the actual voice of Murray the Kay; he's adopted neither his dialect nor word choices. Instead, he implements his pace and rhythm—Murray the K's signature *style*. And juxtaposed against the already established reverence for his subject, it is clear that in moments such as these, Wolfe seeks to effect an artistic (and thus personal) identification.

23. Laurence Bergreen, *James Agee: A Life* (New York: E. P. Dutton, 1984) 164.

24. See Paula Rabinowitz, "Voyeurism and Class Consciousness: James Agee and Walker Evans, *Let Us Now Praise Famous Men*," *They Must Be Represented* (London: Verso, 1994) 35–55.

25. John C. Hartsock, *The History of American Literary Journalism: The Emergence of a Modern American Form* (Amherst: U of Massachusetts P, 2000).

26. Wolfe first published the anthologized pieces of *Streamline Baby* separately in *Esquire, Harper's Bazaar, New York* (the Sunday magazine of the *New York Herald Tribune*), and the book, *New York, New York*.

27. Tom Wolfe, *The Kandy-Kolored Tangerine-Flake Streamline Baby* (New York: Pocket Books, 1967) 54.

28. Wolfe, *Streamline Baby* 50.

29. Reed, "Unimagined Existence" 171.

30. Michael Jacobs, "Confronting the (Un)Reality of Pranksterdom: Tom Wolfe and the Electric Kool-Aid Acid Test," *Literary Journalism Studies* 7.2 (2015): 136–137. Wolfe, *Streamline Baby* 60. Of course, many of Wolfe's readers were part of the very cultures and subcultures examined in his work and thus readily identified with his subjects. Still, it seems clear that in both *Streamline Baby* and *EKAT*, Wolfe is intently focused on provoking the advocates and adherents of middle-class morality and status quo.

31. Wolfe, *Streamline Baby* 34.

32. Wolfe, *Streamline Baby* 74.

33. Tom Wolfe, *The Electric Kool-Aid Acid Test* (Toronto: Bantam, 1981) 6. All references cited are to this edition. *Acid Test* and *The Pump House Gang* were published on the same day.

34. Stott 262.

35. "Furthur" is the purposely misspelled name of both the Prankster school bus and their adventure across the US.

36. As part of their journey "Furthur," [*sic*] the Pranksters adopt names (and personas) like "dis-MOUNT" (Sandy Lehmann-Haupt), "Mal Function" (Mike Hagen), and "Gretchin Fetchin, the Slime Queen" (Paula Sundstren).

37. Perry Lane was the Menlo Park artists' colony where Kesey wrote *One Flew Over the Cuckoo's Nest* in 1962.

38. John Leo, "Dominant Mothers are Called the Key to Hippies," *New York Times* 6 Aug. 1967: n. pag.; Martin Arnold, "Organized Hippies Emerge on Coast," *New York Times* 5 May 1967: n. pag.

39. An important result of this teasing out of distinctions is Wolfe's ability to reveal the ways in which the general Prankster ethos—which is largely defined by a veneration of freedom and mobility (embodied in their celebration of the open road) and the stuff of space age American culture—aligns with the established value system of mainstream America in the 1960s.

All over Alabama:
On the Road to Hobe's Hill

Andrew Crooke

Wednesday, March 20, 2013. This first day of spring appears promising. The sun will soon penetrate the cloud cover and shake off the morning chill. I pull out of the rental lot in a nearly new Ford Edge with an in-state license plate that won't attract suspicious stares in the countryside and will allow me to feign my origins if I care to. A spur of Interstate 65 stretches southwest out of Huntsville, past the rockets planted roadside and pointed skyward as if about to blast off for the moon. I cross the Tennessee River, widened by one of its many New Deal dams. South of Cullman I begin to notice signs twisted upside down as though they've been sawed off their metal posts. After scanning the AM talk shows a-crackle with sports hype, political outrage, and religious fervor, I take the exit for Highway 69 and pass through the community of Bremen before entering Walker County and stopping for my first sweet tea of the day. PJ's Restaurant and Dairy Bar are both closed, but the mini-mart beside the Citgo gas pumps is open, though a note taped to the door says the credit card machine is out of order because the place just got its power back. A friendly blond woman behind the counter tells me high winds ripped through the area during a thunderstorm on Monday afternoon. I pick up a copy of the *Daily Mountain Eagle* with a front-page shot of a downed tree that crushed several vehicles and a headline that nine thousand homes still lack electricity across the county. It was the most widespread severe weather in this part of the state since a devastating tornado outbreak two years ago. "What about all your chilled things?" I ask the woman. "Luck'ly we was able to save them," she says with a syrupy drawl.

I can't suppress modifying my own accent to country-southern, as Walker Evans recalled James Agee had done during their 1936 sojourn in Alabama. Like them, I am an outsider hoping to ingratiate myself with the locals, as I seek out the sites they documented in *Let Us Now Praise Famous Men*. What do the small towns and farm fields they lingered in look like three-quarters of a century later? How might today's rural poverty compare with that of the Depression, when the condition of southern sharecroppers was a subject of national scrutiny? Or of the eighties, when journalist Dale Maharidge and photographer Michael Williamson coauthored *And Their Children after Them*, a followup study tracing the cotton economy's decline and tracking down the descendants of those three tenant families Agee and Evans "dwelt among, investigated, spied on, revered, and loved"?[1] My aims are more modest but no less ardent: simply to set foot on a little hill that has long magnetized my mind. I embark on this trip with the attitude of one on a quest toward what has become another literary mecca for me: not a writer's home—Rowan Oak, say, or Andalusia, open for tours in the neighboring states—but rather an unmarked place at the heart of myriad words and images, a South located, as Agee exulted on getting lost, "somewhere toward the middle of one of the wider of the gaps on the road map."[2]

But I'm not there yet. Back on the highway I creep along a service strip on the outskirts of Jasper, where the Sons of Confederate Veterans, founded in 1896, keep a camp to the memory of Major John C. Hutto. This is hilly, forested country. Logging trucks rumble toward humming lumber mills. Passing abandoned stores and pristine churches, I stop by the neat brick edifice of Piney Woods Baptist. The cemetery is well-kept except for its rusted, ornate sign affixed to brick pillars. Looming over the entry is a magnificent red pine with enormous cones and sprays of long glossy needles. At the rear of the graveyard are blue trash bins, piles of discarded plastic flowers, and a wooden cross draped with a purple cloth. Birds call smartly from the treetops, and sunlight shines warmly on the tombstones. A staid monument of Jesus, hands held before his chest, stands watch over one lot. Common surnames include Barger, Swindle, and Calhoun. The larger granite stones—such as that of Bazzell Manuel McPherson, who volunteered in the Confederate Army at age eighteen

and lived to be eighty-two[3]—bear finely carved inscriptions, some with an epitaph or image. One man's smiling middle-aged face peers out from an oval likeness above his name, gone but not forgotten. He was buried twenty years after Agee marveled over photographs of the dead reproduced on certain stones at Shady Grove. Here, as there, many headpieces are crudely shaped and scored by hand, the letters of irregular sizes, the words not always fitting on crooked lines. Among these poorer folks are Elizbeth Franklin, Emline Washington, William More, Louis Scales, W. M. Christian (figure 1). Still other stones have cracked, crumbled, or sunk into the ground.

On the road once more I feel the need to hurry, as though I've been approaching my true destination too slowly. Up and down the heavily

Fig. 1. Gravestone, Piney Woods Cemetery, Walker County, Alabama.

logged, sparsely populated hills I roll, over the speedboats on a huge manmade lake, past plenty of roadkill, even a coyote carcass, through the industrial zone of Northport, and straight through Tuscaloosa with scarcely a glance toward the campus. Beyond the big box stores, poor neighborhoods, and new armed forces reserve center on the south side of this college town, which Agee renamed Cherokee City, I come into the country again. No one is around at Back 2 the Land Produce Market, other than a buzzard circling above the locked warehouse. Farther south, the Moundville Flea Market's Home Grown Fresh Produce stand also seems to be deserted, even though its green tables are filled with fruits and vegetables, no doubt not all homegrown in this season. As a decorative touch, two milk cans painted a darker green than the tables hold stalks of cotton with soft, white puffs of fiber clinging to the burst and desiccated bolls (figure 2). The goods are shaded by a long open-air shed with a red-and-white corrugated roof, on the underside of which sag fluffy strips of formaldehyde-free insulation stuffed sloppily into

Fig. 2. Cotton stalks in milk can at roadside produce stand, Tuscaloosa County, Alabama.

the rafters. Beneath the roof, behind the tables, is a storeroom with assorted objects hanging from its façade: hames, horseshoes, iron skillets, frilly nylon wreaths, a crosscut saw, an electric open sign that glows and buzzes faintly.

Nobody materializes to see what I want, so I drive down a row of empty cabins to where two men are fiddling with a boat hitched to a pickup. A whitebeard in overalls grumbles about the outboard motor, while a grizzled gray in sunglasses says he'll come up to help me. Out front I put a single tomato on the scale and hand him a dollar and ask about the cabins. He says they cost him $190,000 to build and hardly any vendors ever rent them. Another building, now used as an antique shop, he'd intended to be a drive-thru veggie mart, but apparently customers prefer to inspect their food before buying it. I ask if there are any good places to eat around here and he says that's 'cording to what I got in mind, and I say how about barbecue and he points across the highway to a windowless, aluminum structure with B. J.'s B-B-Q painted rusty red on the siding and a plump, anthropomorphic pig in blue overalls on a sizzling roadside sign. "Well brother," the man says through his scanty teeth by way of parting.

Inside Big John's, a woman in a Kid Rock shirt with severely cut, dyed blond hair takes my order and brings me a pitcher of sweet tea. It's almost two o'clock, and I'm as thirsty as I am hungry. While waiting for a tangy pork sandwich with fries, I overhear a couple chuckling with the wait staff about the lady's granddaddy who took a notion to settle in a house that hadn't been lived in for near forty years and was crawling with varmints and 'bout ready to collapse. Eager to probe such houses myself, I wolf my meal, pour a refill of tea, and then motor past a trailer park and a cookie-cutter subdivision dubbing itself a residential masterpiece, on into Hale County (figure 3).

The Moundville water tower is emblazoned with a mysterious symbol: two rattlesnakes knotted together and encircling a hand with an eye in the palm. This motif, believed to represent the night sky or a portal to the spirit world, had been engraved on artifacts including a sandstone palette found at a site now known as the Moundville Archaeological Park, where in the thirteenth century an indigenous people (ancestors

Fig. 3. Road sign, Hale County, Alabama.

of the so-called Five Civilized Tribes) heaped up dozens of earthen mounds and surrounded them with a massive log palisade to fortify this capital of their chiefdom along the Black Warrior River. Wandering the blossoming grounds to a lookout bluff, I spot a bald eagle swooping over the water and perching in a sycamore. Atop the grassy flat of the highest mound there's a sorry replica of a chief's abode, less authentic than the museum's cache of tools and pottery. A party of schoolchildren is aghast that murals depict Indian women without shirts. Why, I muse, hadn't Agee pondered local traces of what contemporary scholars call the Native South? For one thing, these relics weren't on view back then. And even if they had been, he might have overlooked them, just as he only dealt briefly with the extensive ongoing presence of African Americans, because *Fortune* magazine assigned him to report specifically on white tenant farmers. In fact, the recently rediscovered typescript of his rejected article does contain a sensitive appendix "On Negroes," as well as a lone reference to these Indian mounds where the remains of ancients were being dug up by Civilian Conservation Corps workers.[4]

Bumping over the railroad tracks down which I saw a train hurtling southward, I think of Agee's diaries ecstatically recounting his journey by rail to Chattanooga and by road to Alabama.[5] "An accounting of the train," he admits in one entry, "in no way advances the narrative and indeed obstructs it," so he wound up cutting his travel tales from the finished text.[6] To keep my own story moving forward, I too must omit various details and detours, yet I'm tempted to take River Bend Road to a public boat access ramp. A black fisherman in work boots, blue jeans, tan jacket, and tan cap sits on a white plastic bucket beside three rods propped among rocks a little ways downriver (figure 4). Walking toward him along the bank, I call out as to what he's fishing for. "Oh, alligators, turtles, whatever'll bite," he calls back. "Catfish and bass," he adds when I ask him again. Harold has a big frame, warm face, jovial laugh, thin mustache, and a toothpick in one corner of his mouth. He grew up in neighboring Perry County and spent twenty years in Chicago, working in a factory that made canvas for warplanes like them that flew to Iraq, until he hurt his knee and came home. Most of Harold's family up north

Fig. 4. Black Warrior River near Moundville, Hale County, Alabama.

will be down for Easter next week. He's surprised that I've driven all this way on back roads, and even more surprised that I'm from Pennsylvania. My John Deere hat, I explain, is on account of brand loyalty to the tractors on our family's dairy farm. "You'll just see beef cattle round here," he says. The main crop used to be cotton, of course, but now the land's mostly done over in soybeans and timber. Harold figures he's hooked something and starts to reel in one of his lines, but it's merely a gust of wind ruffling the water and messing with his bobber. "When the river rises," he says, "you've got to be careful." Once a man who backed down that ramp drowned after he got swept into the current along with his boat and truck. Sometimes the fancy houses nearby get flooded out and the homeowners have to be rescued. A heron flaps across the water and alights on a fallen trunk jutting out in the air from the shore. That gives me an excuse to take out my camera, and Harold obliges when I request his picture, too (figure 5).

After scrambling up the riverbank, I ease the car between swampy stands of thin trees as glistening water rushes through a culvert un-

Fig. 5. Harold fishing in Black Warrior River, Hale County, Alabama.

der the road. Beside a reservoir with a gazebo at the end of a pier, red-headed turkey vultures soar around a pole with sixteen gourd houses for martins suspended from umbrella-like arrays of flexible wires (figure 6). It's a higher-class version of the gourd stick Evans photographed against a cloud-laden sky and reprinted as his portfolio's final plate in the second edition of *Let Us Now Praise Famous Men*. The peopled houses closer to the center of Moundville (Agee's Cookstown) are quite humble, many of them as dilapidated as the cars up on blocks in the yards.[7] I park in an angled space near the brick façade of Miss Melissa's Café. Chained atop a detached pole, a circular burnt sienna Dr Pepper sign creaks in the breeze, which shakes a maroon awning loose from a metal framework above the café's plate-glass windows. Its hours are painted in curlicue cursive on the glass inside an ochre-colored door. Miss Melissa's is closed for the afternoon. Most of the establishments in the row of brick structures across Market Street are closed for good—their windows blinded or boarded, signs faded or awnings removed. The defunct general store has been colonized by the Living

Fig. 6. Gourd houses for martins, Moundville, Hale County, Alabama.

Word Christian Center (figure 7). Mitch Brown is its pastor, or teacher. One shop, selling wigs and beauty products for black women, like the shops on Girard Avenue in Philadelphia, is open. Behind the register, a pretty woman with dangling earrings guesses I'm not from around here and says she isn't either. She makes change for me so I can buy a newspaper from a vending machine. The freestanding brick office of *The Moundville Times* keeps (semi) regular hours three days a week, or else by appointment (or remarkably good fortune), quips a sheet taped to the door. Taped to a window is a colorful poster for the town's Spring Fling, to be held on its square the next four evenings. A carnival crew is setting up rides and booths for the midway. The bank, library, and fire station are in far better repair than the row of shuttered storefronts. Inside the library, at the moment, white patrons have monopolized a handful of widescreen Apple computers. Outside, where the elementary school is just letting out, there are as many black as white townspeople. At one edge of Moundville a forklift moves pallets from the gristmill to the retail room of the Feed and Seed (figure 8). At the other edge cars whiz by on Highway 69, along which, strung out over a few miles, are several gas stations selling diesel and regular petrol but not plus or

Fig. 7. Former general store occupied by religious center, Moundville, Hale County, Alabama.

premium, a billboard for Black Belt Land Sales, a plowed field next to a mobile home sales park, a Dollar General, Ward's Country Market, Hale County High School, the Wildcats' football stadium, Pappy's Bar-B-Q (where Harold does a little yard work), St. Gregory the Theologian Orthodox Church, Pleasant Hill Methodist Church, Indian Mounds Baptist Church, Moundville Church of the Nazarene, and The Miracle House of Prayer Apostolic Church Inc., whose signboard reassures: DO NOT WORRY / IT IS ONLY / A TEST (figure 9).

At the sign for Stewart United Methodist Church—featured in the local paper as "church of the week"—I turn off into pastureland along County Road 42, which runs parallel to a railway embankment with water shimmering in the ditches below grade. The tracks bisect the village of Akron, more remote and rundown than Moundville. All the students coming out of Akron's high school are black. Four girls practice dance steps alongside the road. A woman listening to music heaves up from a chair by her trailer to give me directions back to the highway. Before getting there I happen upon a brilliant white cotton patch that wasn't picked last fall, then an abandoned cotton gin (figure 10), which I recognize from Williamson's photographs.[8] I poke around its sun-

Fig. 8. Moundville Feed and Seed, Hale County, Alabama.

Fig. 9. Church signboard and logging truck, Highway 69, Hale County, Alabama.

splashed interior to take my own photos of its rusty tin walls, pipes, spouts, gears, belts, pulleys, presses, conveyors, augers, and lint-littered floor (figure 11). Two adjacent buildings must have been the cottonseed shed and gin office (figure 12). Agee's "Work" section describes the frenzied din in and around such places during the picking season. But the "dancelike and triumphal" processions of mule-drawn wagons to this gin ended decades ago; now its silence is ghostlike and somnolent, so that all it continues to radiate are "the big blank surfaces of corrugated metal, bright and sick as gas in the sunlight."[9] Despite that overripe patch, the only bale in the vicinity isn't made of cotton but of hay, rolled up like a giant sleeping bag on the ground beside a machinery shed housing a green-and-yellow baler just like ours back home. Nearby is a little burial plot with less than a dozen graves. Two hand-etched inscriptions—those for Bro Johnnie B. Tinker and Bro John W. Monroe—still appear wet in the molded cement, though both brothers have been "at rest" since 1999.

At Havana Junction, a crossroads Agee rechristened Madrid, I pull into a lot shared by a barber shop, a service station, and the sheriff's dispatch office for the north end of Hale County. Evans observed that

Fig. 10. Abandoned cotton gin near Havana Junction, Hale County, Alabama.

Fig. 11. Interior of abandoned cotton gin near Havana Junction,
Hale County, Alabama.

Fig. 12. Abandoned cotton gin office near Havana Junction, Hale County, Alabama.

Agee's innate courtesy toward others didn't extend to the police. I smile at the irony, which I discovered on a recent jaunt up in Jersey, that the house in Frenchtown where the writer composed much of his master-work is now occupied by that borough's police department. Here in Havana, Alabama, no deputies are around. Inside the service station I wait in line with a root beer while a brawny black man pays for a six-pack and a white family of four tarries by the candy shelf. At the counter I tell two women that I'm searching for a place that might not exist any-more, a place called Mills Hill. They can't say right where it is, but that man in the red shirt who just left likely can. Outside I talk to Neal, the father of two towheaded boys who clamor to show me a drawing. After shushing them into the backseat of his muscle truck, he instructs me to go back up 69 and turn right on Gabriel Creek Road. "It'll be a reg'lar paved road at first," he says, "till it turns into dirt and runs on to China Grove." Neal grins at his jacked-up tires and then squints at mine. "Goin ridin?"

The sign for Gabriel Creek Road is tilted at a forty-five degree angle. Beyond a dooryard that warns "No Trespassing" and "Beware of Dog," cows and donkeys pause grazing to gaze my way from behind a barbwire fence. A black teenager wearing headphones and shooting hoops waves to me from the driveway of his middle-class ranch house. Another road sign, for Summer Lane, has fallen down altogether. Soon I am behind a slow-moving pickup carrying a washer or dryer. I pull over when it does between a rotting wood house and a solid doublewide trailer with potted plants and a swing on the attached porch. Kenneth Owens, the high-voiced, bald black man in the pickup, says he isn't from Mills Hill himself but that the older man in the trailer is. Chester Bell steps onto his porch in a navy cap and jean jacket (figure 13). He can't tell me much, however, because his voice box has been cut out due to throat cancer. When he tries to say a word he presses on the white gauze covering his neck below his white goatee and emits a rasping sound that I can barely decipher. But with Ken acting as intermediary, we manage a conversation about the two books I've brought along. As I leaf through them,

Fig. 13. Kenneth Owens and Chester Bell, Gabriel Creek Road, Hale County, Alabama.

Chester's eyes glitter with recognition of the mayor's office and upstairs jail Evans captured in Moundville, while Ken lights up at the shots of Sprott's post office and Greensboro's business block, taken from the same vantage points fifty years apart and arranged for comparison in *And Their Children after Them*. Ken and Chester concur that one black man Williamson photographed in Mississippi was McKinley Ross, who played harmonica, and that the white man Maharidge referred to as Joe Bridges was really Joe Massey, whose sons and widow Ca'lyn still live across the highway at the bottom of the hill.[10] As for going further up it, some of the land up there belonged to a black man named Tom Elliott (pronounced A-yette), but Chester's sister Ruby, who lives across the road here, can tell me more.

Across the road, at the tidy yellow house with maroon trim, no one answers my knocking on the front and side doors. I walk into the garage, between a woodpile and a silver car, ringing the bell at the door Ruby Bell Brown uses. She opens it yawning and saying she's been asleep. She wears a black skullcap, a short-sleeved, white shirt unbuttoned over a red-and-white striped dress, blue socks, and white slippers. Yes, she was born on this road, which had always been Green Leaf but was recently rebranded Gabriel Creek, to her puzzlement because they ain't a Gabriel nor even a creek along it. She knows of Tidmore as a surname locally, but not of Tingle, Fields, or Burroughs, which Agee changed to Ricketts, Woods, and Gudger.[11] But Ruby Bell, one of eight siblings, wasn't born till 1938, two years after his visit. Her family sharecropped under Tom Elliott, whose Ageean alias was Tip Foster, and who lived with his wife, Willie, a bit further up the road in a house that might could've toppled over in the heavy winds the other day.[12] When Ruby was big-grown her childhood home burned down. In 1961 she moved to this house with her husband, Raymond Brown, but he passed in 1975. She still wears her wedding ring. Back then they raised cotton, but Gulf States done planted the whole hill in pine and they's cutting it now. Looking at Evans's photographs, she remembers hauling cotton on a wagon to the Havana gin and cooking on a cast-iron stove. I want to talk with her longer, but I also want to do some more exploring before the sun goes down. Taking off her skullcap and smoothing her hair, Ruby poses for her portrait (figure 14) as proudly as Chester, Ken, and Harold had.

Fig. 14. Ruby Bell Brown, Gabriel Creek Road, Hale County, Alabama.

The paved road gives way to dirt just past Ruby's place. It drops off into a trash-choked ravine on the left and runs deep under a concave red clay bank on the right. Puddles hold muddy rainwater from the storm two days ago. Rounding a curve, I come upon the ruins of that "whole cluster of houses . . . all negroes'," which Agee hurried past at night while walking between the white tenants' farms.[13] Closest to the road, and still standing to the greatest extent, is the one the Elliotts must have owned (figure 15). Its basic rectangular design is that of a dogtrot: two wooden boxes connected via an open hallway, except doors were once installed at either end. On the west side a whitewashed door hinges inward; on the east side doors are missing from frames in this central corridor and out the south room. Remnants of porch boards sag down front and rear.

The entire house is propped up on brick footers three or four feet off the earth, as if on stilts over a bayou, with plenty of space for chickens to scratch and children to scrounge underneath. The tin roof is rusted but sound. All the glass has disappeared from the windowpanes. Beneath the north wall's window, facing the road, is a spray-painted swastika meant to be Nazi but actually Hindu, and to its left, stark white across the pine weatherboarding, are the letters KKK (figure 16).

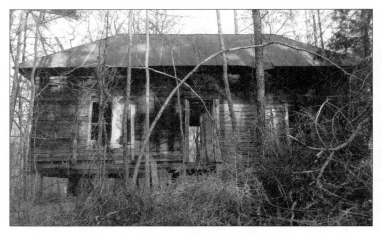

Fig. 15. Ruins of Elliott family home, Mills Hill, Hale County, Alabama.

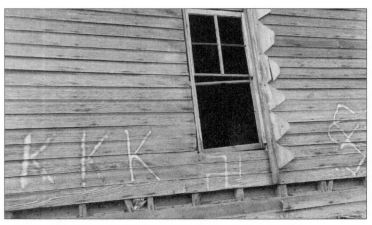

Fig. 16. Graffiti on wall of Elliott family home, Mills Hill,
Hale County, Alabama.

Near this house is another one of comparable size but in worse shape—half-buckled into a heap at the foot of a lonely, lovely stone fireplace and brick chimney (figure 17)—and beyond these two is a clearing with a wrecked outhouse awry on its hinges. A red gash of bulldozed land slopes away from it, punctuated by stumps and scattered with branches. Shadows of spindly trees rake across the west face of a third house, smaller than the others (figure 18). Windows are shuttered on both end walls. A disconnected electric meter is bolted to the east one. In the west room sooty bricks tumble out of a fireplace under a mantel aglow with sunlight (figure 19). Rafters of a derelict porch hang down naked on the north side, while sheets of roofing slide crazily on the south. Out to the east of this cabin is a row of white irises in full bloom.

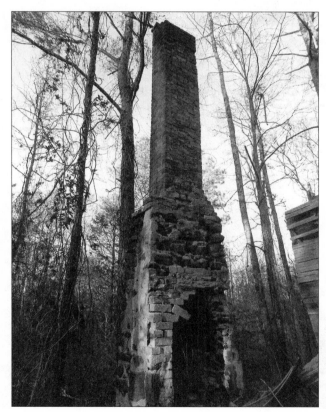

Fig. 17. Fireplace and chimney beside ruins of second house in Elliott cluster, Mills Hill, Hale County, Alabama.

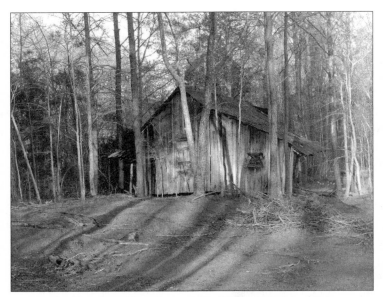

Fig. 18. Third house in Elliott cluster, Mills Hill, Hale County, Alabama.

Fig. 19. Fireplace and mantel inside third house in Elliott cluster, Mills Hill, Hale County, Alabama.

Their petals and sepals curl and droop voluptuously above the blade-like leaves: untended harbingers of ever returning springtime. There's no telling when someone planted these perennials, or when anyone last dwelled here.

Largest of all the structures in this cluster, and farthest from the road, is the barn Agee walked through the middle of (figure 20). Its shape resembles that of a temple—perhaps the first story of a Japanese pagoda—although in actuality its construction is vernacular, not at all as exotic as the kudzu vines surrounding it and engulfing so much of the South. The barn's open doorways are high and wide enough not only to fit a loaded wagon through but also to permit decent ventilation. Thick beams support a loft above livestock stalls and pens on either side of the dirt-floored passageway. I imagine Agee slipping through this barn in the dark, past nickering mules and drowsing cows, trying to muffle his movements in order not to waken the dogs. The footpath curving southwest, which he followed down toward the now effaced Gudger

Fig. 20. Barn belonging to black family on foot path between white tenants' farms, Mills Hill, Hale County, Alabama.

home, is blocked by uprooted trees. A rapidly lowering sun glimmers through the standing pines.

Back on the rutted dirt road I bounce another half mile through the forest that was once cleared fields of cotton, corn, and beans (figure 21). The Woods house, which I know to be obliterated as well, would have stood back a ways on the left, so I'm not expecting the crumpled shack that appears to that side close on the road. Round another curve the woodland opens up on the right into a fallow field of a good ten acres or so. This is the top of Mills Hill, referred to as Hobe's Hill in both books. The Ricketts house, which burned, according to Maharidge, in the seventies, had stood here in the thirties, in all likelihood in the shade of two great oaks and two cedars that still stand here just off the road, at the entrance to a field lane. Where the house had been, there's a pile of vine-encased concrete slabs. Behind it is a bush hog, probably owned by the Masseys, who continued to farm this plateau in soy after cotton went out. I stumble over a hunk of steel and scoop up the handle of a wagon tongue flaked with rust and clogged with clay.

Fig. 21. Dirt road atop Mills Hill, Hale County, Alabama.

Carrying it along, I walk back across the road toward the unexpected shack. Suddenly a logging truck roars up from behind and shifts gears for the downgrade (figure 22). The black driver looks down at me from his cab and raises a hand before pulling past and raising a cloud of red dust. Long-stemmed pink wildflowers grow by the roadside. Twenty yards off it the half-collapsed house huddles amidst spruces and red pines (figure 23). Much of the roof has caved in; a shattered chimney lies among the detritus. Bare pine, horizontal weatherboards are wrenched askew on the outer walls. The dwelling was split into four rooms. An interior door between the two front ones tilts open with a bird's nest on its upper edge and white wallpaper peeling off its vertical boards. This paper, unlike that on the walls, has a pattern to it, with repeated images of a steamboat, sidewalk scene, and horse-drawn carriage. Scraps of paper also cling to the diagonal board of a Z-shaped, see-through door green with mold, swung open at the back of the shack. At the threshold to an undoored hole between the smaller rear rooms is a displaced dresser drawer. Keeping an eye out for snakes and stepping gingerly to avoid exposed nails, I test the loose floorboards inside the far room, where more objects are strewn (figure 24). The floor is too unstable, so I backpedal and walk around the shack to enter that room. One corner is walled off

Fig. 22. Logging truck atop Mills Hill, Hale County, Alabama.

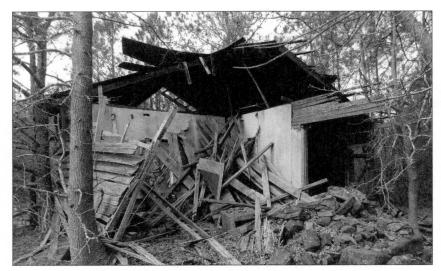

Fig. 23. Ruins of house atop Mills Hill, Hale County, Alabama.

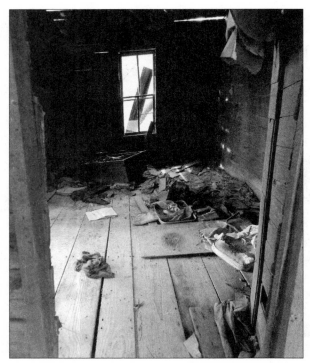

Fig. 24. Room in house atop Mills Hill, Hale County, Alabama.

as a closet or a commode. A smashed, old-fashioned, wood-framed television lies facedown with wires and knobs and tubes sprouting from its backside. Who had watched it, I wonder, and who had worn the rotten clothes on the floor? When was this house built, and when was it forsaken? Neither book about this hill mentions this place, which is odd considering its proximity to the other tenant homes. Now it's too ruined and dangerous even for lovers or troublemakers. Leaning over I pick up a slimy grade-school reading textbook and flip through its waterlogged, rat-chewed, dirt-encrusted pages. Selections of poetry and prose are organized into units geared to improve a user's understanding of one's self, family, nation, and foreign cultures: "Both for your sake and your country's, you need to know as much as you can about other lands and peoples." The platitudes are akin to those Agee and Maharidge quoted from textbooks they likewise found around these parts. Scrawled on this one, in blue ink and schoolkid script, are legendary names: Tom Jones, Camiska Miskelle, Verzelia Whitsett. Jotted in the margins are wistfully romantic yearnings: "Make love to me please"; "Give me back the man I love"; "Darling if no one claims me in 30 days I'm yours"; "I love the way you kiss my" That page, as with many, is torn where the body part was identified. I take the textbook with me, along with the wagon handle, a chimney brick, a splintered weatherboard, and a pinecone.

Breathing in the juvenescent air, so much fresher than that which surely enervates any workers or wayfarers come summer, I get in the car and roll the two miles down off the hill back to the highway. Turning left, I speed south on 69 into the depopulated heart of Hale County, as low late light casts shadows across cattle pastures, wooded hillsides, and hayfields speckled with round bales. There's nary a village and seldom a residence from Epp's Grocery in Havana all the way to the county seat at Greensboro, aka Centerboro, self-proclaimed the state's catfish capital on a blue water tower. A banner tacked to the side of a building before the turn onto Main Street declares that "Farming Feeds Alabama," with agriculture its number one industry. But it's hard to believe anymore. The business block, which thrived during the reign of King Cotton, is sick as could be in the aftermath of its demise.[14] Greensboro in the gloaming is as depressing a place as I've ever been. Agee also deplored its Sunday

afternoon listlessness. I stroll along both sides of the street hunting the precise spot in an upstairs room where Evans positioned himself to snap his timeless photo. The two-story brick buildings are still here, but the old businesses—C. A. Johnson & Son, McCollum Grocery Co., Loftis Café—are gone and few have replaced them. At seven o'clock Sledge Hardware is locked up, as is God's Gift Barber Shop and the Pie Lab. Black men pump iron at Life Fitness, while a white woman answers phones at a land and timber real estate office. Most of the vehicles in town are parked beside a technology center that provides free internet access. The library will be closed tomorrow, however, as it is every Thursday, and the clerk's office at the courthouse was closed today, as it will be every Wednesday hereafter, by order of the state's chief justice Roy Moore, who cited "a substantial lack of adequate funding" as the cause. In front of the courthouse, with its grayish bell tower and greenish cupola constructed in 1907, is the Civil War monument topped with a rifleman facing north, under whose guard are inscribed the names and regiments of ordinary folks who by dint of circumstance, fanaticism, or bravery all became mythic heroes: "Lest We Forget Our Confederate Soldiers." At the base of this selfsame pedestal, Evans and Agee first met the three impoverished men they later praised and made famous. A purple afterglow bruises the sky to the west of the time-warped main drag. Dusk is falling fast. Soon, as Agee rhapsodized, the lamps will be out all over Alabama, or at least all across its vast rural stretches. The stars and half-moon of the vernal equinox will shine hard and bright as city lights. And now, my pilgrimage completed, I am headed for a hotel in Birmingham, where at length I too shall sleep.

NOTES

1. James Agee and Walker Evans, Let Us Now Praise Famous Men: *An Annotated Edition of the James Agee-Walker Evans Classic, with Supplementary Manuscripts*, ed. Hugh Davis, vol. 3 of *The Works of James Agee*, gen. eds. Michael A. Lofaro and Hugh Davis (Knoxville: U of Tennessee P, 2015) 11. Subsequent references to this edition will be noted as Davis, *LUNPFM*.

2. Davis, *LUNPFM* 28.

3. His name is spelled differently—as Basil Manly McPherson—on a military stone at the foot of his grave, and differently again—as B. M. McPhearson—on his wife's headstone, the top portion of which has fallen off so that she remains anony-

mous, at least to passersby like me. Albeit born ten years after her husband, she died thirty-five years before he did.

4. For Agee's rejected *Fortune* article, see "Cotton Tenants," appendix 2 of Davis, *LUNPFM* 565–646. Less delicate than his comments about African Americans, who accounted for every third tenant in the mid-1930s, Agee's mention of the CCC exhumation alludes to the progenitors of these mound-building Native Americans as "the bones of diminutive Mongolians 3500 years dead" (620).

5. For these entries, see Michael A. Lofaro and Hugh Davis, eds., *James Agee Rediscovered: The Journals of* Let Us Now Praise Famous Men *and Other New Manuscripts* (Knoxville: U of Tennessee P, 2005) 3–9, 38–41, 57–61.

6. *James Agee Rediscovered* 8. In spite of this admission, Agee's journals, which served partly as drafts for the manuscript of *Famous Men*, attempt to reconstruct his train and auto trips because they signified the start of his personally electrifying Southern excursion in the summer of 1936. Excluding these passages ultimately helped to tighten a book that became bloated with ancillary digressions. Nevertheless, Agee's endeavors to recapture his ride on a "continent-eating train" (4) do involve some novel features, such as his cinematic panning and adoption of the land's point of view as "a rumor of iron" bears down on it and bruises its integrity (6). Similarly, his descriptions of driving solo from Chattanooga to Birmingham reveal him identifying ever more irresistibly with the rural South. Summing up his giddy experience behind the wheel of a rental car, he writes, "In memory the whole drive reduces and perfects itself chiefly into three things: the sense of movement; the sense of rhythm and phrase in the sum of the major directions taken and magnet-influences undergone; specially clear recalls of a few sights or incidents" (61). My sensations and impressions are much the same as I make my way toward Hale County.

7. In Agee's rejected "Cotton Tenants" article, which offers a fuller account of "communal life" than does the book he went on to write, the reporter delineates Moundville as "a town on the small side of small and the mean (not tough, just mean) side of mean" (620). And in *Famous Men* he refers to it simply as a "bare and brutal town" (280).

8. See the plates on pages 72–73 of the portfolio at the beginning of Dale Maharidge and Michael Williamson, *And Their Children after Them: The Legacy of* Let Us Now Praise Famous Men: *James Agee, Walker Evans, and the Rise and Fall of Cotton in the South* (New York: Pantheon, 1989). These photos, from 1986, show the gin in a state of abandonment similar to that in which I find it. After almost three more decades of dilapidation, I am surprised that it is standing at all.

9. Davis, *LUNPFM* 280.

10. For the men in question, see the photos on pages 37 and 10, respectively, of the portfolio in *And Their Children after Them*. The entrance to Massey Loop Road lies to the west side of Highway 69 just across from Gabriel Creek Road.

11. Throughout his "Cotton Tenants" article, Agee used the actual names for these families as well as for their landlords. In *Famous Men*, J. Watson and J. Christopher Tidmore became T. Hudson and Michael Margraves, while Fletcher Powers became Chester Boles.

12. As my next paragraph attests, this house has not toppled over yet. Williamson and Maharidge also feature its ruins in *And Their Children after Them*. Back when it was inhabited, though, Evans did not photograph it, and Agee mostly skirted it. In the "Education" section of "Cotton Tenants," after noting that in dry weather the white children would meet the school bus beside Tom Elliott's house, he then states parenthetically, "Tom Elliott is a white-skinned, red-haired ill-witted Negro who has nothing to do with our story" (613). And in keeping with this bizarre dismissal of the black landowner, in *Famous Men* the writer only mentions him once, by his pseudonym, when several of the Ricketts kids tell Agee, in nearly indecipherable dialect, that in order to get to the Gudger place from their farm he should "go awn daown the heel twhur Tip Foster's haouse is ncut in thew his barn nfoller the foot paff . . ." (314).

13. Davis, *LUNPFM* 63.

14. In a draft of "Persons and Places," appendix 8 in Davis, *LUNPFM*, Agee describes Greensboro's atmosphere thus: "A pre-civil war seat of a cotton county. The air of a shut room in which someone old and insane has been dying for a long time while the sun stands in brilliantly through many windows" (817).

Contributors

PAUL ASHDOWN, Professor Emeritus of Journalism and Electronic Media at the University of Tennessee, Knoxville, is the editor of *Complete Journalism: Articles, Book Reviews, and Manuscripts*, the second volume in the scholarly edition of *The Works of James Agee*. He edited *James Agee: Selected Journalism* (1985 and 2005) and contributed essays on Agee to *James Agee: Reconsiderations* (1992), *A Sourcebook of American Literary Journalism* (1992), the *Encyclopedia Americana* (1996), *Agee Agonistes: Essays on the Life, Legend, and Works of James Agee* (2007), the *Encyclopedia of American Journalism History* (2007), and *Agee at 100: Centennial Essays on the Works of James Agee* (2012). His latest book is *Inventing Custer: The Making of an American Legend* (2015), the fourth volume in a Civil War-era series written with Edward Caudill.

ANNE BERTRAND, Professor of Art History at the Haute école des arts du Rhin in Strasbourg, France, is at work on a dissertation titled "Walker Evans's Writings and Interviews: Critical Edition," under the supervision of Professor François Brunet (Université Paris Diderot-Paris 7) and Professor Michel Poivert (Université Paris 1 Panthéon-Sorbonne). She previously worked as an editor (Hazan, Encyclopaedia Universalis), and wrote as a critic on art (*Libération*, *art press*), photography (*Vacarme*), and cinema (*Trafic*). She is the author of *Le Présent de Robert Frank* (2008) and the editor of *Tacita Dean, Écrits choisis 1992–2011* (2011). In 2013 she was granted a Fulbright Fellowship and spent six months in New York and New Haven, as a Visiting Fellow at Yale University.

CAROLINE BLINDER, Senior Lecturer in American Literature and Culture at Goldsmiths, University of London, has published widely on

the intersections between literature and photography. Her forthcoming monograph, *The American Photo-Text: 1930–1960*, traces a series of documentary collaborations and creative endeavors between photographers and writers, including Agee and Evans. Blinder has previously written on Agee in her edited collection *New Critical Essays on James Agee and Walker Evans: Perspectives on Let Us Now Praise Famous Men* (2010); in *Fifty Key Writers on Photography*, ed. By Mark Durden (2012); and in "Between the Unimagined and the Imagined: Photographic Aesthetics and Literary Illumination in James Agee's *Let Us Now Praise Famous Men*," *Moments of Moment: Aspects of the Literary Epiphany* (1999).

BRENT WALTER CLINE is an Associate Professor of English at Spring Arbor University, where he teaches courses in American literature. His scholarly work on suffering and disability has appeared in *Disability Studies Quarterly*, The *South Carolina Review*, and in an upcoming collection on Walker Percy's *The Moviegoer* (LSU Press).

JEFFREY COUCHMAN is the editor of the forthcoming book *"The African Queen" and "The Night of the Hunter": First and Final Screenplays* (part of *The Works of James Agee*, published by the University of Tennessee Press). He is the author of *"The Night of the Hunter": A Biography of a Film* (Northwestern University Press, 2009) and has written the book and lyrics for two musicals: *Blood and Fire*, performed in New York City, March 2015, in the Theater Resources Unlimited's New Musicals Reading Series, and *Battleship Potemkin*, presented in Berlin by Gallisas Theaterverlag, September 2015. His articles on film have appeared in *American Cinematographer*, *Journal of Film Preservation*, and the *New York Times*. His fiction has been published in various literary quarterlies. He has collaborated on screenplays for Imagine Films, Warner Bros. Television, and others. He currently teaches screenwriting at the College of Staten Island.

JAMES A. CRANK is Assistant Professor of American literature at the University of Alabama. His work has appeared in *Southern Literary Journal*, *Mississippi Quarterly*, *Southern Studies*, and collections such as *Agee Agonistes: Essays on the Life, Legend, and Works of James Agee* (2007), and *Southerners on Film: Essays on Hollywood Portrayals Since the 1970s*

(2011). His book *Understanding Sam Shepard* was released from the University of South Carolina Press in 2012, and his edited edition *New Approaches to* Gone with the Wind, from Louisiana State University Press in 2015.

ANDREW CROOKE teaches literature and writing at Moravian College and East Stroudsburg University. He has also taught at several other universities in eastern Pennsylvania, as well as at the College of New Jersey. He earned a BA in English (summa cum laude) from Cornell University and a PhD from the University of Iowa, where he was a Presidential Fellow. His dissertation, "In Praise of Peasants," examines photo-textual representations of rural poverty. He previously contributed an essay on *Let Us Now Praise Famous Men* to *Agee at 100: Centennial Essays on the Works of James Agee* (2012).

HUGH DAVIS, Associate Professor of English at Piedmont College in Demorest, Georgia, is the Associate General Editor of *The Works of James Agee*, coeditor, with Michael A. Lofaro, of *James Agee Rediscovered: The Journals of* Let Us Now Praise Famous Men *and Other New Manuscripts* (2005), author of *The Making of James Agee* (2008), and editor of *The Works of James Agee*, volume 3: Let Us Now Praise Famous Men: *An Annotated Edition of the James Agee-Walker Evans Classic, with Supplementary Manuscripts* (2014).

JEFFREY FOLKS has taught in Europe, America, and Japan, most recently as Professor of Letters in the Graduate School of Doshisha University. He has published numerous books and articles on American literature, including *From Richard Wright to Toni Morrison: Ethics in Modern & Postmodern American Narrative* (2001), *In a Time of Disorder: Form and Meaning in Southern Fiction from Poe to O'Connor* (2003), and *Damaged Lives: Southern and Caribbean Narrative from Faulkner to Naipaul* (2005). His articles on American literature and culture have appeared in many journals, including *Modern Age*, *Southern Literary Journal*, and *Papers on Language and Literature*.

SARAH E. GARDNER is Professor of History and director of the Center for Southern Studies at Mercer University where she teaches courses on southern history, literature, and culture. Much of her work focuses on

the production, dissemination, and reception of southern literary texts. She is the author of *Blood and Irony: Southern White Women's Narratives of the Civil War, 1861–1937* (2006) and associate editor of *Voices of the American South* (2004), a collection of southern writing. Her manuscript "Reviewing the South: The Literary Marketplace and the Making of the Southern Renaissance" is at Cambridge University Press. She is currently working on a book-length project that examines reading during the Civil War.

JESSE GRAVES is an Associate Professor of English at East Tennessee State University. His first poetry collection, *Tennessee Landscape with Blighted Pine*, won the Poetry Book of the Year Award from the Appalachian Writers Association. His second collection of poems, *Basin Ghosts*, won the 2014 Weatherford Award in Poetry. He was awarded the 2014 Philip H. Freund Prize for Creative Writing from Cornell University, and the 2015 James Still Award from the Fellowship of Southern Writers. His poems and essays have appeared in such journals as *Connecticut Review, Louisiana Literature, South Carolina Review*, and *Tar River Poetry*.

MICHAEL JACOBS teaches writing, literature, and film courses at Berkeley College in New York City where he is the Co-Chair of English. He is also the founding director of the Consortium for Critical Reading, Writing, and Thinking. He earned a doctorate in English from St. John's University and both an MA in Humanities and BA in Media Studies from the University at Buffalo. His essay, "Confronting the (Un)Reality of Pranksterdom: Tom Wolfe and the Electric Kool-Aid Acid Test" was published in *Literary Journalism Studies* (Fall 2015).

ERIK KLINE is a doctoral candidate in English at the University of Alabama. He has taught a variety of literature and writing courses on visual textual representation, including the national ideation and consumption of the Dirty South. His primary research focuses on twentieth-and twenty-first century American culture and literature, with interests that include fringe- and countercultural histories, perceptions of physical and mental pathologies, and intersections of word and image. His dissertation explores travel, conversion, and addiction narratives by American life-writers.

MICHAEL A. LOFARO is the Lindsay Young Professor of American Literature and American Studies at the University of Tennessee. His book-length work on Agee includes the editing of *James Agee: Reconsiderations* (1992), coediting *James Agee Rediscovered: The Journals of* Let Us Now Praise Famous Men *and Other New Manuscripts* (2005) with Hugh Davis, and editing *Agee Agonistes: Essays on the Life, Legend, and Works of James Agee* (2007); *Agee at 100: Centennial Essays on the Works of James Agee* (2012); and volume 1 of *The Works of James Agee, A Death in the Family: A Restoration of the Author's Text* (2007). He serves as the General Editor of the scholarly edition of Agee's works for the University of Tennessee Press.

DAVID MADDEN is the Robert Penn Warren Professor Emeritus at Louisiana State University. Poet, playwright, critic, and novelist, he has published many short stories, several of which have been reprinted in numerous college textbooks. Two of his novels, *Sharpshooter* (1996) and *The Suicide's Wife* (1978), have been nominated for the Pulitzer Prize. He has edited two editions of *Remembering James Agee* and contributed to four previous Agee volumes. As a historian, he is founding director of the United States Civil War Center and author of *The Tangled Web of the Civil War and Reconstruction* (2015). A book about him is *David Madden: A Writer for All Genres*. His eleventh novel, *London Bridge in Plague and Fire*, appeared in 2010, in 2014, his fourth book of stories, *The Last Bizarre Tale*, appeared, *Marble Goddesses and Mortal Flesh: Four Novellas*, is forthcoming.

DAVID MOLTKE-HANSEN built and directed historical collections and programs at the South Carolina Historical Society, the University of North Carolina at Chapel Hill, and the Historical Society of Pennsylvania. Coeditor of *Intellectual Life in Antebellum Charleston* (1986), he helped found *Southern Cultures*. Since turning to full-time editing and writing in 2007, he has edited seven volumes, contributed two dozen essays, and launched, for the University of South Carolina, electronic and print editions of the writer William Gilmore Simms. Founding coeditor of Cambridge Studies on the American South, he is writing, under contract, *Generations Consumed: The Civil War in Southerners' Lives* and *Southern: The Rise and Ebb of an American Regional Identity*.

Index